"They're Still
Women After All":
The Second World War
and Canadian Womanhood

"They're Still Women After All": The Second World War and Canadian Womanhood

Ruth Roach Pierson

M&S

Canadian Cataloguing in Publication Data

Pierson, Ruth Roach, 1938-
 "They're still women after all"

(The Canadian social history series)
Bibliography : p.
Includes index.
ISBN 0-7710-6958-8

1. World War, 1939-1945 - Women - Canada.
2. World War, 1939-1945 - Participation, Female.
3. Women - Canada - History - 20th century.
4. Women - Canada - Social conditions. I. Title.
II. Series.

D810.W7P53 1986 305.4'0971 C85-090816-7

Printed and bound in Canada

McClelland & Stewart Inc.
The Canadian Publishers
481 University Avenue
Toronto, Ontario
M5G 2E9

Contents

Acknowledgements / 7

Introduction / 9

1 Women's Emancipation and the Recruitment of Women into the War Effort / 22

2 Government Job-Training Programs for Women, 1937-1947, with Marjorie Cohen / 62

3 "CWAC of All Trades" / 95

4 Wartime Jitters over Femininity / 129

5 Ladies or "Loose" Women / 169

6 VD Control and the CWAC in World War II / 188

Conclusion: "When Fluffy Clothes Replace[d] the Uniform" / 215

Annotated Bibliography / 221

Notes / 237

Index / 290

*To those students
who have challenged, inspired,
and sustained me.*

Acknowledgements

This book has been longer in the making than the six years of the Second World War. The people who have assisted me over the long haul are too numerous for all to be named. Nonetheless, without intending ingratitude to the others, there are some I would like to single out for thanks. High on that list is the staff of archivists at the Public Archives of Canada, particularly John Smart, Barbara Wilson, Glenn Wright, and Joy Houston. Equally important on those archival visits was the stimulating company and general camaraderie of other researchers; I remember in that context Suzann Buckley and Jeanne L'Esperance with especial fondness. Nor have I forgotten the "home away from home" that Andrée Lévesque created for me in Ottawa on so many of my research visits to that city. The interest taken in my work in the early years by Terry Copp, Alison Prentice, Susan Mann Trofimenkoff, and Margaret Conrad played an essential role, I am sure, in giving me the confidence to continue. I am also grateful for the encouragement and helpful criticism I received from former colleagues in the History Department of Memorial University, among them James A. Tague, David Alexander, Ralph Pastore, Andy den Otter, and Douglas Hay. To have had the opportunity of collaborating with Marjorie Cohen on one chapter was a special pleasure. And on more occasions than I can now remember, I have drawn incalculable benefit from the advice and example of my friend Jane Lewis.

Over the years I have received funding to help defray the costs of making research trips and preparing a manuscript. In this category I should like to thank Memorial University of Newfoundland for summer travel grants, the Department of National Defence for a post-doctoral fellowship in 1980-81, and the Ontario Institute for Studies in Education for small-scale

grants to hire typing, editorial, and indexing assistance.

This book has been published with the help of a grant from the Social Science Federation of Canada, using funds provided by the Social Sciences and Humanities Research Council of Canada. I am especially grateful to the SSFC for this support.

In the final stages of manuscript preparation, I have been indebted to the energies and skills of a number of people. Helen Lenskyj contributed in key ways to the first round of re-editing and to the compilation of the annotated bibliography. Mona Oikawa made valuable additions to the latter. To Beth Light goes the credit for the expert circle graphs in Chapter Three. Didi Khayatt dispensed some rare Egyptian magic. Margaret Brennan typed and retyped large portions of the manuscript. Kathy Arnup's sharp editorial eye oversaw the agonizing final rewrite (although she bears no responsibility for any excessively long and convoluted sentences still in the text).

Both Marg's and Kathy's contributions, however, extended far beyond the mechanics of manuscript preparation. Marg's unfailing humour and equanimity have often provided the one point of stability amidst a chaos of conflicting deadlines. And without Kathy's standing by, spurring me on and brushing aside doubts, I might never have finished. Gregory Kealey's supportive commitment has also been invaluable. Finally, for the experiment of daily negotiating and renegotiating an equitable division of domestic labour, I should like to thank Dwight Boyd.

Introduction

When the Canadian government declared war against Germany on September 10, 1939, Canada was still in the throes of the Great Depression. Out of a population of 11 million, approximately 900,000 workers were unemployed, and an estimated 20 per cent of these were women. The roughly 600,000 women in gainful employment comprised about 17 per cent of the official labour force and more than one-third of them had jobs as domestic servants. Canada's entry into the war rejuvenated the country's economy and at the same time expanded its military. In 1941-42 attention turned to "womanpower" to relieve the "manpower" shortages threatening both the armed forces and industry. By autumn 1944 the number of women working full-time in Canada's paid labour force was twice what it had been in 1939, and that figure of between 1,000,000 and 1,200,000 did not include part-time workers or the 800,000 women working on farms. Furthermore, most of Canada's three million adult women were contributing volunteer labour to the war effort. And by war's end, nearly 50,000 had served in the Women's Services of the Canadian armed forces. Did this vast mobilization of the female population of Canada lead to a more equal sharing of power and responsibilities between men and women in the public and private spheres of Canadian society? Did war "liberate" Canadian women from patriarchal divisions of labour and conceptions of proper womanhood?

It was an assignment I made in the first course I ever taught in women's history that led to the writing of the original version of Chapter One of this volume. In answer to the question, "Why was there such widespread acceptance of the feminine mystique?" following World War II, one student wrote of her own experience as a young woman in British Columbia during and

9

immediately after the war. Her paper elicited the following comment from me:

> This is a very interesting and valuable document. It certainly throws into doubt the widely held assumption that women's greater participation in the public labour force during World War II greatly contributed to women's liberation. Other sources, as well as the fact of the willing retreat to the home after World War II, have led me to question the "emancipating" effect of WWII on women. I should like to discuss with you how this assumption might be examined and the experience of WWII for women re-evaluated.

The war had been over for thirty years when that paper was written and the author, a middle-class woman in her early fifties, was actively involved in the creation of the St. John's Council on the Status of Women. The various prisms through which her recollections were refracted included, consequently, at least those of selective memory itself, current feminist involvement, and class. I perceive the world, including the world of the past, through some of the same filters and this is perhaps one of the reasons why Shirley Goundry's paper had such a catalytic effect on me. Although originally from the state of Washington rather than the province of British Columbia, I, too, have memories of the Second World War, if only those of a child, and I also share a commitment to feminism as well as a middle-class background.

When Germany invaded Poland in September, 1939, Shirley Goundry was in her last year of high school. For one year following graduation she stayed at home in the small town of her birth and worked in an office. "At that point I saw the effects of the war primarily in terms of the young men leaving," she recalled. The next year, 1941-42, she moved to Vancouver and worked during the day while taking a commercial course in the evenings. After two months she was offered a challenging and fairly responsible job, "which," she realized "in looking back, was available to me only because the man who held the job had enlisted and there was no other man to take the job." Then what she has described as the "great call to patriotism" beckoned and she enlisted in the Women's Division of the Royal Canadian Air Force. As she remembered it,

> the call to enlist was definitely to release men for active duty and the call to work in war factories was to fill in while the

men were away. At no time was there any consideration or thought given to the development of women's talents or potential for their own personal benefit or to prepare for a long term career. I did not, and do not, see this as any part of women's liberation as recruitment was strictly to serve the country while the men were off doing the number one job. Implicit in this was the understanding that this work was as temporary for women as combat was temporary for men.

That paper was submitted to me in February, 1975. In June of that year I went to the Public Archives of Canada to try to test some of Goundry's claims. Providentially, on my first day there, I was introduced to archivist John Smart, who in turn introduced me to the document inventories for the Department of Labour listing the files of the wartime Women's Division of National Selective Service. They kept me busy for a summer and out of that research came my first paper on Canadian women and the Second World War, which focused on the recruitment of women into the labour force. A revised version of this paper appears here as Chapter One.

The sources I consulted largely confirmed Goundry's memories while situating them within the larger context of the state's manipulation of "womanpower" (a new term in the popular vocabulary of the time)[1] for the war effort. Certainly Goundry was right about the patriotic appeal made to women; but her account ignored the economic motivation of vast numbers of women who responded. In either case, the massive recruitment of women into jobs outside the home was intended to be only for the duration of the war and represented no concession of the principle of women's right to work. In 1941-42 Department of Labour officials and economic consultants openly recommended relieving manpower shortages by mobilizing the labour reserve of women. They used more veiled language when planning women's return to "reserve" status at war's end. The only check on women's mobilization was to be respect for their primary commitment to home and family. Nonetheless, income tax concessions were made to induce married women to take war industrial jobs, and, when even the labour of women with young children was needed for the war effort, a Dominion-Provincial Wartime Day Nurseries scheme was worked out. This was not a long-term government commitment to facilitate women's employment by easing their domestic responsibilities;

only the war emergency justified these measures, and they were rescinded once the war was over.

A major addition I have made to this study for the present volume is to include material on the mobilization of women's traditional labour for the war effort. Organized women themselves took the initiative in mobilizing women's volunteer labour; the government stepped in only in 1941. But women's impressive display of patriotism in putting together bundles for Britain and soldiers' parcels, organizing entertainment for service personnel on leave in towns far from home, collecting salvage, monitoring inflation, and selling war bonds won no more than a marginal voice for women within the committees and councils on post-war reconstruction.

Chapter Two of the present work, written in collaboration with economist Marjorie Cohen, takes up some of the same themes pursued in the first chapter, but in the more specific context of education for work. It thus provides a further analysis of the connection between deep-seated popular attitudes toward women's social role and official policies governing women's place in the paid labour force during the period 1937-47. Starting with the proposition that vocational training is one of the determinants of economic status, we examine the availability and kind of government-supported job training for women as compared with men before, during, and after the Second World War. While the training provided for female labourers changed with the changes in the labour market, from overcrowding, to wartime scarcity, back to post-war fear of labour glut, we found a number of policy-determining "perennials" "hardy"[2] enough to survive the impact of war. Most persistent of these was the priority given to the male as breadwinner, a bias strongly reinforced at war's end by society's gratitude to veterans returning from combat service. Also in conformity with male economic primacy, jobs deemed most appropriate for women tended to be ones men had no interest in and hence training women for them posed no threat of female competition. Domestic service was seen as meeting this qualification most satisfactorily, after as well as before the war, despite the distaste shown for this occupation by ex-service-women and unemployed female war workers. Equally persistent was the assignment to women of the primary responsibility for unpaid child care and housework. Post-war policy-makers were by and large blind to the contradiction between the imposition on women of home responsibilities and the promise of equality

in the marketplace. Indeed, egalitarian rhetoric was the main legacy of the Second World War's assault on sex roles, for the talk of equality of opportunity and accessibility was consistently belied by rehabilitation training schemes designed to perpetuate a sex-stereotyped and sex-segregated labour market, as well as by a general "full employment" policy that rested to a significant degree on the retirement of tens of thousands of women to domesticity.

Just as there were women who threw themselves into volunteer work for the war effort from the very outset, so were there women who even before the outbreak of hostilities offered to render military service to their country. But had their desire to serve in uniform not coincided with developing manpower shortages in the armed forces, it is doubtful whether women's services would ever have been formed. The pattern of women's active recruitment into the armed forces during the war followed by the disbandment of the women's services in 1946 parallelled the way women were first mobilized into the civilian labour force when war industry demands were high and then eased out as war production wound down. Chapter Three, on the admission of women into the Canadian Army in the Second World War, begins with the question of how women's labour was used by the military during the war and moves to a consideration of the implications of servicewomen's non-combatant support role for the place of women in Canadian society in general.

In the original version of "CWAC of All Trades," I started with the following observation:

> Patriarchy has survived the industrialization of western society under capitalism. Women as a group have remained subordinate to men as a group. To speak of the subordination of women and the superordination of men reflects the differing relation of women and men to power in the sense of "power over," of dominance.[3] A power difference is part of the inequality of the male-female relationship under patriarchy: male dominance is the other side of women's subordination. The enforced economic dependence of many women on male providers has contributed greatly to the perpetuation of that power difference and the survival of patriarchy. So, too, has the restriction of women's access to arms and the military.

I further pointed out that, in analysing the existing sovereign state system, many political thinkers, including Machiavelli, Engels,

and Lenin, have identified coercive force, in particular military might, as essential to the power of the state. Men's monopoly on official arms bearing must then have contributed to the power of men as a group vis-à-vis women as a group within the Canadian state and society. Did women's admission to the armed forces during the Second World War alter those power relations? Chapter Three is an examination of that question. I conclude that the cautious and carefully circumscribed extent to which women were admitted into the military at that time precluded any fundamental change in gender relations. Above all, women's exclusion/exemption from combat duty and official arms bearing ensured that the male sex retained exclusive access to positions of high command within the military as well as the symbolic power and authority of the "protector" within society as a whole.

Other recent works have also attended to the question of the connection between patriarchy and women's exclusion from combat, as have a number of contributions to the volume *Female Soldiers – Combatants or Noncombatants? Historical and Contemporary Perspectives*, edited by Nancy Loring Goldman.[4] Jeff M. Tuten, describing the Nazis as vociferous opponents of women's emancipation, blames Hitler's ideological commitment to separate feminine and masculine spheres for his refusal to permit the creation of a women's combat battalion until so late in the war that it could never be organized. Furthermore, Tuten holds the German armed forces' insistence on preserving the military as an exclusively male caste responsible for the non-militarization of the women's uniformed service auxiliaries and for the prohibition against their use of firearms even if capture by the enemy was imminent.[5] Similarly, Karl L. Wiegand attributes the total absence of women from Japan's military establishment of the Second World War to the "stereotypically male-dominated" nature of Japanese society.[6] And Mary Wechsler Segal argues that women's exclusion from combat has occurred in societies in which "Men have been the rulers and the property holders" and "have had power over women, in some cases absolute power."[7]

Admission of women to combat, however, has not necessarily led to the erosion of male dominance in a society. Women's use in life-endangering missions and as armed warriors has tended to occur during times of extreme threat to the nation or great social turmoil, as when a country faces invasion and conquest by a foreign enemy or is in revolutionary struggle against a

repressive colonial or indigenous regime. But, Nancy Loring Goldman warns, even very high levels of involvement of women in combat, as in Russia and Yugoslavia during World War II and in Vietnam during the recent war against the U.S., did not guarantee equality in the armed services or in other fields of human endeavour, either at the time, or in the post-war society. Patriarchal power persisted as the military elites remained male and the political and military decisions to put women into combat remained almost exclusively in the hands of men.[8]

Research on the structure and functioning of the Canadian Women's Army Corps led to an exploration of the subjects taken up in the final three chapters of the book. By keeping close tabs on its personnel, the Department of National Defence generated a mine of information for the social historian. In delving into the military sources, it should be noted, I never intended to write an official, regimental history of any one of the women's services;[9] I sought instead to work these rich veins of documentation for what they could yield in the way of insights into the social construction of Canadian womanhood during and immediately after the Second World War.

While researching recruitment literature and newspaper and magazine stories promoting the women's services for "CWAC of All Trades," I kept finding evidence of a preoccupation with the "femininity" of the women in uniform. The extensiveness of this concern persuaded me eventually to set aside that material for consideration in a separate study, here published for the first time as Chapter Four, Wartime Jitters over Femininity.

Growing out of that research was the discovery that behind the recruitment crisis of 1943 lay a "whispering campaign" impugning the sexual morality of servicewomen. Since chastity was widely regarded as the most essential ingredient of proper womanhood, the furore over servicewomen's sexual respectability can be seen at one level as a more extreme expression of the fear of loss of femininity. In this case, the fear focused on the spectre of women becoming sexually independent beings.

To capture the scale of the "whispering campaign" I have employed in Chapter Five the concept of "moral panic." The term refers to an exaggerated reaction to the threat of social change and against " 'A condition, episode, person or groups of persons' " that become identified as the embodiment of the threat.[10] The wholesale labelling of servicewomen in 1943 as "promiscuous" bore little or no relation to the actual, minuscule

incidence of "illegitimate" pregnancy or VD within the women's services. The women in uniform had come to symbolize the war's threat to traditional sexual morality and to the sex/gender divisions of the social order. As Lucy Bland emphasizes in her examination of the hysteria over promiscuity and VD in Britain during the First World War: "I am not arguing that there *was* necessarily an enormous increase in young women seeking sex; the important point here is that there was widely *believed* to be such an increase."

According to Bland's analysis, the VD control program in Britain at that time anticipated many elements of Canada's VD control program in the next war. For one, the label "amateur prostitute," like the term "pickup" in Canada some twenty years later, emerged to designate any woman who allowed more than one man to have sexual intercourse with her and thus served to extend the scapegoating of women for VD considerably beyond professional prostitutes. Furthermore, as in Canada during the Second World War, "the debate over venereal prophylaxis for women" revealed contradictory attitudes toward the need to "protect" female sexuality. Protection did not extend to genuine "protection from disease," through the issuance of condoms or "efficient self-disinfection" kits to women, for that would have eliminated two effective regulators of women's sexual behaviour: fear of pregnancy and fear of disease.[11]

The sexually independent woman was not only represented as a social pariah but was scapegoated as a corrupter of the social order. This emerged from research prompted by another body of documents I encountered. For my investigation of the occupational distribution of members of the Canadian Women's Army Corps, PAC archivist Barbara Wilson had directed me to a set of microfilmed Canadian Army documents. As I wound my way through the miles and miles of microfilm, I found long stretches containing the medical case histories of CWAC personnel suffering from venereal disease and confidential memoranda on the policy for the administrative and medical handling of these cases. I had not gone in search of those documents, but the references to a "whispering campaign" which I was by then encountering convinced me I should take note of them for future investigation. That developed into Chapter Six of the present volume, a case study of the sexual status of Canadian women during the Second World War.

Persuaded by Sheila Ryan Johannson[12] that to determine the

status of women in any given area requires comparing their circumstances with those of an equivalent group of men, I compared the administrative, medical, educational, and preventive components of the VD control programs for male and female personnel in Canada's wartime army. These were devised at a time of increasing knowledge about the causative agents of and effective cures for venereal diseases. These developments in turn encouraged a more enlightened attitude toward the victims of VD, evidenced in attempts to relax or eliminate punitive and stigmatizing measures. Although a commitment to equity on the part of members of the military hierarchy brought near equality in medical treatment, the male-dominant double standard of sexual morality intervened to subvert attempts to eliminate penalty and stigma from the administrative handling of female VD cases. Comparison of the preventive components of the VD control programs revealed the double standard to be at work even more insidiously. Indeed, the lady/"loose" woman polarization that the military sought to combat in the "whispering campaign" was here found to be deeply embedded in the very differences, devised by the military itself, between the men's and women's preventive programs.

When I first began this project in 1975, very little (and almost nothing from a feminist perspective) had been written on the impact of the Second World War on women's status in society.[13] To a great degree that paucity forced me to rely principally on primary sources. Undertaking this work also coincided with the beginning of my "retooling" as a women's historian. Trained in a German and European historiography that largely ignored women, I have developed my knowledge of women's history through teaching it. Over the same period the literature of women's history itself, as well as that of the whole field of women's studies and feminist studies in general, has burgeoned. In particular, there has been a growing interest, influenced in part by the peace movement, in the complex question of the relation of women to war and the military. As I have been researching and writing, others have also been posing similar questions and, working from different angles and on different materials, coming to many of the same general conclusions.

In Canada, theses and articles explore the containment of women's emancipation during the war as well as the reactionary backlash of the post-war period. In an excellent Ph.D. dissertation

for the Department of Communications of McGill University, M. Teresa (Terri) Nash, director of the Academy Award-winning documentary *If You Love This Planet*, studied not only the "Images of Women in National Film Board of Canada Films During World War II and the Post-War Years (1939 to 1949)," as her title implied, but also the position of women at the NFB in that period. She found that, while radical and innovative in other respects, John Grierson, founder and first commissioner of the NFB, tended to hold a prosaic and hide-bound opinion of women's capabilities. Of the nearly 100 persons employed in film production at the height of the war, only three or four women ever rose to prominence as directors and producers. The largest proportion were employed as secretaries, stenographers, librarians, and, in what was a totally female ghetto, as negative cutters. The situation for women at the NFB became even worse after the war.

Examining a different area, Nancy Kiefer's M.A. thesis, "The Impact of the Second World War on Female Students at the University of Toronto, 1939-1949," has shown that war did little to alter women's secondary status at Canada's foremost institution of higher learning. While the number of women enrolling in "masculine" professional programs increased, "they still represented a very small proportion of the total number of female students at the University" (3.9 per cent at the peak in 1944-45, 3.29 in 1945-46). The overwhelming majority of female students were drawn into the arts colleges to keep enrolment high enough "to permit the maintenance of staff and educational levels" in the absence of male students. Neither the slightly higher profile of women at U. of T. during the war nor their extracurricular activities in service of the war effort worked to secure the much needed athletic, residential, and social/cultural facilities for women on campus. Sacrificed to "military exigencies" during the war, their needs were totally eclipsed by those of the veterans who flooded into university in the post-war period.[14]

For the United States and Great Britain, there now exists a considerable body of work on the question of the significance of World War II for women. Some of the most important items I have included in the appended bibliography. One of the earliest of these was Joan Ellen Trey's 1972 article, "Women in the War Economy – World War II."[15] In her overview of the recruitment of women into war production in the U.S., she stressed the short-lived nature of female labourers' wartime gains. Another early

but more detailed article was Howard Dratch's 1974 study of "The Politics of Child Care in the 1940s,"[16] which analysed intragovernmental conflicts over child care in the U.S., opposition to "group" care, union initiatives, and the benefits in labour and public relations that accrued to private industry. In her dissertation on "Government Policy Toward Civilian Women During World War II,"[17] Eleanor Straub maintained that "the extent to which old institutions, values, and modes of thought remained intact" was ultimately more important than the changes brought about by the war. And Sheila Tobias and Lisa Anderson, in their short piece for a 1973 issue of *Ms.*, suggested that post-war reconversion policies subverted whatever liberating potential the war had had.[18]

More recently, book-length studies have begun to appear on the theme of the non-liberating effect of the Second World War on women. Karen Anderson's *Wartime Women: Sex Roles, Family Relations, and the Status of Women during World War II* studies the impact of war on women's status in the labour force and as family members and sexual beings. Focusing on three major centres of defence production – Baltimore, Seattle, and Detroit – Anderson found that, while women enjoyed substantial improvements in paid employment during the war, their "household responsibilities were not significantly lightened by either the family or the community" and the post-war era brought rapid and consistent reversals in both areas. "As the victims of both race and sex discrimination, black women found the postwar employment situation especially difficult."[19] Under the title *The Home Front and Beyond*, Susan M. Hartmann's survey of American women in the 1940's catalogues the extent to which war effected changes in the position and image of women in the labour force, education, law, the political arena, the family, and popular culture. She stresses the limited nature of those changes and the ambivalence that accompanied them. For instance, in discussing women's breakthrough into blue-collar jobs, she points out that they "tended to remain in the less skilled, more routine work." Describing a set of circumstances similar to that which Marjorie Cohen and I found in Canada, she writes: "The assumption that women were around for the duration only made employers more likely to train them for just a single operation and made some women reluctant to learn new skills."[20] Above all, the claim of the family on women's labour and time remained unshaken by the war and was greatly intensified by

the post-war hunger for stability and "normalcy."

The great fear was that the war, by necessitating the mobilization of women on an unprecedented scale, might undermine the established male-dominant sex/gender system. The outward expression of women's place in that system is summed up in the term "femininity." Through dress, deportment, mannerisms, speech, facial expression, cognitive style, and emotive range and mode, femininity "both signifies and maintains"[21] women's difference from, deference toward, and dependence on men. Thus the fear of the loss of femininity occasioned during the Second World War by the sight of women in uniform or slacks and bandanas betokened a fear of structural changes in the sex/gender system – fear, as I argue in Chapter Three, of women's slamming the door on domestic dependence and assailing the segregation of jobs by sex. This phenomenon receives some attention in both the Anderson and the Hartmann books.

Patricia Allatt's "Men and War: Status, Class and the Social Reproduction of Masculinity" examines one of the purposes served by the reassurances that "They're Still Feminine!" For the sake of the war effort in Britain, she argues, the necessity for social upheaval in class terms gained acceptance and plans were drawn up for a limited redistribution of property, wealth, and authority through social security and social welfare measures. No such acceptance, however, was gained for social upheaval in gender terms through the redistribution of access to jobs, higher pay, or greater independence for women. On the contrary, according to Allatt's study of the educational programs set up for British military personnel during the Second World War, as the mobilization of women into war industrial labour and the armed forces threatened to break down the boundary between male and female domains, the response of the state and the media was to assert that this was due to the war emergency and would in no way alter the essentially male identity of the public sphere and female identity of the private. Allatt argues that "irrespective of what people actually [did], public and private domains remain[ed] conceptually unscathed in terms of occupants and tasks."[22] Thus, solidarity among male armed forces personnel could be achieved across class, ethnic, and regional lines by appeal to an interest shared by all men to preserve the right to priority over women in the public realm and to control over women in the private.

At its deepest level, the fear of war's disruption of the established sex/gender system was the fear of loss of male control over female sexuality. "Freedom of sexual expression for women," Anderson points out, tended to be viewed "as a hazard to the institution of the family and to society as a whole." Institutions to keep women's conduct under "constant scrutiny," such as the Protection Division of the Office of Community War Services in the U.S. or, for that matter, the military police (provost officers) of the Canadian Women's Army Corps, reflected, in Anderson's view, "considerable anxiety over the continuation of a marriage and family system predicated on the willingness of women to subordinate their needs and aspirations to those of others."[23] In Hartmann's judgement, "Women's military service represented one of the greatest assaults on traditional practices and values"[24] The campaign of rumours slandering the sexual morality of servicewomen, which occurred in Great Britain and the U.S. as well as Canada,[25] was fuelled by an explosive combination of anxieties and animosities: men's resentment at women's usurpation of the long-time male prerogative of military service; civilian women's jealousy of servicewomen's apparent independence; and a conservative predisposition to believe the worst of women who seemed so markedly in violation of the dictum that women's place is in the home.

Waging war is a destructive process and no war in human history has been more destructive of human life and property than the Second World War. Did destruction on such a scale shake the foundations of the male-dominant sex/gender system of Canadian society? The following chapters seek answers to that question by examining the significance of wartime changes in the labour force participation of women, their job-training opportunities, the ideology of femininity, and women's sexual status.

Women's Emancipation and the Recruitment of Women into the War Effort

It is often assumed that the employment of women in the labour force during World War II greatly advanced the emancipation of women, at least in the sense of women's struggle to achieve equal status with men in Canadian society.[1] Building on that assumption, feminists have lamented the ease with which many of the gains were lost at the war's end. One famous account, concerned with U.S. society but considered to have relevance for Canadian society as well, postulated the propagation of a "feminine mystique" to account for the post-war reverses suffered by women's struggle for equality.[2]

Both the assumption of great gains made by women during World War II and the bewilderment over the post-war reversals rest on an inadequate examination of the context of women's wartime employment and an inaccurate assessment of the degree to which attitudes toward women's proper role in society changed during the war. Canada's war effort, rather than any consideration of women's right to work, determined the recruitment of women into the labour force. The recruitment of women was part of a large-scale intervention by government into the labour market to control allocation of labour for effective prosecution of the war.

Four factors are crucial to an understanding of women's increased participation in the work force. (1) National Selective Service (NSS) and the federal Department of Labour, in their wartime mobilization of the work force, regarded women as constituting a large labour reserve, to be dipped into more and more deeply as the labour pool dried up. The recruitment would first seek young "girls" and single women and then childless married women for full-time employment, next women with home responsibilities for part-time employment, and finally women with children for full-time employment. Starting with the

most mobile, NSS pulled in these groups successively as the war effort intensified. Government officials publicly expressed a reluctance to draw upon those women in the female labour reserve whose mobilization would disrupt the traditional family system. (2) It was the traditional labour of women, their unpaid labour in the home and their volunteer labour, that was mobilized on the grandest scale during the war. (3) The government recruitment agencies viewed their task as service to Canada's war effort. Accordingly, the paramount appeal of recruitment campaigns was to patriotic duty and the necessity to make sacrifices for the nation at war. Women's obligation to work in wartime was the major theme, not women's right to work. (4) Accommodations to the particular needs of working women were made within the context of the war effort. These were generally introduced as temporary measures, to remain in effect only so long as the nation was at war.

I

Canada was not out of the Depression when World War II began. There were about 900,000 registered unemployed in a work force of approximately 3.8 million. In the following two years these unemployed persons largely met the increased demands for workers created by military recruitment and wartime production. By 1942 the slack in the labour market had been taken up. With war industry geared for full production and the armed forces drawing large numbers of male workers from the labour force, the labour market had changed from one of labour surplus and unemployment to one of shortage. "To meet the pressure of war needs attention, therefore, became focussed on the reserve of potential women workers who had not yet been drawn into employment."[3]

By thirteen Orders-in-Council, the NSS program was established in March, 1942, under the jurisdiction of the Minister of Labour.[4] When Prime Minister Mackenzie King in the House of Commons on March 24, 1942, announced the establishment of National Selective Service to co-ordinate and direct the near total mobilization of Canada's labour power for the war effort, he declared that "recruitment of women for employment was 'the most important single feature of the program.'"[5] He went on to outline a ten-point plan for drawing women into industry.[6] In May, 1942, a division of NSS was created to deal with employment of women and related services. Mrs. Rex (Fraudena)

Eaton of Vancouver was appointed assistant (later associate) director of NSS in charge of the Women's Division.

One of NSS's first steps was to measure the top layer of the female labour reserve. "It was decided to conduct a compulsory registration of *younger* women in order to ascertain more definitely what resources of woman power were available."[7] On September 8, 1942, Labour Minister Humphrey Mitchell ordered the registration of all females aged twenty to twenty-four, with the exception of members of religious orders, hospital patients, prison inmates, and women currently in insurable employment.[8] The registration was held from September 14 through September 19, 1942. Although both married and unmarried women were required to register, the main objective of this initial inventory of Canada's womanpower was to determine the size of the labour reserve of young single women. The twenty-to-twenty-four age group had been chosen because: "Single women would compose a higher percentage of the total than would be found in older age groups."[9]

On August 20, 1942, Mrs. Eaton had met in Ottawa with executive representatives of twenty-one national women's organizations to enlist their support for NSS and the September Registration of Canadian Women. She explained that the registration:

> will show us exactly how many single women we have available to meet the increasing shortage of workers in our war industries. Then we will have a pool of single workers from which to draw when an employer asks for additional staff, and single women can be supplied immediately.[10]

The policy was not merely to mobilize single women, but to render unnecessary the employment of married women with children. Mrs. Eaton stated emphatically: "We shall not urge married women with children to go into industry." Married women had been drifting into work in war industries because "no known reservoir of single workers existed." It was hoped that the registration would enable NSS "to direct single women into essential war industries rather than to have employers building up huge staffs of married women with children."[11]

On December 15, 1942, A. Chapman of the Research and Statistics Branch of the Department of Labour submitted a report on the "Female Labour Supply Situation." From the results of the women's registration, interviews by local Employment and

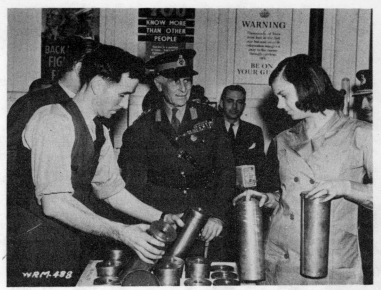

The Earl of Athlone visits a Montreal munitions plant, January, 1941.
Public Archives of Canada (PAC)/Picture Division/C-81419.

Selective Service Offices, and detailed analyses by local offices of the relation of unfilled vacancies to unplaced applicants, she concluded: "Study of the available information regarding the supply and demand for female labour clearly indicates the existence of a large reserve of female labour throughout the country."[12] Beyond "the overall surplus of female labour," the figures showed "that the bulk of the readily available surplus of female labour is concentrated in those areas where war industry is least developed." While allowing for regional variation of response to the registration, Chapman insisted that the figures "do emphasize the tremendous reservoir of female labour in areas such as the Maritimes and the Prairies where development of war industry has been slight."[13] The information from the registration and follow-up interviews led to the adoption of a program for transferring young unmarried women workers from areas of surplus to areas of labour scarcity.

In May, 1942, a survey of the anticipated demand for female labour had shown "that at least 75,000 additional women would

be required in war industries before the end of the year."[14] The registration itself stimulated young women to apply for employment.[15] In addition, NSS launched a nationwide publicity campaign to urge upon women "the need to engage in some phase of the war effort."[16] Editors agreed to give space in their publications to pictures of women working in war production and to stories of accomplishments by individual women. Papers published news releases on NSS and the problems it was facing. The CBC presented over the national network "a series of dramatic plays, written expressly for NSS around the theme of women war workers."[17] The campaign paid off. By January, 1943, the additional 75,000 women required for war industries had been recruited. Indeed, between January, 1942, and June, 1943, 158,000 women had joined the industrial war effort, bringing the number of women engaged in war industries to 255,000. During the same period, several thousand women had volunteered for service in the women's divisions of the three armed forces.[18] The "readily available surplus of female labour"[19] had evaporated.

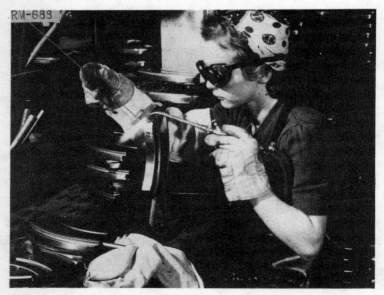

A girl welder at the Bren Gun Plant, John Inglis Co., Toronto. PAC/ Picture Division/C-7481.

By the summer of 1943 serious labour shortages had developed in areas of the service sector long dependent on female labour. Women were leaving low-paid service jobs for higher-paying employment in war industries. Service businesses were clamouring for help. Women were needed as ward aides in hospitals, as waitresses and kitchen help in restaurants, as chambermaids and waitresses in hotels, and for various subordinate positions in laundries and dry-cleaning establishments.[20] The labour pool of single women available for full-time employment was exhausted. "It became necessary to appeal to housewives and those groups who would not ordinarily appear in the labour market."[21] While the first recruitment had sought young unmarried women and then childless married women for full-time employment, in mid-1943, NSS (Women's Division) decided to launch a campaign to recruit women with home responsibilities for part-time work.

The need for part-time workers had been foreseen as early as November, 1942.[22] Supervisors of the women's divisions of local Employment and Selective Service Offices were instructed to persuade employers to make plans for employing women on a part-time basis. At first employers resisted the idea. In a May 7, 1943, memorandum, Mary Eadie, Women's Division Supervisor, Toronto, reported that, although some had "undertaken to use it with success,... the employer as a whole 'will not be bothered' ... with part-time help."[23] Employers cited higher administrative costs and a feared rise in absenteeism and turnover as reasons for their opposition. But when firms producing non-essentials, such as candy, tobacco, soft drinks, and luxury items, were informed that NSS would make no effort to send them "full-time workers while essential services and war industries were short of labour"[24] and when by the spring of 1943 even firms providing essential civilian services were short of labour, many employers became more willing to employ women part-time.

The first campaign for part-time women workers was mounted in Toronto from July 12 to July 26, 1943. To prepare for it, Toronto Selective Service first sought the co-operation of employers. "Several conferences were called" with employers in hospitals, restaurants, hotels, laundries, and dry-cleaning establishments "to discuss the possibility of [their] using part-time" women workers.[25] On May 22, 1943, Mary Eadie reported to Mrs. Eaton that "the Ontario Restaurant Association, the Laundry and Dry Cleaning Association of Toronto and the

Hospital Association of Toronto will co-operate with us because they are in such dire straits for help these days."[26] The Toronto Selective Service also won for the campaign the sponsorship of the Local Council of Women.[27] According to Mrs. Eaton, it was "with great courage" that Mrs. Norman C. Stephens, president of the Toronto Council of Women, "offered to promote a publicity campaign inviting Toronto women to accept part-time work in these occupations which no one will claim to be glamorous or highly paid."[28]

The campaign was "particularly directed to housewives."[29] At the same time, "no women with important home responsibilities were unduly urged to register." Furthermore, "no appeal was made for women to work part-time in addition to a full-time job." However, "many women without children and with few home responsibilities consented, under pressure of the campaign, to accept full-time work."[30]

In her report of July 28, 1943, to the NSS Advisory Board, Mrs. Eaton applauded the results of the campaign: 2,267 women had responded to the call. Of these, 1,518 had been placed in essential services, 643 in part-time, and 875 in full-time positions. Another 599 had accepted part-time employment in war industries. The remainder (150) were yet to be placed. For Mrs. Eaton, "the success of the campaign offered some assurance that there is still a pool of women ready and willing to fill a breach when emergencies arise."[31]

The Toronto campaign served as a model for similar campaigns in other Canadian cities. NSS Circular No. 270-1 (August 18, 1943) outlined the operation. Its goal was to relieve a labour shortage in "essential services such as hospitals, restaurants, hotels, laundries and dry cleaning establishments." Targeted would be "a new type of recruit," namely "the housewife or others *who will do a Part-time Paid Job* for six days per week, perhaps only four hours per day, or perhaps three full days each week." Not only was the campaign aimed at housewives, but the work they were being asked to do was also seen as an extension of housework outside the home. As the circular stated: "It is possible for many women to streamline their housekeeping at home to do the housekeeping in the community for standard wages." Local offices were first to secure the willingness of employers to provide definite orders for part-time workers, then to secure the sponsorship "of an organization of

women who have the high confidence of the community." The Local Council of Women was specifically recommended. The publicity campaign would engage the combined efforts of the employers, the sponsors, and the staff of the local Employment and Selective Service Office. The expenses of the campaign were to be borne by the benefiting employers and the Dominion government on a fifty-fifty cost-sharing basis. Women of the sponsoring organization could help in the local office with registration of applicants, but all referrals to jobs would remain the responsibility of the local Employment and Selective Service Office staff.[32]

The president of the National Council of Women, Mrs. Edgar Hardy, agreed to endorse these campaigns. A letter signed on August 31, 1943, by A. MacNamara and Mrs. Rex Eaton was sent to all Local Councils of Women enlisting their support, stating: "There is no reserve of men in Canada today. In fact there is little reserve of either men or women."[33]

Working in close co-operation with the Local Council of Women, NSS launched special recruiting campaigns for part-time women workers in the fall of 1943 in Edmonton, Saskatoon, Regina, Brandon, Ottawa, Moncton, and Halifax. Appeals to women to take part-time jobs in commercial laundries, dry-cleaning establishments, restaurants, and bakeries made explicit reference to the double burden borne by many women war workers and presented these businesses as serving to ease that burden. A radio address for the Halifax campaign, for instance, reminded listeners that "many women who are engaged in essential war jobs have no time for doing the family laundry" or preparing meals.[34]

The drives also sought part-time workers in some centres, such as Edmonton, for jobs in the garment industry. In some places, such as Brandon and Edmonton, the part-time campaign was combined with a campaign for full-time women workers. In Ottawa, the campaign aimed exclusively at encouraging former female employees of the civil service, now married, to return to part-time or full-time work to alleviate the serious shortage of workers in war departments of government.[35]

Although for as long as possible only full-time women workers were sought for war industries, by the end of 1943 and throughout 1944 women were hired for certain war jobs on a part-time basis. In some areas "housewives' shifts" came into existence, so named

because they were made up primarily or entirely of "housewives who could work only in the evenings" from 6:00 or 7:00 to 10:00 or 11:00 p.m.[36]

Even before the end of the part-time campaign in Toronto on July 26, 1943, NSS faced an acute labour shortage in war industries there. An estimated 3,500 women were needed to fill full-time high-priority jobs in war production.[37] The urgency of the need ruled out transferring women workers from other parts of Canada.[38] At the suggestion of the War Council of the Artists' Guild, the Toronto Selective Service proposed that management "recruit women for employment in war industries for full-time work for a period of not less than three months." Although employers thought they needed long-term full-time workers, they saw advantages to a special appeal for three-month service: it would give the media "a new publicity angle to emphasize the need of war industries for more workers"; women once hired might remain in employment; and it would counteract "the fear of being frozen to the job," which seemed to deter many women from "employment full time in essential industry."[39]

The key note of this special Toronto campaign was "three months' service."[40] Although the call went out to all women, special appeal was made to housewives, with the promise of a counselling service for mothers and endeavours to place women in war plants near their homes.[41] Preceded in early August by radio publicity on the need for women in war industry, the campaign ran from August 30 to September 11. During the first week a "war industrial show" was put on at the T. Eaton Company Auditorium. "Girls" from war plants demonstrated operations they performed "in their ordinary work at the plant" and "a fashion show was given in which the girls wore their plant uniforms."[42] In her final account of the campaign, Mrs. Eaton reported that 4,330 women had been referred to war industries, 168 were awaiting referral until day nursery care for their children had been arranged, and 300 who had applied for part-time work were yet to be placed.[43]

Through the autumn of 1943 NSS continued its recruitment campaigns for full-time women workers as labour demands dictated. Both the garment and textile industries, traditional employers of women in Ontario and Quebec, were feeling the pinch as female workers moved to better-paying jobs in munitions plants. In early October, 1943, an extensive campaign was mounted in Peterborough for 550 new women workers for full-

time jobs in textile factories and other high-priority manufacturing firms.[44] Similarly, in November, 1943, special drives to recruit female textile workers for full-time jobs were carried out in the textile centres of Hamilton, Welland, St. Catharines, and Dunville.[45]

In Montreal, NSS officials began planning in late September a massive recruitment campaign to alleviate a recorded labour shortage of 19,000. But on November 2, 1943, a meeting of Montreal employers with the NSS regional superintendent for Quebec decided to postpone indefinitely the large-scale campaign. As opposition to women's employment still persisted in Quebec, it was felt that the public would be more receptive to a series of small, separate drives specifically for "hotels, laundries, hospitals, textiles, etc."[46]

In December, 1943, the urgency for recruitment campaigns subsided[47] and the first months of 1944 saw a "slow but noticeable reduction in war industry."[48] The number of women in the labour force actually declined by 10-15,000 in the first three months of the year. Although the end of the war was in sight, NSS would not allow any slackening of the war effort until victory was secured. There was some concern that women might leave the war industry in greater numbers than the slowdown in production warranted.[49] Married women might want to return to their homes "and a less strenuous life"; single women might want to secure post-war jobs. NSS countered with publicity asking "women [to] remain steadily on their jobs throughout the year" and instructed women's divisions of local Employment and Selective Service Offices to persuade women requesting separation notices to stay at their posts. To the reluctant they were to suggest a brief holiday, or transfer to a more convenient shift, or "a part-time job in essential work near their homes." These efforts were successful: "there was no general exodus [of women] from war industries and essential services."[50]

Then in June, 1944, came a new emergency. The invasion of France, the Department of Munitions and Supply informed NSS, required ammunition plants in Ontario and Quebec to operate at peak production. An estimated 10,000 additional women workers were required. This made necessary a last large-scale recruitment campaign. It was organized by the Public Relations Office of the Department of Labour[51] and "promoted cooperatively by the plants concerned"[52] with every assistance from NSS. Local Employment and Selective Service Offices "redoubled

their efforts to persuade women to accept jobs" in nearby ammunition plants;[53] and, working with recruiting agents of the munition firms, NSS resumed the transfer of women from the East and West to central Canada. For example, some 350 Alberta women, including many school teachers, were persuaded to forgo their summer vacations for munitions jobs on the agreement they would be back in Alberta for school opening, October 2.[54]

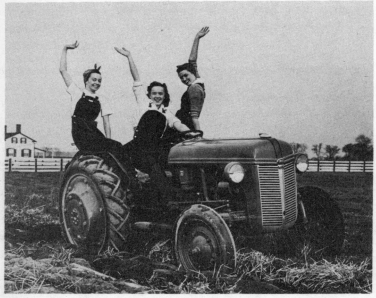

Ontario Women's Land Army, May 3, 1941. York University Archives, Toronto *Telegram* Photograph Collection.

In addition to the wartime recruitment of women into industries and services, there was also recruitment of women into agriculture "to fill some of the gaps in farm man power with female labour."[55] In all provinces farmers' wives and daughters took over farm work in the absence of male relatives and farm workers who had left the land to join the Armed Forces or work in industry. In two provinces, however, special programs were organized to recruit farm labour on the basis of the Dominion-Provincial Farm Labour Agreement, entered into by Ontario in 1941 and by British Columbia in 1943. The Ontario Farm

Service Force divided female labour volunteers into three brigades: the Farmerette Brigade for female students (over fifteen) and teachers during their summer holidays; the Women's Land Brigade for housewives and business and professional women on a day-to-day basis; and the Farm Girls' Brigade for farm women (under twenty-six) to lend a hand where necessary. The work was hard, usually nine to ten hours a day, and the wage rate low, 25 cents per hour. In 1943, "12,793 girls in addition to a considerable number of teachers" were enrolled in the Farmerette Brigade, approximately 4,200 women in the Women's Land Brigade, and about 1,000 in the Farm Girls' Brigade. After its creation, NSS helped to publicize the appeals for Farm Labour Service.[56]

II

Far and away the largest contribution made by Canadian women to the war effort was through their unpaid labour in the home and through "volunteer" work. Women's unpaid domestic work was as crucial to family maintenance in wartime as in peace.[57] The difference, however, was that the war effort brought public acclaim to that everyday labour women perform as housewives and mothers. The mobilization of Canadian society for efficient prosecution of the war called upon the co-operation of women as preparers of food, clothes makers, consumers, and managers of family budgets. Women as homemakers helped the war effort by respecting the limitations that rationing imposed, by preventing waste, and by saving and collecting materials that could be recycled for use in war production. After 1942, urban homemakers in particular had to learn to cook with limited supplies of almost everything from milk to molasses.[58]

To increase Canada's food production women cultivated victory gardens and canned the produce. While many housewives and mothers had been forced to practise severe economies during the depression, wealthier women learned for the first time during the war to remake old clothes into new outfits and to curtail their buying of consumer products in the face of cutbacks in production of everything from brooms to baby carriages. Homemakers saved fat scraps and oils for the ammunition industry and pennies to buy war stamps. As one poster put it, women were to "Dig In and Dig Out the Scrap" and save metals, rags, paper, bones, rubber, glass.[59]

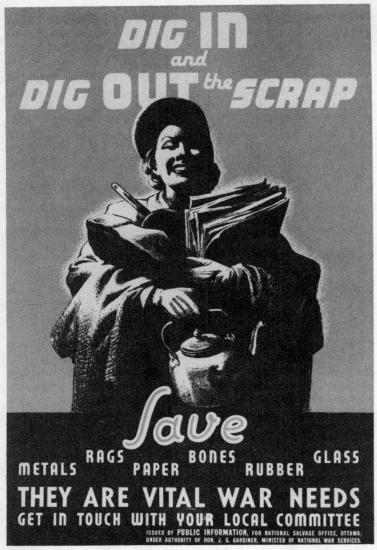

Poster: "Dig In and Dig Out the Scrap." PAC/Picture Division/C-87541.

Someone had to collect the salvage and the contributions to Victory Loans and to pass out information on how to practise domestic economies necessary for the war effort. Almost all of that work at the neighbourhood level was performed voluntarily by women. Indeed, at the local level the voluntary labour of women, who worked in or outside the home or both, sustained a vast network of wartime services and activities. The Department of National War Services established a Women's Voluntary Services Division in the fall of 1941 to co-ordinate these efforts. Mrs. W.E. (Nell) West was appointed director of WVS. While the Ottawa office served to direct and advise, and to supply government information, the main burden of the program was carried by Women's Voluntary Services Centres set up, eventually, in forty-four Canadian cities from Sydney, Nova Scotia, to Victoria, B.C. These centres kept a roster of the local societies and clubs performing war services, recruited volunteers and placed them according to interest and ability, and acted as a clearing-house for information from the war departments of the federal government.[60]

Women's voluntary contribution to the war effort, however, did not have to wait for action from the federal government. Women themselves took the initiative. Immediately after the declaration of war, established women's organizations of all kinds turned their attention to war work and new organizations sprang into being for that express purpose. Even co-ordination of women's voluntary efforts did not have to wait until the Department of National War Services established its WVS Division. In Winnipeg, for instance, a group of women founded a Central Volunteer Bureau for the city early in the war, which registered volunteers and directed them according to skill and interest to the appropriate club or agency. It encouraged the formation of new organizations where need existed and discouraged potential redundancies.[61] This bureau smoothly turned itself into the Women's Voluntary Services Centre of Winnipeg in October, 1941.

In contrast, the private Ontario organization for co-ordinating women's volunteer war work resisted encroachment by the Dominion government. A group of Toronto women had founded it only one month before the creation of the Women's Voluntary Services Division in the federal government, and it was their intention, once they got Ontario organized, to spread into other provinces and develop into a national organization. They called

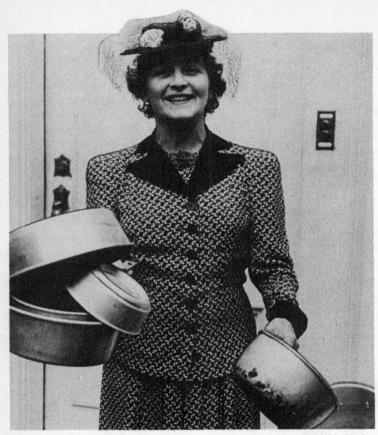

Woman with old pots and pans for scrap metal, September 5, 1941. York University Archives, Toronto *Telegram* Photograph Collection.

themselves the "Canadian Women's Voluntary Services (Ontario Division)" after the British Women's Voluntary Services, which was, however, a government body. Once the Canadian federal government decided to get into the act, it notified the CWVS (Ontario Division) that as of September, 1942, their work would be superseded and, to avoid confusion, they would have to relinquish their name. This touched off a minor furore among members of the Ontario organization. They pelted the Department of National War Services with letters protesting that

unsalaried, charitable work was women's domain and questioning the right of the government to barge in and pre-empt a women's voluntary organization. Some letters even demanded to know why anyone should be getting paid to co-ordinate voluntary work, and, more particularly, why the government should be paying the director and one of the assistant directors of its Women's Voluntary Services Division, when both women were married to men with good incomes. In the end, having appeased the leaders of the CWVS, Ontario Division (one, for instance, was sent on a trip to England to observe the work of the British WVS), Ottawa negotiated a *modus vivendi* with the organization that involved the absorption of its already functioning network into the federal system.[62]

The core of Canada's volunteer war work remained the millions of Canadian women organized into hundreds of local societies and clubs, orchestrated by the local Women's Voluntary Services Centres under the direction of Ottawa's WVS. Most of the centres were staffed voluntarily, although a few of the bigger ones had paid executive secretaries or directors. Fifteen of the centres used a Block Plan to organize the community for house-to-house canvassing and collection, with a hierarchy of responsibility stretching from block leaders through section leaders and zone leaders to director of the Block Plan in the WVS Centre.

The WVS Block Plan was one of the cornerstones of salvage collection. Take, for example, the collection of waste fats and bones. By 1942 Canada's supplies of oils and fats were down to 50 per cent of normal. Phyllis Turner, Administrator of Oils and Fats under the Wartime Prices and Trade Board, took action to save unreplenishable stocks of oil for glycerine, a necessary ingredient in explosives: she set rigid restrictions on the civilian use of oils and fats, such as limiting the number of colours of paints and of shades in lipsticks and rouges and the amount of coconut oil in shampoo and chocolate bars.[63] She also encouraged the Department of National War Services to launch a waste fats and bones salvage campaign, and, through its Women's Voluntary Services Division, to have women mobilize women and children to carry this out. For the fats and bones and other salvage campaigns, a WVS block captain first made door-to-door visits to all the women on her block urging their co-operation, then once a week rallied the block's children to make the rounds and collect what had been saved, and finally arranged for its delivery to the local offices of the National Salvage Committee. Women

also served voluntarily in those offices, helping to sort through the piles of material that came pouring in each week.[64]

Centres participated directly in other national programs, such as distributing rationing cards, carrying out a fact-finding survey on the size and productivity of victory gardens, recruiting and training volunteer staff for wartime day nurseries, and promoting the sale of war savings stamps. Ottawa's WVS Division developed the idea of using attractive young women as "Miss Canada Girls" to advertise the sale of war savings stamps as well as other patriotic events in support of the war. Local women's organizations were given the task of making "warsages," boutonnieres with war savings stamps attached.[65] The Women's Voluntary Services held a "Volunteer Week" September 12-20, 1943, to publicize the importance of voluntary work. The CBC broadcast two programs on the national network in its honour and centres across Canada put on special exhibits, strung WVS banners, gave outdoor concerts, and set up registration booths in the shops of local merchants in an all-out drive to register more volunteers.[66] Recognizing that "a very large proportion of mail to the Troops is sent by women," the Women's Voluntary Services Division threw its centres behind the 1944 drive of the Postmaster General to get more letters written to members of the armed forces.[67] On a regular basis the volunteers mobilized through local WVS centres distributed ration cards, canvassed for blood donors and staffed blood donor booths, gave information to householders on the disposal of books and magazines for the armed services and to apartment dwellers on the cultivation of window box victory gardens, distributed wool to the various "Ladies' organizations" for the knitting of socks and other garments, and arranged hospitality and entertainment for servicewomen and servicemen on leave and far from home. In 1944 and 1945 WVS centres sponsored lectures and the showing of films to members of women's organizations in co-operation with the Canadian Women's Army Corps anti-VD campaign. Meanwhile, at the level of the individual club, women sewed and knitted and quilted and packed parcels and put together "ditty bags" for the servicemen and women overseas. They also made jam, collected bundles, and raised money for milk for Britain.

In the countryside the Women's Institutes, all across Canada, carried the burden of women's voluntary war work. The Women's Institute of Burton, B.C., for example, held "Military Whist

Drives" to raise money for soldiers' parcels.[68] Women's Institutes on the Gaspé gave aid to survivors of torpedoed vessels. In the words of the Convenor of War Services of the Federated Women's Institutes of Canada, speaking of the war work of Canadian rural women:

> They have worked harder at farm work than ever before. They have driven tractors, made hay, picked fruit, raised wonderful gardens and increased the poultry and egg production of all Canada. Yet they have found time to make tons of jam for overseas, clothing for refugees and thousands of articles for the Red Cross.

In the period 1943-1945, the Women's Institutes of Canada had raised "over half a million dollars in cash" and made "nearly the same number of garments . . . for the Red Cross and others."[69] After the war, Women's Institutes and Voluntary Services Centres organized committees to welcome returning veterans and to help foreign "war brides" of Canadian servicemen feel at home in their new country.[70] In October, 1945, these volunteer women helped the National Clothing Collection reach its total of 12 million pounds of used clothing for distribution in war-devastated countries.

Another way in which women voluntarily contributed to the war effort was to help monitor inflation. After the Wartime Prices and Trade Board set price and production ceilings on many consumer items in 1941-42, women's clubs across Canada appointed committees to keep an eye on the movement of prices and availability of goods essential to housekeeping and family care. Women took pad and pencil to food and clothing and hardware stores and made notes of price infractions or commodity scarcities. Once again the initiative of women suggested the establishment of a federal body to co-ordinate their activities and the Consumer Branch of the Wartime Prices and Trade Board was brought into being under the directorship of Byrne Hope Sanders, editor of *Chatelaine*. Canada was divided into fourteen administrative areas, each with a Women's Regional Advisory Committee. Working with these committees at the local level were subcommittees in urban centres with a population 5,000 or more and corresponding members in smaller communities. In addition, every individual women's organization in towns with more than one was asked to appoint a liaison officer to keep

in touch with the local subcommittee. Through this network one million of Canada's three million adult women were mobilized to keep a close watch on the behaviour of price and production restrictions across the country and to report to Ottawa.[71] Women thus played an indispensable role in the Canadian government's wartime fight against inflation.

Despite women's massive voluntary contribution to Canada's war effort, as well as the increased reliance on women's paid labour, women had to struggle to make their voices heard even to a limited extent on any of the various reconstruction committees that emerged during the war to plan Canada's post-war future. One of the most influential, the federal Advisory Committee on Reconstruction, convened in 1941 by the Minister of Pensions and National Health and chaired by Dr. F. Cyril James, principal of McGill University, had no woman among its six initial members. Nor were women or women's issues to be found on the subcommittees subsequently created to explore specific post-war problems: agricultural policy, conservation and development of resources, post-war construction projects, housing and community planning, and employment opportunities. It took repeated lobbying from women's organizations, particularly the Canadian Federation of Business and Professional Women's Clubs and the Quebec-based League for Women's Rights/Ligue pour les droits de la femme, before a sixth subcommittee was finally created in January, 1943, the Subcommittee on the Post-War Problems of Women, composed of ten women.[72] But this concession remained inadequate in the eyes of many women. In the spring of 1943 the Local Council of Women of Toronto voiced its dissatisfaction that the James committee itself still had "NO women members" and that all post-war problems affecting women had been hived off for separate consideration by one subcommittee instead of the appointment of women to the existing subcommittees investigating issues every bit as important to women as to men, especially those on housing and community planning and employment.[73] Throughout 1944 the National Council of Women repeatedly pressed on the federal government the policy "That on all boards and committees dealing with reconstruction and rehabilitation well qualified women shall be appointed." Their efforts met with less than perfect success. The reply from the Prime Minister's Office, for example, regarding the request that a woman by appointed to the Wartime Labour Relations Board in March, 1944, was that neither the labour

organizations nor the employers' organizations had been able to suggest a suitable woman.[74]

III

It was in the name of patriotic duty that women's voluntary services were at first spontaneously offered and later, once government became involved, officially recruited for the war effort. It was also in the spirit of near-total mobilization for war that women's traditional domestic services received new recognition as socially necessary labour, as an examination of wartime advertisements reveals.

Wartime advertising was a complex business, as advertisers competed for customers and sought to protect their trade names for post-war markets while demonstrating a patriotic spirit. The manufacturers of commodities such as guns, planes, and tanks had the least difficulty appearing patriotic, for they could easily show how their product was helping to win the war. Those who manufactured products for use in the home had a somewhat harder time; but, once they took up the theme of how important efforts on the "home front" were to winning the war, they could argue for the contribution, albeit indirect, of the work performed in the kitchens and laundry rooms of homes across Canada to the battles overseas.[75] One finds advertisements celebrating the important war work housewives performed when they kept their families on healthy diets and in clean clothes. One imaginative example was the 1942 advertisement by the Canada Starch Company of Montreal and Toronto. "All honour," it said, "to those mothers and wives who are exerting every effort to keep the workers of Canada fit, vigorous, and keyed to 'victory through production.' *They are Canada's Housoldiers.*"[76]

This "militarization" of women's housework was not limited to commercial advertisers. War departments of government also played on this theme, as when the National Finance Committee advertised to "INVEST IN THE BEST - BUY VICTORY BONDS" with the slogan "She's in there fighting, too" and pictured a mother in an apron drying dishes with the help of her young daughter.[77] Contributors to the women's pages of magazines and newspapers also got into the spirit, as when the director of the Chatelaine Institute entitled a 1943 article on the proper care of woollens "Blitz on Moths."[78] Did women accept this "militarization" of the domestic sphere? The poem "Kitchen Brigade," submitted

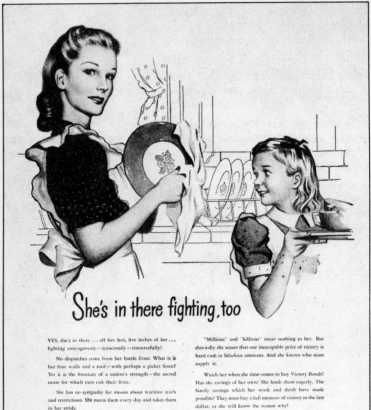

She's in there fighting, too

YES, she's in there . . . all five feet, five inches of her . . . fighting courageously—tenaciously—resourcefully!

No dispatches come from her battle front. What is it but four walls and a roof—with perhaps a picket fence? Yet it is the fountain of a nation's strength—the sacred cause for which men risk their lives.

She has no sympathy for moans about wartime trial's and restrictions. She meets them every day and takes them in her stride.

She needs no picture stories to tell her the truth about war. With the sure instinct of wife and mother, she knows the agony of waiting and the bitterness of loss.

"Millions" and "billions" mean nothing to her. But shrewdly she senses that one inescapable price of victory is hard cash in fabulous amounts. And she knows who must supply it.

Watch her when the time comes to buy Victory Bonds! Has she savings of her own? She lends them eagerly. The family savings which her work and thrift have made possible? They must buy a full measure of victory to the last dollar, or she will know the reason why!

And alongside her realism for today she builds her plan for tomorrow. She fully intends that those savings shall make it come true!

INVEST IN THE BEST

 Buy VICTORY BONDS

Advertisement of women's contribution to war effort. PAC/Picture Division/C-94056.

by May Richstone to the August, 1943, issue of the *National Home Monthly* on the subject of women's work in saving fats and oils, indicates that some may have:

> Behind each gallant fighting man,
> Loyal we stand, the kitchen brigade.
> Our weapon is the frying pan –
> We'll see that glycerine is made.
>
> Out of the frying pan, fat flows,
> Not one drop wasted, if you please;
> Out of the frying pan it goes
> Into the fire – at our enemies![79]

Building on the belief that women's social role was to be emotionally supportive of men, to smooth over difficulties, and to make the home a genuine refuge from the stresses of the larger world, the government actively reminded Canadian women of their duty as morale boosters as well as cooks and housekeepers. In 1942 the Department of Munitions and Supply issued a series of full-page advertisements with this message to be published in Canadian magazines. One bore the title "A Lot Depends on You!" and, in small print, beneath a picture of a woman in whose shadow stand a munitions manufacturer and a soldier:

> THESE ARE TRYING TIMES for your men folk. Some of them are on the firing line; others on the production line.
>
> The men of your household are probably working longer hours these days. Whether in office or factory, they are under a greater strain. For they are striving to get vital equipment to our fighting forces before it is too late.
>
> It's up to you to keep your men folk fit and happy. Men produce more when their minds are at ease, when they are not worried by domestic problems. If you shoulder these worries and help your men to relax, you are playing a real part in winning the war.
>
> Perhaps your husband is irritable when he comes home tired from his work. Perhaps he must be away from home weeks at a time or longer. Be sympathetic and understanding under these circumstances.
>
> Remember, this is an emergency. The more each of us helps, the sooner we can get back to the happy days of peace-time living. So do your part cheerfully for your country's sake. Keep that man of yours fit and happy for his job.

The final motto carried the self-admonition: "Brave Men Shall Not Die Because *I* Faltered."[80]

This wartime mobilization of women's domestic and volunteer labour also capitalized on the traditional housewifely virtue of thrift. "Thrift ... IS PRACTICAL PATRIOTISM" was the headline of a victory loan campaign poster, designed by the National War Finance Committee for placement in rural weekly newspapers. The question "How many ways can you save ... to LEND TO CANADA?" was posed in big letters beneath two drawings of housewives at work in their homes.[81] Another advertisement issued by the National War Finance Committee pictured a sinister, shadowy Hitler whispering into the ear of a woman just reaching into her handbag to extract a five-dollar bill, "GO ON, SPEND IT ... What's the difference?"[82]

Patriotism was also the main motif in the propaganda used to recruit women for paid employment related to the war effort. Labour Department officials, NSS officers, and Farm Service officials, charged with recruiting women into the labour force during World War II, viewed their task as service to the war effort. Accordingly, in their recruitment campaigns, they appealed primarily to patriotic duty and the necessity to make sacrifices for the nation in wartime.

This note was struck in the NSS General Report on the Employment of Women of November 1, 1943. Next to determining the size of the existing labour reserve of women, the NSS's main task was "to outline to all Canadian women the part they would be expected to play in the anticipated expansion of all war demands."[83] It was NSS's job to convince women "that it was their duty to go to work" and to persuade women "that work in war industries offered the most direct contribution which could be made to the prosecution of the war, apart from enlistment in the Armed Forces."[84] The overalls and bandana of the woman war worker "became a symbol of service."[85] The "vigorous publicity campaigns" of the Ontario Farm Labour Service laid "considerable stress on patriotic service."[86]

"There must be no let up in the supply of vital arms and equipment – no let up in food production – no let up in essential services" stated the letter sent by the director of NSS and Mrs. Eaton to the Local Councils of Women enlisting their help for the campaigns in the fall of 1943 to recruit women workers. The letter made two suggestions:

Advertisement on thrift as "practical patriotism" in war effort. PAC/
Picture Division/C-93633.

Arrange for an inspirational address in which the prestige and importance of any work essential to the war or to the home front is stressed, as well as a tribute to women now so employed.

Stress the need of women for the armed services but point out essential employment as an opportunity for women not of military age to serve with equal effect.[87]

The NSS circular of August 18, 1943, outlining the Campaign for Part-time Women Workers in hospitals, laundries, dry-cleaning establishments, restaurants, and hotels, ended with this ringing declaration: "The health and wellbeing of the Canadian people must be maintained while they participate in the March to Victory. The civilian essential services in the community are of vital importance."[88]

"Roll Up Your Sleeves for VICTORY!" was the headline of the December, 1943, design prepared by the Information Division of the Dominion Department of Labour for a full-page newspaper advertisement to recruit women for war industry. In the centre of the ad was a drawing of a woman, shoulders squared, rolling up her sleeves. Behind her, a montage of photographs of women working, one a taxi driver, another a nurse, and the rest on production lines in war industry. The caption read:

The women of Canada are doing a magnificent job ... in the Munitions factories, making the tools of war, in the nursing services ... in the women's active service units, on the land, and in many other essential industries. But the tempo of war is increasing, and will continue to increase until Victory is won. We need more and more women to take full or part time war work ... Even if you can only spare an hour or two a day, you will be making an important contribution to the war effort.[89]

In May, 1944, when it was feared that women were wearying of war work and might be leaving the labour force altogether or changing to jobs promising more of a future, Mrs. Eaton drafted a letter to the local Employment and Selective Service offices. It contained this directive:

Try to change the attitude of mind represented in the words: "I want to get a post-war job" or "I am tired of making munitions." We need to remind ourselves and others that the

war has yet to be won and completed. It is too early to express other ideas. Service and sacrifice are yet the key words.[90]

Finally, in the massive campaign of July, 1944, to recruit women for labour in the Ontario ammunition plants, the slogan was: "Women! Back Them Up – To Bring Them Back." This slogan appeared on advertisements placed in the major newspapers, reprints of which were delivered to thousands of homes in the neighbourhoods of the war plants, and on posters attached to the fronts and backs of street cars and displayed in store windows, outside movie theatres, and in theatre lobbies. The press release prepared for Moffats Ltd., manufacturer of ammunition boxes for the 25-Pounder gun, quoted this appeal: "Only by the single and married women coming forward and offering their help will it be possible to get these ammunition boxes out in the required time and thus keep faith with the boys at the front."[91] The call to patriotism, to sacrifice for the nation at war, to loyalty and service to the troops fighting overseas – that appeal dominated the recruitment of women workers from beginning to end.

At the same time Labour Department and NSS officials were aware that many women were in the labour force, or applying to enter it, out of economic rather than patriotic motives. In a March 5, 1943, memorandum to Mrs. Eaton, Renée Morin of the Montreal NSS reported the observation of a personnel officer for the Dominion Rubber Company:

> Most of the married women with children who seek work in our factory are in need of money to help their family. Those who are working merely to buy luxuries have not the courage to stick to their work. Very few have in mind a contribution to the war effort.[92]

On March 30, 1943, the Women's Division of the Toronto Employment and Selective Service Office ran a questionnaire on married female applicants over thirty-five years of age. The fifth question asked: "What is the prime object in your securing employment?" Of the women questioned, 9 per cent indicated patriotic motives, 59 per cent wanted "to supplement family income," and 32 per cent stated "personal needs."[93] *Relations* in May, 1943, disclosed the results of an investigation carried out by the Quebec *Jeunesse ouvrière catholique* into the working experience of 700 of its gainfully employed female members: 31.4 per cent of the women had given "as their reason for

working economic necessity – no other source of revenue."[94] Although the representativeness of these studies is not established, some discrepancy clearly existed between the official emphasis on patriotism and the actual motivation of women workers.

Not all reports to NSS on the motivation of female workers cast doubt on their patriotism. On April 30, 1943, the director of technical education of Nova Scotia sent this account of the motivation of women workers in a munitions plant in his province: "Their general attitude showed that they felt their effort was directly connected with war activity and based on a keen feeling of patriotism."[95]

Advertisements for women workers did include mention of appeals to economic incentives. The caption on the "Roll Up Your Sleeves for Victory" ad ended: "By taking up some form of war work you will not only be showing your patriotism in a practical way, but you will also be adding to the family income."[96] Besides the slogan "Back Them Up – To Bring Them Back" the advertisements in July, 1944, spoke of: "Opportunity for Women in Modern War Plant ... [for] doing an important job and at the same time making that extra money which you can use to plan your future."[97] Nonetheless, patriotic service to the war effort was the main motif of campaigns to recruit women workers.

IV

From the start of attempts to bring increasing numbers of women into the labour force, it was realized that the needs of working women, especially married women and women with young children, would have to be accommodated. By and large, however, such accommodation was justified by the war emergency and would not outlast it.

One accommodation, an economic incentive to married women, was the Amendment to the Income War Tax Act of July, 1942. Before that date, a married woman whose husband also received an income could earn up to $750 without her husband losing his claim to the full married status exemption. The July, 1942, revision of the tax law granted the husband whose wife was working the full married status exemption "regardless of how large his wife's earned income might be."[98] The "special concession" was a "wartime provision,"[99] designed "to keep married women from quitting employment"[100] and to "encourage

the entry of married women into gainful employment."[101] Through 1946, the husband paid no tax on any income up to $1,200, regardless of his wife's earnings. The wife paid tax on income exceeding $660.[102]

The incentive came to an end after the war. As of January 1, 1947, once a wife's income exceeded $250, the married status exemption of her husband would be reduced by the amount of her income in excess of $250. This post-war change did not simply return the income tax regulations for married couples to the status quo ante bellum. On the contrary, it introduced a disincentive to married women's working for pay outside the home that was more penalizing than that of the depression years. Many married working women figured that the tax change would seriously diminish their actual contribution to the family income after taxes. Many employers of married women feared the change would deplete their skilled female labour force. Representations poured in to the Departments of Labour, Finance, and National Revenue. Fruitpacking and canning firms complained that their most skilled female packers and sorters were quitting once their earnings reached $250.[103] Textile firms complained that they were losing many of their most experienced power sewing machine operators, silk cutters, winders, and carders.[104] Similarly, business offices reported losing stenographer-typists;[105] hospitals, married nurses;[106] school boards, married women teachers;[107] department stores, married female employees.[108] The Deputy Minister of Labour, Arthur MacNamara, denied that his department had intended the tax change "to drive married women out of employment," and certainly not "out of nursing, teaching and any other line of employment where their services are so seriously needed."[109] But as the spokesman for the Primary Textile Institute, Toronto, reasoned: since the 1942 revision had been designed to draw married women into industry, its cancellation would have the opposite effect.[110] And the federal government admitted as much: the tax concession of 1942 had been a war measure, "justified only by the extreme state of emergency which then existed."[111]

Perhaps the major wartime accommodation to the needs of working women was the establishment of child-care facilities in Ontario and Quebec on the basis of the Dominion-Provincial Wartime Day Nurseries Agreement. But this, too, was made in the context of the war emergency and viewed as right only so long as that emergency lasted.

In 1942, when it was realized that the Canadian economy would have to draw more extensively on women's labour, it was also recognized that government provision of child-care facilities for working mothers might become necessary. The Prime Minister's address to Parliament on March 24, 1942, explaining NSS and outlining a program for bringing women into industry had called for "The provision of nurseries and other means of caring for children."[112]

Although the Women's Division of NSS did not begin in 1942 to campaign for the employment of mothers, women with young children had been in the labour force before the outbreak of war and had continued to enter it as production quickened.[113] As Mrs. Eaton wrote in June, 1942, "without any urging on the part of Government, married women, usually on the basis of need of further income, have already gone into industry and are doing a good job."[114] The mothers among these married women had to make their own arrangements for the care of their children, with the help of relatives and neighbours.[115] "But these unorganized arrangements do not always work out so well and break down for days and weeks at a time."[116] The number of existing private nurseries, run by churches and charitable organizations, was inadequate. In 1942, in Ontario, especially in the Toronto area, public pressure for government provision of nurseries and after-school supervision of children increased. There was mounting concern over "latch-key" children and the possible connection between working mothers and the rising rate of juvenile delinquency.[117] Asked by the Minister of Labour for ideas on child care for his upcoming meeting with Ontario and Quebec Ministers, Mrs. Eaton replied that:

> Consistent and well-founded reports lead one to believe that children are neglected – thus becoming unhappy, undernourished and delinquent. Such a situation must be accepted as a responsibility of government in these days, when it has become a burden too heavy for private agencies.[118]

Before the end of April, 1942, the director of NSS was in contact with the government of Ontario concerning "the setting-up of nurseries in co-operation with the provinces as needed."[119] In May Mrs. Eaton conferred with the Minister and Deputy Minister of Public Welfare in Ontario and with the Minister of Health and Social Welfare in Quebec.[120] Experts in child care, such as George F. Davidson, executive director of the Canadian Welfare

Council,[121] and Dr. W.E. Blatz, director of the Institute of Child Study of the University of Toronto,[122] were consulted.

On the basis of these preliminary talks, a draft for a Dominion-Provincial agreement on child care was drawn up. On June 16, 1942, the federal Minister of Labour called a conference in Ottawa to discuss the proposed agreement with the Minister and Deputy Minister of Public Welfare of Ontario and the Minister of Health and Social Welfare of Quebec. After clause-by-clause consideration of the draft agreement, it was approved.[123]

Then on July 20, 1942, through Order-in-Council PC 6242, the federal Minister of Labour was authorized to enter into agreements with any of the provinces to establish day-care facilities for children of mothers employed in war industries, in accordance with the draft agreement. A copy of the agreement and a letter inviting participation in the plan were sent to every province. The two most industrialized provinces signed that summer: Ontario on July 29, 1942; Quebec on August 3.[124] The only other province to sign was Alberta, in September, 1943.[125] But the Alberta Provincial Advisory Committee on Day Nurseries, set up to assess the need in that province, voted on April 26, 1944, that there was none,[126] despite considerable pressure from groups in Edmonton and Calgary for day nurseries in those two cities.[127]

In the meantime, Ontario and Quebec, the only two provinces to make use of the agreement, began to implement it. The agreement provided that capital and operating costs were to be shared equally between the Dominion and the province.[128] The initiative for establishing particular day nurseries rested with the provinces.[129] Ontario and Quebec each created an Advisory Committee on Day Nurseries and local committees in urban centres to determine where need existed. Provincial directors were appointed, and in Toronto, a director for the city.[130] At the federal level, Miss Margaret Grier was appointed in October, 1942, as assistant associate director of NSS, under Mrs. Eaton, to administer the Dominion-Provincial Wartime Day Nurseries Agreement.[131] Local Employment and Selective Service Offices were to interview applicants on need for child care, determine their eligibility, make referrals to operating child-care facilities, and keep records of the numbers of applicants and referrals.[132]

The program was slow in getting off the ground. In fact, the first day nursery to open, at 95 Bellevue Avenue in Toronto on October 6, 1942, was initially a provincial project and only later

brought under the terms of the Dominion-Provincial Agreement.[133] A second day nursery in Ontario, the first under the agreement, was opened in Brantford on January 4, 1943. February brought the opening of Ontario's third, fourth, and fifth day nursery units in St. Catharines, Oshawa, and Toronto; March, the sixth and seventh, also in Toronto.[134] To accommodate the increasing number of married women entering the labour force in the spring and summer of 1943, six more day nurseries were opened in Ontario between April and September.[135]

Initially Women's Voluntary Services volunteers assisted at the nurseries one whole day or two half-days a week and in preparation for this were given a twelve-lecture WVS training course in child care. But it was soon found that day nurseries had to be fully staffed by paid workers. In Ontario these received an intensive course in the psychology and care of the child at the Institute of Child Study in Toronto. The Bellevue Avenue centre gave demonstrations in practical administration of a day nursery to those who would later take charge of other units. The Women's Division of NSS sponsored radio dramas to convince mothers working in war industry that day nursery care would benefit their young children. Journalists also sang the praises of the new child-care program. For instance, in an optimistic article for *Saturday Night* entitled "Nursery Schools in Canada Have Come to Stay," Mary Weeks wrote approvingly of the personnel and sound principles in child development that the Institute of Child Study had imparted to the program. And Marjorie Winspear in the *National Home Monthly* applauded the gentle but firm discipline used to get the two- to six-year-olds to eat everything on their plates and to take afternoon naps without fuss.[136]

The nurseries were open Monday through Friday, from 7:00 or 7:30 a.m. to 6:30 or 7:00 p.m., and Saturday mornings until noon. Children were given two full meals a day, dinner at noon and supper at five, plus a morning snack. A few day nurseries were set up in houses, but more often church, Sunday school, or community halls were converted for the purpose. Independently of the Dominion-Provincial Wartime Day Nurseries Agreement, some companies, such as the Canada Rubber Company in Galt, Ontario, built day nurseries near their factories and operated them exclusively for their own employees.

In addition to day nursery care, the Dominion-Provincial Wartime Day Nurseries Agreement also provided for foster home

care for children under two and school day care for children between six and sixteen. The latter included supervision of school-age children during vacations as well as provision of a hot noon meal and supervision before and after school during the regular school term.[137]

By September, 1945, there were twenty-eight day nurseries in operation in Ontario: nineteen in Toronto, three in Hamilton, two in Brantford, and one each in St. Catharines, Oshawa, Galt, and Sarnia, caring for about 900 children in all. In addition there were forty-four school units, thirty-nine in the Greater Toronto area; Hamilton had two, and Windsor, Oshawa, and Sarnia each had one. The Wartime Day Care Program for School Children accommodated approximately 2,500 children.[138]

The child-care program was even slower getting off the ground in Quebec and never developed there to the extent it did in Ontario. The first wartime day nursery in Quebec opened on March 1, 1943, in Montreal. The site chosen for it was in the Maisonneuve district close to the station where women left for work in the Cherrier shell-filling plant of Defence Industries Limited. In 1943 five others opened in Montreal, four on May 1, and one on October 1. As the latter closed on December 31, 1944, there were in September, 1945, only five wartime day nurseries operating in Quebec, all in Montreal, and accommodating on the average between 115 and 120 children.[139] There was no development of school-age day care in Quebec.[140]

From the outset, the federal agencies involved viewed the establishment of child-care facilities as a war emergency measure designed "to secure the labour of women with young children" for "war industry."[141] One of the principles drawn up to govern federal aid for day nurseries stated: "That any such service should be strictly limited to provision for the children of women employees in war industries."[142]

The actual Dominion-Provincial Day Nurseries Agreement departed somewhat from that original intention.[143] Clause 11 provided that up to 25 per cent of any facility could be opened to children of mothers employed in other than war industrial occupations. Furthermore, Clause 1(d) gave a broad definition to "war industries."[144] In practice, however, only firms with an A (very high) or B (high) labour priority rating were considered to be "war industries."[145] The federal government's position was that child care was "normally the *responsibility* of the Province, in cooperation with its local groups." Only the additional burden

on the provinces "caused by war conditions" justified the federal government's sharing that responsibility. Therefore the program should "relate *chiefly* to war industries."[146]

In 1943 strong objections arose to Clause 11 of the Day Nurseries Agreement, particularly from the Toronto Welfare Council and the Toronto Board of Education. Officials of the Toronto Board of Education wrote to Humphrey Mitchell, Minister of Labour, and to Prime Minister Mackenzie King.[147] They asked that "war work" be broadly defined as "anything essential to the community at war" so that the children of all working mothers would be eligible. The quota, they pointed out, put the principals administering the school day-care program in the difficult position of having to refuse some children while accepting others. Limiting eligibility discriminated against mothers working in firms with a low labour priority rating. This was unfair, they argued, as all working mothers were contributing to the war effort, if only indirectly. In many cases, the woman doing the "non-essential" job was freeing a man or another woman for work in war industry.

On June 10, 1943, Mrs. Eaton chaired a meeting in Ottawa of NSS, Labour Department, and Quebec and Ontario officials to assess the Wartime Day Nurseries program. Heading the agenda was criticism of Clause 11. The meeting agreed that "the ratio of 75 and 25 for mothers employed in war industry" should continue and that the interpretation of "war industry" as firms with A and B labour priority ratings should still hold. Labour Minister Humphrey Mitchell approved this decision.[148] To Mrs. Eaton's mind, "If the Agreement is extended to include the children of all mothers who work, there is a further case that could be made out quite logically for the children of the woman who is ill or who is doing essential voluntary work."[149]

But objection to Clause 11 persisted. Newspaper editorials took up the criticism.

> We are now into the fifth year of war. For at least three years the pressure has been heavy to get more women into the industry. In the last year Government agencies have urged women with children to fill the gaps so that the nation's economy could continue to function.
>
> If mothers are to follow the advice of those agencies, then surely this division of children of working mothers into two classes is beyond common reason.[150]

So editorialized *The Globe and Mail* on October 28, 1943. "It is a sort of crusade taken up by the papers, churches and women's organizations to get the children admitted regardless of any other consideration," Mrs. Eaton observed in a memorandum to NSS Director MacNamara on December 1, 1943.[151]

Under this mounting pressure, the Ontario Minister of Public Welfare "gave way publicly" in November, 1943, and NSS officials began to reassess their stand.[152] Mary Eadie, Women's Division Supervisor of the Toronto local office, was asked to estimate the consequences of increased enrolments if the Day Nurseries Agreement were extended "to cover the children of all employed mothers."[153] By December 1, 1943, Mrs. Eaton had concluded that: "It is now apparent the 25 percent [quota] does not altogether suffice."[154] Negotiations with Ontario and Quebec to revise Clause 11 were begun.

By Order-in-Council, on April 6, 1944, for Ontario, and on May 18, 1944, for Quebec, Clause 11 was amended to extend the Wartime Day Nurseries Agreement to include children of all working mothers. Nonetheless the amendment stipulated that "children of mothers working in war industry shall have priority at all times in admission" to any child-care facility established under the agreement.[155]

That the Dominion-Provincial Day Nurseries Agreement was construed as a wartime emergency measure is underscored by the relative swiftness of the program's discontinuance. On August 23, 1945, J.A. Paquette, Quebec's Minister of Health and Social Welfare, informed Labour Minister Mitchell that he planned to close the day nurseries in Quebec on October 1. His argument read:

> Article 23 of the Agreement, signed by the Federal Government and the Province of Quebec on the 3rd of August 1942, provides that the Agreement shall continue in force for the duration of the war.

> Now that the war is over, I would be inclined to close these Day Nurseries immediately, but I feel that a month's notice to the parents would only be fair.[156]

Although W.S. Boyd of National Registration argued that Canada was still legally at war since no final peace treaty had been signed and neither His Majesty nor the Governor in Council had proclaimed that the war had ended (as Section 2 of the War

Measures Act required),[157] nonetheless on September 1, 1945, Mitchell wrote Paquette that he, "as chief administrator of the scheme," had the right to close the nurseries when he chose and "upon such notice as is deemed advisable."[158]

The closing of the Dominion-Provincial Wartime Day Nurseries in Quebec was set for October 15, 1945. In mid-September day nursery staffs were sent a letter from the Deputy Minister of Health and Social Welfare that their services would no longer be required after that date.[159]

Margaret Grier, the NSS official in charge of day nurseries, received appeals to keep open the five Montreal day nurseries from the Montreal Council of Social Agencies,[160] from officials of the Welfare Federation and the Federation of Catholic Charities, and from the Montreal Association of Protestant Women Teachers.[161] As early as April 20, 1945, mothers of children attending the first wartime day nursery established in Montreal had drawn up a letter urging the government to continue the day nurseries after the close of the war.[162] In October these women gathered signatures on a petition to be sent to Dr. G.L. LaPierre, Director of Wartime Day Nurseries for Quebec.[163] A major reason the mothers gave for continuance of the program was that the mothers who placed their children in the nurseries were working out of economic necessity, because of separation from, or the death, war injuries, sickness, or inadequate income of the husband. Further, the mothers argued that, compelled as they were to work outside the home, they could do so, thanks to the day nurseries, relieved of anxiety over the well-being of their children. In fact, their children were receiving better day care in the day nurseries than they would have under any other circumstances: better health care, training, and diet. The day nurseries were actually helping the mothers keep their families together.

These appeals were of no avail. The Quebec government's position remained firm: the Dominion-Provincial Day Nurseries program had been a war measure; the war was now over, and therefore the agreement was no longer in force.

The situation was different in Ontario where more wartime child-care facilities had been established and there was correspondingly greater pressure to keep them open after the war. It was the federal, not the provincial, government that opened discussions to end the Dominion-Provincial Wartime Day Nurseries Agreement in Ontario in the fall of 1945.

On September 11, Fraudena Eaton reported to Arthur MacNamara that applications for day care in Toronto had "increased rather than diminished during the past two months." She was having Miss Grier investigate "this seemingly unreasonable situation."[164] Although the Wartime Day Nursery and School Day Care Centre in Oshawa were closed on October 21, 1945, due to decreasing enrolment,[165] elsewhere in Ontario reports from local employment offices showed in November "a continuing high demand for day care of children of working mothers."[166]

Mrs. Eaton's reaction was to give a gentle nudge to MacNamara:

> The time will come fairly shortly when the employment of mothers will not necessarily be related to production for war purposes or for highly essential civilian goods. It brings the matter of providing day care for children back to the point where it may be reasonably looked upon as a responsibility of the Provincial Government.[167]

MacNamara took the hint and instructed Mrs. Eaton to draft a letter to the appropriate Ontario minister asking his views on when to end the agreement on day care of children.[168] In his letter of November 22, MacNamara wrote:

> You understand that the financing of these and similar plans by the Dominion Government has been done as a war measure and our Treasury Board naturally takes the position "now that the war is over why do you need money?"[169]

He suggested as the termination date of the agreement "the end of the Dominion Government fiscal year or soon thereafter."[170]

Investigations indicated that the mothers using the child-care facilities in Toronto were, in fact, in desperate need of full-time day care. Fifty per cent of the women were working full time out of economic need: some were widows without, or with very small, pensions; others were deserted and unmarried mothers; still others had husbands who were unemployed or ill or earning inadequate wages. In 5 per cent of the cases husbands had been "apprehended because of conduct." Thirty per cent of the mothers were working full time to help husbands pay off debts, purchase homes, or get re-established in business. Fifteen per cent were working part time to supplement family incomes.[171]

Hope was growing in Ontario that, after the Dominion

government pulled out of the agreement, the provincial govern-
ment might pick up the whole tab. Margaret Grier informed
Arthur MacNamara on February 15, 1946, that Deputy Minister
of Public Welfare B.M. Heise himself had told her "he now had
every hope that the Province would continue to maintain the
day nurseries."[172] In early February deputations went to Toronto
City Hall, the Board of Education, and the provincial Depart-
ments of Education and Public Welfare to press for the
continuation of day care in Ontario.

Meanwhile, four months had elapsed since the Dominion
government's proposal to end its participation in the day nursery
project. On February 18, 1946, Mrs. Eaton wrote to MacNamara
suggesting that, as Ontario might continue the operation of day
nurseries, provincial authorities were in no hurry to see federal
funds cut off. The time, however, had come. "No suggestion could
be made now or even four months ago, that the employment
of those women whose children are in day care centres is essential
for work of national importance."[173] Humphrey Mitchell took
up this argument in his letter of February 26, 1946, to W.A.
Goodfellow, Ontario Minister of Public Welfare. "As you know,"
Mitchell wrote, "the Dominion share in financing this project
was undertaken as *a war measure* for the reason that women
whose children were in day care centres were engaged in *work
of national importance*." Implying that the employed mothers of
Ontario were no longer doing work of national importance, he
announced his department's decision to stop Dominion partic-
ipation on April 1.[174]

Now a three-way passing of the buck began. Goodfellow
informed the federal minister that enabling legislation was before
the Ontario legislature to make day nurseries a municipal
concern, with the provincial government sharing costs. The end
of federal contributions on April 1, together with the planned
transfer of day nurseries from the Department of Public Welfare
to municipalities, threatened to disrupt the running of existing
child-care facilities before the end of the school year. In view
of that, Goodfellow asked Mitchell to consider extension of the
Dominion-Provincial Wartime Day Nurseries Agreement to June
30, 1946.[175]

Humphrey Mitchell approved the extension to June 30,
although this information got lost in the shuffle of intradepart-
mental memoranda and did not reach the Ontario Minister of
Public Welfare until April 2, 1946.[176] In the interim, the Ontario

legislature had given first and second reading to Bill 124 authorizing municipalities to "provide for the establishment of day nurseries for the care and feeding of young children" and the provincial government to contribute one-half of the operating costs. The bill passed third reading on April 4 and became law as The Day Nurseries Act, 1946.[177] The day-care program for school-age children was to be dropped altogether.

On May 17, 1946, Goodfellow wrote to Mitchell with a new request. Some of the municipalities had indicated that, as their budgets for 1946 had already been passed, they had no funds to pay 50 per cent of the operating costs of day nurseries for the last half of 1946. Toronto, for example, the city in which most of Ontario's wartime nurseries and day-care centres for school children were located, had made no provision in its 1946 budget for assuming the day nursery costs. Therefore, Goodfellow asked Mitchell to consider the following proposition:

> For those municipalities which indicate a desire to have the [day nursery] programme continued and which are prepared to assume the administrative responsibilities from July 1, would you consider continuing the 50 percent net cost of operation until December 31, 1946?[178]

On the same day Mrs. G.D. Kirkpatrick, chairman of the board of directors of the Welfare Council of Greater Toronto, forwarded to Mitchell the board's resolution not only that the Dominion government continue to contribute 50 per cent of the funding for Ontario's day nurseries through December 31, 1946, but also that the provincial and Dominion governments continue their support of the day care for school-age children.[179] A second letter from Mrs. Kirkpatrick to the Minister on May 29, 1946, reiterated the concern of the Toronto Welfare Council's board of directors that the day-care program for school-age children not be eliminated.[180]

On May 21, 1946, Humphrey Mitchell wrote to Brooke Claxton, Minister of National Health and Welfare. In Mitchell's view, the current pressure on the federal government was the result of "the Ontario Government's endeavouring to arrange for municipalities to pay the fifty percent heretofore paid by the Dominion Government and the municipalities are objecting."[181]

Claxton replied on June 7 that he could "see no reason why the Dominion Government should continue in peacetime to share in the costs of a program, the interest in which is apparently

centred almost entirely within one province, and indeed largely within one large city in that province." Claxton had learned from his deputy that Hamilton had agreed to pay its share of the day nursery costs from its 1946 budget. In Claxton's opinion, if Hamilton could do that, "even after the municipal tax rate has been struck and the budget set for the year," certainly other cities, such as Toronto and London, should have been able to do likewise."[182]

On June 12, 1946, Mitchell conveyed to W.A. Goodfellow the government's decision not to grant Ontario a further extension.[183] On June 30, 1946, the Dominion-Provincial Wartime Day Nurseries Agreement with Ontario came to an end. All the day-care facilities for school children ceased to operate in Ontario on that date, though eight were eventually re-opened. By the end of November, 1946, nine out of the twenty-eight day nurseries were closed and by 1948 the total number had been reduced to sixteen.[184]

V

The post-war abrogation of government-supported day nurseries in Quebec and most of the day care for school children in Ontario, the post-war reduction of government support to day nurseries in Ontario, as well as the post-war cancellation of the tax concessions to employed married women, were all in keeping with the official attitudes toward working women that prevailed during the war itself. As labour shortages developed in 1942, women were regarded as a large labour reserve that Canadian industry could draw on in the war emergency. But women's place was in the home, and so initial recruitment was directed at young unmarried women and then married women without children. To meet increased labour shortages in 1943, however, government had to dip deeper into the female labour reserve, down to women with home responsibilities, even to mothers of young children. In deference to "majority opinion" that tended "to favour mothers remaining in the home, rather than working, where at all possible," NSS and Labour Department officials appealed to the fact of war conditions to justify their having to encourage mothers with young children "to accept industrial employment, as an aid to our national effort."[185] Even after the establishment of child-care facilities in Ontario and Quebec, the Department of Labour insisted that its policy was "to put

emphasis on single or married women without children accepting employment in the first instance."[186] As only war service justified a mother's leaving home for the public workplace, the Dominion-Provincial Wartime Day Nurseries Agreement was intended to provide day care primarily for the children of mothers working in war industries. According to Mrs. Eaton, the Women's Division of NSS had "found that women with children were unwisely deciding to look for employment," and had therefore in October, 1943, advised the counselling service of local Employment and Selective Service Offices "to hold back from employment those who seem to be neglecting their home and family."[187]

Where there was opposition to the employment of women in industry, as there strongly was from certain quarters in Quebec,[188] the Women's Division of NSS did not respond with arguments of women's equal right to work but instead invoked the necessity of sacrifice for the nation at war and stressed the temporary nature of that sacrifice. Where women accepted jobs previously held only by men, they were generally regarded as replacing men temporarily. The large-scale part-time employment of women was not supposed to last. The very increase in numbers of women in the labour force, from approximately 638,000 in 1939 to an estimated 1,077,000 by October 1, 1944,[189] was regarded as a temporary phenomenon. Therefore, it is not surprising that, faced with problems of women's unemployment and economic dislocation in the post-war period, the Women's Division of NSS sought to return married women to the home and to channel young unmarried women into traditionally female occupations: domestic service, nursing, and teaching.

But even the wartime recognition of women's crucial domestic contribution to society and women's centrality in the wartime anti-inflation and conservation drives did not translate into an equal place for women on the post-war councils of the nation. Women were not represented on the post-war reconstruction and rehabilitation committees in any way commensurate with their proportion of the population or the socially necessary nature of their labour.

2

Government Job-Training Programs for Women, 1937–1947

with Marjorie Cohen

The question of women's economic self-determination has constituted one of the major focal points for feminist analysis of women's oppression. A crucial dimension of women's inferior position in the labour market is the concentration of women workers in low-paying, low-status job ghettoes. Some of the processes that operated before, during, and after the Second World War to narrow the range of jobs to which women could gain access are the subject of this chapter.

Contemporary opponents of women's employment in non-traditional occupations sometimes argue that women are not in such jobs because they choose not to be.[1] Underlying that argument is an assumption of freedom of choice and equality of opportunity that flies in the face of historical experience, for even the briefest look at the historical record reveals the powerful social and economic forces channelling women into certain work areas and erecting barriers to keep them out of others. The type and accessibility of job training constitute one such force, at the same time as it is linked to, influenced by, and indicative of others. An examination of three vocational training programs developed in Canada under federal legislation between 1937 and 1947 – the Dominion-Provincial Youth Training Program of 1937-40, the War Emergency Training Program of 1940-44, and the rehabilitation component of the Canadian Vocational Training Program, 1945-47[2] – demonstrates the relationship between economic conditions, social definitions of femininity, and women's employment.

During this ten-year period, Canada underwent three distinct labour market phases. Of particular interest are the effects on women as training programs changed to accommodate labour glut, labour scarcity, and the transition from wartime to

peacetime economy. The type of training provided for women did indeed vary with changes in demands on the labour market, but what was considered "normal" work for women remained surprisingly constant, even after the experience of war. In fact, throughout the period the training possibilities for women were limited by conceptions of women's social role and fears of female competition for men's jobs. Furthermore, it will be seen that middle- to upper-class women's organizations,[3] recognized by government as the representatives of women's interests, placed their influence behind the prevailing inclination of public policy to preserve sex-typed occupations, the sexual division of labour, and the class-based occupational structure.

The Dominion-Provincial Youth Training Program

The first program, the Dominion-Provincial Youth Training Program, was introduced in 1937 as a means of alleviating unemployment among people between the ages of sixteen and thirty. Four main types of training project were developed: (1) training in the primary resource industries of forestry and mining; (2) urban occupational training, for "skilled" or "semi-skilled" jobs; (3) rural training designed to keep young people on the land; and (4) physical recreation and health training. Within the program as a whole, the courses for men and for women were kept separate and distinct. Women were totally excluded from training in mining and forestry. The fourth type was not really vocational training at all, but rather physical education intended to raise the morale and increase the physical fitness of Canada's young people, with only two provinces, Alberta and British Columbia, participating. Domestic training for women predominated in the remaining two categories, especially in the rural training courses for women, where it was seen as preparatory to a life as farm wife. While young men were given courses in general agriculture, farm mechanics, rural community leadership, and even egg and poultry grading and beekeeping (occupations traditionally within the preserve of farm wives and daughters), young rural women were offered courses in handicrafts and homecraft. Domestic training for women also came first in urban occupational training. While men were offered industrial apprenticeships and training courses in such fields as motor mechanics, carpentry, electronics, machine shop, building construction, welding, and even ski instructing, the most prevalent

form of training for women in almost all provinces was that provided in Home Service Training Schools. Indeed, approximately 60 per cent of the women in urban occupational training were enrolled in these schools to be trained as domestic servants.[4] The remaining 40 per cent were scattered through an array of other sex-typed courses including dressmaking, retail selling, catering for tourists, waitressing, home nursing, interior decorating, "commercial refresher," and "industrial learnerships" in power sewing machine operation.[5]

This emphasis on domestic training as primary vocational training for girls and women was no historical aberration. Faced with a chronic shortage of domestic servants since the late 1800's, organized women, both urban and rural, pressured governments to meet the need through immigration policies favouring female domestics and through the promotion of domestic science instruction in the public schools.[6] With immigration restricted after the onset of the depression, emphasis by necessity shifted onto training as the method of recruiting domestics, and many women's organizations, such as the National Council of Women and the YWCA, appealed to the government with a new urgency for the establishment of state-supported schools for domestic servants. Members of women's organizations were believed to have special knowledge of training requirements, as well as the ability to influence potential employers regarding working conditions. Thus, they were directly incorporated into the program's administration once the schools were established.

Setting up schools for domestic servants had also been the advice of the Women's Employment Committee of the National Employment Commission.[7] In studying the effects of the depression on women's employment opportunities, the Women's Employment Committee had found unemployment in almost every classic women's occupation except domestic service.[8] Indeed, domestic service was one of the few areas in which there was actual expansion in employment for women.[9] Contributing to this were the changes in income distribution occurring during the depression: some lower middle-class housewives could now afford a maid, given the low pay that many desperate women were forced to accept.[10] Despite the employment opportunities in domestic service, the supply did not outstrip the demand, primarily because of the unattractiveness of the occupation: the low pay, irregular and long hours, isolation, poor working

conditions (including employer-employee relations), and social stigma.

The Home Service Training School program had as its objective eliminating all those rebarbative features and raising the status and prestige of domestic work. A presupposition underpinning the program was that proper training was necessary, not to stimulate demand for female domestic workers, but to stimulate supply. The architects of the household training schemes reasoned that once women were properly trained and certified, then employers would begin paying them higher wages and more respect, with the result that more women would seek jobs as domestics.[11]

The Home Service Training Schools drew on the model of servant training courses set up by women's voluntary organizations like the YWCA[12] earlier in the Depression. Approximately half the schools were fully residential; in the others, trainees took turns living in a "practice house." Instruction was provided in the basic skills of housework: preparation and serving of food, daily and weekly cleaning of rooms, laundry, sewing and mending, and answering the door and telephone. Certain subjects, such as table setting and use and care of electrical equipment, clearly indicate the perceived gap between the accustomed standard of living of the trainee and that of her prospective employer. Marketing and budgeting were not taught universally; and child-care training, where it appeared, was connected with home nursing and occupied a relatively insignificant place on the curriculum. Classes on "deportment," "personal attitude," "employer and employee relationships," and "personal habits and appearance" were designed to promote "the development of right attitudes to work,"[13] clearly a high priority among employers.

The term "hostess method" was applied to the approach adopted by some schools of having the trainees go out to work in selected local homes to obtain practical experience. The federal Department of Labour official report of November, 1938, acknowledged that the possible benefits of the hostess method could well be outweighed by its inherent dangers, the chief one being that the trainees could too easily be exploited and used to replace charwomen or other casual household help.

Despite the project's stated objective, the Home Service Training Schools had limited success in improving the status, pay, working conditions, or employer-employee relations of domestic

service. One report noted that talks to women's organizations were necessary to educate "employers to their responsibility in the treatment of girls who come into their homes for home service work" for it was "quite apparent that some employers have much need of education along this line."[14]

On the issues of working conditions and pay, there were clear differences in perspective between labour and management.[15] While the women in Vancouver who organized the Domestic Workers' Union No. 91 in 1936 were demanding a forty-eight-hour week and inclusion in the minimum wage laws, the Victoria Branch of the YWCA, the first in Canada to inaugurate a "Household Training Course" to train young women for domestic service, was recommending that the hours of work for "girls" employed in homes should not exceed sixty per week and the national YWCA was only willing to endorse a recommendation for a maximum eleven-hour day or sixty-nine-hour week.[16] Similarly, while the Saskatchewan Provincial Executive of the Trades and Labour Congress of Canada sought inclusion of domestic workers under the Minimum Wage Act, the 1940 Household Employment Study Group of Preston, Ontario, composed of housewife employers of domestic help, concluded "that the situation is not ready for legislation as to hours and wages" since "it is better for a girl to be in a home with room and board, even at low wages, than to be without work."[17] Clearly, self-interest motivated such pronouncements.

Nor did the Home Service Training School project succeed in removing the social stigma attached to domestic service in the eyes of prospective household workers. The November, 1938, survey reported that:

> In many localities it has been found difficult to get girls from families in receipt of direct relief to undergo such a course of training, or to accept work on its conclusion. There is a deep-seated prejudice against this type of work, not only among the young women themselves, but among their parents.[18]

Although the Youth Training Program was implemented specifically to help young people "not gainfully employed and certified as being in necessitous circumstances, including deserving transients,"[19] the administrators of the Home Service Training Schools took a dim view of recruits who were overly "necessitous," such as " 'problem' girls" sent to the schools for training

by social welfare agencies. A general assumption in operation by late 1938 was "that the more necessitous the trainee, the less suitable she is for the work."[20] There thus remained an unresolved contradiction between the employer's desire for "a finer type of girl" and the stubbornly unattractive nature of the live-in servant's job, which repelled all but the most vulnerable and least advantaged women in the labour market. While official reports at the time stated that the Home Service Training School project was successful, the small number trained (3,683 by May, 1940) and the fact that the schools' enrolments rarely reached capacity indicate that it was not the raging success its planners had hoped it would be.[21]

This solution to female unemployment was generally viewed, however, as both sensible and feasible. Domestic service was an occupation traditionally associated with women where there would be no competition with men and where demand perpetually outran supply. Members of women's organizations found the promotion of domestic training compatible with their conception of the proper niche for a certain class of women; with their perception of the only alternative for unfortunate women forced onto the job market; and with their charitable impulse to help needy women find work during difficult economic times, an impulse that dovetailed more often than not with their own demands for domestic help. Neither government nor women's groups questioned the assumption that housework was woman's responsibility, whether performed directly or supervised by women, and neither questioned the class structure that made paid housework the obvious occupation for poor females. Moreover, the fact that women's organizations pushed for domestic training programs was as much a function of the members' own confinement to the domestic sphere and of their own responsibility for housework as it was of the lack of alternative job opportunities for women.

The Dominion-Provincial War Emergency Training Program

The second program, the War Emergency Training Program, formally came into being in 1940. Under it women were trained for employment in some trades previously operated as male enclaves, but that training was still designed to prepare women differently from men, above all for a more circumscribed working life.

As early as 1938-39, when war was only a strong possibility, the government began adapting the Youth Training Program to national defence purposes. Specifically, in 1938, arrangements were made for certain provinces to train men in aircraft manufacture and, in the spring of 1939, to train ground mechanics for the Air Force. With the actual outbreak of war in September, 1939, the Youth Training Program was further altered to meet the growing needs for war industrial training and trades training in the armed forces. A plan for a special War Emergency Training Program was drawn up during the summer of 1940, but as the scope of the program would have been limited by the eligibility requirements of the Youth Training Act as well as by the provincial liability for 50 per cent of the cost, the War Measures Act was invoked to override those restrictions and to make it possible for the Dominion government to assume almost 100 per cent of the cost of war-related training projects.[22] Provinces and municipalities contributed the shops of their vocational and technical schools during summer vacation and after regular school hours. On December 28, 1940, the Inter-Departmental Committee on Labour Co-ordination, which had been studying the question of labour supply, recommended an expansion and gearing up of the program. With cabinet's adoption of that report, "the War Emergency Training Programme ... formally came into being after a year and a half of progressive evolution from the old Youth Training Programme."[23] Projects formerly carried on under Youth Training were allowed to lapse while schedules of new projects to be undertaken were attached to new federal-provincial agreements.[24]

Labour power *per se* did not become a problem in Canada until almost two years after the start of the war. By the late 1930's the Depression had eased somewhat but in September, 1939, the official unemployment rate still included some 600,000 to 900,000 unemployed, depending on the source. In the early stages of the war, Canada's production effort, principally in the primary sector providing raw materials and food, was not strained, but after the fall of France in June, 1940, as Canada's production of war equipment for allied armies was stepped up, her industrial sector began increasingly to suffer shortages of skilled and semi-skilled labour. Hence, there was a need to expand and formalize a War Emergency Training Program.

At the outset practically all the trainees were male. "All other

factors being equal unemployed men will be first assigned provided they have the requisite capacity to benefit from the training or to perform the work," the *Labour Gazette* reported in January, 1941, as one of the principles that would govern the implementation of the War Emergency Training Program.[25] Preference was to be shown to veterans of the Great War, soldiers discharged from the armed forces in the current war, and men over forty years of age. The minimum age of admission was sixteen.[26]

Female trainees were enrolled only in Ontario classes, and they numbered a mere 271 out of a total 10,156 enrolled in classes throughout Canada during the first four months of 1941.[27] At that time women were being accepted for training only when "specifically sponsored by employers."[28] In such cases, the employer would select the trainees and specify the kind of training desired. Since training was usually quite specialized, the time the trainee spent at the school could be as little as two weeks, in contrast to the normal course of more general training, which lasted three months.[29]

At least until the end of 1941 women continued to be trained for domestic service under the Youth Training Program. More than 847 received training in Home Service Schools in Manitoba, Quebec, Alberta, and British Columbia in 1941.[30] During that year women in New Brunswick, Quebec, Manitoba, Alberta, and British Columbia were also given specialized training in dressmaking, power sewing machine operating, and handicrafts. In November, however, the Director of Training in the Department of Labour informed the Minister that instructions had been sent out to all regional directors to arrange for war industrial training for women as soon as the local supply of male applicants ran out.[31] By the end of 1941 war industrial training had been given to 3,341 women, albeit mostly in Ontario, and they constituted approximately 17 per cent of the total then enrolled.[32]

The industrial training program itself was expanding. In June, 1941, training was being offered at seventy-five vocational schools across the country.[33] By the end of the year there were 101 located in all provinces except P.E.I.[34] The number of training centres in operation fluctuated with the changes in demand in different areas, but settled by mid-1943 to an average of about 120. Where there were not enough vocational shops in existing technical schools, former Youth Training centres were taken over for the War Emergency Training Program or

additional special centres were opened and equipped. "When the demand for training was at its peak most of the centres operated two shifts and some of them three shifts per day."[35] For instance, Toronto's Central Technical School, which helped pioneer the program, operated on a three-shift, twenty-four-hour basis, with regular public school classes for boys and girls from 8:45 a.m. to 3 p.m., and two shifts for war trainees, the first from 3:30 to 11:20, and the midnight shift from 11:30 p.m. until 7:30 a.m. No women were allowed to attend the midnight class.[36]

In September, 1941, training within industry was also brought under the jurisdiction of the Training Branch of the federal Department of Labour. And in early 1942 the War Emergency Training Program acquired authority to co-operate with industry in the organization and operation of plant schools that would provide types of training not available in the pre-employment centres. By mid-1943, 105 approved plant schools were in operation and receiving financial and technical assistance from government. In addition, part-time classes to facilitate the upgrading and promotion of persons already employed in industry were started and quickly expanded during 1942.[37]

Besides training for war industry, the War Emergency Training Program was also designed from the start to supplement the trades training of the armed forces.[38] Shortly after the creation of the women's services,[39] female personnel also became eligible for training. The trades training in the services was offered in separate classes for men and women, and, although it increased over the years, the number of trades in which women could be trained remained only a fraction of those open to men. The largest proportion of servicewomen were trained as clerks, cooks, and drivers.[40] Of the ninety other ranks graduating from the CWAC basic training centre at Kitchener, Ontario, in February, 1943, and tapped to go on for trades training, forty were to be "despatched" to clerks' courses, thirty to a cooks' course, twenty to a drivers' course, and nine to a fixed wireless operators' course. Of those completing basic in March, 1943, and designated for training in a trade, sixty were down for clerks' courses, thirty for a cooks' course, twenty for a drivers' course, and twenty for a non-commissioned officers' course.[41]

As the expansion in the War Emergency Training Program was occurring, Canada's sources of labour supply among men, however preferred, continued to decline sharply. When Prime Minister Mackenzie King announced on March 24, 1942, the

establishment of National Selective Service and designated bringing women into industry as "the most important single feature of the program," he specified a series of ten measures to be undertaken, including the provision "of training programs specifically designed for women."[42] Even before he spoke, arrangements had been made to increase the numbers of women in pre-employment industrial training, especially in Ontario but elsewhere as well. By the end of February, 1942, training schools in Quebec, Saskatchewan, Alberta, and British Columbia were also enrolling women in industrial classes. From April to December, 1942, the female proportion of full-time pre-employment trainees overall rose to 48 per cent (total men: 12,453; total women: 11,579). Meanwhile, the proportion of female trainees in full-time and part-time plant school classes as well as in part-time classes in technical schools was also increasing.[43]

The trades in which instruction was being given to women included: machine shop practice; ammunition filling; fine instrument mechanics; power machine operating; welding (arc and acetylene); aircraft sheet metal and aircraft woodworking; aircraft fabric and doping; bench fitting and assembling; electric wiring and radio and electric assembly; industrial chemistry; drafting and mechanical drawing; inspecting; and laboratory technician work.[44] Clearly, women were being trained in skills previously confined to males. Nonetheless, the policy was to protect men's privileged position as "skilled" workers in industry and thus keep women's admission to "skilled" jobs to a minimum.[45] This policy was implemented in a variety of ways.

First, there was the general policy of giving priority to eligible men over eligible women. The first Director of National Selective Service made assurances to that effect in April, 1942, when he explained that "we don't intend to bring women in one door and have skilled men forced out the other." Acknowledging that there still was unemployment among skilled male workers in some sections of Canada, he agreed that "it would be folly to recruit women in these places, until the men have been absorbed." Furthermore, he declared that it would be "contrary to the principles of the selective service regulations that an employer utilize those regulations to replace men with women merely for the sake of having the same work done at lower cost." He ended with an emphatic endorsement of the principle of the primacy of the male breadwinner.[46]

Another way in which women's access to skilled work was circumscribed resulted from a reorganization of production. This was most easily effected in those plants that had to undergo considerable reorganization in any case to convert from peacetime to wartime production. Impressed by "scientific management schemes" developed in Britain and the United States, the Inter-Departmental Committee on Labour Co-ordination recommended in December, 1941, that, to reduce the demand for skilled labour,

> Jobs will be broken down, and the trained mechanics will devote their time to the most skilled part of the work. The rest of the work will be divided among others next [to] the mechanics in line, each of whom ought to be broken in on his part of the job with a few weeks training. New employees will be taken on at the bottom on the least skilled jobs and moved up as rapidly as circumstances and their abilities permit.[47]

This increased subdivision and stratification of the production line made it possible to reserve the most "skilled" jobs at the top for long-term male employees while bringing in at the bottom new employees to perform minute and monotonous operations requiring a minimum of training.[48] Despite the promise of advancement contained in the Report of the Inter-Departmental Committee on Labour Co-ordination, the actual possibility of many of the minimally trained new workers moving very far up the ladder of skill was strictly limited by the imperatives of the war emergency with its short-term goals.

The introduction of improved machinery facilitated reorganization. Praising the revolution in technology necessitated by the war effort, a *Maclean's* article spoke reverently of the new machines developed to remove the responsibility for accuracy from human beings and rigged with so many stops and checks that the possibility of error was reduced almost to the vanishing point. The novice operator, "schooled in a few simple tasks and motions," could hardly go wrong unless he or she fell asleep on the job.[49] These changes in the organization and technology of production meant that industry could rely increasingly on inexperienced and minimally trained workers. By 1942-43, as production was stepped up in munitions, ammunition, aircraft, and fine instrument manufacture, their ranks were increasingly female.

The media played up the connection between the greater use of women in war industry and the introduction of machines compatible with women's learning capacities. Thus a female trainee was quoted in *Maclean's* as saying of her lathe, "with a look of amazed delight on her face, 'Why, it's easier to run than a sewing machine.'"[50] And according to *Canadian Aviation*, Vultee Aircraft Incorporated had made a careful study of the problems involved in employing women and found that if machines could be developed to compensate for women's alleged inferior co-ordination and inferior weight, height, and strength, then "women make loyal and productive workers, and can handle a surprising number of type of jobs."[51] Another *Canadian Aviation* article gave detailed examples of "methods improvements" introduced into the production of the Harvard advanced trainer at Noorduyn Aviation Limited, which allowed female operators to work more efficiently than male operators using the old methods.[52]

Training provided for women under the War Emergency Training Program was designed to fit them for a specific job for the duration of the war, not for lifetime careers as skilled workers, much less skilled mechanics who might compete with men in the post-war job market. This was obvious in the generally shorter training period for women. At the beginning of the program the length of the normal course was set at three months, but increased specialization in industry and the attendant need for workers trained in a very narrow range of skills led to the introduction of a wide variety of shorter courses. Two weeks was set as the minimum training period. This reduction in the training period, as the *Labour Gazette* reported, was "particularly evident in regard to women, where the majority of the training courses last from two to six weeks." "Inevitably," the *Labour Gazette* continued, "this type of training produces people who can only perform one job and are lacking in a wider range of skill."[53]

At Toronto's Central Technical School, the average length of industrial training courses was ten to twelve weeks, but some highly technical subjects, such as industrial chemistry and machine drafting, went on for twenty weeks. "On the other hand," a *Maclean's* article noted, "three weeks instruction is sufficient to teach most women to run a power machine, or to work efficiently on assembly jobs requiring only a single main operation."[54] At Small Arms Limited, makers of the Sten gun

and the Lee-Enfield rifle, new female employees found them-
selves on the production line after only one day in the plant
classroom. Instruction was limited to four basic machines, a
milling machine, turret lathe, drill, and surface grinder, and, with
some continuing supervision from " 'patrolling instructresses,' "
women who had had no previous industrial experience were
found to perform well after the single day's training. As one
woman recalled, "they showed you on your first shift" – that was
the extent of her training.[55]

In general, war had necessitated a revolution in vocational
training because, to meet the demands of war production, "Skill
had to be created overnight." Justifiable only because the war
emergency left no alternative, the crash training courses were
seen as a radical departure from the "normal vocational training"
aimed at producing a well-rounded (male) worker with a wide
range of skills. During the war men as well as women underwent
"hurried training in specialized tasks,"[56] but women's training
was by and large the more hurried and the more specialized
of the two.[57]

Women's access to skilled trades was also restricted by the
job-specific training they received. In war industry "many
employers" showed "considerable reluctance" at first to taking
women into non-traditional job sectors.[58] That reluctance was
overcome in one way by the designation of certain work processes
as ideally suited to innate female traits. Women workers could
then be concentrated in those "feminized" tasks. Improvement
of machinery in the direction of increased automation and
mechanization, which was fundamental to the subdivision and
de-skilling of production, also made possible the "feminization"
of those operations.

It was widely believed that women were by nature more patient,
more dexterous, and more capable of detailed, eye-gruelling work
than men.[59] The *Canadian Aviation* article on female workers
at Vultee Aircraft Incorporated, for example, conceded that there
were certain advantages to employing women: "Women thrive
on routine, continued repetition of which would drive men to
distraction," and "Women are faster than men at sorting small
objects and any operations requiring digital dexterity."[60] Thus,
women came to be regarded as eminently well suited for precision
work in any kind of fine instrument assemblage, in electronics
and optics, in various stages of aircraft, gun, or ammunition
manufacture, and in the inspecting of war equipment. Thelma

LeCocq wrote in *Maclean's*, for example, about the "deft-fingered" women who excelled at fine precision work in a plant that made airplane instruments, including finely adjusted meters to register voltage, current, and fuel. About 40 per cent of the workers in the plant were women. On the meters they did

> close machine work, winding wires only a few thousandths of an inch in diameter on tiny spools the size you'd find in a child's sewing set. They set jewels, synthetic sapphires hardly larger than a granule of white sugar, using fine tweezers to convey them to the lathe. They run machines that cut screws almost as delicate as the screws in a watch.

And to provide training for these jobs, management did not even have to draw on the War Emergency Training Program because the precision work could be learned by the women, given their "natural" endowments of "dexterity, patience and keen eyesight," in "only two or three days training right in the plant."[61] It was precisely the dull, repetitious, eye-straining jobs created by the

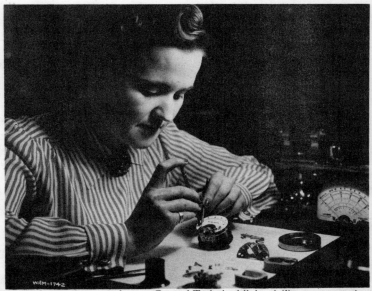

In the fine instrument class at Central Technical School, Toronto, a student learns to break down and assemble aircraft equipment. Credit: Nicholas Morant/Public Archives of Canada/PA-145670.

greater subdivision of the production process that could be "feminized" and that women could be prepared for with a minimum of training.

Although the specific war industrial jobs for which women were recruited and trained extended into a large range of occupations formerly confined to men,[62] the woman in the non-traditional job had probably received less extensive training than her male counterpart. The narrow, job-specific instruction that characterized women's training under the War Emergency Training Program handicapped any woman who desired to continue in a non-traditional occupation at war's end.[63] That narrowness of training was based in part on the assumption that women had come forward to work in machine shops out of patriotic motives and only for the duration of the war. As the Nova Scotia director of technical education wrote of the women trained in his province, the general and theoretical aspects of the machine tool trade "did not interest them as much as the practical shopwork because they had no long-term ambition to become journeymen in order to continue in the trade after the war."[64] Whether such statements were based on fact or prescription, they nevertheless reflected a set of attitudes and practices that served to curtail any such "long-term ambition."

A minimum of training had brought the largest proportion of women war workers onto the production line at the lowest levels of skill where they could be concentrated in "feminized" tasks that depended for smooth performance on the allegedly superior female capacity for monotony and intricate work. During the war more than 50,000 civilian women had taken training for work in war industries, in addition to the women who had been trained for trades in the armed forces.[65] The tendency of that training to be different and unequal prepared the way for the separate treatment of women in the rehabilitation training programs of the post-war world.

Canadian Vocational Training and Rehabilitation for Women

However truncated and task-specific, War Emergency Training for women had extended into non-traditional trades. Rehabilitation training of women for the post-war world, in contrast, reverted to more conventional pre-war conceptions of labour suitable for women. As early as January, 1943, when war

employment was nearing its peak and a shortage of even women's labour was beginning to be felt, the Director of Training in the federal Department of Labour stressed, in a routine letter to regional directors, that in arranging for vocational training for ex-servicewomen, they should "keep in mind the employment opportunities as they may exist in the post-war period, and the likelihood that employment of women may be discontinued entirely or at least greatly diminished, in the metal trades and other heavy industries."[66]

It was estimated that at the height of women's involvement in war production in October, 1943, 261,000 women had been recruited into war industrial jobs. Already by April 1, 1945, thousands of those jobs had been eliminated, resulting in the layoff of more than 80,000 women war workers.[67] In addition, approximately 50,000 women had served in the armed forces, of whom all but some Nursing Sisters faced discharge as the women's services were slowly reduced in strength after V-E Day until finally being disbanded in the second half of 1946.

Fears that massive demobilization at war's end would lead to a recurrence of post-war slump as after the Great War, or to a return to the dismal conditions of the 1930's, were counter-balanced by a heightened confidence in capitalism's ability to produce and in government's ability to plan.[68] As it was believed that planning in a democracy should not be arbitrary,[69] planners conducted surveys of post-war employment intentions. The 1944 Weir Report on post-war employment prospects in Canada sought to ascertain what type of occupation armed forces personnel were planning to enter or train for after discharge. With respect to servicewomen's preferences, " 'an extraordinary preponderance,' " as the Minister of Pensions and National Health expressed it, put stenography as the occupation of their choice. Even marriage, as indicated by the choice of "home-making," was "a poor second, followed by nursing, university courses, teaching, book-keeping and clerical work."[70] These results are not surprising, given the apparently sex-typed list of choices offered the servicewomen and the fact that the overwhelming majority of women in the armed forces had been trained as clerks and clerk-stenographers.[71] Furthermore, stenography was, after all, at the top of the hierarchy of clerical skills. Unfortunately, Weir did not survey the post-war employment preferences of the over 200,000 women war workers. There never was a reliable

survey made of how many women employed during the war at non-traditional jobs would have wanted to stay in such work after the war.

On the equally crucial question of whether or not women wanted to stay on in paid work outside the home, the surveys came up with conflicting results. On the basis of questionnaires distributed among women war workers and interviews with employers and business experts, the 1943 government Sub-committee on the Post-War Problems of Women estimated that between 45 per cent and 55 per cent of the 600,000 women who had entered the paid labour force since 1939 would be responding to "the normal urge towards marriage, and home, and family life" and therefore would be leaving their paid jobs once the war was over.[72] In contrast, one Labour Department survey of the "post-war working intentions" of 19,710 civilian men and 10,135 civilian women, conducted in 1944, showed 28 per cent of the women, as compared with 2 per cent of the men, intending to quit work after the war to take care of a home. That left 72 per cent wanting to stay in the work force.[73] A Gallup poll of the Toronto area found that 80 per cent of all women employed full-time intended to continue after the war and that one-half of the married women workers hoped to keep their jobs. Moreover, some unnamed but "large" trade union had recently surveyed 1,000 of its female members asking whether or not they would continue to work after the war if a job were available. Eighty-four per cent of the married women, 95 per cent of the single women, and 100 per cent of the widows answered "yes."[74]

Faced with such survey results and committed to the principle of freedom of choice, post-war planners might conceivably have done everything within their power to safeguard a woman's right freely to choose her occupation as well as whether or not to work for pay. The possibility for change in the post-war economy, including change in the direction of improving women's economic position, was enormous. Women's contribution to the war effort had been impressive and they had received recognition as capable workers in areas normally the preserve of men. Important also was the vision of a more egalitarian society that the war effort had generated. Dr. Olive Ruth Russell, appointed in January, 1945, to the Department of Veterans' Affairs as an executive assistant specializing in the rehabilitation of service-women, was fond of quoting Winston Churchill's claim that " 'War

has taught us to make vast strides forward toward a more complete equalization of the parts to be played by men and women in society.' "[75]

But undercutting any commitment to equality was the conviction on the part of most post-war planners that the primary role for most women should be the dual one of wife and mother, a role not to be combined, except in the direst circumstances, with paid employment outside the home. That belief coloured the major statements of reconstruction social policy that dealt with women, from Leonard C. Marsh's *Report on Social Security for Canada 1943* to the *Final Report of the Sub-Committee on the Post-War Problems of Women*. Marsh made adult women fit into his social security scheme principally as wives dependent for benefits on "the husband as the chief wage-earner."[76] Similarly, while asserting the principle of women's right to work, whether married or not, the government subcommittee nonetheless deferred to the contradictory principle of male economic primacy. This is most apparent in the fact that they regarded the creation of "sufficient well-paid employment for men" as of primary importance and as the necessary precondition for the ideal solution to the problem of women's crowding the labour market after the war – their withdrawal from wage work to devote themselves to home and family. Furthermore, the committee advocated a nursery school program that, because of its short hours (9 a.m. to noon), would have provided a respite to mothers at home all day but no help at all to those employed at full-time jobs outside the home.[77] Finally, in its look at the post-war future, the Wartime Information Board based its "full employment campaign" largely on the expectation "that a good many *women* in the Services and in civilian jobs are looking forward to changing their tunics and overalls for aprons, as soon as the woman-power shortage is over."[78]

So, in spite of the vision of a more egalitarian society in the future and a professed confidence in the ability of government to plan for post-war full employment, there was no attempt in the post-war planning schemes to maintain the gains for women in social and employment policy that had been made during the war.[79] Rather, the aim was to return to a pre-war social reality, but without the disability of the pre-war economy, that is, without unemployment. The result was rhetoric that stressed the equal application of the training schemes to men and women; at the same time, a program was instituted that stressed women's

traditional role as paid or unpaid worker in the home and that reinforced the segregated participation of women in the labour force.

Government officials responsible for the post-war rehabilitation training program, initially designed for armed services personnel but extended in March, 1945, to civilian workers displaced by the close-down of war industries,[80] were proud of Canada's progressive treatment of women. Dr. Russell doubted that any country had gone as far as Canada in "abolishing sex discrimination and the granting of equal status to women" in its legislation pertaining to ex-service personnel.[81] A Department of Labour booklet listed as one of the principles governing Canadian Vocational Training that "Women have equality with men in all opportunities for training."[82]

Equal opportunity, however, was not understood to mean the same opportunity or the same training. Commonly it was assumed that when women were given the freedom to choose, they would conform to traditional expectations. For instance, Dr. Russell told a Department of Veterans' Affairs counsellors' training course in February, 1945, that it was unlikely that women would "be interested in pursuing some of the training open to men," because of the "physical requirements, or other conditions of the job," although it would be "poor psychology to close any courses to them."[83] Similarly, Mrs. Edgar Hardy, president of the National Council of Women, advised the Training Branch of the Department of Labour, " 'Open all courses equally to men and women and you will find only very few women will enter what might be classed as courses typical for men.' "[84] Comments like these seemed to indicate support for an "open-door" policy on the grounds that it would not impede the desired return to pre-war sex roles. In fact, deliberate steps were taken to ensure that the program's structure limited the choice women could make: the selection process, the distinctly unequal treatment married women received in rehabilitation measures, and the designing of training courses specifically for women all served to make women's choice a narrow one indeed.

Although the overall administration of the veterans' rehabilitation program was vested in the Department of Veterans' Affairs,[85] the training component was principally the responsibility of the federal Department of Labour. While the Department of Veterans' Affairs paid the maintenance grants to veteran trainees, the Department of Labour supervised the provision of

training in co-operation with the provinces under the Canadian Vocational Training Program. If interested in vocational training, an ex-serviceman or woman would consult an Employment and Selective Service Office, at which both the Department of Veterans' Affairs and Canadian Vocational Training had representation.[86] From there an application for training would be forwarded to a District Rehabilitation Board, which would consider the individual's request for a specific type of training and approve it if the training desired conformed to what "would be most desirable in view of each applicant's background and aptitudes."[87] The District Rehabilitation Board was instructed to keep the following criteria in mind: (1) the trainee's physical condition; (2) previous education; (3) occupational experience prior to enlistment or while in the forces; (4) trainee's own preference and aptitudes; and (5) employment opportunities.[88] These criteria built the potential for discrimination against women into the selection process.

The training itself occurred in a variety of institutions, such as regular technical or vocational schools, privately owned trade and business schools approved by CVT, and training centres established under the War Emergency Training Program.[89] If there appeared to be substantial demand for specific occupational training and prospects of subsequent employment, CVT would initiate its own course, usually in the facilities that had been used for pre-employment training during the war. Trainees placed in private trade or commercial schools would have the fees paid by the Department of Veterans' Affairs. In special cases trainees could also be placed in regular pre-matriculation or vocational classes operated by municipal or provincial governments. CVT also sponsored on-the-job training as long as the training was adequate and lasted at least two weeks and in the opinion of CVT was not exploitative of the trainee.[90]

The unequal treatment of married women in provisions for subsistence allowances constituted another restriction on women's access to training. Unemployed civilians being trained in full-time classes were paid subsistence allowances at the following rates: $1.15 per day for a single person living at home; $1.50 per day for a single person living away from home; $2.15 per day for heads of families living at home; and $3.00 per day for heads of families living away from home.[91] The scale of maintenance grants to be paid to veteran trainees provided for payment of $60 a month to single men and women and $80

a month to married men. In addition, monthly allowances were to be paid for each dependent child up to six and for dependent parents. Although the language of the rehabilitation pamphlets issued by Labour and Veterans' Affairs was ambiguous on this point, it would appear that neither married female veterans nor married civilian women out of work were entitled to their own maintenance or subsistence grants while in training. It also seems reasonable to infer that, because servicewomen were not entitled to dependants' allowances for husbands or children while in service, they would not be as ex-servicewomen. Certainly in the case of the out-of-work benefit available to ex-service personnel, it was clearly specified that a married female veteran whose husband was "entirely or mainly capable of supporting her" was not eligible.[92] In post-war rehabilitation and reconstruction policy generally, married women with husbands deemed capable of maintaining them were not regarded as independent agents.

Equally discriminatory in the post-war world were the barriers being erected or re-erected to keep women out of certain jobs. The Re-instatement in Civil Employment Act of 1942 provided that ex-service personnel be given back their old pre-enlistment jobs with full seniority rights on discharge.[93] While this was to apply equally to ex-servicewomen and men, it tended to work to the disadvantage of women: not only were there many fewer female than male veterans, but also many civilian women had worked during the war in replacement positions.[94] Furthermore, a Civil Service Act provided that preference be shown in all Civil Service Commission appointments to ex-service personnel who had seen active service overseas or on the high seas.[95] As stated, the law placed ex-servicewomen at a disadvantage, since only approximately 7,000 had been posted to overseas duty and none had seen service on seaborne vessels. But worse than that, there was an unlegislated rule that "'overseas veteran' means a male person." Indeed, in employment placement generally, this was how the term had been interpreted by National Selective Service since 1943.[96]

Another significant barrier for women was the renewed enforcement of the civil service regulations barring married women from working for the federal government. Dr. Russell, in opposing this policy, argued that if the civil service set the example of refusing to employ married women, the government could scarcely blame other employers if they also refused to employ married women and pursued "policies of retrenchment

based on fear, rather than policies of expansion based on courage, confidence and initiative."[97] But her protest was not enough to reverse this component of the post-war drive to return women to the home. The regulations barring married women from federal civil service employment were not rescinded until 1955.[98] Such barriers had a strong indirect effect on women's opportunities for training, since women were unlikely to be granted permission to train for jobs in which they were not likely to be employed.

While women were technically eligible for all training courses, the government, through various surveys, predetermined what would be the best areas for women to train in. The surveys were notable for the extent to which the procedure prejudiced the information received. For instance, a 1945 Committee on Post-War Training carried out a special survey to ascertain what pre-employment vocational training programs would be appropriate for women given local employment opportunities across Canada. The questionnaire "guided" those conducting the survey by providing a list of employment areas, all classically female, to be looked into: (1) household employment; (2) hotels and restaurants (room service, waitressing); (3) hospitals (ward aides); (4) sales work; (5) stenography; (6) power machine sewing; (7) hairdressing; (8) dressmaking. The results of this survey were submitted to Canadian Vocational Training "to serve as a basis for further inquiry and planning."[99]

Across the country, the local offices of the National Employment Service, through the machinery of their women's divisions, regularly attempted to assess the projected labour demands for women. The monthly reports submitted to the head offices of National Selective Service in 1945 gave prominence to traditional women's trades: the consensus was that textile workers, nurses' aides, and domestic servants would be needed in the post-war period in far greater numbers than were likely to be supplied.[100] Local women's groups, still regarded by Labour Department officials as uniquely knowledgeable about "employment demands and opportunities" for women, were also of the opinion that chronic shortage of domestic labour offered a ready-made solution to the anticipated post-war problem of an excess of female labour.[101]

During the war the shortage of domestic servants had been patriotically endured, but the perception of this problem as acute immediately resurfaced once the pressure of war production

priorities was eased.[102] The urgency of the problem was brought home in March, 1945, to Employment Service officials in Toronto by the requests for assistance which poured in from prominent residents, such as senators, MPs, the U.S. consulate, and the chancellor of the University of Toronto, who had been without domestic help for six months.[103]

The demand for household training came overwhelmingly from women's organizations, prospective employers, and government officials. It had been one of the main recommendations of the Final Report of the Sub-Committee on Post-War Problems of Women. The other ready-made solution to a surplus of women workers on the post-war labour market was the departure of the independent waged or salaried female employee into marriage and economic dependency.[104] Herein lay the two-pronged thrust of Canada's rehabilitation training program for women, what Dr. Russell called the "special challenge for women in planning for the post-war period": "to develop ways and means of making employment in housework, waitress work, etc. 'attractive and desirable occupations'" and to convince married women that *"household management and the successful care and management of children is an art and a science that has endless possibilities and requires unlimited training and skill if it is to be managed successfully in the new world of to-morrow."*[105]

The need to reconcile women's private role as wife and mother with the more public role gained during the war was a prominent feature of post-war discussions of women's training. These, however, reflected no awareness of the fact that a rigid sexual division of labour that automatically and categorically assigned child-rearing and housework to women restricted women's access to paid jobs and limited the choices women could make. Dr. Russell is a good example. She fought against sex discrimination in employment and for recognition of women's right to work,[106] pleading the case of those thousands of Canadian women who would have to *"accept the permanent function of breadwinner because of loss of husbands or prospective husbands in the war."* She also spoke up publicly for the women, including married women, who had found "a new, hard-won economic independence" that they did not want to lose.[107] Nevertheless, she argued at the same time for women's "special responsibility for family life"[108] and advocated a homemaking course for the brides and prospective brides among women leaving the services.

Within the rehabilitation training program of CVT, provision

of household training initially was to begin "just as soon as sufficient requests are received from young women to justify the opening of schools or special training centres."[109] But it soon became apparent that only a "very, very small number of service women" had any intention of working as domestic servants when they left the armed forces. Rather than abandoning the scheme to re-establish home service training schools for women, the Director of Training proposed expanding the program to include "not only training for home service work," but also "training in home making" for those women being discharged from the forces who were married or about to be married.[110] This was the same idea that Dr. Russell had been pushing from within Veterans' Affairs ever since her appointment.[111] While various surveys taken of women in the armed forces and of those already discharged indicated that there was no interest in training for paid domestic employment, there did appear to be some interest in a short course in homemaking among those women who expected to be running their own homes soon after discharge.[112] Because of the very different objectives of training in home management and training for household service, two distinct courses were developed – a homemakers' course for brides and prospective brides and a home assistants' course for wage labourers.

The "brides' course" became a pet project of Dr. Olive Russell. Initially she envisioned a program involving both men and women, thus putting "appropriate emphasis on marriage and homemaking as a partnership," and which would last, at least for the women, as long as a year.[113] As the discussions regarding the course progressed, however, both suggestions were quietly dropped. Dr. Russell stressed that these courses should "not be confused with the pre-war youth training programmes, which though admirable in many ways, are associated in many people's thinking with depression years and training for 'domestics.' "[114] The intention was to focus the course on the more psychological, emotional, and social aspects of marriage and family relations, "on the over-all management of a home, child care and all the things that go into making a successful home," rather than on the more physical aspects of housework, like cleaning and ironing.[115] Under the title "Home Making and Family Living," the course for brides and potential brides among ex-service-women was designed to last three or four months.[116] Toronto was the first place it was offered, starting in February, 1946.

By April home service training schools were planned or in operation where the course could be offered in Vancouver, Calgary, Saskatoon, Winnipeg, Toronto, Montreal, and Quebec.[117]

Public health nurse Clara Vale explains what constitutes a baby's wardrobe to CWAC discharges in homemaking course. York University Archives, Toronto *Telegram* Photograph Collection.

All homemakers' courses throughout the various provinces followed a common outline that Dr. Russell had invited Doris Runciman, president of the Canadian Home Economics Association, to draw up. It had fallen to various home economists connected with extension departments of provincial universities across Canada to develop the subjects suggested by Runciman's topical headings.[118] The Toronto homemaking course operated out of a practice house at 216 Huron Street where ex-servicewomen took classes five days a week from 9:30 a.m. to 4:30 p.m. for four months at a stretch. There was instruction in interior decoration (with emphasis on "how to make a home beautiful

on a limited budget"), meal preparation and nutrition, consumer education, home planning and management, and child care (for which "small guests" were "borrowed for observation and demonstrations"). While domestic training courses in the depression years had not emphasized child care, in the pronatalist atmosphere of post-war Canada, prospective brides were encouraged to prepare for early motherhood. In addition, trainees were given tips on entertaining and party refreshments. Once a week husbands and fiancés were invited to attend "special" evening lectures on home life and family relations given by "well qualified speakers."[119]

Some, like Dr. Russell, believed that helping to "develop better, more happy homes" belonged in Canada's rehabilitation program every bit as much as training for gainful employment.[120] Others, particularly in the Department of Labour, had serious misgivings over including a "brides' course" in a program designed to train for paying jobs. When he finally got wind of it, the Deputy Minister exploded in a letter to Fraudena Eaton, National Selective Service Associate Director in charge of the Women's Division: "How in the world did we get into the training of homemakers? I thought we had enough responsibility without taking on the 'Instruction to Brides.' "[121]

His reaction is not surprising given his association with a Department of Labour that recognized only work for pay as labour and that was in the business of providing training only for paid work. From his perspective, therefore, training for unpaid domestic labour was not part of his mandate and unpaid housework in general, by departmental definition not labour, was not a matter of concern, except when advocating women's confinement to the home as a solution to male unemployment. In her response to the Deputy Minister, Mrs. Eaton even lost sight of this last connection and condemned the brides' course for not being able to "solve any employment problem" as she saw the courses for paid household workers doing.[122] But other women officials in Labour, the Women's Services, and Veterans' Affairs had no difficulty accepting that the government should provide training in homemaking for ex-servicewomen. A Labour official warned the Deputy Minister that it was too late to "retreat on this training," for not only "Service women heads" and "DVA women training people" but also "our own female training staff are 100% behind this."[123]

Meanwhile there was unanimity among the leaders of women's

organizations and government officials that the greatest unful-
filled demand for female labour was in the field of paid
housework. The result was that the most ambitious and most
widely touted training schemes for women centred on household
service (training in the needle trades came in a distant second).
No other training schemes consumed so much time and effort
on the part of the planners or persisted so long in spite of obvious
failure; among servicewomen and women war workers there
remained pretty nearly universal and unvaried resistance to
accepting paid work as maids and housecleaners.

This led women's organizations to recommend changes in
legislation to improve the status of domestic workers and
publicity efforts to make employers realize their responsibili-
ties.[124] The National Council of Women at its annual meeting
in July, 1945, passed a resolution urging "the Dominion
Government to extend the provisions of the Unemployment
Insurance Act to include household workers."[125] The month
before the National Council of the Canadian YWCA, in addition
to having passed the identical resolution, had also resolved to
"work to secure Provincial legislation establishing minimum
wages, workmen's compensation, and maximum hours for
household workers."[126]

In their repeated representations to federal and provincial
governments to enact legislation that would regulate the wages
and hours of domestic servants and have them covered by
unemployment insurance and workmen's compensation, the
women's groups of the post-war period went beyond their pre-
war position. In a repetition of depression strategies to raise the
status of household workers, women's organizations also under-
took, with government urging, to launch educational campaigns
among their own members about the problems and points of view
of their household assistants. It was felt that the development
of "a relationship of mutual concern, co-operative interest, and
initiative on the part of both employer and employee in the
management of the home" would be an important step toward
improving the social status of household workers.[127] Another
frequently recommended tactic was to avoid the term "domestic
servant" or even "domestics."

From the point of view of the employers and government,
which was more inclined to view the problem from the employers'
than from the employees' perspective, training itself was still
thought to be critical to improving the status of household work.
The push for improvements in wages and conditions of work

could meet with success only when the *quality* of the supply of labour was guaranteed. This the government felt it could do if it could find enough women to train. Equipped with three- to six-month training courses (depending on the experience of the trainees) and proficiency certificates entitling them to recognition as skilled workers, household assistants, it was believed, could then establish their claim to the same respect and benefits as other workers.[128] The contradiction, of course, was that the precondition for enticing trainees into the program proved to be improved wages and conditions of work, while the objective of the program was to improve the quality of the supply of labour so that the conditions would improve.

Ultimately, no changes were made in protective legislation or in the eligibility of domestic workers for unemployment insurance and workmen's compensation. Nor did employers have need to worry about the wages of household help becoming exorbitant.[129] Thus, in spite of much publicity for the household assistants' training program, few women could be convinced to enrol in the courses. Even after the CVT rehabilitation training program was extended to civilian workers, the domestic workers' courses failed to draw.[130] A CVT report of April, 1947, noted that "enrolments did not warrant continuing this type of training," even though it was still of paramount interest to the various women's organizations across Canada, and plaintively conceded that "It was most disappointing that more veterans did not make application for training in this field, since an 'all out' effort was made to make this training attractive and beneficial."[131]

In the pre-war home service schools, women were trained specifically for live-in positions, and that type of training was resumed in the CVT home assistants' course. But by the post-war period, the construction of smaller houses, combined with a growing distaste among housewives for lack of privacy and among household workers for the lack of personal freedom involved in being a live-in maid, led some planners to consider schemes to promote live-out household labour. Live-in domestics were still widely advertised for, but the new trend toward daytime, hourly work could not be ignored as a solution to the problem of domestic labour shortages. The most ambitious training scheme to stimulate the supply of this type of labour, especially among former war workers, was the "Home-Aide" project developed by Fraudena Eaton in the Women's Division of National Selective Service.[132]

In contrast to the CVT-sponsored course for brides and the

home assistants' course for paid workers, which involved full-time training ranging from six weeks to six months, the training provided by NSS's "Home-Aide" project consisted of only three or four one-hour lectures or films to supplement the practical experience to be gained on the job. CVT regional directors refused to incorporate the "Home-Aide" scheme into their program,[133] because, as so little actual instruction was involved, they regarded it as "almost entirely a placement project rather than a training plan."[134]

In addition, the "Home Aide" scheme could in no way be construed as fulfilling the regulation governing veterans' training that specified that any program qualifying as rehabilitation must last at least two weeks.[135] The more serious issue, however, was that the "Home-Aide" project was seen as detrimental to the prospects of the ex-servicewomen who were training as home assistants.[136] The home assistants' course involved lengthy training for general household workers or specialists, such as cooks, laundresses, and children's attendants, in a program drawn up and supervised by trained home economists. Having less-trained workers receiving the government stamp of approval was seen as potentially undermining the more comprehensive program. The problem of inadequate training was a persistent criticism of the "Home Aide" project. In the words of one critic,

> Housewives who employ these home aides, who are to be paid at a rate considerably beyond what most people have been paying even in War time, will expect much more competent service than they were receiving from a maid they employ all the time.[137]

Mrs. Eaton's response was that, as past experience had shown "no great demand on the part of a woman seeking employment for training in housework," this short unimposing course would serve to introduce the prospective household worker to "the idea of training being a necessity."[138] But Mrs. Eaton's hopes were not to be fulfilled, and in the end an inadequate supply of trainees doomed the "Home-Aide" project to failure, just as it had the other domestic training programs of the post-war period.

Although few women veterans responded to the government's initiatives to push household training for paid or unpaid work, of the almost 50,000 former members of the women's services, more than 25 per cent took advantage of rehabilitation training and education benefits, a higher proportion than that of the male

veterans.[139] Over 10,000 availed themselves of vocational training or high school courses to prepare for university or to meet educational requirements for a job. More than 2,600 enrolled in university, with what Dr. Russell regarded as "encouragingly large groups in Public Health, Social Service and Education."[140] Fully 85 per cent of those taking vocational training chose the following top five out of the ninety-one occupations in which women were taking courses: commercial (which included training for work as secretaries, stenotypists, clerks, and office machine operators); hairdressing; dressmaking; nursing; and pre-matriculation. At least half chose to be trained for one of the jobs under the heading "commercial."[141] The attraction to commercial courses persisted in the face of a decided attempt to deflect women from them in the belief that clerical jobs would not expand as they had in the past. Mrs. Eaton, for example, assumed that increasing automation, in the form of "the dictaphone, electrotype, and automatic calculator," was reducing the demand for clerical workers.[142] Counsellors were also instructed to warn trainees that more women were training as hairdressers and "beauty operators" than the market could absorb. The task of the counsellors, then, was to discourage large numbers of women from training in either area. Dr. Mary Salter, superintendent of Women's Rehabilitation in the Department of Veterans' Affairs, lectured a CVT conference of supervisors of women's training in February, 1946, on how the fields of hairdressing and stenography were becoming rapidly overcrowded while, in contrast, "household employment offered a very wide scope for ex-servicewomen."[143] Mrs. Eaton was making the same point to a west coast regional rehabilitation conference a month later.[144]

The only areas where women's demand for courses appeared to correspond to government's perception of where they should be finding jobs were dressmaking and practical nursing. The demand for pre-matriculation courses, for example, was considerably higher than expected. Consequently, in some places this training for ex-servicewomen was so over-subscribed that only those who needed it for university qualification were being accommodated, not those who required it for a purely vocational goal.[145]

Meanwhile, the courses for home assistants had gone begging. The main cause was that the occupation was one of desperation, only to be contemplated when all other employment possibilities

were exhausted, a situation that did not materialize after the war. Unemployment among ex-servicewomen simply did not reach the proportions feared by some. The explanation, according to government officials, was that servicewomen enjoyed a reputation for efficiency and hard work.[146] This may have been partially true, but there is considerable evidence to show that government policy to eliminate child-care services for working mothers and tax concessions for working wives was fairly effective in driving women from the labour force altogether, and thereby also removing them from unemployment statistics.[147]

While government officials had been unsuccessful in their attempt to channel women's post-war training into the traditional field of paid housework, they enjoyed greater success in keeping the training sexually segregated and confined to occupations perceived to be appropriate for women. Nonetheless, the wartime spirit of proclaiming the diversity of training opportunities open to women persisted in some publicity. In a 1946 article in *Echoes*, for instance, Dr. Russell played up the ninety-odd occupations for which women were being trained, "ranging from those requiring long years of study, such as law, architecture, medicine, pharmacy and social work, to those occupations requiring shorter periods of training, such as bookbinding, lineotype operation and photography."[148] She made no mention of housework and gave no indication of the disproportionate weight she was attaching to occupations in which only a handful of women were being trained. A January, 1946, survey taken of press reports about women's rehabilitation revealed that it was the unusual training experience that attracted the publicity.[149] In fact, in February, 1946, Canadian Vocational Training was offering training in over 100 types of trades in vocational schools and over 300 types under training-on-the-job schemes, yet women were to be found in only thirty-five types of trades in vocational schools and in only ninety-two under training-on-the-job schemes.[150] And even within this range there was considerable concentration, as we have seen, with most training for women confined to a limited number of traditionally female occupations.

Conclusion

One of the myths about World War II holds that it broke down the sexual segregation of the labour force and removed the sexual barriers to occupations. Although not all evidence is in on this

question, what can be learned from an examination of a decade of job training programs is that, while the demarcation lines were in some cases redrawn during the war, they remained distinct. In light of this, the re-emergence in the post-war world of the traditional sexually segregated occupational structures becomes more understandable.

Underlying the failure of the extraordinary experience of the war to secure greater economic equality for women in the post-war period was the persistence of the patriarchal family model with its sexual division of labour between the worker for pay outside the home (male) and the dependent unpaid worker inside the home (female). This is reflected in a consistency in government ideology toward women's work throughout the years 1937-1947. One unchanging assumption was that women had a special responsibility for and tie to the domestic sphere. Added to that was the related assumption that the male should be the primary breadwinner and therefore have his privileged position in the paid labour force protected. Also unquestioned was the belief that, insofar as women had to go out to work for pay, they should be accommodated in sex-segregated jobs and this segregation of labour by sex should be hierarchical, with men at the top.

Together with these beliefs was an acceptance of the existing class structure, which is evidenced in the fact that, when in doubt, government consulted upper- and middle-class women's organizations as to what would be appropriate for female labourers. Members of these women's groups did not challenge the ideological structure; rather, they shaped their advocacy of women's interests to fit within it. These normative beliefs were so deeply entrenched that a female rehabilitation officer in the Department of Veterans' Affairs was unaware of the contradiction between them and an espousal of equal opportunities for women. As we saw in Chapter One, the tension between woman as homemaker/mother/wife and woman as paid worker was eased somewhat during the war by tax breaks to married women workers and a modest program of subsidized child care to war-working mothers. Post-war planners and policy-makers, however, insofar as they gave the problem thought, assumed its resolution to lie in women's having to choose between the two.

The training programs enforced the dominant gender ideology. For instance, government-supported vocational training tended to be segregated by sex, even when women, as in the war, were

sometimes being prepared for non-traditional occupations. Similarly, women were rarely trained to the same extent or to the same degree of complexity as men. In times of unemployment or fear of unemployment, paid domestic labour or withdrawal from the labour market was seen as most appropriate for women; but even in times of high labour demand, the threat of competition from women was to be avoided by the temporary nature of any non-traditional jobs for which women were trained or by the concentration of women in "feminized" work processes.

The extraordinary demand for female labour during the war generated a rhetoric of egalitarianism that made it look as if sexual divisions of labour had been significantly modified in the direction of greater equality. In actuality the rhetoric hid the fact that those changes were more apparent than real and were, in either case, designed to be temporary. Furthermore, the sexual division between men's privileged access to paid labour in the public sphere and women's responsibility for unpaid labour in the private sphere had not been seriously challenged. Nonetheless, certain egalitarian pronouncements made it appear that the government had changed its most fundamental assumptions with regard to women's work; in fact, while government policy toward women had been modified to meet the emergency of war, patriarchal ideology had not changed. If the rhetoric of sexual equality had had any substance at all, one might have expected women's wartime gains to be consolidated in post-war plans. What occurred, however, was a use of the planning apparatus to confine women to traditional occupations more reminiscent of the pre-war period.

"CWAC of All Trades"

In addition to the mobilization of women's unpaid and voluntary labour for the war effort and women's paid labour for civilian war industry and essential services, women during World War II were also mobilized in the thousands for the first time in history for service in the armed forces of Canada. Throughout most of history, with very few exceptions, the military of any given society has been seen as an exclusively male concern.[1] One might understandably presume, therefore, that the entrance of women into the military, a masculine institution *par excellence*, would be a revolutionary step with revolutionary consequences: the admittance of women to a source of power and prestige theretofore a male monopoly.

Before the Second World War, Canada's military had been male with the exception of the Nursing Service of the Royal Canadian Army Medical Corps, first admitted to the reserve in 1904 and to the permanent force in 1906.[2] The first armed service to open its doors to women beyond Nursing Sisters was the Air Force. The Canadian Women's Auxiliary Air Force (CWAAF) was established by Order-in-Council of July 2, 1941, and made an integral part of the Air Force from the start. In February, 1942, it was redesignated the Royal Canadian Air Force (Women's Division), com—— —ferred to as the WDs. The second service to move was t_____ An Order-in-Council of August 13, 1941, authorized the _____ n of the Canadian Women's Army Corps (CWAC), but it _____ gration into the Canadian Army (Active) had to wait un____ ____ 1942. The last service to admit women was the Navy v____ ____ ablishment of the Women's Royal Canadian Naval Ser___ ___NS) on July 31, 1942. It remained the smallest and m____ ___ ve of the three women's services.[3]

Did the entr____ ____ ¿n into the military increase the power

of women as a group in Canada? This chapter attempts to answer that question by examining the role of women in the Canadian Women's Army Corps, the largest of the three women's wartime services.[4] Under consideration will be the circumstances that gave rise to women's admission to military status, the jobs assigned to members of the Canadian Women's Army Corps, their pay and benefits, and the place of the CWAC in the command structure of the Canadian Army.

"Canada," C.P. Stacey asserts in his official history of the Canadian Army in the Second World War, "is an unmilitary community."[5] Military heroes are not the most celebrated Canadians and are not numbered among Canada's prime ministers. When necessary, of course, Canadians have fought in wars, for the defence of Canadian soil and of Britain, the seat of the Empire. But in peacetime, the strength of the Canadian military has never been great, military expenditure never large. In the two world wars of this century, opposition to conscription of men for overseas combat service has been so strong, above all among the French-speaking population, as to strain Canada to the point of crisis.[6]

Militarism, then, in the sense of exaltation of military heroes and glorification of heroic death, has not been characteristic of the Canadian spirit. Nonetheless, Canadians took pride in "the outstanding performance of the Canadian Expeditionary Force in the First World War" and "between the wars the professional army preserved a distinctive military tradition."[7] Prestige attached to the Canadian Militia Officer's Commission and attendance at Royal Military College were regarded as signs of membership in Canada's elite.[8] So, although weaker than in some other countries, such as Germany, a link existed in Canada between the military and power and prestige. Furthermore, as Patricia E. Roy has pointed out with respect to Canada's reluctance to recruit Canadian-born Japanese and Chinese for military service during the Second World War, "Military service is the ultimate test of citizenship. By allowing Chinese and Japanese Canadians to serve in the armed forces, Canada would concede them a claim for equality"[9] Shouldering arms for the defence of one's nation, then, is regarded as both a privilege and a duty. Implicit but unexamined in the above quotation, however, is the assumption that this has also been a male

prerogative, a test exclusively of male citizenship. "To fight for one's country, when that fight has been a righteous one, has always been the privilege of man ... exclusively the right of man," wrote a contributor to *Saturday Night* in January, 1942.[10]

The admission of women besides Nursing Sisters into the Canadian Army during the Second World War was the product of two sets of circumstances. First and foremost was the Army's need to alleviate manpower shortages. But, as C.P. Stacey rightly argues, the formation of a Canadian Women's Army Corps was also product of the keen desire of some women to render military service to their country.[11]

In the late 1930's and early 1940's, Canada had thousands of women eager to serve in the armed forces. A host of unofficial women's paramilitary corps sprang up across Canada.[12] Where this military fervour on the part of women cropped up first and grew largest was in British Columbia. There, on October 5, 1938, only days after the Munich crisis had ended, a group of ten women met in Victoria to found a service club they hoped would become the first unit of an official "Auxiliary Militia Service of Canada."[13] Their inspiration was the official women's auxiliary of the British Army, the Auxiliary Territorial Service, royal warrant for the formation of which had only been granted on September 9, 1938.[14] In the course of 1939, the Victoria service became the headquarters of an unofficial British Columbia Women's Service Corps, which, under the command of Joan B. (Mrs. Norman R.) Kennedy, expanded to other British Columbian centres until by August, 1940, it could claim 1,200 active members organized in eleven separate units.[15]

After the outbreak of war, similar women's volunteer corps were formed in other Canadian cities and towns. The B.C. Women's Service Corps could take credit for organizing affiliated groups in Edmonton, Saskatoon, Peterborough, and Halifax.[16] According to a rough estimate made at National Defence Headquarters, some 6,700 women were believed to be enrolled in such unofficial corps by early 1941.[17] Rivalling the B.C. Women's Service Corps in size were the Women's Volunteer Reserve Corps of Montreal, known as the Canadian Beavers, with "fifteen branches throughout the Maritimes and the Provinces of Quebec and Ontario,"[18] and the Canadian Auxiliary Territorial Service (CATS) of Toronto, with affiliated detachments as far away as Saskatoon and Vancouver. French-speaking Canada fostered the *Corps de Réserve National féminin* and the *Réserve*

canadienne féminine.[19] In some cities two or more women's volunteer corps competed with one another for recruits.

Young women spelling CATS in semaphore, December, 1941. York University Archives, Toronto *Telegram* Photograph Collection.

Women who joined these corps received training in military drill and etiquette and in the jobs they believed women could perform for the armed services. Joan Kennedy could report in May, 1940, that training in the B.C. Women's Service Corps has consisted of "regulation infantry drill" plus

lectures (with as much practical work as facilities would permit) in Anti-Gas Precautions, first aid, transport driving and motor vehicle maintenance, map reading, Army clerical instruction, quartermaster's duties, Army Cooking, visual signalling and de-coding work.[20]

Members had also heard general lectures in hygiene, sanitation, dietetics, and nutrition. Some corps went further and put the emphasis on marching in formation, physical drill, and rifle

practice[21] or, as the commanding officer of the Women's Auxiliary Service Patrol of Niagara Falls put it, "musketry."[22] In many instances the specialized army instruction could have come only from men who had military experience. Indeed, leaders of various corps referred with gratitude to the help they had received from "army or ex-army men."[23] On behalf of the British Columbia Women's Service Corps, Joan Kennedy acknowledged "the kind interest and co-operation of the District Officer Commanding Military District No. 11," who had allowed units of her corps to use "Drill Halls in Victoria, Vancouver, New Westminster, Vernon and Prince Rupert" and had also "detailed officers and NCOs to give" to members of her corps "lectures and instruction in drill." In British Columbia towns "where no units of H.M.C. Forces" were stationed, units of Kennedy's corps had found veterans willing to act as instructors.[24]

Undoubtedly a fascination for things military, as well as the desire to serve King and Country, could account for the emergence of the women's volunteer corps. Organizers and members apparently wanted a share of the respect and authority attaching so conspicuously to the manner and trappings of the military in wartime. The corps leaders assumed military titles of rank, such as colonel, major, and captain, and organized themselves into hierarchies of command with appropriate titles for positions in the hierarchy, such as officer commanding or chief commandant and adjutant. Susceptible to the mystique of the uniform, members of the corps outfitted themselves in military garb, ranging from simple armbands to, when affordable, smartly designed and expensive uniforms of serge or barathea. On various occasions the Department of National Defence considered issuing warnings that it was in violation of the Criminal Code as well as Defence of Canada Regulations for members of unauthorized paramilitary groups to wear uniforms or badges mistakable for those of His Majesty's Forces or to use titles of rank common to those of His Majesty's Forces.[25]

Official recognition that would legitimize their uniforms and titles of rank as well as their activities and service was precisely what the various women's volunteer corps sought. As early as December, 1938, the women of the Victoria service club approached the Department of National Defence with a request that the department form an official "Auxiliary Militia Service of Canada" and recognize their service club as that auxiliary's

first unit "in connection with coastal defence."[26] At a meeting in February, 1939, the military members of Defence Council decided against the proposal on the grounds that any limited funds that might be forthcoming were "more urgently required for other purposes in the interests of the Militia."[27] Undaunted, the B.C. Women's Service Corps repeatedly renewed their appeal for recognition, in June, 1939, in September, 1939, shortly before the outbreak of war, and in May, 1940.[28] By then other women's volunteer corps had joined in bombarding the Department of National Defence with pleas for recognition. These were orchestrated into a nationwide campaign from October 10 to December 5, 1940, when Joan Kennedy and one of her cohorts from the B.C. Women's Service Corps toured Canada to assess the strength of the women's paramilitary movement. Empowered, by the end of the tour, to represent a number of other women's volunteer corps in addition to their own, they presented a brief at Ottawa outlining the extent of Canadian women's preparedness to give military service and requesting some commitment from the Department of National Defence.[29]

It is doubtful whether anything official would have come of the keen desire of these women to render service in uniform to their country had not the Canadian Armed Forces begun to feel the pinch of a threatening manpower shortage. As early as June, 1940, National Defence Headquarters began looking into the possibility of putting women into Army uniforms and using them in support staff positions to release men for active service elsewhere.[30] Meanwhile, in February, 1941, the British government inquired as to whether the Women's Auxiliary Air Force of Great Britain could "be allowed to recruit personnel in Canada for service with the RAF transferred schools" (called in Canada the British Commonwealth Air Training Plan schools), or if not whether the RCAF would "form its own women's service"[31] to perform ground duties at those schools. This inquiry from the U.K. prompted the Departments of National Defence and War Services to prepare the machinery for raising a Canadian women's air service.[32]

A group of interrelated problems faced the Department of National Defence starting at least as early as the summer of 1940 and continuing into the summer of 1941. Although not yet plagued with a general lack of manpower, the Canadian Army confronted shortages of well-qualified male military personnel for specific jobs, clerks and cooks being the most frequently

mentioned. Furthermore, with an eye to the anticipated increasing demands for combat troops, authorities at National Defence Headquarters felt the time had come to consider using female labour to release medically fit men for duty in fighting formations. With the Army definitely able to use female labour two further questions arose, regarding whether the women to be employed by the Army should be brought under military discipline and whether the creation of an official women's service corps would be the most efficient means of doing so.

By the summer of 1940, the military was, in fact, already making use of female labour. Authorities in Military District No. 11 had been using female *voluntary* labour since as far back as September, 1939. Having supplied instructors to the B.C. Women's Service Corps, the officers commanding various military units stationed in the province sought the co-operation of these women volunteers after the outbreak of war as clerks, drivers, and telephone operators.[33] The Canadian Army had also been using *paid* female labour. At National Defence Headquarters and District Headquarters, a considerable number of civilian women were employed as clerks, typists, and stenographers, eighty-four holding down permanent civil servant positions, 509 temporary ones.[34]

In both cases greater control was the main advantage the Army stood to gain from enrolling women workers and employees under the Department of National Defence.[35] Over the civil servants detailed to it, the Department of National Defence had little control: it could not hire or discharge, regrade, or promote or demote them as it deemed fit. It could not move them about from station to station as it deemed necessary. Nor could it compel them to be available for work "on Sundays and holidays, when needed." By turning their female workers and employees into servicewomen, the department also hoped to get secretaries and file clerks who were fluent in military jargon and who would look upon their work as part of the war effort and not just as a job.[36] As it turned out, having women's labour much more completely at the disposal of the forces was an advantage gained by putting female employees into uniform and under service discipline. One woman who served with the CWAC in Regina has recalled that whenever a battalion was getting ready to move out, all "the girls" who could type would be called back after dinner to work all night preparing the men's overseas dossiers. Not a word was spoken; there was "just the clack of these

typewriters," dozens of old Underwoods.[37] In the army there was no overtime, only duty.

Once the value of having women workers in uniform and under military discipline was granted, the Minister of National Defence and his colleagues at National Defence Headquarters were but a step away from the conclusion that official women's service corps would be the most efficient means to that end. Few alternatives were considered, certainly not the possibility of enlisting women directly into the Canadian Army.

A further question exercising the department was whether such an authorized women's corps should be built up by open recruitment of individuals or by granting official recognition to the already existing women's volunteer corps and incorporating them as regimental units. On the question of recognition, the Department of National Defence equivocated, as did also the Department of National War Services when it became involved. Authorities in both departments realized that "to ignore the existence of these unauthorized corps" might be "suicidal," for it was necessary that "the personnel of existing women's [paramilitary] organizations ... be utilized."[38] These same authorities, however, were on the whole opposed to "recognition." The Adjutant-General gave one reason for the opposition when counselling the Minister of National Defence to refuse the application of a particular corps in August, 1940:

> Recognition of this Corps or any other Corps would at once commit the Department not only to wholesale recognition of existing organizations, but many others which would spring into being, asking for recognition and whose recognition would be difficult to refuse.[39]

Interest in retaining control over the standards to be met by recruits and fear of being deluged by "rival claims for preferment" decided the Department of National Defence against embracing the existing women's corps, with their rank structure, identity, and esprit intact, as the building blocks of an official corps.

But the war effort could not afford to waste the womanpower of those volunteer organizations. A compromise was hit upon. At the formation of the official Canadian Women's Army Corps (August 13, 1941), the Department of National War Services, which was initially in charge of recruitment, granted a kind of

limited recognition to women's paramilitary organizations as a source of individual recruits for the CWAC. Women's volunteer corps so recognized were regarded as units of "the Women's Auxiliary Service" and, in the first months of the CWAC, a new recruit, if a member of such a women's volunteer corps, was permitted to wear her corps uniform until the CWAC uniform was issued.[40] But after the value of the women's volunteer corps as a source of recruits had been exhausted, and after recruitment for the CWAC had been taken out of the hands of the Department of National War Services, the Department of National Defence allowed that limited recognition to lapse. Once again, leaders of women's volunteer corps, whose ranks remained strong even after the departure of all members both willing and qualified to serve in the official women's services,[41] began beseeching the Department of National Defence for recognition, this time as an official reserve corps. Their appeals were in vain.[42]

There was another reason why the Department of National Defence had originally been reluctant to grant official recognition to the women's volunteer corps. In a memorandum of September 4, 1940, the Adjutant-General, Major-General B.W. Browne, had reported to Colonel J.L. Ralston, Minister of National Defence:

> It has also been noticed in the various applications received from women's organizations for recognition, that their activities have been concentrated mostly on Rifle shooting, Map Reading, Signalling and not on the particular duties for which they are required.[43]

If the Canadian Army needed women in uniform in World War II, it was not for rifle shooting (nor, initially, for map reading or signalling). Indeed, it is the division of labour in a modern army between fighting force and support staff that made the creation of a women's army corps socially conscionable in Canada during the Second World War.

In the past much of the support work for armies had been done by non-military personnel, some of them women. In the case of armies with female camp followers, those women performed labour for the troops as cooks and laundresses as well as mistresses and wives. In the evolution of the modern army, both the warfare and the work involved in administering, maintaining, and transporting the combat troops were brought under professional military discipline. In an all-male institution,

which the military was, the division between support staff and fighting force could not be sexual, for men served at the blunt as well as the sharp end.

When during World War II the formation of an official women's corps was under consideration in Canada, the only purpose envisioned for it was to supply female labour to the support staff, not to the fighting force. With the creation of the Canadian Women's Army Corps, the division of labour between support work and combat did not become thereby strictly sexual. Even in wartime the support staff of a modern army comprises a larger proportion of military personnel than does the fighting force, and as the CWAC at the time of the German surrender constituted only 2.8 per cent of the total strength of the Army,[44] the largest percentage of male soldiers still served behind the lines in non-combatant roles(Nevertheless, there was a fundamental division of labour by sex: between front-line combat, from which women were excluded, and support work, to which women were admitted as replacements for some men.) Women had penetrated that sacrosanct male preserve, the military, but had not broken the male monopoly on the primary purpose of the military, the provision of an armed fighting force.

Uneasiness at the prospect of women under arms may have led Major-General Browne to exaggerate the degree of rifle shooting women's volunteer corps had been concentrating on. Only a few even mentioned it as part of their training. More importantly, the largest and best organized of the women's paramilitary groups, such as the B.C. Women's Service Corps, made explicit in their bids for recognition that performance of non-combatant duties was the service they offered.[45] They looked upon their movement as one "to train women to complement the work of the forces."[46] By and large, then, agreement prevailed between the women eager to serve and the authorities at National Defence Headquarters (NDHQ) on the general purpose of an official women's corps: to replace medically fit men in support jobs in order to release them for duty with forward formations.

In drawing up plans for an official women's corps, the Adjutant-General and his branch at NDHQ, on whom this task mainly fell, also needed to determine in which specific categories of support work the Army could employ uniformed women. For opinions on this question an Adjutant-General's secret circular letter of October 1, 1940, canvassed all Officers Commanding Military Districts, the Commandant of Royal Military College,

the Commandant of the Ottawa Area, and all Branches and Directorates of National Defence Headquarters. The suggested categories were clerk, telephone operator, cook, cook's helper, officers' and sergeants' mess waiter, canteen helper, and possibly MT (mechanized transport) driver. The responses were illuminating, not least for the degree to which they sought to hedge round the employment of servicewomen with conditions and qualifications.[47]

One condition agreed on by all was the provision of suitable and properly segregated accommodation. District Officer Commanding MD No. 6 (Halifax) cautioned that "the quartering of women in isolated camps would require careful consideration." Fear of mixing the sexes, "the inadvisability of mixing men and women," even in work situations, was expressed in a number of reports. Some countenanced the use of women as waitresses in officers' messes, but not, for reasons of discipline, in sergeants' messes or as canteen helpers. One reply questioned the use of women as waitresses even in officers' messes. That same report doubted the feasibility of employing women as cooks and cooks' helpers, unless "the whole kitchen was composed of women."

A number of replies laid down as a condition that the supply of men medically unfit for service be exhausted before women were taken on in any support jobs. Some suggested the further condition that women not take over as clerks, telephone operators, cooks, or even officers' and sergeants' mess waiters and canteen helpers at district depots and training centres where male soldiers needed the opportunity to receive training in these jobs "prior to proceeding overseas."

Concern that men remain in charge furnished another qualification. The report from MD No. 12 (Regina) allowed that women could be used in all the positions mentioned in the circular letter so long as "certain key positions such as those filled by senior clerks, operators, sergeant cooks, etc.... continue to be filled by men." District Officer Commanding MD No. 13 (Calgary) thought it "practicable to replace clerks by women provided a sufficient number of soldiers are left who will be responsible for the work being done."

The idea of using women as MT drivers was granted limited acceptance in every report that considered the question. The consensus was "that women are quite competent" to drive "the lighter motor vehicles," staff cars, ambulances, motorcycles, station wagons, but that "the handling of trucks and heavier

vehicles is beyond the strength of the average woman." Some mentioned as further limiting factors "winter driving conditions in Canada," "night driving," and "indifferent roads and great distances." Nor was it recommended that women be used as MT drivers at training centres, for there one of the primary duties of MT drivers was "to train personnel for reinforcements" and it was not felt that women "would prove satisfactory as instructors."

Even when conditions were stipulated, few reports contested the feasibility of using members of women's corps for clerical duties. Indeed, their urgent desirability was stressed in a number of replies, providing further evidence that there was an already pressing shortage of clerks. Even the Officer Administering the Corps of Military Staff Clerks found it "necessary to report that increasing difficulties are being met in securing competent male stenographers."

Those replies to the Adjutant-General's inquiry indicated the general pattern of employment for women in the CWAC that would prevail from the Corps' formation in August, 1941, through to the end of the war: the use of women in subordinate service jobs "where the physical strain is not too great" and for the purpose of releasing men "for employment in forward formations and units." The major change would come in the number of occupations for which women could be considered. Some of those canvassed in October, 1940, had already suggested job categories suitable for women beyond the eight mentioned in the Adjutant-General's letter, chief among them dental assistant, tailoress, and storekeeper. The Acting District Officer Commanding MD No. 2 (Toronto) had even predicted rightly that "much of the prima facie objection to employing women on certain duties and in certain places would be overcome and a change in the mental attitude towards women so employed would become apparent if a recognized corps of women were organized."

Indeed, the list of occupations open to women in the CWAC did grow. The first set of regulations for the Canadian Women's Army Corps (August, 1941) provided for some thirty.[48] In February, 1943, a CWAC recruiting officer could speak of between forty and fifty occupations for CWAC personnel.[49] It remained, however, the exception to the rule for CWACs to hold down traditionally male jobs.

The introduction of trades training in the latter half of 1942

extended the number of specialized technical trades open to members of the CWAC. A survey of employment of CWAC personnel in all military districts and commands in Canada in July and August, 1942, had shown that "it comprises mostly clerical workers (stenographers, typists and clerks), cooks, waitresses, storewomen and general duties." The surveyor attributed the "conspicuous absence of demand for technically trained girls" to the lack of trades training for the CWAC.[50]

Even before the results of that survey were in, the successor to B.W. Browne as Adjutant-General, Major-General H.F.G. Letson, in a secret memorandum of July 19, 1942, had proposed advanced trades training for members of the CWAC to widen the employment of women in the Army. Responding to "the large drain that has been made on manpower in this Country for the Armed Services," Letson advocated extending "the field of employment of women to the fullest extent" and called for employing women "in all places where they have the physical ability to perform the necessary duties." He even suggested that, as this was already the trend in Great Britain, "women could be used extensively in Anti-Aircraft Artillery, actually manning and firing the gun" Asked for their opinion, the Master General of the Ordnance, the Quartermaster General, and the Chief of the General Staff all concurred in the policy of "women being used in Canada as operational personnel."[51]

In midsummer 1942, then, all four senior officers at NDHQ were prepared, owing to manpower shortages, not only to welcome women into a wider range of Army support jobs, but to contemplate using women to operate weapons. At its meeting of July 29, 1942, the Army Council "decided that experimental training should be carried out with a view to [women's] being eventually employed in the actual handling and firing of anti-aircraft guns."[52] Although this policy was never implemented, it is worth noting how limited a violation of the taboo against putting women in combat situations was being contemplated: women were being considered for service not with front-line combatant units, but only on anti-aircraft batteries involved in coastal home defence. In justifying the policy, the distinction between offensive and defensive weapons undoubtedly would have become crucial, as in this caption to a photograph in *Saturday Night* showing members of the Women's Home Defence Corps in Britain learning to use service rifles "with a view to gaining admittance to the Home Guard": "While Britain still

believes that use of offensive weapons in warfare is a man's job and always will be, nevertheless her women are taught how to defend themselves."[53] Even had CWACs been used on Ack-Ack batteries in Canada, there was no consideration given to extending their basic training to include arms drill. Fighting for one's country would still have remained an exclusively male activity.[54]

Investigation of the possibility of using women in operational units revealed that "the heaviest demands" throughout command and district establishments were "for stenographers, typists, cooks and clerks for stores and equipment." Among those in the Adjutant-General's branch investigating the policy, it was felt that the Army "should first of all concentrate on filling the sedentary occupations before attempting to place CWAC in operational duties."[55] Meeting the demands for womanpower in suitably female jobs took precedence over experimentation. Insofar as CWACs were eventually detailed to operational duties, they were employed with coastal defence units in both Atlantic and Pacific Commands as "operators of predictors and fire control instruments." Starting in the spring of 1943, CWAC personnel were trained for service with anti-aircraft regiments as kinetheodolite operators (testing the accuracy of the height-finders, range-finders, anti-aircraft guns, and coastal defence guns) and as gun operations room broadcasters and plotter-telephonists.[56] With servicewomen's participation in operational duties thus circumscribed, CWAC recruitment literature could still assure the Canadian public that the young woman who enlisted would be serving in a non-combatant role: "No, not actually on the firing line. You do not pull any triggers or throw any hand grenades." So a recruiting pamphlet of 1944 answered the hypothetical question of a prospective CWAC recruit.[57]

The Adjutant-General's secret memorandum of July 19, 1942, did not lead to the handling and firing of anti-aircraft guns by women, but it did instigate a trades training program for CWACs. This innovation allowed recruitment propaganda to boast of the "many and varied ... trades at which Canadian Women's Army Corps personnel are now employed": thus the caption to a Canadian Army photo of a CWAC private "operating a home-made bullet separating machine in the Ordnance Salvage Depot at Aurora, Ontario." Similar in slant was the recruitment line that played up "the more spectacular jobs in the Canadian Women's Army Corps," the "unusual and interesting" jobs, such as night

vision tester "*operating one of the machines that test men's ability to see in the dark*," or kinetheodolite operator.[58] " 'Jill' Canuck Has Become CWAC of All Trades" punned the headline to a March, 1944, promotional article in *Saturday Night*.[59]

In actuality, however, even after the general introduction of trades training, the overwhelming majority of trainees were sent on cooks' and clerks' courses.[60] Although drivers' courses occupied third place, demand remained greatest for CWACs in occupations that were extensions of housework or that had become female ghettoes in the civilian world of employment. Shortly before National Selective Service was to begin assisting with the recruitment of women for the armed services (on February 22, 1943), NSS officials were told that the "greatest need in all services" was for "Stenographers, Clerical Help and Cooks."[61]

The CWAC never acquired a pattern of employment disturbing to the male-female division of labour in the larger civilian society. On May 8, 1945, a "machine record" study was done of the

CWAC clerk, Canadian Army Overseas photo. York University Archives, Toronto *Telegram* Photograph Collection.

CWAC Jeep driver. Manitoba Archives, Canadian Army Photograph Collection #157.

occupational distribution of all CWAC "other ranks" serving in Canada and the United States as of March 28, 1945.[62] Almost half (5,729) of the total number (11,706) were non-tradeswomen, that is, not entitled to draw trades pay. Their occupations included driver (without technical training), laundress, medical orderly, batwoman, canteen helper, waitress, and office orderly (the sole qualification for which was "ability to tolerate sedentary and inactive work, with fairly long periods of nothing whatever to do").[63] Even among tradeswomen, the overwhelming majority were assigned to office or kitchen duty. Of the 5,977 tradeswomen stationed in North America in March, 1945, fully 70 per cent were employed as clerks (62.4 per cent – there were only four "clerks superintending") and cooks (8 per cent). Almost 87 per cent are accounted for if one adds the storewomen (6.9 per cent), switchboard operators (4.5 per cent), postal sorters (2.7 per cent), and dental assistants (2.2 per cent). Driver mechanic was the one non-traditional occupation that had any significant number of CWAC: 111, or 1.9 per cent. The remaining 11.4 per cent were distributed among the other forty-six trades. Next highest in concentration were keyboard operator (with 77), fixed

wireless operator (69), tailoress (66), bandswoman (66 – the Canadian Women's Army Corps had both a pipe and a brass band), and nursing orderly (65). There were, by the way, twenty-two kinetheodolite operators.[64] Occupations with the lowest concentrations included butcher (7), shoemaker (7), lithographer (2), welder (2), saddler (1), pharmacist (1), and masseuse (1). Only in the last days of the war, and only after repeated intercession on her behalf by the Director-General of the CWAC, was Private Molly Lamb (later Bobak) promoted to Lieutenant and appointed an official War Artist (Army).[65] The secretary in uniform was the typical CWAC.

This employment pattern, it should be noted, was not far out of line with the desires and expectations or work experience of applicants. According to an analysis of the type of women applying to join the CWAC up to midsummer 1942, of the over 75 per cent who were employed at the time of application, 24 per cent were domestic servants, 24 per cent office workers, 15 per cent store clerks, 10 per cent factory workers, and 4 per cent professional women and teachers. The analysis lumped together into the 23 per cent unemployed both young women who were out of a job at the time of application and those who had never held a job and were applying for admission straight from home or school. Approximately 70 per cent had had some high school education, while only 6 per cent had attended university. Thirty-six per cent of those seeking admission wanted office work of some kind, 19 per cent wanted duties in the mess or canteen, 15 per cent wanted to be drivers, and 10 per cent wanted to be store clerks.[66] It remained as much the exception to the rule for a servicewoman to desire a non-traditional job as for the services to assign her to one.

An overseas posting was the most coveted assignment for members of the Canadian Women's Army Corps. It gratified the second strongest motive after patriotism for joining the Corps – the urge for travel and adventure. Overseas service in the U.K. (the first draft arrived in November, 1942) or later behind the lines on the continent was a thrilling experience for most of the CWACs chosen to go. They faced the dangers of a North Atlantic crossing through U-boat-infested waters, of German air attacks on the British Isles, and, for a CWAC mobile office unit close behind the front lines in Belgium in late 1944, of booby traps left behind by the retreating German army. But while the overseas setting provided excitement, the work itself

A. Employment at Time of Application

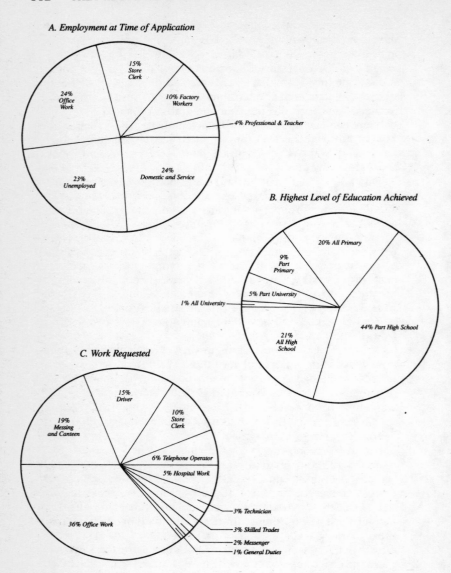

B. Highest Level of Education Achieved

C. Work Requested

Figures A-C: Profiles of Approximately 1,500 Women Applying to be CWACs to midsummer 1942

was often menial and tedious. Of the 853 "other ranks" serving overseas in the spring of 1944, 390 were general duty personnel (approximately a third of whom worked at No. 1 Static Base Laundry in London); of the rest, there were 22 drivers, 378 clerks, 29 cooks, 17 switchboard operators, 4 cipher clerks, 4 dental assistants, 3 keyboard operators, 2 postal sorters, 2 driver mechanics, one storewoman, and one draftswoman.[67]

The main purpose of enrolling female workers under the Department of National Defence had been to make them subject to military discipline and military hours. For many who joined, the military regimen, parades, barracks, and mess halls constituted the main change from their civilian work experience. The list of jobs open to CWAC personnel grew longer without materially changing the general pattern of employment: the overwhelming majority of CWACs remained in subordinate service jobs identified as women's work in the outside world. Occupationally, the sexual division of labour was carried over from civilian society into military life.

Ethnic and class as well as gender divisions in the larger society were replicated in the women's services. Not all women living in Canada could join the forces. To be eligible in the early days of the women's services, an applicant had to be a British subject, in good health, between the ages of twenty-one and forty-one, and have Grade 8 education. She could be married but could not be encumbered with dependent children. There was a higher educational requirement for officers: university education or equivalent training and qualifications.[68] The minimum age for recruits was later lowered first to nineteen and then to eighteen and the maximum age was raised to forty-five. The RCAF (Women's Division) and the WRCNS set similar requirements. While both of those women's services retained the criterion that the applicant be a "British subject, of white race," the CWAC eventually opened its doors to welcome a "citizen of any of [the] United Nations."[69] In July, 1942, Mary Greyeyes from the Muskeg Lake Reservation in Saskatchewan became the first Canadian Indian to enlist in the Canadian Women's Army Corps.[70]

The women who were accepted did not receive the same pay as their male counterparts for their service. At the time of the formation of the women's services, basic pay for all ranks was set at two-thirds that of men holding equivalent rank. In the case of the Canadian Women's Army Corps, a volunteer on enrolment

(later enlistment) received ninety cents a day ordinary pay while a male recruit to the Canadian Army received $1.30. This inequality extended to the officer corps: for instance, while a Chief Commander (later regularized to Lieutenant-Colonel) in the CWAC received $6.70 per day, her male counterpart drew $10.[71] One rationale for this was the original expectation that the ratio of replacement might be three servicewomen for two servicemen.[72] Another rationale was that, as the pay scale in the women's services was not to be competitive with that for women in the civil service, the expense for services provided free of charge in the armed forces, such as clothing, food, lodging, and medical and dental care, needed to be deducted from the comparable female civil servant's salary,[73] which says something perhaps about the low level of pay for women as compared with men in the civil service. National Defence Headquarters must have regarded this as a tolerable difference in wage, as there was concern "that it would be against public opinion for [members of a Women's Army Corps] to draw rates of pay considerably lower than men."[74] At the same time the advantages of lower rates of pay were not forgotten. Until the actual formation of the CWAC, the intention had been to have no tradesmen's rates of pay paid to members of the women's corps. Planners could thus calculate an "estimated annual saving" of $18,786 by subtracting the "estimated cost of proposed plan" from the "estimated cost of soldier personnel being replaced by women."[75] In the end trades pay was granted to CWAC personnel, but on a schedule substantially lower than that for male soldiers with the same grouping in the same trades classification.[76]

Nor were dependents' allowances equal for male and female military personnel. Although early thought on the subject had been to exclude married women from military service,[77] on their formation the Canadian Women's Auxiliary Air Force and the Canadian Women's Army Corps were opened to married as well as unmarried women provided they had no dependent children.[78] That proviso eliminated the need for dependents' allowances to children of women in the services. But the servicewomen were initially not provided with allowances for any other dependents, be they husbands, mothers, fathers, sisters, or brothers. This complete lack of provision of dependents' allowances hurt "many girls" who had "been contributing to family income."[79] Furthermore, the woman married to a serviceman who herself

joined up ceased to be eligible to receive a wife's separation allowance.[80]

The Department of National Defence was mistaken if it thought the inequality of pay and dependents' allowances for women in the services would go unchallenged. In the civilian labour market, job segregation provided one means for employers to pay female workers less while still acceding to the principle of equal pay for equal work. (The Canadian Women's Army Corps, however, was created to supply soldier replacements to the Army, and the overwhelming majority of CWACs took over clerical jobs that they then performed, as was widely acclaimed, more efficiently than the men they replaced.)Thus, the inequality of pay and benefits was too glaring to be overlooked. Senior officers of the women's services themselves protested against this discrimination.[81] Civilian women, particularly the National Council of Women, took up the cause of their sisters in uniform. Responding to petitions and resolutions sent forward from local and provincial councils, the executive of the NCWC in May and again in December, 1942, made representations to the Department of National Defence and to the Prime Minister, urging equal pay for men and women of the armed forces and provision for allowances for dependents of servicewomen. At their Fiftieth Annual Meeting and War Conference in Toronto, June 16-19, 1943, the National Council of Women found it necessary once again to pass a series of resolutions calling for equality of pay and benefits for servicewomen, including the recommendation "that a woman in the Armed Forces who has been successful in passing the same trade test as a man should be entitled to receive the same rate of pay as that of the man she has replaced."[82]

National Defence Headquarters was aware of the negative effect of unequal pay and benefits on prospective volunteers. While later studies would uncover other inhibiting factors, a survey carried out in July and August of 1942 claimed that "the greatest deterrent to enlistment appears to be the smallness of the basic and trades pay given to CWAC volunteers."[83] To mitigate this effect the Directorate of Army Recruiting touted the free clothing and excellent medical attention available to all CWACs, as well as the generous leave, free lodgings, and plentiful, wholesome food. It also pointed out that the daily pay, though not high, was drawn by the servicewoman even when on sick

leave. The general line was that "the actual pay in the Women's Services of the Armed Forces is of small consideration," for "when all other benefits are considered, a girl would have to earn a fairly good salary to have as good a job."[84]

But resistance to female enlistment persisted. Two surveys carried out in the first half of 1943 revealed that low pay was one of the causes.[85] According to the public opinion survey, while only half the respondents offered suggestions on "How Enlistment in Armed Forces Might Be Made More Attractive," 22 per cent of those suggested increasing pay. Of the "young eligible women who considered the idea of joining the forces but later abandoned it," 7 per cent gave "poor pay" as their reason.[86] The report of the survey of CWAC opinion listed reluctance "to trade good civilian salary for army pay and allowances" as the eighth of ten "Main Reasons Why Women Do Not Enroll." In a list of seven "Main Sources of Dissatisfaction Among CWAC Women," the report put in fifth place the CWAC grievance that "while they were replacing men they were not given the same pay and allowances. They wanted at least the same trades pay as men"[87] Although there were other causes for reluctance to join the CWAC,[88] poor pay and allowances, the two reports left no doubt, could not be ignored.

Nor were they being ignored. Even before the second report was ready for distribution, authorities at National Defence Headquarters had the pay scale for servicewomen under review. On July 24, 1943, in an address before the House of Commons, Colonel J.L. Ralston, Minister of National Defence, made the official announcement of adjustments in pay and allowances for women in the services. The basic pay of women in the forces was to be raised to 80 per cent of that paid to men in the same rank, the pay increase retroactive to July 1. In addition, servicewomen would henceforward "receive trades pay according to their grouping on the same basis and at the same rates as" servicemen. Furthermore, a woman in the services married to a man in the services would not be prevented in the future from receiving a dependent's (separation) allowance from her husband, provided the woman's total annual income, including the allowance, did not exceed $2,100. Finally, dependent mothers, fathers, sisters, and brothers of servicewomen would be entitled to claim the same allowances as such dependents of servicemen.[89] The new provisions left two major inequalities outstanding: a 20 per cent discrepancy in basic pay (albeit

reduced from 33⅓ per cent) and no allowances for dependent husbands or children.[90] Servicewomen's subordinate position in income as well as occupation was thus preserved.

District CWAC officers at their conference in April, 1944, pronounced personnel well-satisfied with the changes.[91] A survey carried out in 1944, however, found servicewomen still aggrieved that their pay was not equal to that of the men they relieved.[92] Although the new provisions did not remove all inequalities, the services were nonetheless ahead of private industry in narrowing the gap between men's and women's pay and benefits. While the good wages paid in war industry made women's industrial earnings increase at a more rapid rate than men's from 1939 to 1944 (69.3 per cent compared with 54.1), the average hourly wage of women in industry climbed only to two-thirds of that of men (47.9 cents as compared with 71.2 cents).[93]

As for the status of the Canadian Women's Army Corps in relation to the Canadian Army, it was at best a stepdaughter of the military. On first formation, the CWAC was set up as a separate corps, supplementary to, rather than an integral part of, the Canadian militia and not subject to military law. The model was the Auxiliary Territorial Service in the United Kingdom. The Order-in-Council (PC 6289 of August 13, 1941) authorizing the formation of a Canadian Women's Army Corps stipulated that it would "not be comprised in, or form part of the military Forces of Canada." The women of the Corps were, however, to "be organized on a military basis so that ... they will be under military control and supervision," as provided in the regulations for the Canadian Women's Army Corps appended to the Order-in-Council.[94] "The primary role of the Canadian Women's Army Corps" was "to replace Army Personnel in non-combatant activities."[95] Arrangements were made for the Department of National War Services to be in charge of recruitment. Its job was to create "a pool" of prospective soldier replacements on which District Officers Commanding Military Districts would draw to meet their labour demands.[96]

Although one could speak of the organization of the Corps as "broadly similar" to that of the Canadian Army,[97] it was more a case of parallel but unequal. The Corps had a headquarters, located at National Defence Headquarters, Ottawa, and its own officers: an Officer Administering to command the Corps, CWAC staff officers appointed to each Military District Headquarters, and CWAC officers or NCOs to command CWAC units. Given the

purpose and anticipated size of the Corps, the company was the largest organizational unit provided. Both CWAC officers and other ranks were carried on strength of CWAC companies; those "not required for Corps administration" were posted for employment to stationary units of the male Army "to replace men fit for active service."[98]

The hierarchy of ranks was parallel to that of the Army, but truncated – the rank initially crowning the list was the equivalent of Colonel. Because the CWAC was not under military law nor part of the genuine military forces, officers were not commissioned and their titles and badges of rank could not be those authorized for use in the military. By adoption from the British ATS, the titles for officer ranks became 2nd Subaltern (the equivalent of 2nd Lieutenant), Subaltern (Lieutenant), Junior Commander (Captain), Senior Commander (Major), Chief Commander (Lieutenant-Colonel), and Honorary Controller (Colonel).[99] For badges of rank the French emblem of the *fleur de lis* and the British emblem of the rose were originally considered,[100] but in the end the Canadian symbols of the maple leaf and beaver were chosen, in combinations ranging from one maple leaf for a 2nd Subaltern to one beaver and two maple leaves for an Honorary Controller.[101]

The powers of the officers were limited. While on duty with the Army, CWAC personnel replacing soldiers at military establishments came under the command of the officers, warrant officers, and non-commissioned officers of the Army. Furthermore, although Army officers and other ranks did not have the power to place CWACs under arrest (the CWAC had its own provosts, military police, for that), the authority to punish CWAC personnel was invested in CWAC officers only in cases involving the lower ranks and minor punishments. Otherwise that power was reserved, not for the officer administering the CWAC, but for senior officers of the male Army, station commanders, district officers commanding, the Adjutant-General, or, in the case of dismissal of CWAC officers, the Minister.[102] The CWAC may have been governed by its own regulations, but those had been drawn up by the Adjutant-General and officers of his branch at NDHQ, in consultation with the Judge Advocate-General, and they provided at many points for the interposition of male Army control and authority over the CWAC and its members.

The British ATS had provided the model for the separate status of the CWAC. However, by the time the CWAC was formed,

experience had convinced some British military authorities that it would have been better to make the women's corps part of the Army. Although in September, 1940, the Minister of National Defence had been the one to suggest to the Adjutant-General that women's services "could be administered by the Department of National War Services,"[103] after a visit to the United Kingdom in November Ralston had swung round to favouring their incorporation directly under the armed forces.[104] Others at National Defence Headquarters strongly opposed that view, chief among them Brigadier Orville M.M. Kay, Deputy Adjutant-General, and his superior, Major-General B.W. Browne, then the Adjutant-General, who never changed his opinion on the matter.[105] Presumably Browne was against making the CWAC a part of the Canadian Army out of concern to preserve the masculine exclusiveness and solidarity of the military. He later opposed "the formation of Girl Cadet Corps as a component part of the Royal Canadian Army Cadets" on these grounds: "Bringing girls into the Royal Canadian Army Cadets would alter its status as being purely a boys' organization and might very well interfere with its growing popularity."[106]

In the summer of 1941 Ralston had yielded to Browne and Kay. But by the start of the next year the disadvantages of having the CWAC separate from the Army were seen to be outweighing the advantages: there was growing dissatisfaction with the necessity "to constantly be passing special regulations"[107] and with the Department of National War Services' handling of recruitment.[108] Most importantly, as long as the CWAC was not "part of the military Forces of Canada," members of the CWAC would not be eligible for post-discharge and rehabilitation benefits without passage of a particular Order-in-Council for each and every benefit. Much the simpler way, the chairman of the General Advisory Committee on Demobilization and Rehabilitation urged Major-General Browne, would be "if members of the Canadian Women's Army Corps were recognized as members of the forces."[109]

The replacement of Browne as Adjutant-General by Major-General H.F.G. Letson early in February, 1942, smoothed the way to incorporating the CWAC within the active Army of Canada. The separate status of the CWAC was abolished by Order-in-Council PC 1965 of March 13, 1942, and the Canadian Women's Army Corps was placed on active service and under military law as part of the defence forces of Canada.[110]

Henceforth, CWAC volunteers would be "enlisted" and not "enrolled." CWAC officers acquired the right to hold commissions, use military titles of rank, and "replace their beaver and maple leaf rank badges with crowns and stars."[111]

Although the Officer Administering the CWAC referred to the Corps as having "been absorbed in the Armed Forces of Canada,"[112] the CWAC remained a segregated Corps, its members retaining a status different from that of male members of the Canadian Army. The term "soldier(s)" was still reserved for male other ranks; the collective term for "all ranks in the CWAC other than Officers" was "Volunteer(s)."[113] The degree to which members came under military law was limited by modifications and exemptions spelled out in the revised CWAC regulations of 1942. For instance, the severest penalties (death, penal servitude, imprisonment, detention) were not to be inflicted. Also, while members of the CWAC now had the right to elect trial by court martial and officers were eligible to sit as members of courts martial at trials of CWAC personnel, no CWAC officer could be appointed president of a court martial.[114]

In general, measures were taken to preserve wherever possible the male-female hierarchy of authority. Although the revised CWAC regulations and a reorganization of companies in August, 1943, extended the disciplinary powers of CWAC commanding officers over CWAC personnel, "Officers of the Canadian Women's Army Corps" were to "have no powers of punishment over Officers, Warrant Officers and soldiers of other Corps."[115] Three paragraphs in the revised regulations laid down the rules of precedence and command between officers of the CWAC and officers and other ranks of other branches and corps of the Army.

5. Officers, Warrant Officers and Non-Commissioned Officers shall rank with Officers, Warrant Officers and Non-Commissioned Officers in other branches of the Army according to the dates of their appointments in their respective ranks, but where such appointments bear the same dates, Officers and Other Ranks of the Canadian Women's Army Corps shall rank junior.

6.(a) Officers, Warrant Officers and Non-Commissioned Officers of the Army, of Corps other than the Canadian Army Corps, shall have power of command over personnel of the Canadian Women's Army Corps who are junior to them by rank, appointment or seniority.

Defence Minister J.L. Ralston chatting with CWAC lieutenant while reviewing CWAC company. Manitoba Archives, Canadian Army Photograph Collection #3.

(b) Officers, Warrant Officers and Non-Commissioned Officers of the Canadian Women's Army Corps, shall have power of command only over Officers and Other Ranks of other Branches of the Army as may from time to time be placed under their command.[116]

In other words, all determinants of rank being equal, the CWAC officer, non-commissioned officer, or private was junior to her male Army counterpart. And while male Army officers and NCOs always enjoyed power of command over CWAC personnel junior to them, CWAC officers and NCOs could exercise power of command over junior male Army officers or male other ranks only under exceptional circumstances.

The status and power of the Corps Command underwent many changes from the creation of the CWAC to its dissolution after war's end. To serve as first commander, National Defence Headquarters looked to the Nursing Service of the Royal Canadian Army Medical Corps for a woman experienced in military affairs and administration and chose Matron-in-Chief Elizabeth Smellie. Her first duty as Officer Administering, CWAC, was to tour every military district in Canada in search of women qualified to form the initial nucleus of administrative officers and NCOs for the CWAC. Her recruiting ground was the commandants of "local women's corps" and other leading women in the communities.[117] Appropriately, her first selection, recommended as Staff Officer for Military District No. 11, was Joan B. Kennedy, Controller of the B.C. Women's Service Corps and destined to be Matron Smellie's successor as O/A, CWAC.[118]

If anything, the CWAC's incorporation into the Army brought an initial downgrading of Corps Command. In the fall of 1942, CWAC Headquarters was dissolved, CWAC administration having been apportioned out among the appropriate branches and directorates of NDHQ, and the position of Officer Administering, CWAC, abolished. Lt.-Col. Joan Kennedy was now given the title of Director, CWAC, but the terms of reference of her directorate were never formally approved. The Corps Headquarters had been "replaced by a Directorate which was never legally authorized," and the Officer Administering "by a Director with little official power."[119]

Corps Command was further eroded in May, 1943, when the unauthorized directorate was abolished and in place of a director, two senior officers' appointments were made, that of Lt.-Col.

Joan Kennedy as General Staff Officer Grade 1 in the Directorate of Military Training to advise on all CWAC training and that of Lt.-Col. Margaret Eaton as Assistant Adjutant-General, CWAC, to co-ordinate all CWAC matters handled by the directorates of the Adjutant-General's branch.[120] The CWAC had thus been left with no official head within its own Corps.

But a year later, for reasons of Corps morale, that decapitation was reconsidered. On April 28, 1944, Margaret Eaton was promoted to Acting Colonel and appointed to the new position of Director-General, CWAC.[121] This time the terms of reference were formally authorized: she was "under the Adjutant-General" and "responsible to him for the wellbeing and efficiency of the CWAC as a Corps and of its personnel." Nonetheless, although she was to "be consulted by all Branches" on matters of CWAC policy and administration, and in such matters had direct access to the Minister, the final term specified:

> The duties and functions of the Director-General, CWAC, will not alter the responsibility of the various Branches and Directorates of the Army for the training, administration, organization, spiritual and medical care, welfare, accommodation and clothing of the CWAC, subject always however to the obligation to consult the Director-General

Margaret Eaton must have won the respect and confidence of National Defence Headquarters to have been elevated at thirty-one to the position of Director-General. She came from the Timothy Eaton family and, when first approached to become an officer, had demurred on the grounds that her only qualifications were that she "knew the best night clubs in London and hunted with the best packs." But after promotion to the position of Director-General, it was precisely her high social standing, as she herself has observed, that put her in such a "strong position *vis-à-vis* the boys": it was difficult for the male officers, no matter how high their military rank, to pull social rank on her. The top ones, she has recalled, never addressed her as Colonel but rather always as Miss Eaton. Her powers as Director-General, CWAC, albeit ultimately consultative, were not inferior to those held by the heads of other Army Corps, such as the Service Corps or the Corps of Military Staff Clerks. Indeed, in one respect, her position carried a privilege beyond that granted even to the Director-General of Medical Services: direct access to the Minister as well as to the Adjutant-General.[122]

Nonetheless, there was one important difference. Her male counterparts were of the same gender as the senior officers over them, while overarching the CWAC at every point was a higher authority exercised by members of the opposite sex. And those higher positions were closed to all Army women, excluded or exempted as they were from field training and segregated, except for the Nursing Sisters and female doctors of the Medical Corps, within the Canadian Women's Army Corps.

Upon Margaret Eaton's relinquishing of her appointment on October 29, 1945, it was the wish of the Adjutant-General that the title of DG/CWAC lapse with her retirement. Although her designated replacement, Lt.-Col. Daisy I. Royal, fought hard for promotion to the rank of colonel and use of the title of Director, CWAC, or failing that, of Officer Administering, CWAC, the strength of the Corps was steadily diminishing and advice in the Adjutant-General's branch was that promotion should be discontinued. During the next few months the title and power of the head of the CWAC was gradually downgraded, and on January 19, 1946, Lt.-Col. Royal was informed of the Adjutant-General's ruling that "the head of the CWAC Section at NDHQ shall in future be known as 'Staff Officer' and that under no consideration are the terms 'Director' or 'O.A.' to be used."[123]

On the whole, the expendability of women's labour in the public sphere was nowhere more dramatically illustrated at the end of the Second World War than in the armed forces. In the course of 1946, all three women's services were disbanded. A number of both male and female officers in the RCAF and the Canadian Army proposed the inclusion of women's corps in Canada's post-war reserve forces, but the cabinet did not give approval to the proposal.[124] Final disbandment of the Canadian Women's Army Corps came on September 30, 1946.[125] It demonstrated that women could serve as a reserve army of labour for the armed forces just as well as for the civilian labour market.

The coincidence of groups of women eager to serve and an army short of men gave rise to the possibility of admitting women into the Canadian military in World War II. The creation of the Canadian Women's Army Corps was heralded as a history-making event in recruitment propaganda and promotional news stories.[126] Women who joined the CWAC during the Second World War were understandably impressed by the novelty of the

enterprise and deservedly proud of their service to Canada's war effort.[127] But scrutinized closely, in retrospect, the Canadian Army's admission of women can be seen to have been cautious, gradual, and carefully contained.

Kept separate from the Army on first formation, the Canadian Women's Army Corps, even after its incorporation within the Army, remained a segregated corps, its functions supplementary, its proportion of overall Army strength peripheral. Men and women inside and outside the Army were wary of challenges to the established division of labour by sex and the patriarchal hierarchy of authority. Although the Army took the big step of admitting women to its ranks, it did not venture far in the direction of upsetting the established sexual division of labour and authority. Insofar as it did, the war emergency, exigent but temporary, provided justification.[128]

The paramount purpose of the CWAC remained from beginning to end to supply a pool of subordinate labour under military discipline as replacements for men needed for more important Army duties. The subordination of women in the civilian labour market carried over into the military employment of women: the concentration of women in jobs drawing lower pay, requiring less skill, and involving less exercise of authority or control.[129] Only servicewomen's lower pay and benefits were contested by organized protest, with some positive effect. No protest was mounted against the assignment of the vast majority of CWACs to subordinate service jobs identified as women's work in civilian life. On the contrary, the fact that women were needed by the Army principally to do "women's work" had facilitated acceptance of the idea of a women's corps in the first place and was later used to make female enlistment palatable to a dubious public. In February, 1943, the Directorate of Army Recruiting could assure the Canadian public that "women are needed and wanted to release men from trades that women can do – that is why women are, for the first time in Canada's history, part of the active fighting force."[130]

This assurance meant not only that servicewomen were needed mainly as clerks and cooks; it also meant they were not needed for combatant duties. It is true that the High Command at NDHQ in midsummer, 1942, seriously contemplated using women to "man" anti-aircraft artillery guns, but the idea was abandoned in the face of more urgent demands for female labour in traditional women's occupations. As it was, the Army did not

"Rifle shooting popular with CWACs": *Sergeant Gertrude Wurtz, Kelvington, Sask., and Lance Corporal Grace Bain, Toronto*. Canadian Army Photo, York University Archives, Toronto *Telegram* Photograph Collection.

have to breach the barrier against using women in combat, and the division between man the protector/aggressor and woman the protected/victim remained inviolate. No "Pistol Packing Mommas,"[131] members of the CWAC, without exception, were assigned to non-combatant duties. The largest proportion of male soldiers in the Canadian Army in World War II also served safely in support and rear echelon positions. They, however, whether holding down a desk job or driving a supply truck, had all been put through training in combat duty and the bearing and firing of arms. Although the CWAC could boast of crack shots with a rifle, like Captain Jean I. Rayment (one of the founders of the Victoria service club) and a group of sharpshooters in Company 42 in England who consistently outshot their male competitors, members of the CWAC could take up rifle-shooting and target practice with small arms only as a recreational activity.[132] A spokesman for the Directorate of Army Recruiting could announce in 1943, "I would protest in no uncertain manner should anyone dare to call, or even think of, our Canadian women in uniform as Amazons"[133] Exclusion from combat duty and the official bearing of arms remained the most salient feature of women's service in World War II, whether in the CWAC or the Royal Canadian Army Medical Corps, the only other Army Corps that women were eligible to join.

The armed might of the military is not wielded by the rank-and-file soldier, but by the high military command. The ordinary infantryman or artilleryman is not by virtue of his bearing arms in a position of power within the Army. On the contrary, he is in a position to be used as cannon fodder by the high command, who do exercise the power and whose power consists in the aggregate of men and material at their disposal. Members of the CWAC were exempted from use as cannon fodder. That exemption was protective in intent. The taking of life was seen as incompatible with woman's role as bearer of life.[134] Women were protected from having to kill in combat and, on the whole, Canadian servicewomen were protected from being killed in combat, as well as from the death penalty by court martial. But that protective exemption precluded the rise of female officers to positions of high command in the Army as a whole. Further-more, arms-bearing duty, despite the risk of maiming and death it carries, bestows authority and an aura of power on the officially armed over the officially unarmed. Hence, the wholesale exclusion of women from arms bearing meant the retention of

an at least symbolic authority and power by the male sex as a whole over the female sex as a whole. Thus, neither the inauguration of the Canadian Women's Army Corps nor its incorporation within the Army brought an increase in power to women as a group in Canada. Women officers rose to positions of limited authority over subordinate female officers and female other ranks, but the higher command of the Army remained closed to women, and the male monopoly on the armed might of the state was unbroken. Women's admittance to the Army in World War II had not brought about a change in the distribution of power between the sexes in Canada.

4

Wartime Jitters over Femininity

"They're Still Women After All" was the title given, with an audible sigh of relief, by L.S.B. Shapiro, Canadian foreign correspondent and future novelist, to a piece he did for *Saturday Night* in September, 1942. In a light, jocular vein, the article expressed one man's fears, aroused by the British wartime sight of so many women stepping into formerly male jobs, that women might cease to be women, that is "feminine individuals," synonymous terms in Shapiro's vocabulary. Although closer observation convinced Shapiro that his fears were unfounded, similar fears continued to plague many other Canadians, male and female, as they viewed women entering the munitions plants and, what in the eyes of some was even worse, joining the armed forces.[1]

As the primary purpose of the services is the provision of the armed might of the state, their male exclusivity had been in keeping with a deeply rooted division of labour by sex that relegated women to nurture, men to combat, women to the creation and preservation of life, men, when necessary, to its destruction. Closely connected to the sexual division between arms bearers and non-arms bearers was a gendered dichotomy of attributes that identified as masculine the military traits of hardness, toughness, action, and brute force and as feminine the non-military traits of softness, fragility, passivity, and gentleness. Hence, the very entrance of women into the Army, Navy, and Air Force sharply challenged conventions respecting women's nature and place in Canadian society.

As pointed out in the preceding chapter, two specific sets of circumstances induced the Department of National Defence to admit women into the armed services: manpower shortages, felt first by the Canadian Army and the Royal Canadian Air Force,

129

and a reserve of womanpower embodied in a Canada-wide paramilitary movement of women eager to serve. For the men in charge of Canada's military, efficient prosecution of the war was the reason for putting women in uniform and under service discipline. They had no desire to tamper with existing gender relations by altering the sexual division of labour or the male-over-female hierarchy of authority. Obviously the members of the women's volunteer corps eager to become part of Canada's official forces wanted to end the male exclusivity of the military. But even they gave no indication of a desire to erase the demarcation line between male and female spheres. There was thus a tension inherent in the admission of women to the armed services: the tension between the Canadian state's wartime need for female labour within those pre-eminently masculine institutions and Canadian society's longer-term commitment to a masculine-feminine division of traits as well as separation of tasks. This tension was also apparent, albeit to a lesser degree, in the entrance of women into non-traditional trades in war industry. In both cases, under the pressure of the war emergency, women appeared to be breaking sex barriers on an alarming scale.

Reactions to women's admission to the forces, similar to but more pronounced than those to women's mobilization for war industry, provide a good index of the social attitudes toward women prevailing in Canada at the time of the Second World War. And the records of the Department of National Defence provide a good source for those reactions. The department had to be sensitive to the values of the larger civilian society: its dependence on women volunteers, not conscripts, made it especially so. To inform itself of those attitudes it made use of opinion surveys and to influence public opinion it made use of the media. Also, as a part of the established order, the Department of National Defence itself incorporated and acted on widely held, unexamined notions of women's nature and capabilities. The dilemma facing the department thus brought the current social attitudes toward women into high relief: by admitting women to the services it had violated the convention that the armed forces were no place for a woman; in seeking volunteers, it had to advertise its conformity with as many other received notions of proper womanhood as possible.

What were the reactions to women's entrance into the armed forces (as well as into non-traditional trades in war industry)?

One was that the war was opening up for women a world of opportunity unrestricted by sexual inequalities. The ceremonial launching of a ship that women workers had helped to build "from the first bolts and staves to the final slap of paint and piece of polished brass" moved journalist Lotta Dempsey to suggest that the event symbolized the launching of women as well: "the great and final stage of the movement of women into industry ... on a complete equality with men."[2] The office of the Directorate of Army Recruiting suggested in February, 1943, that recruiting officers should speak of the war's having "finally brought about complete emancipation of women."[3] Evidence for this was to be found in women's admission to the forces and to an ever-increasing number of jobs within the forces. News stories designed to promote interest in and support for the women's services often played up the achievements of individual women. And women were racking up many firsts. "First woman in the history of the R.C.A.F. to take the officers' administrative course at Trenton ..." read the caption of a photograph in the *Globe and Mail* of December 24, 1942; "First Class of Airwomen Graduated from RCAF Photography School" was the headline of an article in the same newspaper later that same month.[4] The 1944 article in *Saturday Night* celebrating the expanding number of trades open to CWACs singled out in illustration the first "qualified girl armourer in the CWAC" and the first CWAC to operate "a Telecord recording machine."[5]

This perception of the war's having fully emancipated women and of the war's having made it possible for women to "Achieve Heights Hitherto Undreamed Of"[6] meshed with the view that women were participating in the war effort on an equal footing with men. "Shoulder to Shoulder," which was an Army motto adopted by the Canadian Women's Army Corps and made the title of their official marching song, epitomized that sense of the equality of women's and men's service. When the Corps was celebrating its second anniversary in August, 1943, Headquarters of Military District No. 12 (Regina) dedicated its regular monthly bulletin to the CWAC and placed under the bulletin's title, *Shoulder to Shoulder*, an illustration of a CWAC marching shoulder to shoulder with two army men, all three wearing steel helmets on their heads and gas mask bags on their chests (but only the men shouldering rifles).[7] This image was also used on a recruitment poster for the Corps.

Of a piece with the celebration of equality and emancipation

was a kind of wartime advertisement that proclaimed the end of women's confinement to the domestic sphere. Many companies advertising in the Canadian press between 1939-1945, especially those trying to hold on to post-war markets, sought to give a patriotic cast to their messages. One such series of advertisements run by General Motors of Canada in the special 1943 issues of *Mayfair* on "Women at War" took as its theme women's movement into the wide open spaces of the public domain. Running for five pages, the ad was set up so that a reader would encounter in bold print on a right-hand page "Woman's place ..." and then turn to find not "is in the home" but "is Everywhere ..." followed on the fourth and fifth pages by the qualifier "with Victory as Their Business" and a brief description of the many fields in which women were serving the nation at war.

Canada's mobilization of women for the war effort necessitated violation of the social ideal of the woman dedicated to home and family. Even without challenging established patterns of work and behaviour considered appropriate to each sex, war cruelly disrupted and dislocated human lives. To contain the disruptive and destructive forces of war as far as would be compatible with its efficient prosecution seems to have been a goal tacitly agreed upon by those in charge of the war effort and by many in the media. Thus, with respect to women's participation in the armed forces, alongside the talk of emancipation, equality, and the overcoming of tradition, recruitment propaganda and wartime advertising also sought to minimize the degree of change required and to hint at and occasionally even stress the expectation of a rapid return to normalcy once the war was over.

So, at the same time recruiting officers were led to speak to NSS officials of the war's "complete emancipation of women," they were also instructed to stress that women's employment in the armed forces was "an emergency measure" and that "After this war they will go back to their place in civil life; they will retake their positions in the household and in the office or anywhere else where they originally came from."[8] For *Mayfair*'s 1943 celebration of women's contribution to the war effort, Westinghouse of Canada provided a more graphic statement of the expectation that at war's end women would return to motherhood and child-rearing as their principal life's work. A large two-page ad headed "These Are Tomorrow's Yesterdays" showed the

pride the future son of the female war worker would take in his mother's war service. Looking through a book on *Women At War* in the school library in 1955, the boy was surprised by a picture of his mom, taken in a war plant in 1943. Overcome with emotion, the child has sat down to write his mom to say how proud of her he is. The ad carried not only a tribute to Canadian women's role in Canada's struggle, but also the projection that in ten or twelve years' time the women would all be back where they belonged, taking care of the home and rearing Canada's future generation.

Recruitment propaganda, promotional newspaper stories, and patriotic advertising, then, reveal a deep ambivalence toward women's joining the armed forces. On the one hand was the celebration of the trailblazing and achievement of women in the services and, on the other, the assurance that joining the forces changed nothing in women's nature and place in Canadian society. In 1943 the ambivalence intensified as more and more women were needed but recruitment met resistance and monthly enlistment figures dropped. From the first enrolments in September, 1941, to July, 1942, 3,800 women had "stepped forward to serve" and been accepted into the Canadian Women's Army Corps. Many of these came from the women's volunteer corps.[10] By March, 1943, the strength of the Canadian Women's Army Corps had risen to just over 10,000.[11] Although the CWAC's peak strength in 1945 would not exceed 14,000 (636 officers plus 13,326 other ranks totalling 13,962, on April 25, 1945),[12] military authorities in 1943 geared up for a considerable expansion of the women's forces on the assumption that "the Army, Navy and the Air Force urgently need 65,000 more service women to release men for combat duty."[13]

In February, National Selective Service began participating "in the recruiting of women for the Navy, the Army, and the Air Force" by providing information to interested applicants and referring them to recruiting offices.[14] In March the Defence Council concurred in the recommendation of the National Campaign Committee for an intensive tri-service campaign to recruit women for the three armed services.[15] A Combined Services Committee was established to co-ordinate joint promotional and publicity endeavours for the CWAC, the WRCNS, and the RCAF (WD). The recruitment push coincided with the growing signs of opposition to women in the military.

CWAC information booth. Manitoba Archives, Canadian Army
Photograph Collection #162.

The monthly enlistment figures for the women's services in
late 1942 and early 1943 were disappointing.* Faced with this
slowdown, the National Campaign Committee granted author-
ization to two opinion surveys in the first half of 1943.[16] The
Combined Services Committee charged with joint recruitment
endeavours for the three women's services proposed that a
commercial market research agency conduct a general survey
of public opinion. The firm of Elliott-Haynes Limited of Montreal
and Toronto was retained to determine: (a) public awareness of

* Comparative monthly enlistment figures for CWAC:

October, 1942	843
November, 1942	730
December, 1942	530
January, 1943	699
February (3 weeks)	570

the need for women in the armed forces; (b) factors believed to influence women in favour of joining the forces; (c) factors believed to influence women to avoid joining the forces. The survey, which collected the opinions of 7,283 civilian adults from "56 Canadian centres and their surrounding areas," claimed to have covered "both sexes, all races, all geographical regions, all age levels, all economic levels, all occupations and all classes of conjugal condition."[17] Conducted in March and April of 1943, the results appeared under the title *Report: An Inquiry into the Attitude of the Canadian Civilian Public Towards the Women's Armed Forces.*

In April and May the Directorate of Army Recruiting carried out the second survey: a study of CWAC opinion. Based in part on the results of the first study insofar as they pertained to the CWAC, the in-house inquiry drew primarily on the "written answers to a questionnaire prepared by NDHQ in both English and French" and administered to a cross-section of 1,100 CWAC other ranks from all CWAC units, 18 per cent of whom were non-commissioned officers and 10 per cent French-Canadian women.[18] The secret and confidential report of the second inquiry, "Canadian Women's Army Corps: Why Women Join and How They Like it," was ready for limited distribution in July.

Both surveys revealed that there was widespread disapproval of women's joining the armed forces. The public opinion survey disclosed that few Canadians in the spring of 1943 gave high priority to enlistment in the armed forces as a way for women to contribute to the prosecution of the war. In answer to the question "How can women best serve Canada's war effort?" only 7 per cent replied "by joining the women's forces." Five other categories of work took precedence. "Maintaining home life" ranked first in importance for the highest proportion of Canadians (26 per cent), followed by "doing war work in factories" (23 per cent), "part-time voluntary relief work" (13 per cent), "conserving food, rationing" (11 per cent), and "buying war bonds, stamps" (8 per cent).[19] The ranking remained the same when the answers from French Canada were treated separately, the main difference being that an even higher proportion of French Canadians (40 per cent) thought "maintaining home life" was the most important job for women in wartime while only 18 per cent thought working in war industry was; a minuscule 3 per cent thought "joining women's forces" was most important. Separating out the answers from parents and from young men

did not change the ranking either. Only the answers from young women showed a different order of priority: "maintaining home life" switched places with "doing war work in factories."[20] But the young women also placed ahead of "joining the forces" the same five kinds of war service as mentioned above. Furthermore, as "part-time voluntary relief work," "conserving food, rationing," and "buying war bonds, stamps" were all compatible with "maintaining home life," the inescapable conclusion is that an overwhelming majority of Canadians in 1943 saw women's place to be in the home, wartime or not.

Furthermore, according to the public opinion survey, among friends and relatives of young eligible women disapproval of their joining the forces ran higher than disapproval of their taking jobs in war industry. Of parents, husbands, boyfriends, and brothers, 39 per cent disapproved of their daughters, wives, girlfriends, and sisters joining the armed forces (43 per cent approved, and 18 per cent didn't know), while only 27 per cent disapproved of their female friends and relatives entering munitions factories (59 per cent approved and 14 per cent didn't know).[21] When the data for English and French Canada were segregated, the level of disapproval of women in the forces was found to be significantly higher in French Canada.[22] If one took the "don't know" as indifference or neutrality, a more negative construction could be put on the data, as was done in the report of the CWAC survey. "When pressed," it submitted, "57% of the public stated that they would not give open approval to their friends and relatives enrolling in the women's forces."[23] The public opinion survey highlighted another noteworthy contrast in level of disapproval. By separating mothers and fathers from boyfriends and brothers, it revealed that a higher proportion of young men objected to their girlfriends' and sisters' joining the forces than parents did to their daughters'.[24]

Young eligible women were aware of this disapproval among relatives and friends. When asked about expected responses to their joining up, 46 per cent of the women eligible for enlistment assumed their parents' attitude would be unfavourable and 51 per cent expected an unfavourable response from their brothers and boyfriends.[25] The only group from which support was expected to any significant degree was that of young women friends already in the forces: from that quarter 59 per cent of the eligible women responding assumed they would receive

encouragement.[26] According to the CWAC survey, even the women who had ended up joining the Canadian Women's Army Corps had "received about as much discouragement as encouragement" from the friends and relatives whose advice the women had sought.[27] The CWAC survey and the public opinion survey led to the same conclusion: "Women friends already in the forces were the only people which [sic] gave outspoken approval and encouragement."[28]

Given the extent of the disapproval, it is not surprising that 61 per cent of the eligible women (56 per cent in English Canada, 72 per cent in French Canada) responded that they had never considered joining the armed forces.[29] Nor is it surprising that of the 39 per cent who did consider joining, about one-half finally abandoned the idea.[30] There was a connection between the disapproval of family and friends and the reluctance of eligible women to join. Of those who entertained the idea of joining but ended up rejecting it, 33 per cent gave as their reason that the family objected (24 per cent of the English Canadians, 54 per cent of the French Canadians).[31] Of the members of the Canadian Women's Army Corps who remembered hesitating before they joined, the largest proportion (35 per cent) reported that "disapproval of family and friends" was what had given them pause.[32]

In light of that sentiment, it is no wonder that those in charge of women's recruitment for the three services saw their task as essentially one of educating the public. The big push to recruit women for the armed forces, initially planned for March 15 to June 15, 1943, was actually mounted between June 15 and September 15. In late summer 1943 the Combined Services Committee was given the go-ahead to continue its operation from October 1 to December 31. In its proposal to continue the campaign to recruit women for a second three-month period, the working committee of the Combined Services Committee observed that "overcoming established tradition and developing acceptance of a new idea is obviously a long-term educational proposition." The proposal went on to define as the primary object of the campaign and the essential task of the Committee: "overcoming the tradition that women's place is exclusively in the home ... or at least not in military uniform."[33]

Both the inquiry into public opinion and the investigation of CWAC opinion played an important part in the educational

campaign. The results of these surveys were studied and analysed and the analyses pored over by members of the working and policy committees of the Combined Services Committee and officials in the Directorate of Army Recruiting. From the CWACs' answers to the question "How did you first learn of the CWAC?" DAR analysts concluded that recruitment advertising had been woefully inadequate. The more conspicuous "news items, feature stories and pictures about the Women's Services" in newspapers and magazines had been interesting but had not carried sufficient "sell" copy, and radio had "been used extensively and effectively only on the Prairies."[34]

The tri-service campaigns of the second half of 1943 represented a massive increase in promotion of the women's services. The Combined Services Committee paid for 1,000-line recruitment advertisements to be run in all daily newspapers across Canada and for full-page ads to appear in magazines and in the rotogravure sections of the metropolitan weekend papers. It contacted newspaper editors and arranged for them to sell recruiting ads "on a sponsored basis to local advertisers," providing the ad design in mat form and suggesting the pitch to the local businessmen: "a convenient, direct way for him to help along the war effort."[35] At the committee's bidding the National Film Board produced two women's recruitment films: *Proudly She Marches* and *Canada's Women March to the Colours.* Five-minute radio spots and "flash" announcements were scheduled on the CBC national and regional networks and on local radio stations across Canada. Stores and other commercial establishments were persuaded to donate some of their window space to displays promoting women's recruitment. In co-operation with others, "special events," such as conventions held by national organizations, were used to publicize the women's services. Finally, recruitment posters and streetcar signs were displayed as widely as possible.[36] In this intensification of recruitment for the women's forces, the Combined Services Committee and the Army's Directorate of Recruiting aimed to apply the lessons learned from the results of the two surveys. They sought to play up any features that had elicited a positive response and to play down, deny, disguise, or reinterpret the sources of disapproval.

One source of disapproval was a fear, similar to that expressed in L.S.B. Shapiro's *Saturday Night* piece, that the woman who joined the forces did so at the risk of her femininity. Although neither survey posed the question in so many words – is fear of

loss of femininity a reason why their family and friends are reluctant to see them join the forces? - other questions carried much the same meaning, such as, is the reason for objection that military life is considered unsuitable for young women? According to the Elliott-Haynes survey, 20 per cent of the "young eligible women reported that they thought their parents, husbands, brothers, sisters," and male and female "friends would object to their joining the forces" on the grounds that "army life" was "unsuitable."[37]

In the hopes of dispelling that notion, speeches of recruitment officers, recruitment literature, sponsored advertising, and promotional news stories, even before but especially after the surveys, were full of assurances that membership in the CWAC - or RCAF (WD) or WRCNS - was not incompatible with femininity. "Our women in the Canadian Armed Forces are nothing if not thoroughly feminine in manner and appearance," recruiting officers instructed National Selective Service personnel being trained to help with servicewomen's recruitment in February, 1943.[38] Clearly, while the armed forces could persuade a male potential recruit that military service would make a man of him, they felt they had to do the reverse with a female prospective volunteer, that is, convince her that military life would not make her less of a woman.

From the start Army authorities assumed women in the services would be concerned about their appearance. Opposition to wearing a uniform *per se* was not anticipated from the women in the volunteer service corps (as many such corps sported their own uniforms), only opposition to a poorly designed one. In general, the planners of the CWAC calculated they would have a better chance of attracting volunteers the more attractive the uniform. The basic costume "underwent a considerable evolution before it settled into" the two-piece khaki suit identifiable as the CWAC uniform of World War II.[39] After National Defence Minister Colonel Ralston, his wife, the Master-General of the Ordnance, and a Toronto dress designer had all had a hand in the design, a committee at NDHQ produced the final model: the two-piece khaki ensemble of gored, slightly flared skirt and single-breasted tunic with hip pockets and one breast pocket, brown epaulets and brown CWAC and Canada badges, khaki shirt and brown tie, khaki peaked cap, and khaki hose and brown oxfords. According to the Director-General's preliminary history of the Corps, the CWAC uniform was "voted in some American

and Canadian quarters to be the smartest of all women's service uniforms on this continent."[40] CWAC recruitment literature used this reputation to sell the Corps. The 1942 brochure *Women in Khaki* boasted: "C.W.A.C. uniforms have been acknowledged by leading dress designers to be the smartest in the world."[41] Enlistment ads sought to sell the wartime fashionableness of wearing the khaki with the line: "the C.W.A.C., the best dressed women of '43."[42] In addition, the Army went to greater and greater trouble to ensure a good fit in women's uniforms, much more so than in men's. In 1944 it was observed that "The equipping of C.W.A.C. personnel is considerably more complicated than this function for male personnel." And the evidence produced was that "C.W.A.C. clothing is supplied in as many as eighteen different sizes."[43] One ex-servicewoman of Prince Rupert, B.C., recalls that the colour and cut of the CWAC uniform led her to choose the Canadian Women's Army Corps over the WDs or the Wrens.

> Perhaps if I had had big baby blue eyes, I might have considered the blue uniforms of the R.C.A.F. or the Navy, but be that as it may, not only did the khaki match my brown eyes (used for coyly rolling and flirting in those days, besides the lesser use of just plain seeing); the trim, fitted tunic and the A-line skirt of the C.W.A.C.'s was known to be the most attractive of the three services. And the peaked cap fit nicely on the head to allow a modest fall of curls from under its back and sides.[44]

While only 5 per cent of the CWACs surveyed in 1943 mentioned wearing the uniform as a reason for joining, in answer to the further question of why they had selected the CWAC rather than the RCAF (WD) or the WRCNS, the highest proportion (37 per cent) gave "neat, smart uniform" as their reason.[45] On the other hand, only 13 per cent of the CWACs "stating likes" cited "wearing the uniform" as a "factor contributing to satisfaction" with life in the Corps.[46]

Certainly no one would have argued that pride in uniform was exclusively or particularly feminine, for men also took pride in their uniforms. There was, however, an important difference. A long association linked male with military uniform and military uniform with the masculine traits of forcefulness, toughness, and, in the case of an officer's uniform, commanding authority. When a man donned a uniform he stood to see his masculinity

enhanced. Hence the popular notion that uniforms (on men implied) turned women's heads. Literary evidence exists that where the war effort was strongly supported and there were large concentrations of men in uniform (such as in London, England, or Ottawa, Ontario), men of military age not in uniform felt threatened not only by the possible charge of cowardice but by the possible loss of girlfriends to the soldiers, sailors, and airmen.[47]

Just the reverse was the fear in the case of servicewomen in uniform (or, for that matter, of women war workers in overalls and bandanas). Here reassurance was needed that such garb did not diminish femininity. For the January 1, 1943, issue of *Maclean's*, Lotta Dempsey contributed an article entitled "They're Still Feminine!," the point being to convince readers that "khaki, Air Force and Navy blue, or well-worn denim and slacks" had no lasting effect "on the softer side of Womanhood."

> Clothes don't make the man
> and uniforms and overalls
> don't seem to be unmaking
> the female of the species

was set out in bold print. And accompanying the article was a cartoon showing a CWAC, a Wren, and two women war workers congratulating a WD who blushingly holds out a diamond engagement ring for the others' admiration.[48]

Uncertain of the public's attitude toward the uniforms of the women's services, the Combined Services Committee had the public opinion questionnaire pointedly ask: "Do you think the uniforms of the Armed Forces make the average woman more or less attractive?" The results were equivocal: "Overall opinion was split." Once again, when the English and French-Canadian data were looked at separately, it turned out that a much higher proportion of the latter registered a negative attitude. Still, not even half of the English Canadians polled felt that a service uniform made the average woman more attractive.[49] Service-women themselves particularly disliked "certain items of apparel" that they regarded as "definitely unflattering to any woman's appearance."[50] One example was the "antiquated style of overshoes furnished members of the C.W.A.C." and known facetiously as " 'glamour boots.' "[51] CWAC women also resented the dress regulations that required the uniform to be worn even during off-duty hours when out on a date or on a forty-eight-

hour leave. Only on a furlough of seven days or longer (or when taking part in sports) could a CWAC appear in public in civilian clothes. Out dancing in uniform, CWACs felt on an unequal footing with civilian women. They felt particularly disadvantaged by the cotton lisle stockings on issue to all members of the women's services. They wanted to be allowed "to wear civies or at least silk stockings when out with men."[52]

A Combined Services recruitment advertisement developed in response to the opinion surveys of 1943 showed a mother before a framed photograph of her three uniformed daughters, one in the WRCNS, one in the CWAC, and one in the RCAF (WD), confidentially telling the public: "My Girls are the real Glamour Girls." With that heading plus the conventionally pretty faces of the three servicewomen, the ad was clearly trying to overcome the association of women in uniform with loss of glamour. But at the same time, in smaller print, the ad had the mother locating the glamour of her daughters not in their uniforms (or even their pretty faces) but in their service, the important job they were doing. Here the recruitment propaganda was sending out two messages: the first, loud and clear, that the glamorous women of wartime were the women in uniform and the second, more muted, that the real core of their glamour lay in their sacrifice of self to the cause. A year before a woman's magazine had taken practically the same line in promotion of the woman war worker. In September, 1942, *National Home Monthly* chose as its "Glamour Girl" for the year the first woman welder to be approved by the Canadian government for National Defence work and published a picture of her "in blue denim overalls and goggles, and wielding a welding torch." "We chose her," the editors explained, "for exactly the reasons that anyone would choose any glamour girl, for her beauty and for her importance."[53]

Military officers in public relations never lost sight of the promotional value of "sex appeal." To enhance the image of the woman in uniform, recruiting officers singled out the service-women with the beauty-queen or movie-star good looks of the day to advertise the women's services. One "glamour shot" of a CWAC private, complete with respirator and helmet, appeared in the *Montreal Standard* of August, 1943, along with a number of other photos of the same model in a piece promoting the Canadian Women's Army Corps. The same shot was used as the basis for a CWAC recruiting poster. Assuming that a function

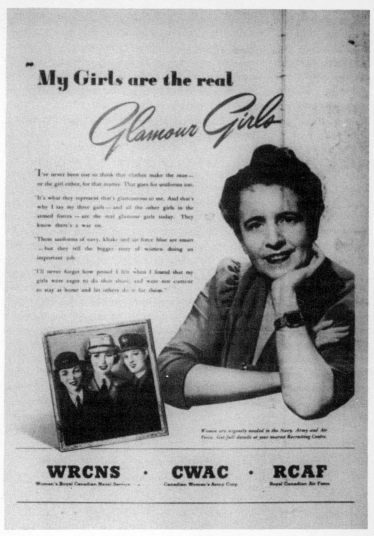

"*My Girls are the real Glamour Girls.*" Public Archives of Canada.

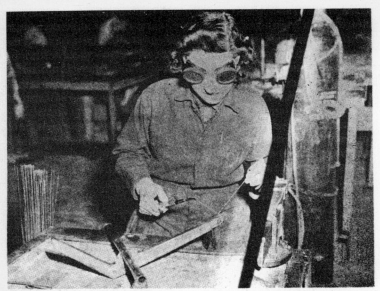

"Glamour Girl of 1942," from National Home Monthly, *September, 1942.* Manitoba Archives.

of good-looking women was to decorate, public relations officers also used "glamour shots" to publicize events in support of the war effort. For example, to draw attention to an exhibit of armaments in Ottawa in May, 1944, Army photographers took a series of shots of war equipment with which they posed a pretty CWAC corporal. The caption to one photograph in the series read:

> The huge spot-light on display with a collection of modern war material in Ottawa, has a valuable use in searching out enemy night raiders, but Cpl. Wilma Williamson, C.W.A.C. of Dundas, Ont., has found another use for it ... it provides an excellent reflection for straightening a crooked Service tie.[54]

A lot was conveyed by that photograph plus caption: the contrast between the serious operational function of the war equipment and the ornamental function of the CWAC; and the assumption of a narcissism on the part of the servicewoman so ingrained that she would even use a piece of war equipment as a mirror.[55]

World War II was the era of the "pin-up" – photos of female models and film stars or drawings of imaginary beauties, often

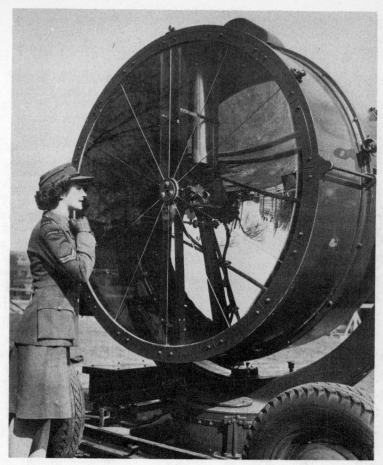

Corporal Wilma Williamson, CWAC, using searchlight as mirror, Ottawa, May, 1944. DND/Public Archives of Canada/PA-141005.

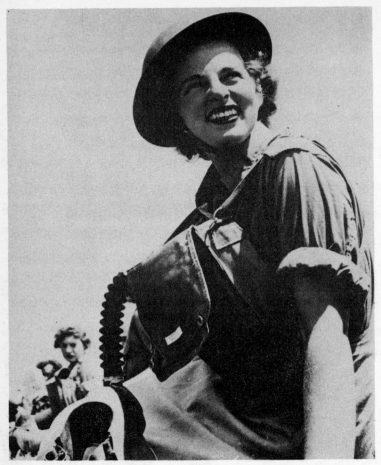

CWAC with respirator, August, 1943. Department of National Defence/
Public Archives of Canada/PA-141007.

scantily clad in bathing suits or less, which soldiers "pinned-up"
on the inside of their lockers. In this way Canadian servicemen
exercised the male prerogative to feed their sexual imaginations
with visual images of beautiful women. Canadian women, by
the same token, were conditioned to see themselves through the
eyes of their male beholders. The more beautiful, the more
feminine, was the equation. The *C.W.A.C. News Letter*, started

in January, 1944, specifically to keep the channels of communication open to CWAC personnel overseas, and generally to keep up Corps morale, encouraged members to participate in pin-up contests run by *KHAKI*, the Army bulletin and parent organ of the CWAC publication. In the September, 1944, issue, *C.W.A.C. News Letter* editor Corporal Caroline Gunnarson urged her readers: "So if you're the type of gal that sends men swoonin' NEL suggests that you get busy and send in your photo." And in the Spring, 1945, issue she proudly reported that Canadian forces overrunning German dug-outs had found on the wall of one a *KHAKI* pin-up of a CWAC.

In the face of the persistent association of femininity with frills, fabrics soft to the touch, cheerful colours, and curving lines, Army authorities made concessions. The 1944 CWAC recruiting pamphlet announced that "recently silk stockings have been issued for off-duty wear."[56] In fact, they were made of rayon; nonetheless, they and their "happy neutral shade" received a warm greeting in the February, 1944, issue of the *C.W.A.C. News Letter*. The April, 1944, issue hailed the order allowing members of the CWAC in future to wear civilian clothes on any pass over thirty-six hours as the "happiest new ruling" governing the Corps. This "weekend permission," the *News Letter* cheered, "will mean that twice a month girls will be able to cast aside the khaki for something more feminine."

Insofar as the four-square, drab and durable uniform resisted feminization, femininity could still find expression underneath the drill and serge. Already in the earliest draft of regulations and instructions for a women's army corps, it was arranged that the women who joined would not have to wear "issue" underclothing or lingerie. Instead each recruit would receive on enrolment (later enlistment) a dress allowance of $15 for "necessaries" and thereafter $3 every quarter for replacements and upkeep.[57] All subsequent revisions of the regulations for the Canadian Women's Army Corps preserved this arrangement for CWACs serving on this side of the Atlantic. Its intent may well have been to spare the Master-General of the Ordnance's branch the headache of providing underclothes for women in suitable styles and a sufficient range of sizes (as the task seems to have been experienced when NDHQ did take over the issuing of underclothes to CWACs stationed overseas). Its effect was to leave open what was perceived as a sphere of feminine self-expression. The 1943 CWAC recruiting film *Proudly She Marches* contains

Private Pearl Saunders, Canadian Women's Army Corps, Netherlands, February, 1945. Ken Bell/DND/PAC/PA-139939.

a sequence in which a female recruit trips on her way up the path to the basic training centre barracks, dropping her suitcase and spilling its frilly contents on the ground. The 1944 RCAF (WD) promotional film *Wings on Her Shoulder* contains an almost identical sequence, thus underscoring the clichéd statement that

femininity consists of a penchant for lacy, diaphanous under-garments (as well as of a certain degree of flightiness).

Not all CWAC other ranks, however, could afford to buy much in the way of finery out of the clothing allowance for necessaries. Its amount was not increased from 1941 to the disbanding of the Corps in 1946, even though CWAC officers testified to its insufficiency before the Army's Dress and Clothing Committee as early as July, 1943.[58] Whether they could afford to or not, servicewomen, according to the press, gave positive proof of their irrepressible femininity in the parade of multi-hued apparel to be seen any night in the living quarters of women in the forces. In the words of Lotta Dempsey:

> ... if you were privileged to sit around a barracks in the evening at a service women's training centre, you'd note a pretty exciting transformation as you look down the long rows of bare army cots, and see the dull drab of the uniform being replaced by the most exquisite array of rainbow-colored dressing gowns and housecoats and lounging robes you could imagine outside of a Hollywood color-picture set.[59]

Even though the intent of the military was not to alter concep-tions of femininity, the campaigns to promote women's uniformed service did have an effect on fashion. Hollywood, that powerful imagemaker, also helped to validate women's military service and the military look for women with such movies as *Here Come the Waves* (1945), starring Betty Hutton, and *Keep Your Powder Dry* (1945), in which heiress Lana Turner joined the U.S. Women's Army Corps. The fashionable "mannish" suit for civilian women, with its severe lines and padded shoulders, could be seen as partly in imitation of servicewomen's uniforms. The clothing regulations issued in 1942 by the Wartime Prices and Trade Board also had an impact. As Thelma LeCocq observed in *Maclean's*, all frills and furbelows, ruffles and ruchings were slashed. There were to be no more five-yard skirts or voluminous, bell sleeves.[60] With all excess yardage and detail shorn, fashions would be, as the *National Home Monthly* put it, "Streamlined for the Duration."[61]

It was also during the Second World War that the popular-ization of pants for women began. This was directly the result of women's recruitment into war industry as factory workers in armament, munitions, and aircraft assemblage plants. Although eventually the overalls and bandana or the slacks and turban

of the women war workers became symbols of service, in the early stages government officials were concerned that disapproving or ridiculing attitudes toward women wearing trousers would keep women from applying for essential jobs. The Department of Munitions and Supply for Canada considered it necessary to issue the message "PLEASE DON'T STARE AT MY PANTS" in March, 1942, and to illustrate it with the following picture: a middle-aged matron in hat, gloves, and furs has stopped to look disdainfully at a young woman in slacks, while a man in white collar and overcoat has a condescending smirk on his face. The fine print gives the supposed reply of the diffident object of all the attention: "Would you like to know why I wear trousers like the men when I go about the streets? Because I'm doing a man's job for my country's sake."[62] Just a year and a half later attitudes had changed enough that *National Home Monthly* could put on the cover of its September, 1943, issue a humorous drawing that reversed the roles depicted in the earlier poster. Now it is the female worker, swinging her lunch pail and striding along confidently in her slacks, who wheels around to take a second rather scornful look at a passing kilt-clad member of a Highland regiment.

The extension of slacks as wearing apparel for female military personnel, however, remained slow and restricted. Only in 1944 did the Navy's traditional bell bottoms begin to be issued for wear to members of the Women's Royal Canadian Naval Service, and then only to a select number of Wrens on coastal duty. To announce the new departure, a photograph was released to newspapers across Canada in June, 1944. When it appeared in the *Toronto Telegram* it carried the following caption:

No wonder this husky sailor seems slightly puzzled. He has just spied a WREN wearing, of all things, bell-bottomed trousers! The once strictly male attire has recently been approved as official working uniform for Wrens on duty as signallers and (the Signalwoman shown here) is one of four west-coast Wrens who is entitled to wear them. She is stationed at a west coast Naval base, where she sends and receives important Navy messages in code and cypher.[63]

Similarly, in the Army, the wearing of trousers by women had to be justified by working conditions or by the task to be performed, but even then could still meet up with opposition. For instance, trousers were authorized early on as part of the

Unidentified WRCNS signaller wearing bellbottom trousers, Vancouver, February, 1944. L.F. Sheraton/DND/PAC/PA-141002.

winter (but not summer) uniform for CWAC drivers of trucks and jeeps, but not of staff cars.[64] Then in the summer of 1944 the Master-General of the Ordnance authorized "Trousers ... for summer wear by C.W.A.C. drivers" but "of Trucks and Jeeps *only* ..." and went on to specify in no uncertain terms that CWAC drivers of staff cars would have to continue to wear skirts, both summer and winter.[65] In October, 1944, the chief commanding officer on the Pacific Coast wrote the Women's Dress and Clothing Committee of the Army recommending the CWAC drivers of staff cars also be allowed to wear trousers for the sensible reason that "drivers may be employed on trucks part-time and then immediately have to switch over to staff car duty." But the committee ruled "that there should be no difficulty in drivers changing from trousers to skirts when it becomes necessary for them to change from truck driving to staff car duty."[66] As at least half of the committee's members were CWAC officers, it was clearly not a male-versus-female decision. Also, as the same committee one month later agreed that thirty-four CWAC personnel employed in a gun operations room should be allowed to wear trousers, the committee members' opposition to staff car drivers' wearing pants had to do with something specific to driving staff cars. In contrast to plotter telephonists in a gun operations room, staff car drivers were visible to the public. But then, so were truck and jeep drivers. Driving a truck or jeep, however, was a lower-class job than driving a staff car. Thus the male and female officers at National Defence Headquarters in Ottawa, who were removed from the workaday reality of the commander in the field, might have regarded pants on the woman staff car driver as inappropriate because too closely associated with manual labour. Also, since slacks would not have been accepted at the time as proper attire for the female secretary of an important businessman, there might have been similar objection to trousers on the female chauffeur of a high-ranking officer, especially if that officer were male. Furthermore, given the public's apprehension that military life was unsuitable for women, officers, particularly female officers, were concerned with building up a genteel image for the women's services. The serious attention given to these regulations governing when servicewomen could or could not wear trousers provides one example of the wartime politics of dress, indicating the symbolic power that could be invested in attire as a regulator of gender and class relations.

Left: *Unidentified member of the Canadian Women's Army Corps pumping up tire of staff car, Ottawa, September, 1944.* DND/PAC/PA-141006. Right: *"I'm a woman in a man's world..."* From *Maclean's,* November 15, 1942.

In the area of makeup, the Army was prepared to make accommodation to current criteria of feminine attractiveness, as defined and limited by officers' conceptions of gentility. The 1920's had seen the introduction of artificial cosmetics as commodities to be purchased on the market. Adoption by women of the middle and upper classes had established their use as fashionable if applied with restraint. Excessive use was associated with less respectable women, especially prostitutes. By the Second World War most urban women were reliant on cosmetics for their feminine self-image. *National Home Monthly*'s "Glamour Girl of 1942" was reported as saying that "you have to work ten hours with a welding torch in a defence factory to really appreciate what soap, cream, rouge, powder and lipstick can really do to a woman's morale."[67] Beauty soap and cosmetic

manufacturers played on the fear of loss of femininity by suggesting that the female factory worker would remain "womanly" only if she made sure to use their product. An advertisement for Palmolive soap, for instance, had a woman war worker proclaiming "I'm a woman in a man's world – But I'm still a woman!" – because she gave herself Palmolive beauty baths and facials.[68]

From first draft to last, the regulations for the Canadian Women's Army Corps permitted women in uniform to wear makeup, as long as it was applied lightly and in moderation. A 1944 CWAC recruiting pamphlet answered the anticipated question "May I Use Cosmetics?" by stating: "Of course the Army wants you to be attractive and feminine, so go ahead and use your lipstick, powder and rouge, but use good taste and make it inconspicuous."[69] Similar restraint was to govern the use of nail varnish: clear or lightly tinted shades were all right but "highly coloured" polish was not.[70]

The wearing of jewelry also came under tight restrictions. For the CWAC in uniform, watch chains, bracelets, earrings, and "trinkets" were expressly forbidden, as were any other than wedding, signet, and engagement rings.[71] Later an exception was also made for identification bracelets. The only other jewelry permitted was the wrist watch. As the 1944 CWAC recruiting booklet explained: "Your shining buttons make enough glitter."[72] These regulations catered to a number of different concerns. The restrictions on jewelry, practically identical to those for men, accommodated the Army's general requirement for uniformity. The pamphlet's warning about "glitter" hints at the preoccupation with gentility. A certain ambivalence is apparent in the regulations on makeup and nail polish. While finding it prudent to allow servicewomen the means to strive to meet the current standards of female beauty, military authorities felt constrained to regulate against possible "vulgarity." On the other hand, the personal decision of the first Officer Administering the CWAC, Lieutenant-Colonel Joan B. Kennedy, to wear no makeup or jewelry was regarded as unnecessarily severe.[73] Concern lest the servicewoman acquire the image of a "painted lady" was counterbalanced by concern lest she appear manly.

Both concerns lay behind the public-spirited decision of the National Council of the YWCA to offer "beauty culture" classes at their Women's Active Service Club in Ottawa. "Seated at long tables before individual mirrors," the servicewomen were "taught

the importance of good skin grooming."[74] " 'Rouge should be natural looking' " was one piece of advice handed out by the "well-known beauty consultant" who acted as "volunteer instructress" of the classes.[75] Open to women of all three services, the classes were photographed by the Army to use as further proof that genteel feminine beauty and membership in the CWAC were not incompatible.[76]

Members of CWAC at tri-service beauty culture classes at Active Service Canteen (National Council YWCA), Ottawa, December, 1943. C.J.Woods/DND/PAC/PA-139919.

All three women's services enforced regulations governing the length at which women in uniform could wear their hair: it had to be off the collar. It was anticipated that this requirement might act as a deterrent to those women whose feminine self-image depended on long tresses and elaborate hair-dos.[77] *Wings on Her Shoulder*, the 1944 recruitment film for the Women's Division of the RCAF, warned that hair had to be worn off the collar of the tunic and therefore recruits would have to sacrifice their "curls and glamour bobs." The film went on to assure the viewer

that styles could still be beautiful and meet regulations. The RCAF (WD) and the Women's Royal Canadian Naval Service took the lead in providing their own hairdressers, while the Canadian Women's Army Corps initially only promised prospective recruits that "pay and allowances" would be "adequate to cover hair-dos even at the better beauty parlours."[78] By 1944, however, the Army was offering training in hairdressing and manicuring to a limited number of CWACs and the beauty salon in the CWAC Basic Training Centre at Kitchener, Ontario, was doing a brisk business.[79] The Army could also show that with or without beauty salons the conviviality of barracks life included CWACs helping one another with hair sets.[80]

In April, 1944, Army Public Relations did a photo series of two CWAC corporals shopping for new spring outfits. The purpose of the series was to demonstrate once again that female personnel retained their femininity even after months of military service. The proof provided this time was that donning the uniform of

Corporal Wilma Williamson, CWAC, trying on shoes. The salesman is Allan Baldwin. Ottawa, April, 1944. B.J. Gloster/DND/PAC/PA-141004.

Corporal Thelma Palmer, CWAC, trying on hats, Ottawa, April, 1944.
B.J. Gloster/DND/PAC/PA-141003.

the CWAC in no way diminished a woman's passion for clothes.
Nor did it weaken her love of the purely decorative, as represented
by choosing a new spring hat. "Off to a head start, Cpl. Thelma
Palmer had only one complaint: 'So many hats and only one
head.' The sympathetic salesgirl spent half an hour offering models
and making suggestions." The series also got a lot of mileage
out of the clichéd identification of frequent changes of mind as
typical feminine behaviour. "A woman's prerogative remains –
even after months of Army life" read the caption to a photo
duplicating countless cartoons of the era: Cpl. Wilma Williamson
sits surrounded by a pile of shoes, unable to make up her mind,
while the salesman, with a look of mild exasperation on his face,
rests his head on his hand.[81]
 The "attractiveness" so central to the prevailing notion of
femininity ultimately meant attractiveness to men. Heterosexu-
ality was certainly one of the norms of femininity subscribed
to in official publicity about the women's services. While

advertisements acclaimed the good wholesome fun women could have together in the services, as in a shot of a Canadian Women's Army Corps Christmas party at Kildare Barracks in Ottawa in 1943,[82] celebrations of female camaraderie stopped far short of any suggestion of lesbianism. Under military law, after all, homosexuality could be construed as grounds for discharge.[83]

The survey of CWAC other rank opinion had revealed that, after patriotism and the urge to travel, the third strongest motive for joining the service had been the desire "to be near family, friends in the forces." While 68 per cent had been influenced by having women friends in the forces, a larger proportion (77 per cent) had followed men friends into the military.[84] Recruitment propaganda, capitalizing on this information, came up with the poster: "Are you the girl he left behind?" In Army photo stories on life in the CWAC, public relations made a point of including material on dances and dates and boyfriends. The first photo in a series on Kildare Barracks showed three CWAC sergeants "with plans for a big evening ahead" approaching the company sergeant-major in the orderly room "on the subject of late passes." The caption to a later photo in the same series read: "There is no place for 'shop talk' in C.W.A.C. barracks after duty hours. Girls go typically feminine." Depicted as "typically feminine" was the one CWAC sergeant writing to a boyfriend in the RCAF while the two other CWAC sergeants looked "admiringly" (if not enviously) at his framed photograph. In the series' last photo the letter-writing sergeant had paused, pen in hand, to gaze dreamily at the photograph, which shows an Air Force officer clenching a pipe between his teeth and looking, even with the trim mustache, a lot like Henry Fonda.[85]

The message of one Army photo in a series on CWACs in Washington, D.C., was that members of the Canadian Women's Army Corps stationed outside Canada could find dates in the armed forces of Canada's allies. It showed two CWAC privates stepping out with a soldier and a sailor of the United States forces.[86] Attached to a similar photo in a later series on the same subject was the caption: "Carrying out the 'Good Neighbour Policy' to a 'T', Private (X) of the U.S. Engineers shows Private (Y), C.W.A.C. of Toronto, Ontario, a few of the scenic highlights of Washington, D.C."[87]

Servicewomen were also shown as not having lost the ability to be pleasing to men. "The Quickest Way to a Man's Heart – Even a Sergeant's Heart" appeared below a photograph

Women of the CWAC in barracks, Ottawa, July, 1943. S. Smith & C. Woods/DND/PAC/PA-139923.

publicizing the parties held in honour of the fourth anniversary of the Canadian Women's Army Corps (August 14, 1945). The sergeant is identified as a guest at the CWAC's birthday party at Kildare Barracks; the CWAC corporal, as the one who "is seeing that the guest is satisfied."[88]

Indeed, the concern whether life in the armed forces made a woman more or less attractive boiled down to a concern whether enlistment made a woman more or less marriageable. The public opinion questionnaire contained the question: "Do you think the wearing of a uniform interferes with a girl's chances of marriage?" While 58 per cent of those polled answered "no" (68 per cent in English Canada, but only 43 per cent in French Canada), a remaining 42 per cent either thought the wearing of a uniform did restrict "a girl's chances of marriage" (22 per cent) or were not sure (20 per cent didn't know).[89] Thus, dispelling the fear that enlistment would scare away dates was not enough. Recruitment literature had to give the further

assurance that membership in the women's services would not reduce one's marriageability.

The 1944 CWAC recruitment pamphlet assured the prospective volunteer that "yes" she could get married while she was in the service, provided she had her commanding officer's permission.[90] The Army's Department of Public Relations encouraged news coverage of marriages between servicemen and servicewomen. The *Globe and Mail* of December 2, 1942, reported "the first marriage of a member of the C.W.A.C. to a member of the Army" (it had taken place the day before in Halifax between a CWAC private and a corporal of the Provost Corps of a Highland regiment) and thereafter announcements of such military weddings became a regular feature of the women's activities columns of Canadian newspapers.[91] Official Army, Navy, and Air Force photographers took pictures of such weddings for release to the press.[92] In the *C.W.A.C. News Letter* announcements of "military alliances," as weddings of armed forces personnel were sometimes called, took precedence over announcements of military promotions. Early issues carried only a few mentions but by the end of 1944 whole pages were devoted to marriage news. "The Bride wore Khaki," a full-page item in the November, 1944, issue, told the romantic story of a Canadian Army sergeant and a CWAC corporal exchanging vows in a bombed-out church in Italy.

One of the least examined and most unshakable notions of the time about women was that subordination and subservience to men were inherently female characteristics that dictated women's role and place in society. As pointed out in the preceding chapter, this assumption converged with the real position of CWACs in relation to Army men, for in jobs, pay and benefits, and place in the command structure of the Army, the servicewomen were in general subordinate. As reflected in mottoes and enlistment slogans, the very function of the women's services was to subserve the primary purpose of the armed forces: the provision of an armed and fighting force. Having been excluded/exempted from combat, the women of the Canadian armed forces could adopt as their motto: "We Serve That Men May Fight."[93] That general motto had been adapted from the airwomen's "We Serve that Men May Fly." Even more expressive of the secondary status and supportive role assigned to Army women was a slogan used on enlistment ads: "The C.W.A.C. Girls – The Girls behind the Boys behind the Guns."[94]

In preserving the male monopoly on armed service, the

*Lieutenant-Colonel Alice Sorby and Lieutenant-Colonel Isobel Cronyn
unpack a wedding dress sent by an anonymous donor for the use of
members of the Canadian Women's Army Corps overseas. London,
England, February, 1945.* Karen M. Hermiston/DND/PAC/PA-139938.

Department of National Defence was acting in harmony with
social convention and conviction. The only evidence of women
strongly desiring admission to jobs classified as operational came
from the handful of women in Canada with pilots' licences who
were eager to put their flying skill at the service of their country,
and who were to be denied that opportunity. A few joined the
British civilian Air Transport Auxiliary, formed to ferry aircraft

from "anywhere to anywhere" and open after 1940 to women pilots.[95] The prevailing view was that men were by nature suited to dangerous, life-risking jobs while women were naturally adapted to monotony and behind-the-scenes support work. This view was reflected in the remarks of one Air Force officer on the suitability of airwomen for the trade of parachute rigger.

Take parachute packing. To a man it's a dull, routine job. He doesn't want to pack parachutes. He wants to be up there with one strapped to his back. But to a woman it's an exciting job. She can imagine that someday a flier's life will be saved because she packed that parachute well. Maybe it will be her own husband's life or her boy-friend's. That makes parachute packing pretty exciting for her and she does a much more efficient and speedy job than an unhappy airman would.[96]

Deeply entrenched as the assumption was that the female was the second sex, there still surfaced from time to time the fear that women who were serving with the Army would lose their deference toward men and become "bossy." Mainly, it was the prospect of female officers that seems to have aroused this fear. When Jean Knox, Director of the British Army's Auxiliary Territorial Service, toured Canada in the fall of 1942, newspaper coverage showed a preoccupation with the fact that she, the first female Major-General in the British Army, outranked her husband. As if looking for qualities to counter-balance her high military rank, news stories invariably described Knox as the "petite and pretty general" or "petite and completely feminine." Speaking of the women of the British Auxiliary Territorial Service and the Canadian Women's Army Corps, she herself remarked: "They're not an Army of Amazons doing men's work – they're still women...." In her view, "All women should share with men the experience of this war – but I would be violently displeased if in so doing, women lost their femininity."[97]

Similarly, when Lionel Shapiro covered Major Alice Sorby's arrival in London, England, to command the CWACs overseas, he approved of the fact that she was "pretty" and had "graciously submitted" to the press conference. But at the perception that she was also "a woman full of the barbed-wire quality of a colonel in the Indian service," Shapiro confessed, "my man's world was beginning to totter before my eyes." But a question of his that "penetrated her military facade and revealed her in all her feminine vulnerability" saved the day for Shapiro. " 'Major

Sorby,' " he asked, " 'your husband is a lieutenant and you are a major. I assume he will have to salute you when you meet. Is that not so?' " After a moment's thought, Major Sorby replied that, yes, she supposed that would be regulations, but as she had not seen her husband for more than a year, she doubted whether they'd " 'bother about salutes.' " Missing the irony of Major Sorby's retort, Shapiro was jubilant. "Moment triumphant!" he exclaimed. "My man's world returned in full flower. Major Sorby was really only Mrs. Sorby with a King's crown on her epaulettes, and Mr. Sorby, though a mere lieutenant, was still master of the Sorby household."[98]

Female other ranks also expressed uneasiness at having women in command over them. The CWAC other ranks surveyed in 1943 registered a lot of complaints against their CWAC commanding officers. The survey revealed that in general female other ranks "disliked taking orders from women" and that "some felt men administrative officers would be better."[99] However large that "some" was (unfortunately not measured by the survey), the existence of such a feeling among female other ranks in a women's corps speaks for the pervasiveness of the association of male with authority and command. One suspects that the charge of "playing soldier"[100] leveled against some female officers was a criticism that such women were putting on "masculine airs" of commanding authority. The apprehension that women serving in the forces would lose their femininity included the fear that the male-over-female hierarchy of authority might be upset.

Just as importantly, the public had to be assured that the work women in the forces were asked to perform was suitable to women. With an ambivalence typical of the promotion of the women's services, speeches or publications in one sentence applauded women's breakthrough into positions theretofore dominated by men and in the next denied that servicewomen were being asked to do anything inimical to their feminine nature. The *CWAC Digest: Facts about the C.W.A.C.*, a 1943 recruiting booklet, is a case in point. The middle pages were given over to photographs with captions of women performing tasks conventionally identified as male: one showed a CWAC fitter working on a lathe; another a class of CWACs at a motor mechanics' school. But the inside cover contained "A Tribute to the Canadian Women's Army Corps" from the Governor General of Canada, stating: "In a modern army women are a

necessity, not in order to replace men in men's jobs, but to take over from men jobs which," while previously done by men, were really women's work and hence more suitably performed by women anyway. "If a woman can drive the family car, she can drive a staff car" is another example of the recruitment line that sought to reassure the public that military jobs for female personnel, although performed in new settings and under different conditions, remained essentially "women's work."[101] Thus the contradiction between the armed services' need for women in uniform and the ideology of woman's place being in the home (or in a paid job long sex-typed as female) was reconciled through the redefinition of certain military jobs as womanly.[102]

In actual fact, as we have seen, the overwhelming majority of uniformed women employed by the Army were assigned to jobs that had already become female niches in the civilian labour market or could be regarded as extensions of mothering or housework.[103] In propaganda and practice, a "woman's place" was created within the wartime armed services. Nonetheless, the very association of women with the military touched off fear of an impending breakdown of the sexual division of labour, akin to that triggered by the entrance of women on a massive scale into waged work. Under the anxiety over the changed appearance of women lay a more profound but less often articulated fear that women were invading male territory and becoming too independent. Humour of various sorts provided an outlet for these fears. In a 1942 article on "Woman Power" in *Maclean's*, for instance, Thelma LeCocq jokingly proposed a number of possibilities "that make strong men break out in a lather." What if, at war's end, she speculated, the thousands of war working women

> refuse to be stripped of the pants and deprived of the pay envelopes? What if they start looking round for some nice little chap who can cook and who'll meet them lovingly at the door with their slippers in hand? What if industry has to reorganize to give these women sabbatical years for having babies?[104]

These fears survived till the end of the war. In September, 1945, despite the fact that approximately 80,000 women war workers had already been laid off by then, *Maclean's* ran a cartoon by Vic Herman that derived its humour from the preposterous yet feared possibility of a reversal of the sexual division of labour

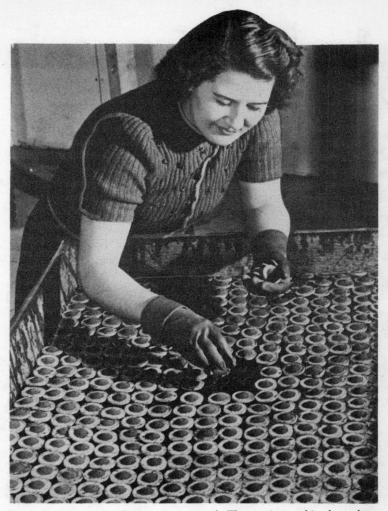

The "domestication" of women's war work. The caption to this photo that appeared in the Toronto Telegram *read: "The young lady . . . appears to be preparing a batch of cookies, but actually she is laying out igniter caps for smoke cartridges . . . for the armed forces." Such manipulation of the separate spheres ideology helped to bridge the contradiction between belief in women's natural domesticity and Canada's wartime need for female munitions workers.* York University Archives, Toronto *Telegram* Photograph Collection.

between male breadwinner and dependent female domestic. A husband wearing an apron and standing with a mop in his hand and a bucket at his feet frowns in annoyance at his overalls- and bandana-clad wife who, home from the factory, has headed straight for the refrigerator, tracking muddy footprints across his nice, clean floor.[105]

After studying the results of the CWAC survey, the Director of Army Recruiting requested discontinuance of the recruitment pitch "You Can Free a Man to Fight." While the strongest reason CWACs had given for enlisting was "patriotism, help win the war," a significant proportion, as already noted, had cited the desire to be near family and friends, a category including fathers and brothers as well as sweethearts. To emphasize releasing men for combat, the Director of Army Recruiting argued, was thus in conflict with the real interest of the women to keep their loved ones alive, as well as contrary to his conception of the eternally feminine – woman's nurturant and preservative nature:

> In reality, women have joined up to be near, help and protect their boy friends and brothers overseas. It is woman's natural tendency to protect her loved ones from danger, not force them into the line of battle.

He inferred from the report also that too many members of the CWAC were not convinced their jobs were essential. He therefore recommended a new line of appeal that would both stress the vital importance of women's work in the forces and identify it as an essential part of the "intricate web of supporting services and pre-battle planning" whose purpose was "to protect their boy friends and brothers from unnecessary battle dangers."[106]

The *CWAC Digest* of 1943 apparently went to press before the analyses of the CWAC survey took effect, for it still stressed the non-combatant servicewoman's part in releasing servicemen for combat. "Would you deprive a fighting man of his opportunity to fight?" it asked. "Do you want some fighting man to do *your* job? ... Don't let a man take your place if you can help it." Other new recruitment material, however, reflected the spirit of the suggestions from the Director of Army Recruiting. In one Combined Services leaflet of 1943, for instance, emphasis was taken off the need for women to release men for combat and put on the vital importance of women's work in the service *per se*: joining the forces was sold as "The Most Important Job Ever Offered Women."[107] And some enlistment ads designed for

Vic Herman cartoon. From *Maclean's*, September 15, 1945.

sponsorship by patriotic businesses took up the theme of women's respect for life. Under the heading "YOUR TALENT may save a life," one asked the prospective volunteer to reflect on "what it would mean to you in long years ahead, if you carried in your heart the knowledge that some talent of yours – great or small – had saved a life in a battlefront – perhaps even dozens of lives." Another interpreted the slogan "This is a Woman's War, too" to mean enlistment was a way of hastening the return of loved ones. "THIS IS *OUR* WAR, TOO," said the pretty CWAC in the drawing, "– our homes are upset, sons, brothers, husbands away defending *us*. Help bring them home sooner!"[108]

Here the military was no longer seeking only to mollify a public fearful that women in uniforms would lose their femininity. The military had turned inward and was re-examining its own policies for fear they were not attending sufficiently to important components of the feminine nature of women. This was occasioned by the knowledge of a deterrent to women's recruitment more serious than the fear that servicewomen would cease to be women: the fear/suspicion that they would become "loose" women. The preoccupation with preserving women's sexual respectability, like the preoccupation with preserving women's femininity, was triggered by war's destabilization of gender relations and both reflected and reinforced prevailing definitions of womanhood.

5

Ladies or "Loose" Women

One former servicewoman has recalled the climate of opinion in Canada with respect to the women's services when she and a friend volunteered in the winter of 1943:

> We both came from over-protective, middle class homes. It was a major step for us, fraught with emotion. There was great consternation in our families when we revealed what we had done.
>
> ... During the Second World War, there was a steady undercurrent of publicity directed toward young women, discouraging them from enlisting in the Armed Forces. It took the form of a whispering campaign – really nice girls would not do such a thing etc. It was picked up by the newspapers, not to mention fathers, mothers and brothers. As a result, the majority missed the opportunity to be involved equally in the most significant event for women, of the generation.[1]

Wartime's widening of women's sphere aroused, as we have seen, the fear that sexual divisions might break down completely. This uneasiness at the prospect of women's abandonment of domesticity was nowhere more acutely felt than in response to women's entrance into the military.

In actual fact the armed forces were "breaking down" the tradition that women's place was in the home only to a limited extent. They were not, for instance, taking mothers of young children away from their families. Married women were eligible to join the Canadian Women's Army Corps (and according to the CWAC survey of 1943, 7 per cent of the privates were married and 11 per cent of the NCOs),[2] but mothers of dependent children were not.[3] The armed services were, however, taking unmarried daughters out of the family circle. This was resisted in part

because the daughters' services were needed to "maintain home life." But more serious resistance was rooted in the concern that out of the family circle daughters would be away from parental surveillance.

The assumption that daughters needed more surveillance than sons was shared by Army authorities. Regulations defined dependency in children differently for male and female: sons ceased being regarded as dependent after age sixteen, daughters not till after age seventeen. The same assumption underlay Army policies affecting the dispatch of CWACs overseas: the age limit for CWACs was twenty-one,[4] for men in the Canadian Army (Active), eighteen. In the spring and summer of 1945 Army headquarters established a policy of limiting the tour of overseas duty for CWAC personnel to two years because the Minister (Colonel Ralston) and the Adjutant-General (Major-General A.E. Walford) felt strongly that "it is inadvisable to have women serve too long away from [their] homeland."[5] These policies sprang in large measure from society's stance toward female sexuality: regarded in one light, it needed protection, in another, regulation.[6] There was, as we have seen, widespread fear that women's joining the forces would result in their loss of femininity, and the very heart of respectable femininity was chastity. It is not surprising, therefore, that there was even greater fear that servicewomen, removed from parental control and thrown together with men on military bases, would lose their sexual respectability. A more sinister version of that fear was the suspicion that, free of parental regulation, young women would become licentious. The apprehension unleashed by women's incursion into the formerly male domain of the military assumed the proportions of a "moral panic": the protective fear concerning female sexual vulnerability metamorphosed into the accusation that servicewomen were sexually loose.

This "whispering campaign" was already in evidence by the summer of 1942 and by early 1943 was causing alarm among military authorities.[7] Those in charge of women's recruitment were gravely concerned that the ugly rumours were having an adverse effect on enlistment and morale. The April 29, 1943, progress report of the Combined Services Committee observed that "The need for recruits will not be met unless we beat down the negative factors at present retarding recruiting, the malicious rumours and gossip"[8] The Wartime Information Board made a study of the "whispering campaign" and in its confidential

report of March 19, 1943, gave examples of the slanderous stories in circulation. One was that the first recruits "were girls from the Red Light districts" and another was that "over 18% of the women have become pregnant since joining." Still another was that all members of the CWAC "had syphilis."[9]

Both the 1943 survey of public opinion and that of CWAC opinion were designed in part to gauge the extent of the damage. And on March 31, 1943, the Director of Personnel, RCAF, directed the chaplains under his command on air stations throughout Canada to conduct an informal survey of the attitude of airmen and the civilian population in the vicinity toward the employment of women in the Air Force.[10] The results of these studies were not comforting: suspicion existed in the public mind that a young woman joining the forces was embarking on a life of promiscuity. According to the Elliott-Haynes public opinion survey, a significant proportion of the parents and young men who disapproved of women joining the forces gave as their reason that "it was an unladylike occupation" in which a young woman "would lose" her "self-respect." In the language of the survey, both "unladylike" and "lose self-respect" were code words for female sexual licence, revealing the identification of ladylike behaviour (gentility) with female sexual decorum.[11] The CWAC report stated with less circumlocution that "the general public felt that young women avoided enrolling in the women's services because of the fear of association with women of poor moral standards" and it was clearly implied that the morality in question was sexual morality.[12] The summary of the surveys by RCAF chaplains reported that among civilians: "Most have the idea that a girl's morals grow lax from the very fact that she is living a life which, according to them, is for men only." Such a high proportion of French-Canadian parents and young men objected to women's enlistment on moral grounds that, the Elliott-Haynes tabulators concluded, "their opinion unduly influenced the national totals." Still, the highest proportion of English-Canadian parents and young men objecting also gave "unladylike, lose self-respect" as their grounds for disapproval.[13] From its analysis of the "Type of Advice C.W.A.C. Women Obtained From Their Relatives and Friends," the CWAC report concluded that "members of the men's forces and boy friends were the most antagonistic towards the women's forces" and linked that antagonism to the belief "that women in uniform are immoral."[14] In general, then, one could conclude from the reports that whether

in the case of the part of the country with the highest opposition to women's joining the forces – French Canada – or in the case of the category of the population with the highest opposition – young men, particularly servicemen – the opposition was related to the bad reputation tainting the servicewomen.

There was a limited basis in fact for what recruiting officers wanted to dismiss as "baseless gossip."[15] There were cases of VD and "illegitimate" pregnancy among servicewomen. As early as December, 1941, medical officers of all three services were meeting to discuss "the methods of handling and disposition of cases of venereal disease discovered in female personnel enrolled in the three services."[16] In the spring of 1942 pregnancy in unmarried servicewomen joined venereal infection as a serious problem of medical treatment, welfare, and "wastage" of female armed forces personnel.[17] The incidence of VD was calculated as 25.8 per thousand members of the CWAC for the first half of 1943. A comparable statistic calculated for the Army as a whole (including the CWAC) was 32 per thousand in the same year. There were no comparable civilian statistics. The incidence of pregnancy among unmarried members of the CWAC for the period December, 1943-December, 1944, was 32.01 per thousand strength in Canada, 14.27 overseas. The civilian rate for a similar age group (18-28) was approximately 10.4 per thousand in 1941.[18] These statistics measured a problem requiring administrative and medical handling. But in the atmosphere of exaggerated opprobrium dogging the women's services, it was difficult to dissociate the medical and administrative from the moral and ideological.* Indeed, in the late spring and summer of 1943, while the office of the Director-General of Medical Services was compiling data on the relatively high incidence of "pregnancy among unmarried personnel of the C.W.A.C." and of VD within the Corps, the Directorate of Army Recruiting and the Combined Services Committee began seeing as one of their most important tasks the need to spike the rumours giving servicewomen a bad name.

Although the incidence of VD among male soldiers was higher than that among members of the CWAC, and although in one study servicemen made up 86.3 per cent of the putative fathers

* The next chapter will analyse ways in which the ideological affected the administrative, medical, and educative handling of VD in the CWAC.

named by CWACs discharged for "illegitimate" pregnancy,[19] the male Army, by virtue of the double standard of sexual morality, was not made the object of a vicious "whispering campaign." It was expected of men in the forces to have a fling: any consequent "illegitimate" pregnancies were unfortunate, but the woman's responsibility; any consequent VD infection was socially undesirable and, when the rate got high, cause for alarm and a massive campaign to control its spread. But men did not risk acquiring a bad reputation by joining the forces (or by engaging in such behaviour!). Indeed, society was probably more tolerant of the promiscuity of young male recruits isolated from "normal" community life than it was toward that of their non-military counterparts.

Quite the opposite was true in the case of the servicewomen. Their being away from parental regulation aroused, as we have seen, the fear of their fall into promiscuity. Furthermore, any "deviant" behaviour on their part was highlighted by the public nature of life in the services. In any case, the "whispering campaign," with its character of "moral panic," was not grounded in fact. Only a tiny percentage of servicewomen became pregnant out of wedlock or contracted VD. Yet the rumour-mongers, exaggerating their charges of immorality out of all proportion to the actual facts, sought to tar the entire CWAC and Women's Division of the RCAF with the same brush. The WRCNS was spared most of the calumny, largely because it had been able to create the impression of being very selective and thus of having as members only "the better type of girl."[20] One ex-servicewoman has described the powerful attraction the Wrens' image of lady-like gentility could exercise on a young woman:

> I was standing on the corner and I saw these two Wrens cross the street towards me. They looked so tidy that I followed them up the street. I noticed that the heels shone as much as the toes and there wasn't any fleck on their uniforms. They spoke so quietly. They were perfect ladies so I decided that there had to be something. So I followed them up to the corner and went down to the recruiting office.[21]

The Wartime Information Board, in its March, 1943, report on the "whispering campaign," concluded that "the frequency, persistency and wide distribution" of the rumours suggested "a strongly entrenched prejudice against the Women's Services." It explained the imputation of "immorality" historically, pointing

out that sexual respectability had been for centuries "woman's vulnerable point, the traditional focus of attack by those who resent any extension of her prerogatives."[22] Wearing a uniform, marching, standing at attention, and saluting were, traditionally, masculine behaviour. The woman who behaved so appeared unconventional, "unwomanly," and it was thus easy to assume that she would have broken with moral convention as well. The possibility of such a suspicion explains in part the connection in tradition-bound French-Canadian opinion between opposition to women joining the forces and the belief that women in uniform were immoral. It also explains in part why servicemen expressed their opposition in the form of jokes about the moral character of servicewomen. Generally speaking, "there has always been criticism of anything new and radically different," observed one civilian member of the Combined Services Committee who believed the "rumour-mongers" belonged to just such "a witch-hunting category."[23]

The study by the Wartime Information Board anticipated the finding of the Elliott-Haynes and CWAC surveys that servicemen headed the list of "ill-will groups." According to the Directorate of Army Recruiting: "Men friends dislike endorsing a career for a woman in uniform mainly because they feel it is another male job on which women have encroached."[24] The RCAF Command Chaplain observed that:

> Where the airmen resent airwomen it is because women in uniform share, with men, the "protective role" which properly belongs to men.... and when women perform ground crew duties better than the men (which they do in certain occupations) the situation becomes intolerable for the men. They become jealous of these women.

Resentment at women "pushing themselves into a strictly male preserve" was one explanation for the servicemen's opposition.[25] Another was discovered in the bitter denunciations of the women's forces that some servicemen overseas wrote in their letters home: these men wanted their women to hold the fort while they were away and to be at home and unsullied when they returned.[26] The surveys by RCAF chaplains captured the dichotomous response of many airmen to having women in the Air Force. While many were willing to admit that the airwomen were doing a good job in the kitchens and at the typewriters, few were prepared to encourage their own sisters, girlfriends, or wives to join the

service. Servicemen's lewd jibes at servicewomen also had an aspect of dodging guilt by blaming and slandering the victim, since in the overwhelming majority of cases servicemen were named as the putative fathers of the "illegitimate" children with whom unmarried servicewomen were pregnant and the sexual partners of the servicewomen who became infected with VD. Indeed, the chaplains' surveys uncovered a quite cynical attitude on the part of some airmen who regarded the Women's Division "as an 'auxiliary' meaning that they are handy aids for immorality." At the same time, the Wartime Information Board report pointed out that:

> Paradoxically, some of these stories are probably the result of the service women's high standard of conduct. It is unfortunately true that the ignorant soldier who has tried to "make" a CWAC and been repulsed may take his revenge by blackening the character of the whole corps.[27]

Another ill-will group identified by both the Wartime Information Board and the RCAF chaplains was civilian women, particularly the wives of servicemen who were jealous of the beauty of servicewomen as portrayed in "glamour shots" and resentful of their proximity to the men in uniform. It was the opinion of one officer reporting to the Adjutant-General that "the Women's Services provide, perhaps, the most difficult publicity problem of the whole Canadian war effort."[28]

It is clear from their counteraction that the top brass at National Defence Headquarters were convinced that male other ranks (and also lower-ranking officers and NCOs) were guilty of spreading ugly rumours about servicewomen. Assurance was given at a meeting of the Combined Services Committee on June 9, 1943, that "a directive was going forward from Ottawa to Commanding Officers at all Stations advising them to inform ... their Officers and Men that any word or action on their part that might be found to reflect upon the character of girls in uniform will be punishable."[29] An Adjutant-General's circular letter of May 31, 1943, warned that officers and other ranks who "discouraged prospective recruits to the Women's Services of the Armed Forces by circulating stories which have no foundation in fact" were guilty of "directly violating Regulation 39 of the Defence of Canada Regulations." It further directed District Officers Commanding to "take immediate steps to curb this tendency and to take drastic action against such offenders under their Command."[30]

There is evidence that these counteractions of the high command did not succeed in putting a stop to the rumours. A year later, the Adjutant-General issued another circular letter that spoke of the continuation of "insinuating rumours against members of the C.W.A.C.," and of the necessity to make "every effort ... to counteract this malicious slander." Officers Commanding were instructed "to investigate any derogatory reports and to stamp these out at the source, rather than that they should be allowed to spread and become distorted and exaggerated." It ended with the order that "an all out effort be made to stamp out these false rumours."[31]

The rumours were a matter of grave concern to high-ranking Army officers because of their adverse effect on women's recruitment and on morale within the Corps. Because the CWAC survey had revealed that a large percentage of the CWACs had been informed and positively influenced about the Corps by women already in the forces,[32] the Director of Army Recruiting concluded that this, "the only goodwill group," should be more fully exploited.[33] One means hit upon was for CWAC women to write letters to their civilian girlfriends. Set in motion in the summer of 1944, this so-called "in-service recruiting drive" was not terribly successful.[34] Indeed, at times it actually backfired. In August, 1944, the District Recruiting Officer of Military District No. 13 (Calgary) forwarded to the Directorate of Army Recruiting in Ottawa a venomous reply to such an "in-service recruiting letter." As if in response to a deep insult, the correspondent had angrily written:

> I resent your bringing into the subject of me joining up, my brothers. Have you ever heard a serviceman speak well of the W.D.'s, Army, Air Force, or Navy? Nine out of every ten resent having girls in uniform and my brothers, Sterling included, said they would disown me if I ever join with such scruff.[35]

A CWAC officer at the Directorate of Army Recruiting (Lt.-Col. Mary Dover) ruled that the angry reply should be preserved to "be included in the history of recruiting, to show how difficult their job has often been." The letter also serves to document the connection between the slandering of women in uniform by servicemen and their resentment of women encroaching on a formerly male preserve.

Servicewomen were stung by the discrediting innuendoes circulated about women in uniform. Some made efforts to counter

the rumours, as in this poem for the March, 1944, *C.W.A.C. News Letter*:

"THE GOSSIP-MONGERS"

"The Khaki-skirt is just a flirt,"
Or so you'd think to hear
The population of the town,
So come and lend an ear.

"Those awful girls in uniform."
It keeps them mighty busy
Talking about the CWAC's in camp
It really makes them dizzy.

Now they will gossip all they can
Of Mary, Jane and Sadie,
So think of this when you go out –
Remember, you're a lady!

Sgt. D.B. Fultan, CWAC

Defiant in tone, the poem at the same time signals how service-women themselves internalized the dichotomization of woman-kind into "ladies" and "loose" women.

In the fight against the "whispering campaign," military authorities publicly spoke of the rumours' groundlessness, or at least distortion and exaggeration. Not to add fuel to the fire, officers at Defence Headquarters decided "that no published statistics or retorts should be made" in their attempts to combat the rumour-mongering.[36] Military authorities could not, of course, deny to themselves the hard evidence of VD infection and "illegitimate" pregnancy among servicewomen. And these cases were perceived not simply as administrative and medical problems, but, given the prevailing moral climate, as problems of immorality above all. The VD-infected or "illegitimately" pregnant servicewoman had obviously fallen into promiscuity. In their secret deliberations, officers asked themselves how such cases of immorality came to be in the women's services and what could be done about them. Their explanations and proposed remedies reveal sexual and class bias, and dominant conceptions of femininity.

For many CWAC officers the explanation was to be found in the policy of "mass recruiting" and the consequent "influx of undesirable types" into the CWAC. This was the explanation favoured by Captain Ruth Crealock in her appraisal of the CWAC

for the Directorate of Army Recruiting in September, 1943; also by Colonel Margaret Eaton, Director-General of the CWAC, in her preliminary history of the CWAC of mid-1945; as well as by Lt.-Col. Daisy Royal, Senior Staff Officer of the CWAC, in her Report and Recommendations on the Corps of August, 1946.[37] According to this interpretation, the Director of Army Recruiting, faced with increasing demands for CWAC personnel "to release soldiers for the defence of Britain," inaugurated a policy of "wholesale enlistment" in the summer of 1942. Earlier, in April, 1942, the age limit for other ranks had been broadened from 21-40 to 18-45. The wholesale recruiting meant throwing open the doors to women without civilian trades training and with poor education and low intelligence. The fruits of the "indiscriminate enlistments," apparent by the spring of 1943, were lowered morale in the CWAC, an increasing number of discharges, and a bad name for the Corps. CWAC officers, all university graduates or with equivalent "training and qualifications," equated unskilled and poorly educated women and those low in intelligence with "bad type." They in turn blamed these "lower-grade women" for the problems of "discipline, unhappiness, discharges and ugly rumours" plaguing the Corps. In Captain Ruth Crealock's estimation, "if this number of lower-grade women can be decreased, many of our present problems will automatically disappear."

Male Army officers also explained high rates of VD infection or "illegitimate" pregnancy in terms of the "quality of recruits" having been "sacrificed in the interests of quantity."[38] Although the results of some studies purported to show that there was a correlation between low level of skill, education, and intelligence and high incidence of VD and "illegitimate" pregnancy, they could hardly be adduced as incontrovertible evidence.[39] Furthermore, there was evidence that pointed away from that conclusion. As early as July, 1943, authorities at Defence Headquarters began discussing the introduction of a policy of "selective recruiting."[40] What this meant, in fact, was "discrimination at the recruitment level between low calibre, poor character, women and women [who] have good character, trades experience or trainable qualities."[41] When it was introduced in February, 1944, its stated aim was to restrict acceptability for enlistment to "tradeswomen or potential tradeswomen."[42] In practice a quota was established that "demanded that 67% of enlisted personnel be tradeswomen

material" (by August the quota had dropped to 62 per cent and by November to 55 per cent).[43]

Meanwhile, another kind of screening had been introduced, that of carefully examining all potential recruits for pregnancy. A study of ninety-five women discharged from the CWAC for "illegitimate" pregnancy between January 1 and May 31, 1943, had disclosed that 31.5 per cent of them had been pregnant before enlistment.[44] After June 1 that percentage was reduced, presumably because medical boards were checking for pregnancy more carefully. "The exclusion of women pregnant before enlistment," however, did "not appear to have lowered the incidence of illegitimate pregnancy."[45] Calculated at 32.1 per thousand unmarried women in the CWAC per year on the basis of figures for January 1, 1943, through April 30, 1943, it had risen to 33 per thousand per annum based on the figures for April, May, June, and July. Nor did the "selective recruiting" introduced in February, 1944, result in a reduction of "illegitimate pregnancies." At the end of 1944 it was reported that "the incidence of illegitimate pregnancies has remained consistent at approximately 35 per thousand strength per annum" for the past two years.[46]

When the incidence of VD in the CWAC was reduced in the last three quarters of 1944 "to half its former figure," the lowering was not credited to a higher calibre of recent recruit but rather to "the campaign of education undertaken by the Venereal Disease Control Section." The assumption that "an influx of bad types" explained the "excessively high" rates of VD and "illegitimate" pregnancy in the CWAC is a striking example of the survival into World War II of the sexual double standard's division of women into two rigidly separated categories, the pure and the impure, the virgin and the whore. By that dichotomization, if a CWAC were pregnant out of wedlock or infected with VD, she was *ipso facto* a "bad type." Blaming high rates of VD and pregnancy among unmarried CWACs on a superfluity of "lower-grade women" in the Corps was also clearly rooted in class bias. With the "selective recruiting policy appealing for enlistment of skilled and well-educated women,"[47] the Army hoped to attract a higher grade of woman. "University women" were regarded as "generally of a superior type – in many instances belonging to prominent families "[48] Ads began to speak of the CWAC's urgent need for university graduates.[49]

Another way Army officers explained to themselves the CWAC's high rate of VD and "illegitimate" pregnancy involved conceding one of the grounds objectors gave for disapproving of women in the armed forces: that the life was unsuitable for women. According to this explanation the incompatibility of the masculine armed forces with femininity lowered the morale of servicewomen and in that state of low morale they entered into liaisons that risked their respectability. In this explanation, as developed by the Director of Army Recruiting, women's exclusion/exemption from combat was crucial.

The Army is a male society developed by men over centuries around the role of the fighting soldier. This society is traditional and imposes rigid discipline and harsh living conditions on the individual in order to build up and maintain the type of physical and mental fitness required for effective action in the field. Upon entering the Army the modern civilian male soon learns to subordinate his own personality to his new role in the Army, for, he finds out, his life will eventually depend upon it. *He becomes a soldier first and an individual second.*[50]

Women, the Director continued, had been incorporated into modern armies, but in the Canadian Army they were exclusively to perform non-combatant jobs, not to fight. Canadian society had made "this restriction in role" for "a good reason": because it acknowledged "that women are physiologically and temperamentally different from men – they are feminine."

Drawing up a list of four basic characteristics, he defined femininity in terms of delicacy and domesticity. (1) Women "do not possess the same strength and endurance." (2) Canadian society had "encouraged them to have more delicate feelings, more spiritual values and more romantic attitudes." (3) "Their natural role is in marriage and that of a home maker." (4) Their "role in business and industry" was temporary, a job in the paid labour force being only "a preliminary step to marriage." His further argument was that, aside from exempting women from combat, the Army had not otherwise taken these characteristics of femininity into consideration. Instead it had indiscriminately applied masculine standards and imposed "the traditional Army system" to no good purpose since servicewomen were not needed as fighting soldiers. He therefore proposed a new approach, not just to recruitment but to treatment of women in the services

in general: that life for members of the CWAC, "both on the job and in the barracks, be approached completely and totally from the point-of-view that women are different." Since they had resisted becoming soldiers first and individuals second, let them "remain women first and soldiers second."

Underpinning the remarks of the Director of Army Recruiting lay an assumption that others shared: regimentation in the sense of the enforced anonymity and uniformity of military life was antithetical to femininity and womanliness. Doing her part to dispel the public's fears that army life was harmful to women, Lotta Dempsey wrote in her feature article for the third of *Mayfair*'s special 1943 supplements on "Women at War": "Even the younger soldiers who have no traditions of man-only wars are astonished at the adaptability of girls to precision drill and physical training." Her next sentence went on to register astonishment that feminine individuality had not been obliterated by such military regimentation, only temporarily submerged.

[Women's] ability to weld into a composite for training and disciplinarian purposes, and to emerge as definitely distinctive as only women can be, has been a discovery as significant in its way as any of the scientific facts of wartime research.[51]

Whether in Dempsey's rosy picture for public consumption or in the secret deliberations within the Directorate of Army Recruiting, the assumption remained the same: the femininity of a platoon of servicewomen lay not in their ability to perform a faultless march past or close order drill but in their "distinctiveness," "their personal freedom and individuality."

Although those ringing words call to mind proclamations of inalienable human rights, neither Dempsey nor the recruiting officers had anything so lofty in mind. When the Director of Army Recruiting suggested that such slogans as "a man is doing your job" or "there are jobs for women in the Army" would "put across the individuality of [the] contribution which women can make," what he really meant by "individuality" was difference from men.[52] And, indeed, similar slogans were used in the campaign to convey the message that service in the CWAC was not masculinizing. Most often women's individuality was equated with the realm of the personal, the homey: the little "feminine touches" that brighten up a room, such as curtains on windows, flowers in a vase. On close examination what women's alleged

penchant for personal freedom turns out to have meant above all is self-expression through choice of clothes and style of external appearance.

As a means of raising morale and lowering the "illegitimate" pregnancy and VD rates, Brigadier Chisholm, Director-General of Medical Services, stressed the importance not only of developing and increasing recreational facilities and organized sports but the "desirability of introducing the minor appurtenances women usually surround themselves with" into service-women's living quarters and recreation rooms. Since at the time these rooms were being maintained as "regimental Barracks," women were seeking "an outlet for their feminine characteristics elsewhere."[53] Other Medical Corps officers made similar recommendations. In order to raise the morale of the CWAC, one wrote, "the question of curtains and book shelves and such like and cupboards for personal belongings in C.W.A.C. barracks should be thoroughly considered."[54] It was recommended that the recreation rooms "be furnished in a home-like manner," that single beds be substituted for double-decker bunks in barrack rooms "to produce a more home-like atmosphere." It was also urged that CWAC personnel required more "privacy" than the Army men, especially in the rooms containing bathing and toilet facilities.

Some of these recommendations were implemented. A 1944 recruiting booklet pictured curtains on the windows of CWAC sleeping quarters, spoke of "barracks partitioned into cubicles," four "girls" to a cubicle, and promised "mirrors and bureaux" and "attractive recreation rooms."[55] Still, the CWAC district officers at their February, 1945, conference felt the deregimentation had not proceeded far enough and therefore recommended that "regimentation of C.W.A.C. personnel be considered from all aspects in an endeavour to reduce same wherever feasible."[56] And in August, 1946, just before the dissolution of the CWAC, the Senior Staff Officer, in her report on the Corps and recommendations for the future should such a women's service be formed again, pointed out areas where deregimentation had fallen short. Showers and baths had not been partitioned. The partitioning of sleeping quarters was incomplete: the partitions had not reached from floor to ceiling, nor had they been provided with doors. Greater "latitude in decoration of sleeping quarters" should have been allowed: "the provision of bedspreads as well as the curtains, already on issue, would do much to create a pleasant, homelike atmosphere." Also in the future all mess halls

used by servicewomen should be "bright" and "attractive" and furnished with "chairs rather than benches to sit on," for "women especially need a homey atmosphere in the dining hall."[57] Throughout the discussion an identification was made between women and the private sphere: home and the comforts of home. The armed forces had wrenched women out of that feminine realm and plunged them into an implacably masculine one: no wonder some of them had broken down.

Despite the doubts expressed among themselves, however, recruiting and promotion officers worked hard to dispel from the public mind any notion of immorality tainting women in uniform. In enlistment appeals, emphasis was put on the high calibre of women drawn to the Canadian Women's Army Corps. "The C.W.A.C. ... A Cross Section of Canada's Finest Womanhood" proclaimed the CWAC recruiting pamphlet from the second half of 1943. It went on to assure prospective recruits that the "standards of conduct" of CWAC women were no different from "those of representative Canadian women, for putting on a uniform does not change them, except insofar as they are imbued with pride in that uniform and would not do anything to bring it into disrepute."[58] When a CWAC in uniform did do something to discredit the Corps, immediate action was taken. Reports of unmarried CWACs en route to depot companies for discharge who had been seen travelling in uniform in advance stages of pregnancy (and in one case, with a baby in arms) reached NDHQ in February, 1944. As soon as the military machinery could be set in motion, it was arranged for servicewomen in such condition to travel in civilian clothes.[59]

Despite such occurrences the Army sought to persuade the public that the "girls" in uniform were well looked after. The officer commanding a CWAC unit was to be thought of as "trying to take the place of [a girl's] parents."[60] The public was told that service policewomen were "uniformed guardians of the morals and manners of the Women's Army and Air Force," their job "to play big sister to girls in uniform."[61]

Another tack taken in advertising the propriety of the Corps was to stress parental pride in a daughter's joining up. "I'm proud of you, Daughter" was scrawled in large writing across the top of one ad for the Canadian Women's Army Corps. Below appeared the drawing of a father with his arm around a sweet-faced, smiling young woman in uniform.[62] "MAKE YOUR FAMILY PROUD!" urged the heading of another ad, which in small print carried the coaxing message:

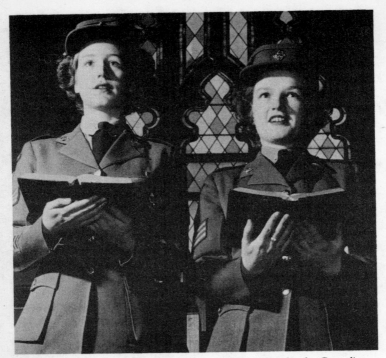

Two CWACs singing hymns in a church, a photo taken by the Canadian Army to illustrate the high calibre of women in the service. Manitoba Archives, Canadian Army Photograph Collection #194.

If you have any least thought that Dad or Mother might even silently hesitate to approve your becoming a member of the C.W.A.C. – banish that thought by looking ahead to the day when they will see you in your first "March Past." *Then* they will nudge each other. "There goes *our* girl" they will want to tell by-standers. Their hearts will leap with approval of your decision – their eyes will sparkle with joy and pride[63]

Promotional materials also sought to paper over the ill-feeling of some servicemen toward the women's services by playing up the evidence of appreciation for servicewomen shown by other male personnel. The publicity given military weddings mentioned in the previous chapter served this purpose, as well as the enforcement of heterosexual norms. "So the Soldier Wed the

C.W.A.C." ran the headline of a post-war article in the *Vancouver Sun*. "One of Canada's biggest official marriage bureaus was the wartime Army, . . . responsible for 18,000 weddings between servicemen and servicewomen. This record," the article maintained, "dispels the rumor that soldiers didn't like C.W.A.C.'s."[64] And at the height of the "whispering campaign," Lotta Dempsey wrote of "the wives, sisters, sweethearts and daughters of active service men," "scattered through all ranks" of the women's divisions, thus strengthening "the bond of fellowship between the men's and women's services."[65] Publicizing the closeness of attachments between servicemen and servicewomen was, however, a double-edged sword. In the climate of "moral panic," the Wartime Information Board report saw the widely used "shoulder to shoulder slogan" as ill-advised, since it implied that women were "mixed up with men," and recommended its withdrawal, a drastic measure as that was the title of the official recruiting song of the Canadian Women's Army Corps.[66]

The Combined Services Committee realized that one of the most effective means to combat the "whispering campaign" would be to get endorsement of the women's services from the eminently respectable National Council of Women. One member of the committee wrote in June, 1943:

> if we can ever reach a stage where the women's organizations look upon the Women's Forces as one of their particular war jobs, I think we will do a great deal to break down the rumour situation, which is now a serious problem.

His aim was "to establish a sort of parental feeling amongst the women's groups for the women in the Armed Forces" for the reason that while "any woman reserves the right to criticize her own children" she "will cut the heart out of anyone else who undertakes to criticize them."[67] Actually, the Minister of National Defence and representatives of the Navy and Air Force had been writing the president of the National Council of Women since early May, 1943, seeking her organization's support of the drive to recruit women for the armed forces.[68] At its fiftieth annual meeting (June 16-18, 1943) it passed a resolution stating:

> The National Council of Women of Canada desires to express admiration for, and confidence in the women of all ranks in the Women's Divisions of the Armed Services of Canada, and will support in every way the further recruiting of women for all branches of the services.

But at the end of July the Department of National Defence was still seeking public endorsement by the National Council of Women for the drive to enlist women in the armed services.[69] The patience of the authorities at NDHQ was finally rewarded on July 30, 1943, with the public statement of "The Stand of the National Council of Women of Canada on Recruiting of Women for the Armed Forces" by Mrs. Edgar D. Hardy, president. "In encouraging women of military age to enlist," Mrs. Hardy said of the thousands of respectable women her organization represented, "we are not asking the mothers of Canada to do any more than we are doing ourselves," as "many of ... our daughters ... have given up good positions and substantial pay cheques" to join the forces "because loyalty to their country means more to them than easy living." Mrs. Hardy then put herself on the line. Mentioning that she had made it her own "particular job to investigate in detail the supervision given to the women of the Armed Forces," she went on to declare herself to be "in a position to assure Canadian mothers that their daughters joining the forces will receive a supervision, physical, mental and moral equal in every way to that which they had in civilian life." The Combined Services Committee could not have asked for any firmer endorsement. But even it, released to the press on August 16, was not enough, as we have seen, to scotch the ugly rumours and salacious jibes once and for all.

Caught between a patriotic desire to make an all-out effort to win the war and a conservative unwillingness to change society's relegation of women to home and family (or temporary and lowly places in the paid labour force), Canadian society responded with ambivalence to the admission of women into the armed forces during the Second World War. There was no clear polarity of opinion on the issue: many of those who favoured women's military role – the servicewomen themselves, female journalists, recruitment and public relations officers – displayed some of the same underlying fears as the opposition: that a woman's femininity and sexual respectability might not survive enlistment. No one took the position that such concerns were either unfounded or absurd. Military authorities acknowledged the validity of these fears from the outset. The attention directed at servicewomen's uniforms and grooming, the emphasis on their "normal" interest in dating and marriage, the campaign to "feminize" the institutional atmosphere of the barracks – all attested to the pervasiveness of such attitudes. Enlistment

necessitated the removal of young women from the usual surveillance of family and community during the crucial years between school and marriage, and while commanding officers undertook to guard femininity and respectability *in loco parentis*, conditions of army life hampered their ability to do so. The drive to make women's barracks "homelike" and to relax the regimentation required of female recruits can be viewed as an attempt to recreate a family atmosphere as well as to preserve women's commitment to domesticity. The ambivalent response of Canadian society to women's admission to the armed forces indicates a widespread consensus during the Second World War on what the respectable woman should be: attractive and submissive to men and hence marriageable, but at the same time sexually chaste, that is, sufficiently self-controlled to limit sexual activity to the confines of marriage and motherhood. The opposition that took on the dimensions of a "moral panic" indicates the degree of alarm occasioned by the prospect of an end to sexual divisions, particularly among those committed to the survival of the patriarchal order. Perhaps because the combatant role always lurked in the background as a threatening possibility for women in uniform, the reaction to women's admission to the armed forces was at its most Victorian.

6

VD Control and the CWAC in World War II

"Male pursuit of control over women's sexuality," Catharine A. MacKinnon has argued, lies at the heart of the unequal distribution of social power between men and women.[1] Historically that pursuit has had a double-edged expression in cultures where monogamous heterosexual marriage reigns as the moral ideal: on the one hand, men have required that their own women – wives and daughters – be chaste, that is, keep their sexuality under the control of the husband/father; on the other hand, other women have been required to be sexually available outside the familial context. In the preceding chapter's study of the "whispering campaign," we saw such a dichotomous conception of women's sexuality at work in the attitudes of some servicemen toward having women in the services: it was a fine idea for women other than their own wives, sisters, daughters, sweethearts.

Policies instituted to control female sexuality have tended also to have a two-sided nature. In high-level debates preceding the founding of the women's services, commanding officers expressed considerable concern about the "mingling of the sexes" that such a move would entail.[2] This fatherly "protective" concern was given concrete expression in such measures as the protection-in-numbers policy requiring CWAC personnel to be sent on duty assignments in units no smaller than twelve.[3] But commitment to "protection" of women's sexuality was compromised by the requirements of the lady/"loose" woman polarization. The history of the VD control program in the Canadian Women's Army Corps (with occasional side glances at the other two women's services) casts a bright light on the social implications for women of this two-sided conception of female sexuality. Examination of the disposition of cases, medical treatment, and

educational and prophylactic measures of the VD control program for servicewomen compared with that for servicemen indicates important connections between social attitudes and social policy and thus provides a revealing case study of the sexual status of Canadian women during World War II.[4]

By 1943 official concern over VD in the civilian and military population reached a high pitch. After questions in the House of Commons, government machinery was established to co-ordinate a civilian/armed forces and federal/provincial campaign of prevention and control. Within the Royal Canadian Army Medical Corps, a Division of Venereal Disease control was established at National Defence Headquarters. To head it Dr. D.H. Williams, director of the Division of VD Control of the British Columbia Board of Health, was appointed at the rank of Lieutenant-Colonel.[5] To assure co-ordination, he was also appointed chief of the re-established Venereal Disease Control Division of the federal Department of Pensions and National Health,[6] which had been allowed to lapse in 1932.[7]

As discussed in the preceding chapter, 1943 also brought increasing concern over "illegitimate" pregnancy and venereal infection in the women's services and their effect on public opinion and, hence, on recruitment.[8] In February it was accepted that the chief Army VD control officer might need an assistant "to handle all problems which may arise in regard to C.W.A.C." and in October that appointment was made.[9] But as early as November, 1941, the Director-General of Medical Services had raised the question of what medical or administrative action should be taken with respect to personnel of the Canadian Women's Army Corps with venereal disease. The DGMS recommended they "should be discharged on medical grounds and not retained for treatment in the service as in the case of the Canadian Army."[10] That became official policy when, on December 22, 1941, medical and administrative officers of the Army, Navy, and Air Force met with representatives of the CWAC and the Canadian Women's Auxiliary Air Force, as it was initially called, and agreed that the method "of handling and disposition of Cases of Venereal Disease discovered in Female Personnel" should be discharge from the service with notification of need for treatment to the federal Department of Pensions and National Health or the appropriate provincial authorities.[11]

That policy was certainly easiest for the Army. It also indicated the lower value put on womanpower than on manpower. The scarcity of men made the Army's retention and treatment of VD-infected males preferable to discharge. Some medical officials favoured discharge for servicewomen because VD was a greater cause for shame in women and they would be less exposed to scandal outside the service than within.[12]

Others reached the opposite conclusion: medical care could "be carried out more expeditiously and with less public knowledge in the Army than in civilian life after discharge." A June, 1942, memorandum stressed the bad feelings toward the Army that the policy created in the discharged woman and her parents, "an attitude which will not help recruiting." The memo pointed out that "the girl involved" and her parents would "probably attribute her trouble to the change that took place in her surroundings and general mode of living when she enlisted." Their impression would be "that the Army was pleased to have her services whilst she had a clean bill of health, but the moment this health is impaired" (by reason of her Army surroundings) "the Corps washes its hands of her and her trouble."[13]

The March, 1942, integration of the Canadian Women's Army Corps into the Canadian Army (Active) made it difficult for the Army to have different policies for males and females. The June, 1942, memo queried: "Should not the same conditions apply in the case of members of the CWAC as are applied to soldiers, that is cure and retention in the Army?" On June 26, 1942, the Adjutant-General agreed "that the Army should take care of all cases [of VD] in the C.W.A.C. in exactly the same manner as it does in the case of male soldiers."[14] From the other three senior officers at National Defence Headquarters, the Adjutant-General received concurrence in his view that "the preponderance of argument in equity and expediency favours retention rather than discharge."[15] A sense of fairness was winning out over all other considerations. "As no reason could be advanced why women personnel should not be treated in the same manner as male personnel," at a meeting called on July 28, 1942, "it was conceded by the Navy, the Army and the Air Force that [female] personnel of the three services should be afforded exactly the same treatment for venereal disease as that given male members."[16] The principle of equal accessibility to VD medical services was established. As official policy, discharge from the services of

women suffering from VD had been in effect just over six months.

Recognition of servicewomen's equal right to treatment did not bring elimination of all differences in treatment and disposition of cases. One difference occurred in the treatment of gonorrhoea. In 1942 and 1943 medical officers were instructed that "the treatment of Syphilis for C.W.A.C. will be the same as that for men in the Army," while the treatment for all cases of gonorrhoea in the C.W.A.C. would be hospitalization.[17] In the case of males suffering from "acute uncomplicated gonorrhoea," the Army was experimenting with treatment "on a duty status." The Director-General of Medical Services gave no explanation for requiring hospitalization for all cases of gonorrhoea in females; but for males he cited the adoption of ambulatory treatment by the British and American armies and its "universal" acceptance in "war industry and private practice." He pointed to two developments responsible for this widespread endorsement: the availability and effectiveness of sulpha drugs for gonorrhoea and new knowledge about communicability of venereal diseases. He was convinced "gonorrhoea cannot be contracted by the casual contacts of army life." The Army could keep gonorrhoea-infected men in training or on the job while treating them with sulphathiazole. The beauty of the scheme was that it greatly reduced the "wastage" caused by venereal disease, which was of overriding concern. A "less tangible but equally important" saving was "less physical softening of robust men while in hospital."[18]

The Army had no reason to worry about "physical softening" of female personnel, as they would not be in combat. But all the other considerations could have applied to women as well as men. Surely some unexamined assumptions were at work, such as that women's labour (or training) was less valuable than men's, that women had frailer constitutions than men, or possibly that women were more infectious than men.[19] Or could the greater difficulty of detection and proof of cure in women have been behind their hospitalization? As the gonorrhoea in those hospitalized had already been detected and hospitalization could not improve the criteria for cure, one is left with the suspicion that the policy rested on less rational foundations, that is, a fear that these women were dangerous. Their isolation thus served both a precautionary and a punitive function.

In Canada as elsewhere in the Western world,[20] the subject of VD had long been encumbered with moralizing attitudes. An

historian of venereal disease control in Canada, writing in the thirties, found society's conception of venereal disease as "punishment for sin" to have placed great obstacles in the path of combatting it effectively.[21] Occasionally in the 1920's and 1930's officials of the federal or a provincial VD control program made conscious efforts to defuse the issue. During World War II, under the impact of war emergency and certain pharmaceutical advances, those efforts gained momentum, particularly within the VD control divisions of the armed forces, but the progress was smoother in the program for men than in the one for women. The aura of prejudice surrounding VD clung more tenaciously to female victims than to male.

Susan Sontag has argued that demystification of illness is related to the state of knowledge of its cause and the availability of cure.[22] The causative agents of the two most common venereal diseases, the spirochete *Treponema pallidum* of syphilis and the gonococcus *Neisseria gonorrhoeae*, had both been identified by the first decade of the century. Considerable progress in chemotherapy followed with the sulphonamides of the late 1930's. By 1943-44, these were superseded in the treatment of gonorrhoea by penicillin. This "wonder" drug was also beginning to be used in combination with older remedies (arsenicals and bismuth compounds) in the treatment of syphilis. These developments, together with the crisis of wartime, accelerated the campaign of VD control officials and epidemiologists to have gonorrhoea or syphilis regarded as "a disease – not a disgrace."[23]

The Canadian Army was in the vanguard of the movement to liberalize VD policy, as indicated by its cancellation of punitive measures once imposed on infected personnel. During the first two and a half years of the war "officers and soldiers admitted to hospital by reason of venereal disease" were subject to stoppages of pay.[24] This practice was discontinued in 1942.[25] The ending of segregation of those infected was another example of liberalization. A 1936 article on syphilis, written for the general public, had warned: "A single kiss may be all that is necessary to transmit the infection."[26] As late as 1942 the Director of Medical Services in the Department of Pensions and National Health and the Adjutant-General of the Army were still convinced that venereal cases necessitated isolation during the infective period.[27] But medical research was establishing the almost exclusively venereal communicability of syphilis and gonorrhoea. In 1943 the Department of National Defence

reversed its stand and opposed provision in military hospitals of "special accommodation for the treatment of venereal disease."[28] The Director-General of Medical Services now instructed that: "Toilets, ablution rooms, food handling, dishes, etc., *do not* play a role in the spread of Gonorrhoea." Therefore, "provision of separate facilities" was to be ended because such segregation not only was "inefficient and unscientific" but caused "unnecessary stigmatization of personnel."[29] By 1944 this order was being interpreted to cover all male and female persons in the Canadian Army requiring care for venereal infection, whether syphilis or gonorrhoea.[30]

This policy of divesting VD control of punitive implications was not extended with equal ease and thoroughness to female personnel. At about the same time (summer 1943) that the Director-General of Medical Services was instructing medical officers to make "every effort ... to remove unscientific, restrictive, stigmatizing procedures," the Adjutant-General issued a circular letter specifying that "upon return to duty after treatment for Venereal Disease, a volunteer of the C.W.A.C. will, if there are two or more companies at the same station, be posted to another company." The instruction was designed to protect the woman from public shame, for the letter went on to promise that, "When treatment is required following discharge from hospital, every endeavor will be made to ensure that the nature of the treatment being given does not become common knowledge."[31] By the summer of 1944, however, it had become clear that the order to post CWAC personnel "to another unit on completion of treatment for V.D." was having a stigmatizing rather than protective effect. In September, 1944, the Adjutant-General duly cancelled the order.[32]

Just as that stigmatizing measure was withdrawn, a new discriminatory policy was introduced. Early in 1944 the District Officer Commanding in Military District 4 (Montreal) initiated a policy of rejecting CWAC recruits on the basis of a positive blood test for syphilis.[33] On July 19, 1944, Routine Order 4694 made this practice mandatory for the entire Canadian Women's Army Corps.[34] In November, however, the Acting Director-General of Medical Services questioned the policy on the grounds of its unfairness to the women thus rejected, as well as its inconsistency with the general policy of the Army's VD control program. As he wrote to the Director-General, CWAC:

V.D. control general policy ... provides treatment for all cases diagnosed on enlistment blood test, on the contention that the man or woman can still be an efficient soldier, even though he or she has syphilis.

Furthermore, he argued, the rejection on the basis of a single positive blood test was "unfair" and cruel, for it doubtless caused "unwarranted" "concern and anxiety to the girl in question" since "false positives" were known to "be caused by a number of common conditions, such as ... vaccination and ... certain respiratory diseases." He recognized the purpose of the routine order was "to exclude those with syphilis" on the assumption that such women "would be undesirable as members of the C.W.A.C.," an assumption he did not question even though it contradicted his earlier statement that a woman with syphilis could "still be an efficient soldier." The Director-General, CWAC, agreed to the cancellation of the order as long as "it be made clear to Districts that there must be adequate screening and social service investigation in order to carry out" the policy's intent.[35] On January 31, 1945, the Adjutant-General rescinded the policy of rejecting CWAC applicants on the grounds of a positive serologic test for syphilis.[36]

Implementation of NDHQ's policy of removing penalizing and stigmatizing measures from VD control was an uphill struggle where servicewomen were concerned because of society's double standard of sexual morality. Rather than attach any blame to the servicemen who impregnated or infected servicewomen, many officers were convinced, as was shown in the preceding chapter, that the incidence of "illegitimate" pregnancy and VD in the CWAC was the result of an influx of "bad types" into the Corps,[37] and were keen to devise an effective screening procedure.

In August of 1944 authorities in Military District 13 (Calgary) instituted a "social screening procedure" that pried so deeply into the past life of CWAC applicants that the autumn conference of Army venereal disease control officers requested an investigation. An officer reported in November that:

Because it was found in [MD 13] that over 25% of the cases of Venereal Disease amongst C.W.A.C. personnel were diagnosed within three weeks of enlistment, it was felt that the screening procedure might be tightened up with a view to excluding individuals who might have VD at the time of

enlistment or whose background would lead one to believe that they were likely to develop V.D. before very long.

The tightened screening procedure included cross-checking the applicant's name with the provincial Division of Social Hygiene and the police. Of 163 investigated in this manner, eight had been rejected on the basis of reports from the Division of Social Hygiene that they had at some time received or were then receiving treatment for venereal disease. Six of them would have otherwise been accepted into the CWAC. On December 15, 1944, the Acting Director-General of Medical Services wrote to the medical officer in Calgary to stop the practice. He commended "the efforts to improve social screening of applicants" but pointed out that transmission of such information to a recruiting officer "contravenes medical ethics."[38] A routine order communicated this decision to all districts and commands.[39]

Differences in the handling of VD cases of servicewomen and servicemen survived efforts at fairness and equality. Modernizing, rationalizing, and goal-directed as the military was, the Army did not stand so apart from Canadian society as to be ready to launch an attack on a moral code that placed more opprobrium for promiscuity on women than on men. There was for men only one exception to the policy of retention and treatment of VD patients within the Army - neurosyphilis.[40] For women, however, not only pregnancy[41] but the mere reputation of promiscuity could create an exception. In the spring of 1944, the Director-General of Medical Services learned that at Regina Military Hospital women not responding to sulphonamide treatment of gonorrhoea were being discharged from the Army. The reason for discharge was that "the girls were promiscuous and undesirable persons for the Army. Several had more than one attack of VDG." The district medical officer assured the Director-General of Medical Services that "Only in those cases in which it is not desirous to keep the Volunteer for other reasons is she discharged uncured to" the Department of Pensions and National Health.[42]

Concern that "such personnel, who had gonorrhoea on discharge from the Army," might "spread the disease further" prompted the Director-General of Medical Services to recommend "that penicillin be made available for treatment of sulpha-resistant gonorrhoea cases among female personnel in the Canadian Army."[43] On June 8, 1944, all district VD control officers

were advised of the ruling of the Joint Services Penicillin Committee: "to treat all cases of sulpha-resistant gonorrhoea in female service personnel with penicillin, and that any cases not cured by two courses of sulphonamide should be referred at once for penicillin therapy."[44] That communiqué marked the beginning of availability of penicillin to female personnel.

When penicillin first made its appearance in 1943 as a cure for VD, in particular gonorrhoea, its use was reserved for male personnel. On December 21, 1943, when the Director-General of Medical Services recommended to the Joint Services Penicillin Committee that penicillin be made available for the treatment of "sulphonamide-resistant hospitalized cases of gonorrhoea," he specified those occurring in key male personnel.[45] Faced with a penicillin shortage in late February, 1944, medical officers ranked needs in an order of priority that put overseas first, urgent civilian next, and uniformed personnel in Canada last.[46] In military districts in Canada, penicillin was still in short supply through March of 1944.[47] Given the military's priorities and the scarcity of the drug, the time lag between its availability for male personnel in Canada and its availability by early June, 1944, for females was short. At a meeting of June 19-20, the Joint Services Penicillin Committee agreed that penicillin should replace sulphonamide therapy in all cases of gonorrhoea in female personnel. Despite the alarm over the incidence of VD in the female services, the actual numbers involved were small and the drain on the drug supply would be minimal. From January to June, 1943, only 127 cases of VD had been reported in the 9,829-strong CWAC stationed in Canada.[48]

With the introduction of penicillin, sulpha-resistant VD was no longer to be reason for discharge or retirement from the Canadian Women's Army Corps. But despite the general policy of retention and cure and despite the routine order that in screening recruits "a history of V.D., or evidence that a girl has syphilis, should not be used to discriminate against her,"[49] contraction of VD continued to serve as evidence of disreputable character and therefore as grounds for discharge or retirement.

For example, in September, 1944, the District Officer Commanding Military District 4 (Montreal) requested a ruling from National Defence Headquarters on a difficult case. What was, he asked,

the possibility of discharging a high profile volunteer who has

had V.D. on one or more occasions and who is known to be a "loose" type, thereby becoming a menace to all male soldiers of the unit to which they are attached, and contributing to the discrediting of the C.W.A.C.

The Acting Adjutant-General replied: "There is no objection to submitting recommendations for discharge of Volunteers C.W.A.C., who may be discrediting the Corps through immoral conduct."[50]

The medical treatment given women differed little from that meted out to men. But the policy to de-stigmatize and de-penalize proceeded more haltingly with the CWAC. Subconscious inhibitions worked overtime where women were concerned and blocked efforts at equality. If it was difficult to divorce VD control from moralizing attitudes, it was doubly so where women figured because the moral precepts in operation were more demanding, more critical, and more restrictive of female sexuality than male. Two instances of this asymmetry appear in the September, 1944, question to the Adjutant-General from the commanding officer in Montreal asking about "loose" women who in his view were a "menace" to men. The concept of a " 'loose' type" of woman rested on subconscious assumptions about the differences between male and female sexual needs, rights, and proprieties.[51] The misogyny and "gynaephobia" of a masculinist perspective, combined with a military outlook sharpened by wartime, took the stereotype of the "loose" woman and turned her into a "menace to male soldiers." If one seeks from a history of VD control in the CWAC insight into the sexual status of women in World War II, it becomes necessary, then, to examine the perspectives, presumptions, and fears that made the program for women different from the one for men.

One source of distortion was simply the wartime military perspective. The argument invariably used to justify the need for a thoroughgoing VD control program in the Canadian Army was that VD was a major cause of wasted man hours. A memorandum of February 1, 1943, to the Adjutant-General from the Director-General of Medical Services detailed a proposal for the establishment of the VD Control Division and contained a statistical summary of the wastage in the Canadian Army caused by VD from September 10, 1939, to December 31, 1942, including number of "man-power days lost" (402,653), "hospital beds occupied" (20,260), and "direct cost of this hospitalization and loss of training days" ($4,956,658.43). An appended chart

showed VD to be the leading cause of medical non-effectiveness in the Canadian Army, far ahead of flu and all other communicable diseases.[52]

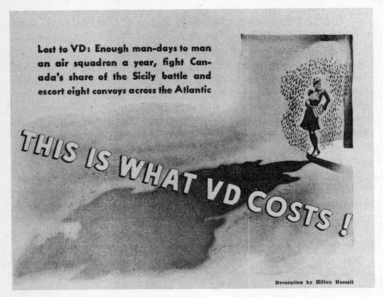

"This Is What VD Costs!" From Maclean's, *March 1, 1944.* Public Archives of Canada.

In February and March, 1944, *Maclean's* took the same vantage point in alerting people to the dangers of VD. Blair Fraser's "VD ... No. 1 Saboteur" sought to arouse concern over "an enemy that has put more of our fighting men out of action than any other." And "This Is What VD Costs!" by the Department of National Defence carried in bold print above the title:

> Lost to VD: Enough man-days to man an air squadron a year, fight Canada's share of the Sicily battle and escort eight convoys across the Atlantic.[53]

The principal job of the Army was to build up, train, and support the fighting force. While the war was on, the danger of VD was

seen as coming from the civilian population, and after the war Air Force authorities spoke of its having been "our duty to protect our personnel from venereal disease."[54] As the Chief of the General Staff wrote in his circular letter of June 28, 1943: "Venereal infection in the Army is acquired in civilian communities from civilian contacts associated often with unsavory civilian conditions."[55] The protection that military authorities felt dutybound to provide certainly included female personnel in its purview. Servicewomen were explicitly mentioned in the circular to all officers commanding on the imperative need to deal vigorously with VD. The Canadian Army, the Chief of the General Staff wrote, had a "responsibility to the citizens of Canada for the men and women entrusted to its care" and was "determined to preserve and maintain the health of these men and women."[56] But the protective side of the VD program for women fell short of that for men, and the dominant idea was that men needed protection from women, not vice versa.

The Army developed no program of "Early Preventive Treatment" (EPT) for women as it did for men. Education was *the* preventive measure in the CWAC VD control program, and it contained "no instruction in prophylaxis."[57] Nor with ease could the Army have done otherwise, for apologies and justifications had to be made for prophylaxis for men. At a Medical Services meeting in February, 1944, the Director-General reminded the group that "this was a very ticklish subject in view of repercussions from church authorities" and gave as an example "that a member of the House objected only last night in the Legislature to the fact that education in prophylaxis made it relatively safe for the soldier to participate in promiscuous behaviour."[58] He nonetheless agreed that, because of high VD casualties among overseas personnel, education in prophylaxis was necessary. A post-war report on the venereal disease control program in the Canadian Army claimed that EPT was the least developed aspect and that "first emphasis" had been placed "on continence." The introduction of EPT was justified on the grounds that it had been impossible to know "who would continue to take foolish risks, or who, under certain provocation, would expose themselves to infection."[59] The booklet *Protection Against V.D.*, prepared in the spring of 1944 "for the use of officers and N.C.O.'s as teaching material," stressed that "clean living and continence are the only absolute protection against V.D." Failing

that, it outlined protective measures, consisting of "personal protection" (by means of the rubber condom) and "personal decontamination" through use of a chemical prophylactic kit and a visit to an EPT station.[60]

Disclaimers and apologies notwithstanding, condoms and "v-packettes" were freely issued and EPT stations were set up on bases and in leave centres. The ration of condoms, three per month per man at the beginning of the war, had become by 1944 "free on demand as required by user." Although not precisely measurable, their effectiveness was recognized. Air Force authorities after the war acknowledged that the most likely explanation for the sharp decline in the incidence of VD in their service in 1944 lay in "the concomitant increase in condoms and prophylactic kits issued."[61] Among soldiers overseas with the First Canadian Army, reports showed that a full 56 per cent of those who contracted VD in November, 1944, had used no prophylaxis whatsoever. For only one per cent had the visit to the Prophylactic Ablution Centre failed them and for another mere one per cent, the combination of condom and prophylactic kit.[62] As the booklet *Protection Against V.D.* assured its male readers: "A man exposed to V.D. is not necessarily an immediate casualty. He only becomes one if immediate steps are not taken to prevent the germs getting established."[63]

A woman exposed to VD, however, was left to become a casualty. Women were not issued any contraceptive devices and they were not provided with any chemical or other means to cleanse themselves after possible exposure to infection. Even if "it is more difficult for the female than the male to prevent infection after exposure,"[64] the fact remains that no effort was made to overcome that greater difficulty. A circular letter of April 25, 1944, to all commanding officers of the CWAC simply stated without explanation that "early preventive treatment, which is valuable in reducing the number of infections among the male members of the Armed Forces, cannot be utilized for female personnel."[65]

VD control in the Canadian Women's Army Corps fell back on "education" as its mainstay. But even here women got less than men. Posters, regarded as an important medium of education, were in short supply for CWAC.[66] More educational material was produced for men because they so overwhelmingly outnumbered female personnel. In May, 1945, the Corps' strength of 636 officers and 13,326 other ranks was only 2.8 per cent

of the total strength of the Army.[67] But differences in quantity and quality of educational material had other roots.

One goal embraced at the December, 1943, conference in Ottawa for the federal/provincial, civilian/military VD control program was to "end the conspiracy of silence, banish outworn fallacies, and remove false fears."[68] Certainly the production of pamphlets and films for both the civilian and military populations, as well as the launching of a six-week national advertising and educational campaign through newspapers and radio in November and early December, 1944, attests to a determination to dispel "the hush-hush attitude toward venereal disease."[69] But where an item was produced specifically for men with a counterpart specifically for women, one can see a lingering equation of female purity with ignorance. An example is the pair of RCAF films, *For Your Information*, designed for female audiences, and *It's Up To You*, for male.[70] Not sparing its audience, the latter used scare tactics, blunt language, and photographs of actual syphilitic chancres on male genitalia. The former had a gentler tone, avoided the vernacular, and relied on anatomical drawings and diagrams of the female sex organs. As Blair Fraser summed it up in *Maclean's*, the "women's film is a masterpiece of delicacy" while the "airmen's film is about as delicate as a sock in the jaw, and has something of the same impact."[71]

The potentially harmful protectiveness extended to women rested on the assumption that women are either ladies or "loose" women: the former needed protection, the latter, regulation. The Army regarded its female personnel as sexually innocent until proven guilty. Its VD educational material for women presumed their gentility and so sought to protect them from "vulgar" truths by using euphemisms. By the strict terms of the sexual double standard, with one slip a woman passed from pure to impure. Insofar as the Army sought to apply the principle of equity in the medical treatment and the administrative disposition of VD cases, it fought against so rigid a polarization, with, as we have seen, only partial success. In the educational component of the VD control program, however, the virgin/whore dichotomy reigned supreme.

Another instance of the inescapability of the pure/impure framework was the notion of women's greater need for modesty and potential for shame. The motion picture *For Your Information* and its accompanying pamphlet catered to that vulnerability: both

laid great emphasis on the confidentiality of all VD information by showing venereal disease case records being kept separate from other medical documents in a metal filing cabinet under lock and key.[72] The point was not emphasized in *It's Up To You.*

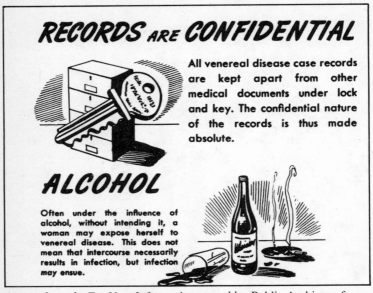

RECORDS ARE CONFIDENTIAL

All venereal disease case records are kept apart from other medical documents under lock and key. The confidential nature of the records is thus made absolute.

ALCOHOL

Often under the influence of alcohol, without intending it, a woman may expose herself to venereal disease. This does not mean that intercourse necessarily results in infection, but infection may ensue.

A page from the For Your Information *pamphlet.* Public Archives of Canada.

The threat of serious social consequences for women who violated the code of sexual morality was used as a VD control measure in the CWAC. The April 25, 1944, circular letter of all CWAC commanding officers on VD education in the Corps addressed itself to the question of motivation. One paragraph counselled that "The fear motive cannot be neglected and yet cannot be overemphasized, to avoid fostering the old, unhealthy attitude of prudery in connection with this subject." The fears referred to were "fear of ill health and the possible consequences of V.D. in relation to marriage and future hope of a home and family," that is, the fears of damage to reproductive organs and the resultant inability to have healthy, normal children, the fear of sterility, of "childless homes." All were played upon in the

movie and pamphlet *For Your Information*. And rightly so, the circular letter held, as long as it was done with moderation. Another fear, although it was not labelled as such, was the subject of a paragraph that recommended the use of social disgrace for the purpose of "reducing promiscuity." "The position of the promiscuous girl in society and the masculine opinion of a girl who is labelled as promiscuous," the circular letter urged in open acknowledgement of the overriding social importance of the male perspective, "are two strong points of attack against promiscuity and loose behaviour, which are the basic causes for the high rates of venereal disease and illegitimate pregnancy in the C.W.A.C."[73] And the threat appeared strongly worded in *You and Your Corps*, a VD control pamphlet for members of the CWAC. "The woman who lowers her standard of moral behaviour," the pamphlet warned, "makes herself vulnerable in many ways. It rarely remains a secret, and once labelled as 'easy' she will never again command the respect of the men and women she knows."[74] The same threat of social disgrace was simply not present in the VD lectures, pamphlets, or movies for servicemen.

The social consequences of acquiring VD were used to warn soldiers from risking exposure. The pamphlet *Protection Against V.D.* suggested seven "personal appeals" that VD instructors could use to motivate men, the third of which, following "patriotic" and "unit pride," was "home and family ties." "The sheet anchor of human behaviour," soldiers were to be reminded, "is family life." And therefore they should be warned to "avoid any action that will endanger your home."[75] Here the emphasis was on what the soldiers might do to the cornerstone of Canadian society, home and family. "Suggested Lecture Material for Non-Medical Officers of M.D. 3," however, actually recommended holding up to soldiers the threat of becoming "a social outcaste," but that was defined as "unable to visit your home for fear of infecting those most dear to you," which implied a kind of self-imposed social ostracism. Still, lecturers were to pose the further question: "Would you like your wife, your mother or father, your daughter or your son to know that you have been so indiscreet?" Here surely was an appeal to fear of social opprobrium, as there was also in the next question: "Your community feels proud of you for giving your services to the Army. How would you like them to know you are spending your time being treated for venereal disease?"[76]

Indisputably those questions contained an appeal to the fear of loss of status and loss of prestige in the eyes of one's family and local community. But the force of that appeal, for a number of important reasons, was less personal and more an appeal to social responsibility than the comparable one used with women. First, it was immediately followed, and hence undercut, by the extensive discussion of prophylactic procedures. Second, men were not threatened with the probability of an actual change in their being. As in the "Suggested Lecture Material for Non-Medical Officers of M.D. 3," men were discussed as having been "indiscreet," in the sense of having committed an "indiscretion." Earlier we saw prophylaxis criticized for making it "relatively safe for the soldier to participate in promiscuous behaviour."[77] Promiscuity for men was a matter of external behaviour they chose to participate in or not. The sense of its externality is present in an instruction in the booklet *Protection Against V.D.* that the soldier should not regard it as a mark of manhood or a perquisite of service: "He must be stripped of the wishful idea that promiscuity is either essential or a liberty due a soldier."[78] And when the same booklet went on to speak of the "good soldier" as one who "does not get venereal disease," it was not saying that the serviceman who got VD became a bad person, only that he became a bad soldier in the sense of diminishing the Army's fighting efficiency. By having illicit sexual intercourse the male soldier was thought at worst to have done something bad or immoral, not to have *become* bad or immoral.

This was not so with women. Promiscuity did not remain something external to them; it came rather to affect their essence, the very nature of their womanhood. Promiscuity in the case of the female changed from external behaviour to become inherent quality, and that quality, the literature admonished, inhered permanently.[79] Thus, the medical officer of Military District 12 could write of discharging members of the CWAC in the spring of 1944 who had been found to be "promiscuous and undesirable persons."[80] And servicemen, in lecture, pamphlet, poster, and film, were forever being warned against "loose" or "promiscuous women."

That brings us to the very nub of the problem and the third reason the threat of social opprobrium had less force in the VD educational material for men: it paled next to the warnings against the diseased, predatory female. And that is also the main reason why the Army had such difficulty overcoming the lady/

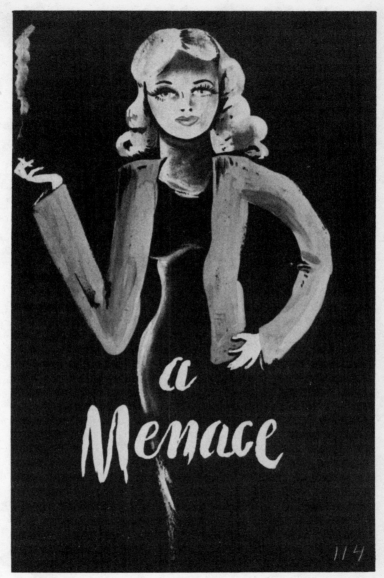

Canadian Army poster, April, 1943. DND/Public Archives of Canada/
PA-141001.

"loose" woman split when attempting to implement a policy of de-stigmatization and de-penalization with servicewomen: the military was too deeply committed to that dichotomy in its VD control program for men.

The educational material warned women that, under the influence of alcohol, they might dangerously lower their standards of morality; men, their standards of female companionship. "Liquor plus loose women equals Syphilis and Gonorrhoea" soldiers awaiting repatriation were to be admonished.[81] Blair Fraser in his article for *Maclean's* cited the results of a British Army survey that boredom and loneliness could "drive a boy into *evil* company."[82]

Unrivalled in presentation of the "loose woman" as a menace was the booklet *Three Queens But I'll Pass*.[83] Brought out in the fall of 1944 and "distributed generally," the booklet personified gonorrhoea and syphilis as two adult females named "Gonnie" ("she'll fix you up anytime!") and "Syph" ("Boy! is she a killer!"). In lurid cartoon drawings they were portrayed as a couple of short-skirted, heavily lip-sticked, cigarette-smoking "gals" who "travel around arm-in-arm with 'Easy' Women" and prey on men.

> The gals certainly get around ... you'll
> find them almost any place in the world
> ... looking for
> *y o u*!

So read the message on one page atop a pictogram of a desperately sweating soldier being pursued by the two female figures running with predatory hands outstretched to nab him. "They'll dive into your blood stream because you've been playing around," the booklet warned. And to reinforce the message the final page advised:

> *Always* ask yourself ...
> is this a date with O N E
> ... or a date with
> ALL THREE?

It is the identification of gonorrhoea and syphilis as human females that makes the booklet so pernicious.[84] In August, 1944, Lieutenant-Colonel D.H. Williams recommended cancellation of the printing of *Three Queens But I'll Pass*, not because it was degrading to women, but because it "could be interpreted as an

undignified presentation of a serious problem." But the Director-General of Medical Services ruled that printing should proceed as "it was considered that this booklet would reach, effectively, a larger number of Armed Forces personnel than the more orthodox type of V.D. educational publications."[85]

The educational material for women contained no counterpart to the predatory and infected bogeywoman of the men's films and booklets. The RCAF's *For Your Information* did not attempt to scare women away from certain kinds of men the way *It's Up To You* – in elongated letters looming diagonally across the screen – screamed to men the warnings "BEWARE OF PROSTITUTES!" and "BEWARE OF PICKUPS!" The CWAC pamphlet *You and Your Corps* spoke calmly of the changed circumstances of wartime, pointing out that "loneliness, discontent, and the uncertainty of the future may lead [young people] to find solace in the companionship of the opposite sex." But there was no "loose man" equivalent to the "loose woman."[86] At most the pamphlet told its women readers that the men they were likely to encounter would be, like themselves, "in uniform, removed from the influence of family life and home," and then cryptically advised: "You should not judge these men on the same basis as the boys you knew at school and who grew up with you, or the men with whom you had common interests based on long acquaintanceship." While cautionary, the passage is a far cry from the frightful image in the men's literature of the "easy" or "promiscuous" woman, leaning against lampposts and lurking in doorways, just waiting to pass on her disease to some sucker of a man.[87]

The interests of the military in wartime could be invoked to explain the discrepancy. Wastage of armed forces personnel had to be prevented and the personnel were overwhelmingly male, so it was men who needed protection from women rather than women from men. But that explanation is insufficient to account for the appeal to fear and loathing in the image of the "loose" woman. When one looks beyond the military to the VD control program in civilian society, where the population was half female, one finds the same priorities, the same preoccupations. Seeing women as the menace was not simply an Army perspective; it was a male perspective that equally dominated the VD control program in civilian society. Whether civilian or military, VD authorities tended to see women as the source of infection. Air Force authorities immediately following the war looked optimis-

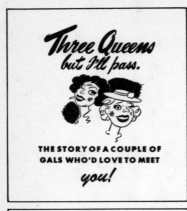

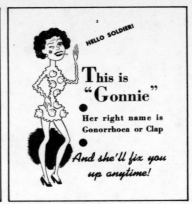

Pages from Three Queens But I'll Pass *booklet*. Public Archives of Canada.

tically to a policy of offering penicillin treatment to alleged female contacts as ensuring "some inroad into the huge reservoir of gonococcal infection in this country." Certainly "the difficulty of establishing a diagnosis of gonorrhoea in the female, even in the best of clinics,"[88] and "the asymptomatic course the infection takes in many women,"[89] contributed to the view of women as the pool of infection. But the extent to which women were blamed for the spread of VD seems to have gone beyond those epidemiological facts and drawn on a deeper, unarticulated notion of woman as polluter.[90]

For instance, in concluding in 1944 that "Inter-command and inter-province spread of venereal disease" was "a serious problem," the RCAF Medical Branch held the female "sources of infection, in any area,... responsible for dissemination of infection to distant points in the nation."[91] It thus overlooked the infected airman who, in most cases, did the travelling and hence was the actual carrier.

During the war civilian and military authorities alike saw in female prostitution a "reservoir of VD" or even "cesspool" of infection.[92] The educational side of Canadian VD control at home and abroad stressed the connection between venereal disease and prostitution. The 1944 booklet *Protection Against V.D.* maintained that "about 90% of all prostitutes are infected and, therefore, highly dangerous."[93] For those reconciled to prostitution as a necessary and ineradicable evil, the solution lay in licensed brothels and frequent medical examinations of the female prostitutes. The dominant opinion among Canadian VD control officials, however, held that no system of checkups and certificates was sufficient to control infection, and so favoured suppression of prostitution. Neither side, it should be noted, considered requiring examination and certification of the male customer. Army, Navy, and Air Force VD control officers, blaming the high rate of VD infection among armed forces personnel in Military Districts 4 and 5 on the commercialized prostitution in Quebec City and Montreal,[94] worked hard from November, 1943, through March, 1944, to suppress prostitution in both cities and succeeded in getting some brothels closed down and certain hotels marked off-limits.[95] As for the civilian contribution to VD control in Canada, the chief constable of Vancouver proudly reported that during the war civil police authorities had made an "all out effort to suppress prostitution."[96]

A kind of scapegoating of women was undoubtedly going on

in the naming of prostitution as the "main source and root of these diseases."[97] While the head of civilian and military VD control, Lieutenant-Colonel D.H. Williams, acknowledged that the individual female prostitute was often an "exploited unfortunate sick" individual and urged that blame (and with it the harassment of the law) for the spread of VD be shifted from her onto the "exploiting, wealthy, healthy facilitator," he failed to abandon the perspective that saw VD control as the need to protect healthy men from diseased women. To be sure, he advocated suppression of "facilitation rather than prostitution," but for him "the basic principle behind all action" taken against the facilitation process "was that of making it as difficult as possible for apparently healthy men to meet potentially infected women." His report of specific actions taken to suppress facilitation in the Greater Vancouver area included getting dance hall managers "to refuse admission to unescorted women" and forcing "certain beer parlours which were literally anterooms to brothels" to close. The remainder were compelled to have partitions, "so that each premise was divided into two sections," one admitting "men only, the other, women or women escorted by men." By this means, "tired war-industry workers late in the day going into cash a wage cheque are not confronted brazenly by venereally-infected women at adjacent tables." The female war worker was presumably not expected to want a beer at the end of the day; if she did, she either risked identification as "loose" and probably diseased or had to find a male escort willing to bend an elbow with women of questionable reputation. The vision of the world here is one of men in need of protection against sexual harassment from dangerously infected brazen women.[98]

Both 1944 *Maclean's* articles on VD reiterated the notion "that commercialized prostitution remains the primary source of venereal infection for the whole country,"[99] although evidence of the negligible role of the female prostitute was mounting. According to the Army's February, 1944, Venereal Disease Control Inspection Report on Pacific Command, "amateur pickups" were "responsible for approximately 70% of the infections" and VD Control reported from Military District 12 in April, 1944, that "in Saskatchewan the problem of the pickup is the most serious one" and that "prostitution is not a problem."[100] From a study of 1,764 venereal disease reports received at Air Force headquarters during 1943, it was reported in November, 1944,

211 CONTROL AND THE CWAC

that "in only 7.0% of the infections ... were prostitutes named as alleged contacts," while in 90.4 per cent, "pick-ups" were.[101] In an analysis of RCAF data from 1944, less than one per cent of the cases in which an alleged contact was reported "involved a prostitute in a brothel," only 2.5 per cent if the category "prostitute" was stretched to include all other "fee-paid contacts"; the "casual 'pick-up'" had become "the leading source of infection," being named in over three-quarters of all VD cases.[102] VD educational material for servicemen accommodated this information: the dangerously infected "loose" women the men were to beware of included "pick-ups" as well as prostitutes.

The net of definition of a "pick-up" was cast wide. How wide can be seen from the juxtaposition of two assertions made in the RCAF report on its 1943 data: that 90.4 per cent of the alleged contacts were "pick-ups" and that "waitresses, office workers, factory workers, domestic help, prostitutes, and housewives were of importance as alleged contacts, in that order."[103] According to the "Outline V.D. Lecture for Soldiers Awaiting Repatriation," a "pick-up" was defined as "any girl you can pick up or who picks you up and lets you have intercourse with her."[104] And the men were warned that these amateur "'good time gals'" were almost as likely to have VD as the professional prostitutes. "Any woman who indulges in promiscuous sexual intercourse is very likely to have V.D.," warned the booklet *Protection Against V.D.*; "any girl" who "lets you have intercourse with her probably has one or other or both" venereal diseases, the soldiers awaiting repatriation were to be told.[105] According to Blair Fraser, American Army doctors coined the derogatory term "'patriotutes'" for women who committed such "sexual delinquency" with servicemen, indicating clearly how thin a line separated the fee-taking from the non-fee-taking female provider of sexual services.[106] The crucial definition of the "loose woman" was not taking money for sex, but having sexual intercourse out of wedlock and with more than one partner. It was as sexually independent women that both prostitutes and "pick-ups" were blamed as the primary source of venereal infection.

In vain one looks in the official sources for a world of women in need of protection against sexually demanding, aggressive, or overpowering men. Neither the word "rapist" nor the notion of VD spread by rape occurs. The sources do mention a category of innocent women deserving protection: those who did not take their place out in the public world but stayed in the private – the

innocent wives. It was recognized that Canada's national health required prevention of "the innocent infection of young Canadian wives following marriage."[107] And it was known that husbands did infect wives: "One analysis revealed that 75 per cent of syphilitic married women acquired the disease from their husbands."[108] In D.H. Williams' view, the fight against the facilitation of prostitution would indirectly protect the blameless wife within the home. One part of his program, for instance, was to persuade taxicab drivers "no longer [to] wish to be accessory to the infection of a visiting convention delegate with a fine wife and children back home whose health thereby may be endangered."[109] The concern over "the conjugal spread" of VD increased at war's end as demobilization went into effect and men began streaming back to Canada from overseas. The Army now stood to infect civilian society and in the documents men began to be spoken of as active disseminators of contagion. In August, 1945, for example, the medical officer of Military District 10 (Winnipeg) cabled the Director-General of Medical Services, Ottawa: "Infected men must not be allowed to scatter infection gained abroad across Canada."[110] Routine Order 4793 of 1944 had provided that "Medical Board examination prior to retirement or discharge shall include a blood test for syphilis for all personnel."[111] If the serologic test proved positive, no provision was made to defer a serviceman's demobilization until he was cured or at least out of the infectious state. Sometimes he managed to leave the service even before the results of the blood test were in.[112] In face of the fear that venereal disease infection in Canadian society might reach the epidemic proportions it had reached after the Great War, demobilizing servicemen were talked about as active carriers of infection but even then not as the primary cause of the spread of VD.

In his World War II novel *The Sixth of June*, Canadian writer Lionel Shapiro has a colonel's wife at a London cocktail party say "brightly":

> "You know, darlings, one of these nights, Lord love us, the war is going to end and I can only think a great big gong will crash and a supernatural voice will say, 'Time's up, ladies, everybody back to their own husbands.' "[113]

Certainly promiscuity was not uncommon among those serving

the war effort, both at home and abroad. Air Force authorities wrote at war's end: "Considering the vast numbers of condoms and chemical prophylactic kits issued, the conclusion is inescapable that promiscuity [was], to put it mildly, anything but exceptional."[114] But the prevailing sexual morality did not condone promiscuity, any more than did the moral order of Shapiro's novel, according to which the male protagonist in the end chooses faithful monogamy over the temptation of the wartime love affair.

While wartime advances in medical knowledge and treatment opened the doors to a demystification of venereal disease, Canadian VD control officers and officials were still caught within the confines of a tight syllogism: promiscuity is immoral; VD is spread by promiscuity; therefore contraction of VD is shameful. And they also worked with a double standard of sexual morality that penalized and socially stigmatized women who had sexual intercourse with more than one partner. The conviction that promiscuity was immoral hampered the campaign to get VD recognized as "a disease – not a disgrace." The double standard sabotaged that campaign for women. The differences between the VD control program in the CWAC and the one for male soldiers of the Canadian Army in World War II illustrate the effects of the double standard. These were not so apparent in actual medical treatment provided by the Army, once members of the Canadian Women's Army Corps were granted the right to it. The double standard did, however, cause shortcomings in the application to servicewomen of the Army's policy of de-penalization and de-stigmatization. It also ensured a serious inequality in the protection against VD provided by the Army for its female as compared with its male personnel.

The authors of the VD educational material were unaware of the hypocrisy involved in that inequality as well as of the double bind it imposed on women. While provision of prophylaxis for men presupposed the existence of women who would "participate in promiscuity," the double standard made of such women a handy scapegoat on which VD could be blamed. That was the most serious inequality: the absence of male figures from the demonology of VD. Labelling the "pick-up" as well as the prostitute a primary source of infection was potentially degrading to any woman, especially given the wide definition of "pick-up." Perhaps most members of the Canadian Women's Army Corps themselves subscribed to the dichotomization of women

and therefore felt above degradation as they believed themselves immune to VD. "Always there is a feeling 'It can't happen here'" was the reaction reported in one CWAC unit to the Army's VD educational program.[115] Nonetheless, although one does not find in the documents a call for recognition of women's equal sexual rights and needs, CWAC officers did record their dissatisfaction with the inequalities in protection and de-stigmatization. The April, 1945, confidential report on "Venereal Disease Control in the C.W.A.C." contained a plea for "an understanding that VD is an illness, which should not be tinged with implications of immorality and misconduct."[116] And also in April, 1945, a Captain Sara Dubo, psychiatrist in the Royal Canadian Army Medical Corps, singled out as a factor contributing to the incidence of VD in the CWAC: "the inconsistency in the attitude adopted towards men and women in the service in regard to promiscuity."[117] Denied effective protection in deference to her innocence, the woman who contracted VD won the label "loose" or "easy" or "promiscuous." Such was the double bind of the double standard.

Conclusion

"When Fluffy Clothes Replace[d] the Uniform"

We women of the so-called second wave of feminism sometimes look back nostalgically to the Second World War as a period of women's emancipation. The temptation to do so is great, especially in the face of certain kinds of visual evidence. Photographs show female munitions workers operating lathes with smiling confidence and uniformed servicewomen marching in formation with disciplined precision. But such images do not give the whole picture. One needs to place them alongside other, more conventional representations, for even at the peak of the war effort, mobilization propaganda and wartime advertising were delivering another message, less subversive of pre-war gender relations. The self-reliant woman, performing competently in a traditionally male sphere of activity, was all right, these other images said, as long as she remembered that "THERE'LL COME A DAY"[1] when the men would return to reclaim their rightful place – of privileged access to the public world of paid work and of lordly authority within the private domain of home and family.

And that day did come. Women's participation in the paid work force, which had risen from 24.4 per cent in 1939 to a high of 33.5 per cent in 1944, began to slide in 1945 and then, in 1946, to plummet. It reached its post-war nadir of 23.6 per cent in 1954 and would not climb back to its 1945 level until 1966.[2] Post-war restrictions on women's gainful employment coupled with inducements to return to the home took effect.

So also did a post-war atmosphere conducive to more, and earlier, marriages. Studies revealed that more women were marrying, and they were marrying at a younger age. The rate of marriage for women twenty to twenty-four years old rose from 75 per 1,000 in 1937 to 100 per 1,000 in 1954, and for younger

215

women aged fifteen to nineteen, from 30 per 1,000 in 1937 to 62 per 1,000 in 1954.[3] This had consequences for the marital status of women in the work force. In 1931 a bare 10 per cent of women in gainful employment were married; in 1941, only 12.7 per cent. Then, as war production gathered momentum, the proportion of working women who were married rose – to an estimated 35 per cent in 1944. By 1951 it had dropped back only slightly to 30 per cent. Thus, even though only 11.2 per cent of married women were working outside the home for pay in the early 1950's, the fact that 30 per cent of Canada's waged and salaried women in 1951 were married indicated that one wartime trend was not reversed: married women continued to make up a large proportion of the female labour force, however reduced in overall size that force was.[4]

The mere fact, however, of a growing tendency for gainfully employed women to combine marriage and job was not in itself liberating. Instead, it heralded the establishment of a pattern that would prove immensely oppressive to women, that of the double day of labour. The war, after all, had not upset the sexual division of domestic labour whereby home exists as a place of leisure for men but of work and service for women. Furthermore, post-war reconstruction had rescinded the wartime accommodations made to the special needs of the working woman burdened with home responsibilities.

Moreover, while the war effort necessitated minor adjustments to sexual demarcation lines in the world of paid work, it did not offer a fundamental challenge to the male-dominated sex/ gender system. And the post-war years witnessed a return to unquestioning acceptance of the principles of male economic primacy in the public sphere and male headship in the private. Research on organized women in the post-war era, particularly women's union activities, would help give us more of a sense of the extent to which some women resisted the pressures to vacate non-traditional jobs and to put marriage and family at the centre of their lives. Some evidence of resistance made it into the popular press. An ex-servicewoman from Winnipeg, writing for the *Canadian Home Journal* in April, 1945, expressed rage at the idea that women whom the war had turned into competent, skilled workers were to be cast aside at war's end. Sending women back home was, in her view, "like putting a chick back in the shell – it cannot be done without destroying spirit, heart or mind." On the other hand, the winner of the

National Home Monthly's contest in 1945 for the best letter on the subject, "If there's a job in industry for you after the war, do you want it?", registered a definite preference for domesticity. "One thing I would like to make clear," she wrote, "I do not feel I am sacrificing myself for housekeeping. The thing I wanted most was a husband and home of my own."[5] And if that meant on patriarchal terms, so be it.

Two years later, a *Canadian Home Journal* article endeavouring to present a balanced account of what had happened to "Canada's 48,000 Ex-Girl-Soldiers," significantly bore the title "When Fluffy Clothes Replace the Uniform." The author, Margaret Ecker Francis, a new mother, had herself served during the war as a staff correspondent for the Canadian Press overseas. On the minus side she noted the failure of a bacteriologist formerly with the Royal Canadian Army Medical Corps to find a post-war job in her field, and the negative observation of another woman veteran that ex-servicewomen were "not getting a fair break as far as pay goes" even though many of them headed families, "supporting parents, educating brothers or sisters or bringing up their own children." But on the whole Francis wanted to leave her readers with a rosy picture of "the ex-girl-soldiers" making good either in career or job or by going "back to the hearthside ... joyfully and gratefully." She recounted stories of individual entrepreneurship, one of a former RCAF (WD) transport driver who used her re-establishment credits to set herself up in the catering business, and another of a former CWAC transport driver overseas who bought a couple of trucks with her credits and opened up a delivery service. In general, Francis presented the women as having made a successful transition from uniformed service to "civvy street." Indeed, she uncritically repeated praise of military service for preparing women so successfully for the assumption or resumption of housewifely chores and/or low-paying, low-status service jobs in the post-war world. She approvingly quoted the assessment of a former Army counsellor that "their experiences did teach them how to manage a home efficiently, and taught them neatness and cleanliness, too." She also cited as evidence of the value of military life that a personnel manager of a large Montreal department store "liked girls who were veterans because they were more punctual and because their years in uniform had taught them to be neat and wear their clothes well." Finally, she reported without comment the assertion of former

Lieutenant-Colonel Joan Kennedy, once administering officer of the CWAC, "now associate private secretary to Rt. Hon. Ian Mackenzie, Minister of Veterans' Affairs," that "Many who two years ago were giving orders now are taking orders from their husbands and loving it."[6]

As recent scholarship has demonstrated, whether in wars or revolutions, if feminist demands have not been on the agenda, feminist gains have been unlikely to survive into post-war or post-revolutionary society.[7] Dorothy Johnson, socialist feminist and member of the Co-operative Commonwealth Federation, recognized this in 1943. She began an article in the *Canadian Forum* by listing a number of wartime developments affecting women:

> Women are gainfully employed again. The cry of patriotism is urging women into all the work they've been trying to get into since World War I ceased. American states which were busy passing acts actually to stop married women from working outside their homes have quietly dropped the matter. School boards are imploring married teachers to return to the fold; hospitals are employing married nurses; aircraft factories are astonished to find women capable of operating simple machines, and even governments are taking a hand in the business of caring for children while mothers work.

She noted, however, that "The feminist movement" could "claim none of the gains" and went on to predict that women "will rush to work now, and they will give up their work to men after the war as soon as they are asked to."[8] While she exaggerated the willingness with which women would retreat to domesticity, Johnson was right about the non-feminist basis and consequent short-lived nature of Canadian women's wartime gains.

Reviewing a recent conference convened at Harvard "to re-examine the effect of the two world wars on women's lives," one scholar commented that the debate over whether war liberates women "must necessarily remain ... inconclusive."[9] On an individual basis that statement is indisputable. Some women without doubt derived experience from their war service that improved their post-war opportunities, particularly exceptional women like CWAC veteran Judy LaMarsh who used her rehabilitation benefits to acquire the education that would launch her on a career as lawyer and politician.[10] One could also point

to individuals whom the post-war anti-feminist backlash helped to propel two decades or more later into the front ranks of the reborn women's movement. Shirley Goundry, the student referred to in the Introduction, is one example. In *Rough Layout*, Doris Anderson describes the disillusioning effect on a young girl of seeing her strong and self-determining mother transformed into a deferential and "feminine" wife on the return of "the Man" at war's end.[11] Furthermore, life in the armed forces and munitions plants of the United States during the war has been interpreted as liberating for lesbian women in the sense that living and working away from home and in same-sex communities provided a better opportunity for discovery and/or expression of their sexual preference.[12] The research to test that hypothesis for Canadian military life is yet to be conducted.

Beyond its arguably inconclusive nature, one should take note of the limitations inherent in the very question of whether war has a liberating effect on women. Obviously, the question is wholly inappropriate in the face of war's destructiveness and the devastating experience of the loss or physical or psychological maiming of loved ones. Nor does this line of inquiry speak to the experience of the victims of national and racial hatreds fanned by war. The question of war's possible emancipating effect on women takes on an obscene quality, for example, in relation to the forced evacuation, incarceration, and dispersal that Japanese-Canadian women suffered together with Japanese-Canadian men at the hands of the Canadian government during and after the Second World War.[13] And clearly principled pacifist women for whom the resort to armed force as a solution to conflict is a violation of their belief in the sacredness of human life have difficulty conceiving of wars as liberating.

The concern in this book has been both narrower and more general. The foregoing chapters have not attempted to capture Canadian women's experience of the Second World War in its full range and diversity. Instead, the focus has been on the larger patterns in government policy and gender ideology that map the determinants to women's social existence. As we have seen, while the war effort necessitated shifts in sexual boundaries in the public workplace and the reformulation of proper womanhood to accommodate those shifts, the seeds of backlash were already present during the war itself, in expressions of the fear of loss of femininity and in the contradictory messages of recruitment literature. The CWAC of the promotion photo wears a helmet and

a respirator, but tilts her head to the side in a "pin-up" pose. The congratulations for breaking into non-traditional fields, which the media and officials gave out to women one moment, were taken back in the next in the assurances and predictions of women's post-war return to hearth and home. To bridge the contradiction between the cult of domesticity and Canada's wartime need for women in munitions plants, doing housework was "militarized" and assembling explosives was "domesticated."

The tension between woman as wife/mother/homemaker and woman as paid worker was eased on only a limited scale and only for the duration of the war, mainly through the Dominion-Provincial Wartime Day Nurseries Agreements implemented in Ontario and Quebec. Furthermore, shifts in sex/gender lines of demarcation took place exclusively in the public sphere. The subject of reorganizing the household division of labour was broached only in jokes and cartoons about male/female role reversal. Women could don military uniforms, but not even for the war emergency were husband/fathers to don aprons. Moreover, the war intensified the traditional demands on women to be emotionally supportive of men. And while promiscuity undoubtedly increased, the disturbing prospect of female sexual independence led to a tightening of the hold on women of respectable femininity. Finally, as the chapters in this volume have shown, the immediate legacy of the Second World War was an indisputable reaction against war's upheaval, including the unsettling extent to which women had crossed former sex/gender boundaries. The war's slight yet disquieting reconstruction of womanhood in the direction of equality with men was scrapped for a full-skirted and redomesticated post-war model, and for more than a decade feminism was once again sacrificed to femininity.

Annotated Bibliography

Allatt, Patricia. "Men and War: Status, Class and the Social Reproduction of Masculinity," in Eva Gamarnikow *et al.*, eds., *The Public and the Private* (London: Heinemann Educational Books, 1983), pp. 47-61.

By analysing the content and presentation of the armed forces' education program in citizenship in England during World War II, the author demonstrates how male solidarity, across class lines, was the major goal of these programs, which were established by the British military hierarchy to address problems of morale and efficiency in a mass conscript army. The texts used in the citizenship program served to reaffirm masculinity and male intellectual superiority, at the same time entrenching women's inferior status.

Anderson, Karen. *Wartime Women: Sex Roles, Family Relations, and the Status of Women During World War II.* Westport, Connecticut: Greenwood Press, 1981.

This book examines the effects of wartime mobilization of women on family, economic, and community life in three major defence production areas – Baltimore, Seattle, and Detroit. Chapters deal with women's status at the time of the war, factory work and the problem of the double workday, the family and child care in wartime, and the long-term consequences of the war. One of the strengths of the book is its consideration of race, as well as class and gender, as an important variable in American women's wartime experiences.

Armstrong, Pat, and Hugh Armstrong. *The Double Ghetto: Canadian Women and their Segregated Work*, revised edition. Toronto: McClelland and Stewart, 1984.

This book examines women's work force participation from

1941 to 1983, using census and survey data. It discusses the structural factors limiting women's options and the effects of work on their consciousness.

Auger, Geneviève, and Raymonde Lamothe. *de la poêle à frire à la ligne de feu: la vie quotidienne des Québécoises pendant la guerre '39-'45*. Montréal: Boréal Express, 1981.
Through the study of advertising in Quebec magazines and newspapers between the years 1939-1945, the authors analyse the propagandistic use of women's images and compare their findings to the actual wartime experience of the Québécoises. By looking at their role in the home, volunteer organizations, wage labour and active service, the relationship of women in Quebec to World War II is examined. Extensive oral interviews and photographs serve to illustrate the authors' thesis that wartime images of women as strong and equal to men did not change the fundamental structures of power and women's inequality.

Bagnold, Enid. *A Diary Without Dates*. London: Virago, 1978 (first published 1918).

Beaton, Lynn. "The Importance of Women's Paid Labour: Women at Work in World War II," in Bevege *et al.*, eds., *Worth Her Salt*.
Using the experience of urban Australian women employed in war industry, Beaton argues that "the social invisibility of women is used to justify paying women lower wages than men" (p. 84). The article documents the attempts of the Women's Employment Board to rule on rates for women in the new areas of employment opened up to them through wartime mobilization: whereas the Board had awarded rates of up to 100 per cent of the male rate in these sectors, the remaining 90 per cent of women workers averaged 54 per cent of the male rate.

Beeby, Deen. "Women in the Ontario C.C.F., 1940-1950," *Ontario History*, LXXIV, 4 (December, 1982), pp. 258-83.

Berkin, Carol, and Clara Lovett, eds. *Women, War and Revolution*. New York: Holmes and Meier Publishers, 1980.
The essays in this collection deal with women's involvement in wars and revolutions from the eighteenth to the twentieth centuries in the Americas, western and eastern Europe, and China.

Bevege, Margaret, *et al.*, eds. *Worth Her Salt: Women at Work in Australia*. Sydney: Hale and Tremonger, 1982.

———— . "Some Reflections on Women's Experience in North Queensland During World War II," in *Worth Her Salt*.

Through interviews with civilian women who lived in Townsville, a Queensland army town, during the war, the author identified ways in which wartime conditions were particularly oppressive to women, curtailing their freedom of movement and suspending normal social relations between the sexes.

Bikin, Martin, and Shirley Bach. *Women in the Military*. Washington, D.C.: Brookings Institute, 1977.

The authors review historical developments, from the 1940's on, in women's role in the American military and discuss contemporary issues, including policies and attitudes, the economics of sex integration, and military effectiveness and sex composition. An appendix summarizes the situations in NATO countries, Warsaw Pact countries, Asia, Australasia, and the Middle East in the last two to three decades.

Bland, Susan M. "Henrietta the Homemaker, and 'Rosie the Riveter': Images of Women in Advertising in *Maclean's Magazine*, 1939-50," *Atlantis*, 8 (Spring, 1983), pp. 61-86.

Bland argues that Canadian women's wartime labour force participation had no lasting effects in terms of liberating them from the constraints of the domestic role. An analysis of advertising in *Maclean's* supports this claim, showing that the post-war image of women was even more domesticated than in 1939.

Boase, Wendy. *The Sky's the Limit: Women Pioneers in Aviation*. New York: Macmillan, 1979.

Biographies of noted female aviators from England, Australia, the U.S., and Germany.

Bowman, Phylis. *We Skirted the War*. Published by the author, 1975.

Memoirs of the author's CWAC experience.

Brandt, Gail Cuthbert. " 'Pigeon-Holed and Forgotten': The Work of the Sub-Committee on the Post-War Problems of Women (1943)," *Histoire sociale/Social History*, 15, 29 (May, 1982), pp. 239-59.

Braybon, Gail. *Women Workers in the First World War: The British Experience*. London: Croom Helm, 1981.

This is a feminist-socialist analysis of women's economic and social roles and women's status in British society around the time of World War I. The author discusses the connections between patriarchy and capitalism, alliances of men

across class lines to entrench sexual division of labour in both the private and public spheres, and the links between women's economic and social roles.

Brittain, Vera. *Testament of Youth: An Autobiographical Study of the Years 1900-1925.* London: Virago, 1978 (first published 1933).

During World War I, Brittain worked as a nurse in the Voluntary Aid Detachment of the Red Cross, serving in England and in field hospitals in France. Her experiences illustrated that the designation of women's place "behind the lines" did not necessarily secure their safety.

Campbell, D'Ann. *Women at War with America: Private Lives in a Patriotic Era.* Cambridge, Massachusetts: Harvard University Press, 1984.

The author explores the response of women in the U.S. to the Second World War, in the armed forces, in nursing, in war factories, in volunteer work, and in the home. Her main thesis is that the 1950's "'suburban' ideal of companionate, child-centered marriages, with little scope for careerism, can be seen as a major result of the interaction between the values of the people and the disruptions of the war."

Carriere, Gabrielle. *Careers for Women in Canada.* Toronto: J.M. Dent and Sons, 1946.

An employment manual for young women in post-World War II Canada.

Chaos of the Night: Women's Poetry & Verse of the Second World War. Selected by Catherine Reilly. London: Virago, 1984.

Chapkis, W., ed. *Loaded Questions: Women in the Military.* Washington, D.C.: Transnational Institute, 1981.

This is a collection of fourteen papers presented at the 1981 conference on women in the military sponsored by the Feminism/Socialism Project of the Transnational Institute. Most papers deal with the ideological and ethical questions surrounding the issue, in the context of international developments in women's military participation over the past two decades, with some discussion of the historical background.

Connelly, Patricia. "Female Labour Force Participation: Choice or Necessity?" *Atlantis*, 3, 2, Part 1 (Spring, 1978), pp. 40-53.

This article examines the census statistics from 1931 to 1971, arguing that in general women work outside the home not out of choice but out of economic necessity.

Conrod, W. Hugh. *Athene, Goddess of War: The Canadian Women's Army Corps, Their Story*. Dartmouth, N.S.: Writing and Editorial Services, 1983.

Douglas, W.A.B., and Brereton Greenhous. *Out of the Shadows: Canada in the Second World War*. Toronto: Oxford University Press, 1977.

Written for the general public, this readable and well-illustrated account of Canada's effort in the Second World War pays only passing attention to women's roles. It also bears witness to the post-war persistence of reducing women to sex objects. During the war the National Film Board took a series of photos of Veronica Foster, the "Bren gun girl" at the Toronto John Inglis plant, to promote women war workers. For a full-page illustration in their 1977 book, the authors have chosen one of Foster jitterbugging at a country club, which, shot from the angle of someone on the floor looking up her swirling skirts, shows her undergarments and the tops of her rolled stockings.

Dratch, Howard. "The Politics of Child Care in the 1940s," *Science and Society*, XXXVIII, 2 (Summer, 1974), pp. 167-204.

Eaton, Lt.-Col. Margaret. "The Canadian Women's Army Corps," *Canadian Geographical Journal*, 27 (December, 1943), pp. 278-85.

This article pays tribute to the activities of the CWAC during its first two years of existence and includes photographs of women in various phases of training and service.

Ellis, Jean M., with Isabel Dingman. *Facepowder and Gunpowder*. Toronto: S.J. Reginald Saunders and Co. Ltd., 1947.

The author's experiences as a member of the Nursing Auxiliary Voluntary Aid Detachment of the Red Cross, working in the First Canadian General Hospital in Normandy.

Enloe, Cynthia. *Does Khaki Become You? The Militarization of Women's Lives*. Boston: South End Press, 1983.

The author, a feminist political scientist, examines the connections between the military and women's lives by looking at female soldiers, military nurses, prostitutes, military wives, and women defence workers. The issue of the militarization of prostitution is examined over a hundred-year period, while other topics are discussed in the contemporary context, with some references to the Korean and Vietnam wars. A central theme of Enloe's analysis is that militaries have been dependent for centuries on women's

services and on specific constructions of femininity.

Gabin, Nancy. "Women Workers and the UAW in the Post-World War II Period: 1945-1954," *Labor History*, 21 (Winter, 1979-80), pp. 5-30.

_____. " 'They Have Placed a Penalty on Womanhood': The Protest Actions of Women Auto Workers in Detroit-Area UAW Locals, 1945-1947," *Feminist Studies*, 8, 2 (Summer, 1982), pp. 373-98.

Conservative interpretations of women's war work portray women as acquiescing to the loss of wartime jobs during reconversion. Gabin refutes this position by documenting the protest actions – from individual grievances to picket lines – mounted by women workers in the automotive industry. The author examines the systematic elimination of women workers in the post-war period; management strategies to achieve this goal included layoffs and violations of women's seniority rights.

Gilbert, Sandra. "Soldiers' Hearts: Literary Men, Literary Women and the Great War," *Signs*, 8, 3 (Spring, 1983), pp. 422-50.

This article examines how the literature of the period of World War I reflected a reversal in established power relations between the sexes: male writers revealed "sexual gloom" and "misogynist resentment" as they observed the liberating effects of the war on many women's lives; female writers demonstrated "sexual glee" and a sense of liberation at gaining the right to vote, entry to the professions, and access to well-paying jobs. The author terms men's wartime experience in all-male environments "No Man's Land," and women's new-found economic and sexual liberation as "Herland."

Goldman, Nancy Loring, ed. *Female Soldiers – Combatants or Non-Combatants? Historical and Contemporary Perspectives.* Contributions in Women's Studies, No. 33. Westport, Connecticut: Greenwood Press, 1982.

This is a collection of papers prepared for a 1980 international symposium by the Inter-University Seminar on Armed Forces and Society. Historical material is provided for the U.S., Great Britain, Israel, Vietnam, U.S.S.R., and some European countries. The perspective is militarist, insofar as the authors take for granted the necessity for militaries, at all times and in all contexts; it is liberal feminist

insofar as most contributors pose the "woman-in-combat" issue as a test of equal rights, while failing to question whether female participation in the perpetuation of patriarchy is a progressive step for women.

Gollan, Daphne. "The Duly and Hansford Strike, 1943: Find the Strikers," in Bevege *et al.*, eds., *Worth Her Salt.*
This is a day-by-day account of the events surrounding a ten-week strike of workers (mostly women) in a Sydney factory engaged in war production. Conflict between unionists and non-unionists, whose slogan was "No strikes in wartime," was a key issue in the strike.

Greenwald, Maurine Weiner. *Women, War and Work: The Impact of World War I on Women Workers in the United States.* Contributions in Women's Studies, No. 12. Westport, Connecticut: Greenwood Press, 1980.
This book examines employment patterns of American women from the 1870's to the 1920's, with particular attention to the war years. Chapters deal with wartime changes in women's employment, scientific management and the work of social reformers, women in railroad work, as streetcar conductors, and as telephone operators.

Greer, Rosamond "Fiddy." *The Daughters of the King's Navy.* Victoria, B.C.: Sono Nis Press, 1983.
The author's memoirs, supported by archival research, on the history of the Women's Royal Canadian Naval Service.

Gregory, Chester W. *Women in Defense Work During World War II: An Analysis of the Labor Problem and Women's Rights.* New York: Exposition Press, 1974.
This is a detailed history of American women's employment in defence production, 1941-1945. It begins by discussing policy, recruitment, training, child care, and workers' health, and proceeds to examine women workers in aircraft production plants, shipyards, steelmaking, artillery and ammunition production, and agriculture. Finally, it deals with black women's participation, comparisons of male and female performance, the equal pay issue, equal rights amendment, and women's war and post-war status.

Hacker, Barton C. "Women and Military Institutions in Early Modern Europe: A Reconnaissance," *Signs*, 6, 4 (Summer, 1981), pp. 643-71.

Hartmann, Susan M. *The Home Front and Beyond: American Women in the 1940s.* Boston: Twayne Publishers, 1982.

This is a general study of changing social and economic patterns during the 1940's and of the extent to which dramatic changes precipitated by the Second World War were, in fact, "only for the duration." Women's work in the armed forces, in war production, and in other areas of the labour force is examined in the first five chapterrs. The other topics of discussion include education, politics, law, the family, and popular culture. Hartmann concludes that the war's potential for challenging sex-role behaviour and attitudes was undermined by the conservative forces of war, the anti-feminist backlash, and the desire for "normalcy" (p. 216).

Hibbert, Joyce, ed. *The War Brides*. Toronto: Peter Martin, 1978.

This is a collection of first-person accounts of the women, mostly British, who immigrated to Canada at the end of World War II; they were the wives (and children) of Canadian servicemen who had married during overseas service. Their testimonies are grouped into six chapters: The War, Meeting their Men, Leaving Home, Canada – First Impressions, Settling In, and Home and Homesickness.

Hoiberg, Anne, ed. "Women as New 'Manpower.'" Special Issue of *Armed Forces and Society*, 4, 4 (Summer, 1978).

This collection of fifteen articles deals with the role of women in each branch of the American armed forces and briefly reviews historical developments. Results of recent research on women's experiences in sex-integrated military academies are reported.

Holm, Jeanne (Maj. Gen. USAF ret.). *Women in the Military: An Unfinished Revolution*. Novato, California: Presidio Press, 1982.

The author reviews American women's military role from 1778 to the present: Part I deals with events up to the end of World War II, Part II, to Vietnam, and Part III, the 1970's and 1980's. This is a very detailed, comprehensive account of women's participation.

Honey, Maureen. *Creating Rosie the Riveter: Class, Gender, and Propaganda during World War II*. Amherst: University of Massachusetts Press, 1984.

To understand how the post-war reaction flowed out of the war itself, the author argues that women's recruitment into the U.S. labour force was subordinated to the goal of welding "the home front into an economic army," that the prop-

agandistic image of woman as "self-sacrificing martyr" "reinforced notions about woman's traditional family role as supporter of the husband" and "promoted the idea of female self-subordination which feeds into the exploitation of women in and out of the home." She further points out that the wartime picture of the men overseas defending "the vulnerable home-maker" idealized "the male breadwinner/ female hearthkeeper" division of labour, and that propaganda's assignment of women to the role of "preservers of peacetime virtues and family life" helped identify domesticated women with post-war security and stability.

Kessler-Harris, Alice. " 'Rosie the Riveter': Who Was She?" *Labor History*, 24 (Spring, 1983), pp. 249-53.

Kiefer, Nancy. "The Impact of the Second World War on Female Students at the University of Toronto, 1939-1949" (M.A. thesis, University of Toronto, 1984).

Kingston, Nance. "My Experiences in the AWAS During World War II," in Bevege *et al.*, eds. *Worth Her Salt*.

These are the author's memories, written thirty-seven years later, of life in the Australian Women's Army Corps. Mainly descriptive rather than reflective, the article conveys some aspects of the ambience in wartime Australia.

Kogawa, Joy. *Obasan*. Toronto: Lester and Orpen Dennys, 1981.

In this novel, a Canadian woman of Japanese origin reflects upon her childhood experience of evacuation, incarceration, and resettlement during and after the Second World War. The author movingly recreates the wartime and post-war events, tracing their impact on three generations of a Japanese-Canadian family.

Martineau, Barbara Halpern. "Before the Guerillières: Women's Films at the NFB During World War II," in Seth Feldman and Joyce Nelson, eds., *Canadian Film Reader* (Toronto: Peter Martin, 1977), pp. 58-67.

The National Film Board produced several films related to women's wartime role in the armed forces and in civilian life. This article traces the struggles of NFB director Jane Marsh in the male-dominated NFB hierarchy and her influence on the content and perspective of women's war films.

Marwick, Arthur. *Women at War 1914-1918*. Fontana Paperbacks, 1977.

Mathews-Klein, Yvonne. "How They Saw Us: Images of Women

in National Film Board Films of the 1940's and 1950's," *Atlantis*, 4, 2 (Spring, 1979), pp. 20-33.

May, Martha. "The Historical Problem of the Family Wage: The Ford Motor Company and the Five Dollar Day," *Feminist Studies*, 8, 2 (Summer, 1982), pp. 399-424.
The ideology of the male-earned family wage is examined in the specific case of the Ford Motor Company at the time of World War I. May argues that the wage operates as "mediating agent between production and reproduction of labor power," and thus is more than simply an example of patriarchy. Ford's "Five-Dollar Day" was primarily a business strategy, providing male workers with an incentive to assume a stable home life.

Milkman, Ruth. "Redefining 'Women's Work': The Sexual Division of Labor in Auto Industry During World War II," *Feminist Studies*, 8, 2 (Summer, 1982), pp. 336-72.
The author illustrates how job segregation by sex can be reproduced in the face of dramatic economic change. She argues that the ideology of sex-typing resisted change despite women's high participation rate in the auto industry; without an organized feminist movement or a fully developed class consciousness among workers, there was no political basis for challenging either job segregation or underlying sexual inequality.

Minns, Raynes. *Bombers and Mash: The Domestic Front 1939-45*. London: Virago, 1980.
Minns documents the deprivations and dramas of women's experience in wartime England. Women's paid work in nurseries, factories, women's auxiliaries of the forces, and civil defence are discussed. Other topics include volunteer work, food rationing, victory gardens, economic cooking, and salvaging – all components of women's voluntary war effort. As well, Minns discusses marriage and family and post-war psychological adjustment.

Myer, Agnes. *Journey Through Chaos*. New York: Harcourt and Brace, 1944.
The author spent a year visiting twenty-seven war centres, from Buffalo to Washington. The book records her interviews and observations of wartime conditions, noting evidence of social disintegration that accompanied the nationwide war production program.

Nash, M. Teresa. "Images of Women in National Film Board

of Canada Films During World War II and the Post-War Years (1939 to 1949)" (Ph.D. dissertation, McGill University, 1982).

Nicholson, G.W.L. *Canada's Nursing Sisters*. Toronto: Samuel Stevens, Hakkert, 1975.

This is a commissioned history that deals primarily with military nursing, documenting its history but providing little analysis.

Nockels, Kate, and Rosemary Richards. "Women in the Armed Services: A Feminist Dilemma," in Bevege *et al.*, eds., *Worth Her Salt*.

The authors review developments in Australian women's position in the armed forces since the Boer War, as background for the main focus of the article, which is the contemporary feminist debate over women in combat.

Ogburn, William, ed. *American Society in Wartime*. Chicago: University of Chicago Press, 1943.

This is a collection of essays by community sociologists from the University of Chicago (Wirth, Warner, Park, Burgess, *et al.*) on the impact of war on social life. Women's wartime factory work was discussed by Ernest Burgess in his essay, "The Family": he claimed that child neglect and delinquency rates were already increasing as a result of mothers' employment.

Pierson, Ruth. " 'Home Aide': A Solution to Women's Unemployment After World War II," *Atlantis: A Women's Studies Journal*, 2, 2 (Spring, 1977-Part II: Conference Issue), pp. 85-96.

Pierson, Ruth Roach. "Canadian Women and Canadian Mobilization during the Second World War," *Revue Internationale d'Histoire Militaire*, 51 (1982), pp. 181-207.

Price, Enid. *Changes in the Industrial Occupations of Women*. Montreal: McGill University Publications, Series 6, No. 5, 1924.

This report of a study of Montreal workers provides statistical and qualitative data on women in munitions plants, railway shops, and factories during the war and post-war years. A finding of particular interest was that 22 per cent of women workers in all plants were married, and 75 per cent in the railway shops, where the union insisted that economic need should be the deciding factor in offering "man's work" to a woman.

Riley, Denise. "'The Free Mothers': Pronatalism and Working Women in Industry at the End of the Last War in Britain," *History Workshop*, 11 (Spring, 1981), pp. 58-118.

Riley argues that the recruitment of mothers into war production was ultimately damaging to liberation and egalitarianism. Pronatalist rhetoric was prompted by low birth rates in the war and post-war years: the alleged "freeing" of mothers through the provision of government child-care services during the war became, after the war, the "freeing" of women to have more children, with four per woman being the recommended number.

Roe, Kathleen Robson. *War Letters from the C.W.A.C.* Toronto: Kakabeka, 1975.

Rogan, Helen. *Mixed Company: Women in the Modern Army*. New York: G.P. Putnam's Sons, 1981.

This is a journalistic account based on the author's observations of women in training at West Point and Fort McClellan. One short chapter reviews the history of women's military involvement from ancient Greece to World War II.

Royce, Marion V. *The Effect of the War on the Life of Women*. Washington, D.C.: World's YWCA, 1945.

The author reports the results of a questionnaire investigating the impact of the war situation on the lives of women in thirteen countries where the YWCA was organized: Australia, Bolivia, Brazil, Canada, India, Jamaica, New Zealand, Nigeria, South Africa, Switzerland, Syria, Uruguay, and the U.S. Home and family life, economic status, and social and legal status were the three main areas of inquiry. A positive finding was women's "newly awakened self-confidence" in both the family and the community as a result of active role in the war effort.

Rupp, Leila. *Mobilizing Women for War: German and American Propaganda, 1939-1945*. Princeton: Princeton University Press, 1978.

This is a comparative study of the ways in which pre-war public images of women in American society, as well as the pre-war Nazi image of German women, were made to accommodate the new wartime demands on women's labour.

Rustad, Michael. *Women in Khaki: The American Enlisted Woman*. New York: Praeger Publishers, 1982.

This is a sociological investigation of women's experiences at an American military base in West Germany. The first

chapter is an historical overview of the association of women to the military and to war, organized in the following periods: women in pre-state armies (1600-1900); women as military reserves (1900-1945); and women's contemporary military roles.

Sackville-West, Vita. *The Women's Land Army*. London: Michael Joseph Ltd., 1944.

Scars Upon My Heart: Women's Poetry and Verse of the First World War. Selected by Catherine Reilly. London: Virago, 1981.

Settle, Mary Lee. *All the Brave Promises: Memories of Aircraft Woman 2nd Class 2146391*. New York: Delacorte Press, 1966.

The novelist Mary Lee Settle, an American from the southern U.S., volunteered as a young woman for service with the British Women's Auxiliary Air Force in 1942. Although deemed "officer material," she chose to remain in the ranks in protest against the extreme class snobbery of the officer corps. Her account, written twenty years after the experience, captures the grimness of Britain during wartime and the nerve-wracking nature of listening for returning planes and guiding them into base.

Shute, Carmel. "From Balaclavas to Bayonets: Women's Voluntary War Work, 1939-1941," *Hecate*, VI, 1 (1980), pp. 5-26.

Australian women's voluntary work is examined in terms of the new social meaning and ideology with which it was endowed during the war years: voluntarism served to bolster traditional sexual division of labour by reaffirming women's unpaid service role to both family and nation and at the same time labelling their work cheap and expendable.

Sinclair, Commander Adelaide. "Women's Royal Canadian Naval Service," *Canadian Geographical Journal*, 27 (December, 1943), pp. 286-91.

Skold, Karen Beck. "The Job He Left Behind: American Women in the Shipyards During World War II," in Berkin and Lovett, eds., *Women, War and Revolution*, pp. 55-75.

Skold examines how and why women entered Portland, Oregon, shipyards, compares men's and women's work, and discusses women's post-war employment plans. She shows that the majority of women were channelled into lower-paying unskilled jobs; women welders were the only exception. After the war, closing of child-care centres and

heavy layoffs resulted in women's shift to more traditional work or to domestic life, despite the fact that more than half of them wished to continue in industrial work.

Stacey, C.P. "Canadian Army in Britain," *Canadian Geographical Journal*, 26 (June, 1943), pp. 254-83.

Steele, Evelyn. *Wartime Opportunities for Women*. New York: E.P. Dutton, 1943.

This guide for women interested in careers or voluntary work related to the American war effort includes information on women's branches of the armed forces and work in industry, war production, medicine and nursing, science and engineering, the civil service, transportation, and volunteer work.

Steinson, Barbara. " 'The Mother Half of Humanity': American Women in the Peace and Preparedness Movements in World War I," in Berkin and Lovett, eds., *Women, War and Revolution*, pp. 259-81.

This article analyses the ideology of "nurturant motherhood" in the early twentieth century and discusses its application in the Women's Peace Party and the Women's Section of the Navy League. The author proposes that women's wartime activism promoted self-esteem, sisterhood, and, ultimately, feminism.

Stiehm, Judith Hicks. *Bring Me Men and Women: Mandated Change at the U.S. Air Force Academy*. Berkeley: University of California Press, 1981.

This is a study of an institution undergoing mandated change, through women's integration into the U.S. Air Force Academy following 1975 legislation. One chapter deals with the Academy's history since its establishment in 1959.

Straub, Eleanor F. "United States Government Policy Toward Civilian Women During World War II," *Prologue: The Journal of the National Archives*, 5, 4 (Winter, 1973), pp. 240-54.

Summerfield, Penny. *Women Workers in the Second World War*. London: Croom Helm, 1984.

"In a nutshell," as the author says in the Introduction to this study of official policy towards working women in Britain in the war, her "argument is that, in spite of challenge and expectation of change ..., continuity with pre-war attitudes and practices towards women was considerable in the areas of both domestic work and paid employment."

Sunahara, Ann Gomer. *The Politics of Racism: The Uprooting of*

Japanese Canadians During the Second World War. Toronto: James Lorimer, 1981.

This book analyses federal government policy during the period 1941-1950 as it was applied to the uprooting, dispossession, deportation, and dispersal of Japanese Canadians. Through the use of government documents, the author traces the development and enactment of government legislation, revealing the racist motivation behind the decisions made by Canadian politicians.

Thomas, Patricia. "Women in the Military: America and the British Commonwealth: Historical Similarities," in Hoiberg, ed., "Women as New 'Manpower,'" pp. 623-46.

A review of developments from World War I to the present.

Tobias, Sheila, and Lisa Anderson. "Whatever Happened to Rosie the Riveter?" *Ms.*, 2 (June, 1973), pp. 92-94.

This early article documents some of the same issues as Gabin's more scholarly piece: the experience of women auto workers in Detroit following the war.

Trey, Joan Ellen. "Women in the War Economy – World War II," *Review of Radical Political Economics*, 4, 3 (July, 1972), pp. 40-57.

This is another early article reviewing women's status in wartime U.S., with a brief discussion of the situation in Germany as well. Recruitment into the war effort, government child-care provision, and the relationship between feminism and the ideology of women's war and post-war obligations are examined.

Van Wagenen Keil, Sally. *The Magnificent Women in Their Flying Machines.* New York: Rawson, Wade Publishers, 1979.

This is the history of the Women's Airforce Service Pilots (WASPS): 2,000 women who trained as pilots on an all-female cadet air base in Texas from 1942 to 1944. The book records the opposition encountered by these women as they developed the flying skill necessary to fly some of the war's most dangerous missions.

von Miklos, Josephine. *I Took a War Job.* New York: Simon and Shuster, 1943.

The author's account of her experiences as a machinist in a shipyard, where she was often the only female worker.

Wade, Susan. "Joan Kennedy and the British Columbia Women's Service Corps," in Barbara K. Latham and Roberta J. Pazdro, eds., *Not Just Pin Money: Selected Essays on the*

History of Women's Work in British Columbia (Victoria: Camosun College, 1984), pp. 407-28.

Walker, Wing Officer Willa. "Royal Canadian Air Force (W.D.)," *Canadian Geographical Journal*, 27 (December, 1943), pp. 268-75.

White, Doris. *D for Doris, V for Victory*. Milton Keynes: Oakleaf Books, 1981.
This is an autobiography of the World War II years, when Doris White was a young woman evacuated from London following the 1940 raids, to take up residence and employment in rural Buckinghamshire. Her work at the railway engineering works during the war years involved repairing damaged aircraft, formerly "a man's world." The hardships and constraints of the war and White's relationships with co-workers and servicemen form the main themes.

Wilson, Barbara M., ed. *Ontario and the First World War 1914-1918*. Toronto: University of Toronto Press, 1977.
This is a collection of documents edited with an introduction by Wilson. Relevant to women's part in the war effort are items on the Women's Emergency Corps, the Women's Volunteer Emergency Auxiliary, and the Women's Convention on Food Conservation.

Women at War, comp. and ed. by J. Herbert Hodgins, David B. Crombie, Eric Crawford, and R.B. Ruestis, with cooperation of the Department of Munitions and Supply and the National Film Board. Toronto: The Maclean Publishing Co. Ltd., 1943.
The republication between hard covers of the May, June, July, 1943, special "Women at War" issues of *Mayfair*.

Zeigler, Mary. *We Serve That Men May Fly: The Story of the Women's Division Royal Canadian Air Force*. Hamilton, Ontario: RCAF (WD) Association, 1973.

Notes

Abbreviations

AG	Adjutant-General
CGS	Chief of the General Staff
CMHQ	Canadian Military Headquarters, London, England
CWAC	Canadian Women's Army Corps
DG, CWAC	Director-General, Canadian Women's Army Corps
DGMS	Director-General of Medical Services
DMO	District Medical Officer
DMS	Director of Medical Services, London, England
DMS, DP & NH	Director of Medical Services, Department of Pensions and National Health
DND	Department of National Defence
DOC	District Officer Commanding
DP & NH	Department of Pensions and National Health
DVDCO	District Venereal Disease Control Officer
FR & I	Financial Regulations and Instructions, Armed Forces of Canada
GO	General Order
MD	Military District
MGO	Master-General of the Ordnance
NDHQ	National Defence Headquarters, Ottawa, Ontario
O/A, CWAC	Officer Administering, Canadian Women's Army Corps
PAC	Public Archives of Canada
QMG	Quartermaster General
RCAF (WD)	Royal Canadian Air Force (Women's Division)
RCAMC	Royal Canadian Army Medical Corps
RO	Routine Order
RVDCO	Regional Venereal Disease Control Officer
VDC	Venereal Disease Control
WRCNS	Women's Royal Canadian Naval Service

Introduction

1. Eleanor F. Straub, "United States Government Policy Toward Civilian

Women During World War II," *Prologue: The Journal of the National Archives*, 5, 4 (Winter, 1973), p. 240.

2. "Hardy perennials!", readers will recall, is the title Nellie McClung gave to her chapter on some of the most common prejudices regarding women in *In times like these* (Toronto: University of Toronto Press, 1972; originally published in 1915), pp. 43-58.

3. Elizabeth Janeway, "On the Power of the Weak," *Signs: Journal of Women in Culture and Society*, 1, 1 (Autumn, 1975), pp. 103-09.

4. Contributions in Women's Studies, No. 33 (Westport, Conn.: Greenwood Press, 1982).

5. "Germany and the World Wars," in *Female Soldiers*, pp. 47-60.

6. "Japan: Cautious Utilization," in *Female Soldiers*, p. 179.

7. "The Argument for Female Combatants," in *Female Soldiers*, p. 282.

8. "Introduction," *Female Soldiers*, pp. 3-17; Anne Eliot Griesse and Richard Stites, "Russia: Revolution and War," in *Female Soldiers*, pp. 61-84; Barbara Jancar, "Yugoslavia: War of Resistance," in *Female Soldiers*, pp. 85-106; William J. Duiker, "Vietnam: War Insurgency," in *Female Soldiers*, pp. 107-22.

9. G.W.L. Nicholson's *Canada's Nursing Sisters* (Toronto: Samuel Stevens, Hakkert, 1975) is an example of a carefully researched and documented regimental history. W. Hugh Conrod's *Athene, Goddess of War: The Canadian Women's Army Corps* (Dartmouth, N.S.: Writing and Editorial Services, 1983) also purports to be a regimental history, and indeed contains a great deal of valuable information about the Corps, as well as many personal reminiscences and excerpts from scrapbooks, but too much of the material the author has collected remains undigested. Large portions of military records as well as of the *C.W.A.C. News Letter* are reproduced verbatim, frequently without identification or citation of source, and little attempt has been made to eliminate inconsistences. Both Nicholson's and Conrod's works are lacking in analysis.

10. The term "moral panic" was first used by Stan Cohen in *Folk Devils and Moral Panics* (London: MacGibbon and Kee, 1972), a study of British society's response to youth in the fifties and sixties, and later employed by Jeffrey Weeks in *Sex, Politics and Society: The regulation of sexuality since 1800* (London: Longman, 1981). I have borrowed Cohen's definition as quoted in Weeks, p. 4.

11. Lucy Bland, " 'Guardians of the race,' or 'Vampires upon the nation's health'?: Female sexuality and its regulation in early twentieth-century Britain," in Elizabeth Whitelegg *et al.*, eds., *The Changing Experience of Women* (Oxford: Martin Robertson in association with The Open University, 1982), pp. 373-88.

12. Sheila Ryan Johansson, " 'Herstory' as History: A New Field or Another Fad?", in Berenice A. Carroll, ed., *Liberating Women's History: Theoretical and Critical Essays* (Urbana: University of Illinois Press, 1976), pp. 400-30.

13. For instance, J.L. Granatstein, *Canada's War: The Politics of the Mackenzie*

King Government, 1939-1945 (Toronto: Oxford University Press, 1975), although concerned with the government's policies with respect to manpower shortages, makes no mention of the creation of National Selective Service in general or of the Women's Division of NSS in particular. Nowhere does the unprecedented mobilization of women's labour for the war effort figure in this study of the politics of Canada's wartime government.

14. Nancy Kiefer, "The Impact of the Second World War on Female Students at the University of Toronto, 1939-1949" (M.A. Thesis, University of Toronto, 1984), pp. 44, 48, 38, 2.

15. *The Review of Radical Political Economics*, 4, 3 (July, 1972), pp. 40-57.

16. *Science and Society*, XXXVIII, 1 (Summer, 1974), pp. 167-204.

17. (Ph.D. dissertation, Emory University, 1973), quoted in Karen Anderson, *Wartime Women: Sex Roles, Family Relations, and the Status of Women During World War II*, Contributions in Women's Studies, No. 20 (Westport, Conn.: Greenwood Press, 1981), p. 10. See also Eleanor F. Straub, "United States Government Policy Toward Civilian Women During World War II," *Prologue: The Journal of the National Archives*, 5, 4 (Winter, 1973), pp. 240-54.

18. "Whatever Happened to Rosie the Riveter?" *Ms.*, 2 (June, 1973), pp. 92-94.

19. Anderson, *Wartime Women*, pp. 155, 172.

20. Susan M. Hartmann, *The Home Front and Beyond: American Women in the 1940s* (Boston: Twayne Publishers, 1982), p. 87.

21. Geraldine Finn, "Questions of Appearance," review of *Femininity*, by Susan Brownmiller (Linden Press/Simon and Schuster, 1984), in *Canadian Forum*, LXIV, 741 (August/September, 1984), p. 45.

22. Patricia Allatt, "Men and War: Status, Class and the Social Reproduction of Masculinity," in Eva Gamarnikow *et al.*, eds., *The Public and the Private* (London: Heinemann, 1983), p. 6.

23. Anderson, *Wartime Women*, pp. 110, 111.

24. Hartmann, *The Home Front and Beyond*, p. 212.

25. See Mattie E. Treadwell, *United States Army in World War II, Special Studies: The Women's Army Corps* (Washington, D.C.: Department of the Army, 1954), pp. 195-218.

Chapter 1, Recruitment of Women into the War Effort

1. Barry Broadfoot, *Six War Years 1939-1945: Memories of Canadians at Home and Abroad* (Toronto: Doubleday Canada, 1974), p. 353. Work is beginning to be done on the relation of women's wartime employment to the long-term trends in women's participation in the labour force. See Hugh and Pat Armstrong, "The Segregated Participation of Women in the Canadian Labour Force, 1941-1971," *Canadian Review of Sociology and Anthropology*, 12, 4, part 1 (November, 1975), pp. 370-84; Paul Phillips, "Women in the Manitoba Labour Market: A Study of the

Changing Economic Role (or 'plus ça change, plus la même')," paper given at the Western Canadian Studies Conference, University of Calgary, February 27-28, 1976; and, for the First World War, Ceta Ramkhala- wansingh, "Women during the Great War," in *Women at Work: Ontario 1850-1930* (Toronto: Canadian Women's Educational Press, 1975), pp. 261-307.

2. Betty Friedan, *The Feminine Mystique* (New York: W.W. Norton and Company, 1963). For the impact of *The Feminine Mystique* on Canadian society, see the report of the *Royal Commission on the Status of Women in Canada* (Ottawa: Information Canada, 1970), p. 2.

3. Chapter on "Employment of Women and Day Care of Children" (completed sometime before August 24, 1950), Part 1, pp. 5-6, in the "History of the Wartime Activities of the Department of Labour," Public Archives of Canada [PAC], RG 35, Series 7, Vol. 20, file 10. Hereafter cited as "Wartime History of Employment of Women" or "Wartime History of Day Care of Children."

4. "The Development of the National Selective Service (Civilian) Organ- ization in World War II to December 31, 1945," n.d., p. 7, PAC, RG 35, Series 7, Vol. 19, file 2; "History of the National Employment Service 1939-1945," n.d., p. 5, PAC, RG 35, Series 7, Vol. 19, file 3.

5. "Wartime History of Employment of Women," p. 6.

6. PAC, RG 27, Vol. 605, file 6-24-1, vol. 1.

7. "Wartime History of Employment of Women," p. 15. Emphasis mine.

8. Government Notice, September 8, 1942, Registration of Women, Order, Department of Labour/National Selective Service, PAC, RG 27, Vol. 605, file 6-24-1, vol. 1. By Order-in-Council PC 1955 (March 13, 1942), every employer subject to the Unemployment Insurance Act (August 7, 1940) was required to register all persons in his employ on forms provided by the Unemployment Insurance Commission. "History of the National Employment Service 1939-1945," p. 6.

9. "Wartime History of Employment of Women," p. 16.

10. "Listing of Women Starts September 14, Says Mrs. Eaton," *The Globe and Mail*, August 21, 1942, p. 12; "Mrs. Rex Eaton Announces Registration of Canadian Women," PAC, RG 27, Vol. 605, file 6-24- 1, vol. 1.

11. *Ibid*.

12. A. Chapman, "Female Labour Supply Situation," December 15, 1942, PAC, RG 27, Vol. 605, file 6-24-1, vol. 1.

13. *Ibid*.

14. General Report on National Selective Service - Employment of Women, November 1, 1943, PAC, RG 27, Vol. 605, file 6-24-1, vol. 2.

15. Chapman, "Female Labour Supply Situation," December 15, 1942.

16. General Report on NSS - Employment of Women, November 1, 1943.

17. "Wartime History of Employment of Women," p. 8.

18. General Report on NSS - Employment of Women, November 1, 1943.

19. A. Chapman's phraseology.

20. Letter of May 18, 1943, from Mary Eadie, Supervisor, Women's Division, Employment and Selective Service Office, Toronto, to Mrs. Norman C. Stephens, President, Local Council of Women, Toronto, PAC, RG 27, Vol. 605, file 6-24-1, vol. 1.

21. General Report on NSS – Employment of Women, November 1, 1943.

22. "Wartime History of Employment of Women," p. 20.

23. Memorandum of May 7, 1943, from Mary Eadie, Supervisor, Women's Division, Toronto, to Mr. B.G. Sullivan, Ontario NSS Regional Superintendent, PAC, RG 27, Vol. 605, file 6-24-1, vol. 1.

24. "Wartime History of Employment of Women," p. 20.

25. Report on Recruitment of Part-Time Workers – Toronto, by Mrs. Rex Eaton to the NSS Advisory Board, July 28, 1943, PAC, RG 27, Vol. 605, file 6-24-1, vol. 1.

26. Letter of May 22, 1943, from Mary Eadie to Mrs. Rex Eaton, PAC, RG 27, Vol. 605, file 6-24-1, vol. 2.

27. The National Council of Women of Canada is a federation of women's organizations, organized nationally, provincially, and locally. For its early history, see Veronica Strong-Boag, *The Parliament of Women: The National Council of Women in Canada, 1893-1929* (Ottawa: The National Museum of Man/History Division, 1976).

28. Letter of September 8, 1943, from Mrs. Rex Eaton to Mrs. H.L. Stewart of the Local Council of Women, Halifax, PAC, RG 27, Vol. 605, file 6-24-1, vol. 2.

29. Report on Recruitment of Part-Time Workers – Toronto, by Mrs. Rex Eaton to the NSS Advisory Board, July 28, 1943.

30. "Wartime History of Employment of Women," p. 22.

31. Report on Recruitment of Part-Time Workers – Toronto, by Mrs. Rex Eaton to the NSS Advisory Board, July 28, 1943.

32. NSS Circular No. 270-1, August 18, 1943, Employment of Women– – Campaign for Part-Time Women Workers, PAC, RG 27, Vol. 605, file 6-24-1, vol. 2.

33. Draft letter of August 31, 1943, signed by Mr. A. MacNamara and Mrs. Rex Eaton to be sent to Local Councils of Women, PAC, RG 27, Vol. 605, file 6-24-1, vol. 2.

34. "Appeal to Women to Take Part-Time Jobs in Essential Civilian Work," Radio Address, September 20, 1943, Public Archives of Nova Scotia, RG 35-102, Elective Municipal Government Records, Series 2, Section B. Vol. 16, no. 178, Correspondence of the Mayor of Halifax with the Women's Voluntary Services, 1943-1945.

35. "Wartime History of Employment of Women," p. 23.

36. *Ibid.*, pp. 20-21.

37. Draft letter of August 31, 1943, signed by Mr. A. MacNamara and Mrs. Rex Eaton, to be sent to Local Councils of Women.

38. "Wartime History of Employment of Women," p. 24.

39. Mrs. Rex Eaton's Report to the NSS Advisory Board on Recruitment of Women for Work in War Industries, July 28, 1943, PAC, RG 27, Vol. 605, file 6-24-1, vol. 1.

40. Letter of August 16, 1943, from B.G. Sullivan, Ontario Regional Superintendent, to Mrs. Rex Eaton, PAC, RG 27, Vol. 605, file 6-24-1, vol. 2.

41. Minutes of July 26, 1943, Toronto, meeting of NSS with local Employers about the Campaign for War Plants, PAC, RG 27, Vol. 605, file 6-24-1, vol. 2.

42. Letter of September 1, 1943, from Mrs. Rex Eaton, to Mr. A. MacNamara, with copy to Humphrey Mitchell, PAC, RG 27, Vol. 605, file 6-24-1, vol. 2.

43. Memorandum of September 22, 1943, from Mrs. Rex Eaton, to Mr. A. MacNamara, PAC, RG 27, Vol. 605, file 6-24-1, vol. 2.

44. Letter of October 13, 1943, from Mrs. Eaton, to Mme. Florence F. Martel, NSS, Montreal, PAC, RG 27, Vol. 605, file 6-24-1, vol. 2.

45. "Wartime History of Employment of Women," p. 23.

46. Minutes of Employers' Committee Meeting held on November 2, 1943, in Mr. Leonard Prefontaine's office, re. Recruiting Campaign for Women War Workers, PAC, RG 27, Vol. 1508, file 40-5-1.

47. Letter of December 2, 1943, from V.C. Phelan, Director of Information, Information Division, Department of Labour, to Mr. MacNamara, PAC, RG 27, Vol. 615, file 17-5-11, vol. 1.

48. "Wartime History of Employment of Women," p. 25.

49. Memorandum of May 8, 1944, from Mrs. Rex Eaton, to Mr. A. MacNamara, PAC, RG 27, Vol. 605, file 6-24-1, vol. 3.

50. "Wartime History of Employment of Women," p. 25.

51. Letter of August 8, 1944, from Gordon Anderson, Public Relations Officer, Department of Labour, to Mr. Arthur MacNamara, Deputy Minister, Department of Labour, PAC, RG 27, Vol. 615, file 17-5-11, vol. 1.

52. "Wartime History of Employment of Women," p. 26.

53. Ibid.

54. Memorandum of July 25, 1944, from Mrs. Kate Lyons, Supervisor of Women's Work, Edmonton, to Mrs. Rex Eaton, PAC, RG 27, Vol. 605, file 6-24-1, vol. 3.

55. NSS Report on "Wartime Employment of Women in Canadian Agriculture," August 17, 1944, PAC, RG 27, Vol. 985, file 7.

56. Ibid.

57. Although the war did see a rise in the collective provision of domestic services, such as communal kitchens and commercial laundries, their main purpose was to ease the burden on women working outside the home in essential industries, who still had primary responsibility for their families' domestic chores.

58. Labour Gazette, Vol. 42 (1942).

59. Issued by Public Information, for National Salvage Office, Ottawa, under

authority of Hon. J.G. Gardiner, Minister of National War Services, PAC, APC C-87541.

60. PAC, Department of National War Services, RG 44, Vol. 34, file "Appointment of a Director"; Department of National War Services, "Wartime History of the Women's Voluntary Services Division," PAC, RG 35, Series 7, Vol. 18.

61. Alice Sorby, "A Volunteer Bureau Emerges," *Junior League Magazine*, October, 1940, pp. 51-52.

62. PAC, RG 44, Vol. 6, file "Canadian Women's Voluntary Services (Ontario Division)"; Vol. 34, file "W.V.S. - Reorganization."

63. Thelma LeCocq, "Lady in Control," *Maclean's*, August 1, 1942, pp. 7, 29-30; RG 44, Vol. 3, file "Fats Salvage Advisory Committee."

64. Marjorie Winspear, "Canadian Women Take to the Block Plan," *National Home Monthly*, July, 1943, pp. 45-46.

65. "Christmas 'Warsages' by W.V.S.," *Saturday Night*, December 16, 1944, p. 31.

66. PAC, RG 44, Vol. 34, file "National Week."

67. PAC, RG 44, Vol. 33, Women's Voluntary Services General, vol. 11.

68. B.C. Provincial Archives, Add. MSS. 174, vol. 1, Women's Institute, Burton, B.C., Minute Books, 1912-1950, Meeting of September 28, 1942.

69. "Report on War Services, F.W.I.C., 1943-1945," presented June 1945 by Convenor for War Services for the F.W.I.C., Mrs. E.E. Morton, Vegreville, Alberta, PAC, RG 44, vol. 45, file "Women's Institute – Alberta"; "Mrs. E.E. Morton of Vegreville To Give War Services Report," *Edmonton Journal*, June 2, 1945.

70. Women's Voluntary Services, Regina Centre, "Report of Voluntary Services in Regina, 1941-1946," Provincial Archives of Saskatchewan. See also Joyce Hibbert, ed., *The War Brides* (Toronto: Peter Martin, 1978).

71. Lillian D. Millar, "Price Control Depends Largely on the Women," *Saturday Night*, October 10, 1942, p. 20; Lillian D. Millar, "Has This Structure of a Million Women Post-War Potentialities?" *Saturday Night*, July 8, 1944, pp. 22-23.

72. For an excellent account of its composition and functioning, see Gail Cuthbert Brandt, " 'Pigeon-Holed and Forgotten': The Work of the Sub-committee on the Post-War Problems of Women, 1943," *Histoire sociale/Social History*, XV, 29 (May, 1982), pp. 239-59.

73. PAC, MG 28, I 25, Vol. 83, letter of April 23, 1943, from Jessie I.A. Archer, Corresponding Sec., Local Council of Women of Toronto, to Miss Beatrice Barber, Hon. Cor. Sec., National Council of Women.

74. PAC, MG 28, I 25, Vol. 85, letter of March 14, 1944, to Humphrey Mitchell, Minister of Labour, from Miss Beatrice Barber, Hon. Cor. Sec., National Council of Women; letter of March 24, 1944, to Miss Beatrice Barber, Hon. Cor. Sec., National Council of Women, from H.R.L. Henry, Private Secretary, Office of the Prime Minister.

75. Clement W. Cook, "Problems of the Wartime Advertising Campaign," *Canadian Business* (March, 1944), pp. 56-57, 170, 172.

76. *Maclean's*, November 15, 1942, p. 50.

77. Poster C 94056, PAC, Picture Archives Branch.

78. *Maclean's*, April 1, 1943, p. 44.

79. *National Home Monthly*, August, 1943, p. 34.

80. *Maclean's*, May 15, 1942, p. 48.

81. Poster C 93633, PAC, Picture Archives Branch.

82. *Maclean's*, July 1, 1942, p. 28.

83. General Report of NSS – Employment of Women, November 1, 1943.

84. "Wartime History of Employment of Women," p. 8.

85. "Comments re Wartime Programme," p. 5, Preface to "Wartime History of Employment of Women."

86. NSS Report on "Wartime Employment of Women in Canadian Agriculture," April 17, 1944.

87. Draft letter of August 31, 1943, signed by Mr. A. MacNamara and Mrs. Rex Eaton, to be sent to Local Councils of Women.

88. NSS Circular No. 270-1, August 18, 1943, Employment of Women – Campaign for Part-Time Women Workers.

89. December 1943 Design for Full-Page Newspaper Ad. to Recruit Women for War Industry, PAC, RG 27, Vol. 615, file 17-5-11, vol. 1.

90. Memorandum of May 9, 1944, from Mrs. Rex Eaton, to Mr. A. MacNamara, with Suggested Draft Circular re Tightening of NSS Regulations for Women, PAC, RG 27, Vol. 605, file 6-24-1, vol. 3.

91. Moffats "Help Wanted" Campaign Breaking July 20, 1944, PAC, RG 27, Vol. 615, file 17-5-11, vol. 1.

92. Memorandum of March 5, 1943, from Renée Morin, NSS Montreal, to Mrs. Rex Eaton, PAC, RG 27, Vol. 605, file 6-24-1, vol. 1.

93. Letter of April 8, 1943, from B.G. Sullivan, Ontario Regional Superintendent, NSS, to Mrs. Rex Eaton, PAC, RG 27, Vol. 605, file 6-24-1, vol. 1. Unfortunately, Sullivan's report of the questionnaire results does not give the number of women questioned.

94. Memorandum of May 11, 1943, from Percy A. Robert, Montreal, to Mrs. Eaton and Mr. Goulet, PAC, RG 27, Vol. 605, file 6-24-1, vol. 1.

95. Memorandum of April 30, 1943, from Dr. F.H. Sexton, Director of Technical Education, Department of Education, Technical Education Branch, Province of Nova Scotia, PAC, RG 27, Vol. 605, file 6-24-1, vol. 1.

96. December 1943 Design for Full-Page Newspaper Ad. to Recruit Women for War Industry.

97. PAC, RG 27, Vol. 615, file 17-5-11, vol. 1.

98. "The Income Tax Change Applying to Married Employees in 1947," n.d., PAC, RG 27, Vol. 66, file 6-24-11.

99. Letter of November 7, 1946, from A. MacNamara, Deputy Minister of Labour, to Mr. Fraser Elliott, Deputy Minister of National Revenue, PAC, RG 27, Vol. 606, file 6-24-11.

100. "Income Tax Change Benefits Employed Married Women/Aims to Keep Wives from Quitting Posts," *The Globe and Mail*, July 16, 1942, p. 1.

101. Explanation received from the Minister of Finance, J.L. Ilsley, by Douglas Hallam, Secretary of the Primary Textiles Institute, Toronto, and conveyed in his letter of November 4, 1946, to Humphrey Mitchell, Minister of Labour, and in his letter of November 13, 1946, to A. MacNamara, Deputy Minister of Labour, PAC, RG 27, Vol. 606, file 6-24-11.

102. Full-page advertisement "To the Man and Wife Who are Both Working," *London Free Press*, December 26, 1946, promoted through the Employer Relations Division of the Unemployment Insurance Commission Office, London, Ontario, and sponsored by the London Chamber of Commerce, PAC, RG 27, Vol. 606, file 6-24-11.

103. Minutes of the January 24, 1947, Meeting of the Vernon Local Employment Committee, a copy of which was sent to officials in the Departments of Labour and National Revenue, PAC, RG 27, Vol. 606, file 6-24-11.

104. J.R. Moodie Company, Hamilton. Information conveyed in memorandum of April 17, 1947, from Margaret McIrvine, Acting Regional Employment Adviser, UIC, Toronto, to B.G. Sullivan, Ontario Regional Superintendent, PAC, RG 27, Vol. 606, file 6-24-11.

105. Memorandum of December 31, 1946, from George G. Greene, Private Secretary, Department of Labour, to A. MacNamara, Deputy Minister of Labour, PAC, RG 27, Vol. 606, file 6-24-11.

106. Memorandum of January 30, 1947, from W.L. Forrester, Manager, Local Employment Office, Prince George, B.C., to William Horrobin, Pacific Regional Employment Officer, PAC, RG 27, Vol. 606, file 6-24-11.

107. School Board of Charlotte County, New Brunswick, Information communicated in a telegram of November 7, 1946, from A.N. McLean, Saint John, New Brunswick, to A. MacNamara, Deputy Minister of Labour, PAC, RG 27, Vol. 606, file 6-24-11.

108. T. Eaton Company Ltd., Toronto, reported that 453 married women had left their employ since January 1, 1947. Information in a letter of April 26, 1947, from G.W. Ritchie, Chairman, Ontario Regional Advisory Board (Department of Labour), to A. MacNamara, Deputy Minister of Labour, PAC, RG 27, Vol. 606, file 6-24-11.

109. Letter of February 12, 1947, from A. MacNamara, to F. Smelts, Chairman, Pacific Regional Advisory Board, Department of Labour, PAC, RG 27, Vol. 606, file 6-24-11.

110. Letter of November 13, 1946, to A. MacNamara, from Douglas Hallam, Secretary, Primary Textiles Institute, Toronto, PAC, RG 27, Vol. 606, file 6-24-11.

111. "The Income Tax Change Applying to Married Employees in 1947," n.d., PAC, RG 27, Vol. 606, file 6-24-11.

112. Ten Points Enumerated in the Prime Minister's Speech of March 24, 1942, with a View to Bringing Women into Industry, PAC, RG 27, Vol. 605, file 6-24-1, vol. 1.

113. According to the 1931 census, there were 128,132 married women, including those divorced or widowed, who were gainfully occupied. Less

than half that number were married women living with their husbands. In 1941, the single women who were working outside their own homes numbered about 688,000, and the others, 166,000. Letter of September 23, 1943, from the Chief, Legislation Branch, Department of Labour, Ottawa, to Miss Marion Royce, Secretary for Young Adult Membership, World's Young Women's Christian Association, Washington, D.C., PAC, RG 27, Vol. 610, file 6-52-2, vol. 2.

114. Memorandum of June 13, 1942, from Mrs. Rex Eaton, to Mr. George Greene, Private Secretary to the Minister of Labour, Ottawa, PAC, RG 27, Vol. 609, file 6-52-1, vol. 1.

115. Report on Day Care of Children, July 1, 1943, PAC, RG 27, Vol. 609, file 6-52-1, vol. 1.

116. Mrs. Eaton's memorandum of June 13, 1942, to Mr. George Greene.

117. "Need for Day Nurseries," Editorial, *The Globe and Mail*, July 16, 1942, p. 6.

118. Mrs. Eaton's memorandum of June 13, 1942, to Mr. George Greene.

119. Letter of April 30, 1942, from E.M. Little, Director of NSS, to G.S. Tattle, Deputy Minister, Department of Public Welfare, Ontario, PAC, RG 27, Vol. 611, file 6-52-1, vol. 1.

120. Letter of May 14, 1942, from Fraudena Eaton, to E.M. Little, Director of NSS, PAC, RG 27, Vol. 609, file 6-52-1, vol. 1.

121. Letter of April 28, 1942, from George F. Davidson, Executive Director, The Canadian Welfare Council, to Mr. E.M. Little, Director, NSS, PAC, RG 27, Vol. 609, file 6-52-1, vol. 1.

122. Memorandum of April 30, 1942, to E.M. Little, Director of NSS, and R.F. Thompson, Supervisor of Training, Training Branch, Department of Labour, subject: Conference with Dr. W.E. Blatz, Director of the Institute of Child Study of the University of Toronto, PAC, RG 27, Vol. 609, file 6-52-1, vol. 1.

123. Report on "Day Care of Children," July 1, 1943, no authorship specified, PAC, RG 27, Vol. 609, file 6-52-1, vol. 1.

124. Letter of March 17, 1943, from Miss Margaret Grier, Assistant Director NSS, to H.F. Caloren, Assistant Director of Administrative Services, Department of Labour, PAC, RG 27, Vol. 609, file 652-1, vol. 1.

125. Memorandum of November 10, 1943, from Mrs. Rex Eaton, to Mr. V.C. Phelan, Director of Information, Information Division, Department of Labour, PAC, RG 27, Vol. 609, file 6-52-1, vol. 1.

126. Letter of April 27, 1944, from Mrs. E.C. (Marjorie) Pardee, Representative of NSS on the Albertan Provincial Advisory Committee on Day Nurseries, to Mrs. Rex Eaton, PAC, RG 27, Vol. 611, file 6-52-9.

127. PAC, RG 27, Vol. 611, file 6-52-9.

128. Mothers were charged fees under the agreement. For day nursery care, mothers in Ontario paid 35 cents per day for the first child, 15 cents for additional children; in Quebec, 35 cents per day for the first child, 20 cents for additional children. Where both parents were working, the fee was 50 cents per child. For day care of school children, mothers in

Ontario were charged 25 cents per day for the first child, 10 cents for additional children. No school projects were established in Quebec. Memorandum of May 27, 1943, from Mrs. Rex Eaton, to Mr. George Greene, Private Secretary to the Minister of Labour, PAC, RG 27, Vol. 609, file 6-52-1, vol. 1.

129. Memorandum of February 8, 1943, from Mrs. Rex Eaton, to Mr. A. MacNamara, PAC, RG 27, Vol. 609, file 6-52-1, vol. 1.

130. Letter of March 17, 1943, from Miss Margaret Grier, to H.F. Caloren, Assistant Director of Administrative Services, Department of Labour, PAC, RG 27, Vol. 609, file 6-52-1, vol. 1.

131. "Wartime History of Day Care of Children," p. 3, PAC, RG 35, series 7, vol. 20, file 10; Memorandum of February 8, 1943, from Mrs. Rex Eaton, to Mr. A. MacNamara, PAC, RG 27, Vol. 609, file 6-52-1, vol. 1.

132. Memorandum of June 16, 1943, from Mrs. Eaton, to Mr. Eric Strangroom, in response to request for information on Day Nurseries for the Minister of Labour, PAC, RG 27, Vol. 609, file 6-52-1, vol. 1; NSS Circular No. 291, October 15, 1943, on Women Workers – Day Care of Children, PAC, RG 27, Vol. 610, file 6-52-2, vol. 2.

133. Memorandum of March 4, 1943, from Mrs. Rex Eaton, to Mr. A. MacNamara, PAC, RG 27, Vol. 610, file 6-52-2, vol. 2.

134. July 1943 Monthly Summary of Dominion-Provincial Wartime Day Nurseries, Ontario, PAC, RG 27, Vol. 611, file 6-52-6-1, vol. 1.

135. September 1943 Monthly Summary of Dominion-Provincial Wartime Day Nurseries, Ontario, PAC, RG 27, Vol. 611, file 6-52-6-1, vol. 1.

136. Mary Weeks, "Nursery Schools in Canada Have Come to Stay," *Saturday Night*, February 26, 1944, p. 4; Marjorie Winspear, "The New Fashioned Woman: Angels in Nurseries," *National Home Monthly*, February, 1943, pp. 44-46; Frances Thompson, "On the Kitchen Front: Nursery Nutrition," *National Home Monthly*, February, 1943, pp. 36-38; Anne Fromer, "Caring for Children of War-Working Mothers," *Saturday Night*, October 24, 1942, pp. 22-23.

137. Memorandum of November 10, 1944, from Mrs. Rex Eaton, to Mr. V.C. Phelan, PAC, RG 27, Vol. 609, file 6-52-1, vol. 1.

138. Survey of the Dominion-Provincial Wartime Day Nursery Programme in Ontario, submitted on October 29, 1945, to Mr. B. Beaumont, Director of Child Welfare, Department of Public Welfare, Ontario, by Miss Dorothy A. Millichamp, Organizing Secretary, Wartime Day Nurseries, Department of Public Welfare, Ontario, PAC, RG 27, Vol. 611, file 6-52-6-1, vol. 3.

139. Report of the Quebec Ministry of Health on the Dominion-Provincial Wartime Day Nurseries, November 15, 1946, PAC, RG 27, Vol. 611, file 6-52-5-2, vol. 2.

140. Memorandum of July 7, 1945, from Margaret Grier, to Miss Norris, PAC, RG 27, Vol. 609, file 6-52-1, vol. 2.

141. Letter of April 30, 1942, from E.M. Little, Director of NSS, to G.S. Tattle,

Deputy Minister, Department of Public Welfare, Ontario, PAC, RG 27, Vol. 611, file 6-52-6-1, vol. 1.

142. Memorandum of May 22, 1942, on Proposals for Day Nurseries for Mothers Working in War Industry, for file in Deputy Minister's Office, Department of Labour, PAC, RG 27, Vol. 609, file 6-52-1, vol. 1.

143. Memorandum of June 13, 1942, from Mrs. Rex Eaton, to Mr. E.M. Little, Director, NSS, PAC, RG 27, Vol. 609, file 6-52-1, vol. 1.

144. "Wartime History of Day Care of Children," Appendix, Part 2.

145. NSS Circular No. 291, October 15, 1943, on Women Workers – Day Care of Children.

146. Report on "Day Care of Children," July 1, 1943.

147. PAC, RG 27, Vol. 610, file 6-52-2, vol. 1.

148. Minutes of the June 10, 1943, Conference on the Day Care of Children, Confederation Building, Ottawa, PAC, RG 27, Vol. 609, file 6-52-1, vol. 1.

149. Memorandum of May 19, 1943, from Mrs. Eaton, to Mr. A. MacNamara, PAC, RG 27, Vol. 610, file 6-52-2, vol. 1, and RG 27, vol. 1508, file 40-5-6.

150. "An Inequitable Division," Editorial, *The Globe and Mail*, October 28, 1943, p. 6.

151. Memorandum of December 1, 1943, from Mrs. Rex Eaton, to Mr. A. MacNamara, PAC, RG 27, Vol. 610, file 6-52-2, vol. 3.

152. *Ibid.*

153. Memorandum of November 22, 1943, from Mrs. Rex Eaton, to Mr. A. MacNamara, PAC, RG 27, Vol. 1508, file 40-5-6.

154. Memorandum of December 1, 1943, from Mrs. Rex Eaton, to Mr. A. MacNamara.

155. Order-in-Council PC 2503, April 6, 1944, PAC, RG 27, Vol. 610, file 6-52-2, vol. 4; Order-in-Council PC 3733, May 18, 1944, PAC, RG 27, Vol. 610, file 6-52-2, vol. 5.

156. PAC, RG 27, Vol. 609, file 6-52-1, vol. 2.

157. Memorandum of August 30, 1945, from W.S. Boyd, National Registration, Department of Labour, Ottawa, to Mrs. Rex Eaton, PAC, RG 27, Vol. 609, file 6-52-1, vol. 2.

158. PAC, RG 27, Vol. 609, file 6-52-1, vol. 2.

159. *Ibid.*

160. Letter of September 20, 1945, from Miss Gwyneth Howell, Assistant Executive Director, Montreal Council of Social Agencies, to Miss Margaret Grier, PAC, RG 27, Vol. 611, file 6-52-5-2, vol. 2.

161. Letter of October 3, 1945, from Renée Morin, NSS Welfare Officer, to Miss M. Grier, PAC, RG 27, Vol. 611, file 6-52-1, vol. 2.

162. PAC, RG 27, Vol. 609, file 6-52-1, vol. 2.

163. Letter of October 3, 1945, from Renée Morin, NSS Welfare Officer, Montreal, to Miss M. Grier, PAC, RG 27, Vol. 611, file 6-52-5-2, vol. 2.

164. Memorandum of September 11, 1945, from Mrs. Rex Eaton, to Mr. Arthur

MacNamara, PAC, RG 27, Vol. 609, file 6-52-1, vol. 2.
165. Letter of October 22, 1945, from B.W. Heise, Deputy Minister, Department of Public Welfare, Ontario, to Mrs. Rex Eaton; letter of October 29, 1945, from A. MacNamara, to Mr. B.W. Heise, PAC, RG 27, Vol. 609, file 6-52-1, vol. 2.
166. Memorandum of November 8, 1945, from Mrs. Rex Eaton, to Mr. Arthur MacNamara, PAC, RG 27, Vol. 609, file 6-52-1, vol. 2.
167. Ibid.
168. Memorandum of November 9, 1945, from A. MacNamara, to Mrs. Rex Eaton, PAC, RG 27, Vol. 609, file 6-52-1, vol. 2.
169. Letter of November 22, 1945, from A. MacNamara, to Mr. B.W. Heise, Deputy Minister, Department of Public Welfare, Ontario, PAC, RG 27, Vol. 609, file 6-52-1, vol. 2.
170. Ibid.
171. Letter of December 17, 1945, from Mary Eadie, Supervisor, Women's Division, Unemployment Insurance Commission, Toronto, to Miss Margaret Grier, Assistant Associate Director, NSS, Ottawa, PAC, RG 27, Vol. 611, file 6-52-6-1, vol. 3.
172. Memorandum of February 15, 1946, from Margaret Grier, to Mr. Arthur MacNamara, PAC, RG 27, Vol. 609, file 6-52-1, vol. 2.
173. Letter of February 18, 1946, from Fraudena Eaton, Vancouver, to Mr. A. MacNamara, Deputy Minister of Labour, Ottawa, PAC, RG 27, Vol. 609, file 6-52-1, vol. 2.
174. Emphasis mine. Letter of February 26, 1946, from Humphrey Mitchell, Minister of Labour, Ottawa, to W.A. Goodfellow, Minister of Public Welfare, Province of Ontario, PAC, RG 27, Vol. 609, file 6-52-1, vol. 2.
175. Letter of March 7, 1946, from W.A. Goodfellow, Minister of Public Welfare, Ontario, to Humphrey Mitchell, Minister of Labour, Ottawa, PAC, RG 27, Vol. 609, file 6-52-1, vol. 2.
176. Letter of April 2, 1946, from Humphrey Mitchell, to W.A. Goodfellow, PAC, RG 27, Vol. 609, file 6-52-1, vol. 2.
177. Bill No. 124, An Act respecting Day Nurseries, 1946, PAC, RG 27, Vol. 609, file 6-52-1, vol. 2.
178. Letter of May 17, 1946, from W.A. Goodfellow, Minister of Public Welfare, Ontario, to Humphrey Mitchell, Minister of Labour, Ottawa, PAC, RG 27, Vol. 611, file 6-52-6-1, vol. 3.
179. Letter of May 17, 1946, from Mrs. G.D. (Beatrice H.) Kirkpatrick, Chairman, Board of Directors, United Welfare Chest, A Federation of Greater Toronto's Social Services, Welfare Council Department, to Humphrey Mitchell, PAC, RG 27, Vol. 611, file 6-52-6-1, vol. 3.
180. Letter of May 29, 1946, from Mrs. G.D. (Beatrice H.) Kirkpatrick, Chairman, Board of Directors, Welfare Council Department, United Welfare Chest, A Federation of Greater Toronto's Social Services, to Humphrey Mitchell, PAC, RG 27, Vol. 611, file 6-52-6-1, vol. 3.
181. Letter of May 21, 1946, from Humphrey Mitchell, Minister of Labour,

Ottawa, to Brooke Claxton, Minister of National Health and Welfare, Ottawa, PAC, RG 27, Vol. 611, file 6-52-6-1, vol. 3.

182. Letter of June 7, 1946, from Brooke Claxton, to Humphrey Mitchell, PAC, RG 27, Vol. 611, file 6-52-6-1, vol. 3.

183. Letter of June 12, 1946, from Humphrey Mitchell, to W.A. Goodfellow, Minister of Public Welfare, Ontario, PAC, RG 27, Vol. 611, file 6-52-6-1, vol. 3.

184. Memorandum of November 28, 1946, from J.C. McK., to Mr. McNamara, PAC, RG 27, Vol. 611, file 6-52-6-1, vol. 4. For information on post-war centres, see Patricia Vanderbelt Schulz, "Day Care in Canada, 1850-1962," in Kathleen Gallagher Ross, ed., *Good Day Care: Fighting For It, Getting It, Keeping It* (Toronto: Women's Press, 1978), pp. 137-58.

185. Report on "Day Care of Children," July 1, 1943, PAC, RG 27, Vol. 609, file 6-52-1, vol. 1.

186. *Ibid.*

187. Letter of April 4, 1946, from Mrs. Rex Eaton, Associate Director, to Miss R.M. Grier, Assistant Associate Director, National Employment Service, Ottawa, PAC, RG 27, Vol. 609, file 6-52-1, vol. 2.

188. Marie T. Wadden, "Newspaper Response to Female War Employment: *The Globe and Mail* and *Le Devoir* May-October 1942" (History Honours Dissertation, Memorial University of Newfoundland, May, 1976).

189. "Wartime History of Employment of Women," pp. 80-81. In February, 1944, Mrs. Eaton estimated the number of women in the labour force at approximately 600,000 in 1939, rising to 1,200,000 by early 1944. Letter of February 2, 1944, from Mrs. Rex Eaton, Associate Director NSS, to Mrs. J.E.M. Bruce, Convenor, Trades and Professions Committee, Local Council of Women, Victoria, B.C., PAC, RG 27, Vol. 605, file 6-24-1, vol. 3.

Chapter 2, Government Job-Training Programs

1. See the arguments brought forward to defend the hiring practices of Canadian National Railway in the case brought before the Human Rights Commission by Montreal-based Action Travail des Femmes charging CNR with sex discrimination. See *Business Week*, June 21, 1982, p. 137.

2. There were no sharp lines of demarcation separating these training programs. Indeed, there was always some overlap, for as each new training program was introduced, projects under the former one were allowed to continue.

3. For the social and political influence of such women's organizations in earlier periods, see Strong-Boag, *Parliament of Women*.

4. Home Service Training Schools were started in the late summer of 1937. During the first year all provinces but Prince Edward Island participated in the program and twenty schools were in operation. By the end of November, 1938, the number had dropped to eighteen, with the closing of all three Quebec schools, one school in Nova Scotia, and two in Ontario

not fully counterbalanced by the opening of four new schools in the West. According to a report of May, 1940, the number had stabilized at eighteen, with one new western school offsetting the withdrawal from the program of Nova Scotia, leaving only six participating provinces. PAC, RG 27, Vol. 748, file 12-15-5, vol. 1. "Dominion-Provincial Youth Training Programme – Home Service Training Schools – Report by the Youth Training Branch of the Dominion Department of Labour," n.d., presents situation as at November 30, 1938, hereafter cited as "Nov. 30, 1938 Home Service Training Schools – Report"; "Training for Household Employment – Dominion-Provincial Youth Training Programme," Department of Labour, Ottawa, May, 1940, hereafter cited as "May, 1940, Training for Household Employment."

5. "Youth Training in Canada in 1938," *Labour Gazette*, May, 1939, pp. 469-72.

6. The 1913 Report of the Royal Commission on Industrial Training and Technical Education mentioned specifically the National Council of Women, the Women's Institutes of Ontario, and the St. Jean Baptiste Federation of Montreal as "active in seeking for the inclusion of provision for the training of girls for housekeeping and home-making in the elementary and secondary schools." Canada, Royal Commission on Industrial Training and Technical Education, *Report of the Commissioners* (Ottawa: King's Printer, 1913), Part II, pp. 364-78; Part IV, pp. 1991-93. See also Strong-Boag, *Parliament of Women*.

7. Its other strong recommendation had been to educate country girls to an appreciation for rural domestic economy as a means of keeping young women on the land. PAC, RG 27, acc. no. 70/382, box 75, "Final Report of the Women's Employment Committee to the Chairman and Members of the National Employment Commission," December 10, 1937.

8. The committee's final report disclosed that, with the exception of domestic service, there was unemployment in all the other major preserves of female labour: teaching, nursing, office work, telephone operating, sales clerking, and factory work in textile, clothing, and food-processing industries. Only certain specialized occupations, such as that of beauty technician, escaped the general pattern. (The number of beauty technicians in Alberta, Saskatchewan, and Manitoba had increased by approximately 33 per cent since 1931, according to the 1936 Census of the Prairie Provinces.) "Final Report of the Women's Employment Committee."

9. The long-term trend toward women comprising an increasing proportion of the counted labour force continued in Canada during the depression despite the economic hard times. The number of women employed rose from 490,150 in 1921 to 665,859 in 1931 and an estimated 744,000 in 1937, and their proportion of the total labour force also grew, from 15.4 per cent in 1921 to 17 per cent in 1931 and 19 per cent in 1941. "Wartime History of Employment of Women and Day Care of Children," completed before August 24, 1950, Part I, pp. 1-5, PAC, RG 35, Series 7, Vol. 20, file 19.

10. L.M. Grayson and Michael Bliss, eds., *The Wretched of Canada* (Toronto: University of Toronto Press, 1971), p. vi.

11. The 1913 Royal Commission on Industrial Training and Technical Education (p. 376) had also argued that training and certification in housekeeping would increase remuneration for and remove social stigma from domestic servants.

12. The YWCA was running training courses for household workers in seventeen cities from Halifax to Victoria according to its own survey of February, 1936, but was handicapped by lack of funds. "Digest of Training Courses for Household Workers carried on by the Y.W.C.A. throughout Canada," February, 1936, PAC, RG 27, Vol. 748, file 12-15-5, vol. 1.

13. "Nov. 30, 1938 Home Service Training Schools - Report"; "May, 1940, Training for Household Employment."

14. "Nov. 30, 1938 Home Service Training Schools - Report."

15. With respect to wage level, experience was more significant than training. For example, one live-in maid with three months' Home Service training was earning $12 a month, another $16 a month, while two with two years' experience were earning $20 a month and another with four years', $25. PAC, RG 27, Vol. 748, file 12-14-5, vol. 1, "Kitchener Household Employment Study Group Report," March 26, 1940; "Findings of Preston Study Group," n.d.

16. Sara Diamond, "You Can't Scare Me . . . I'm Stickin' to the Union: Union Women in British Columbia during the Great Depression," *Kinesis* (June 1979), pp. 16-17; Provincial Archives of British Columbia, Add. MSS 215; Vol. VIII, YWCA, Victoria Branch, Minutes of Board of Directors' Meetings, December 14, 1934, January 11, February 22, 1935, April 17, 1936.

17. *Labour Gazette*, February, 1939, p. 167; "Findings of Preston Group."

18. "Nov. 30, 1938 Home Service Training Schools - Report."

19. "Youth Training in Canada in 1938."

20. "Nov. 30, 1938 Home Service Training Schools - Report."

21. "May, 1940, Training for Household Employment." In 1944, when there was talk of creating a similar institution on a larger scale for the postwar world, R.F. Thompson, Director of Training in the federal Department of Labour, anticipated that low demand from prospective trainees would be a problem because it had been difficult even during the depression "to obtain [a] sufficient number of applications to keep our two dozen schools filled." PAC, RG, 27, Vol. 748, file 12-15-5, vol. 1, letter of November 18, 1944, to Isobel Robson, the Local Council of Women, Winnipeg, from R.F. Thompson.

22. *Labour Gazette*, January, 1942, p. 34.

23. "Summary of Proceedings of Dominion-Provincial Conference on the War Emergency Training Program," *Labour Gazette*, April, 1941, p. 427; "War Development of the Training Programme," n.d., presumed from internal evidence to be ca. mid-1943, PAC, RG 27, Vol. 744, file 12-14-16-12, vol. 1.

24. Such agreements were made with all provinces except Prince Edward Island, which lacked both training facilities and war industry. Applicants for training from P.E.I. were accommodated in Nova Scotia or New Brunswick.

25. "Canada's War Emergency Training Programme for 1941: Report of Inter-Departmental Committee on Labour Co-ordination," *Labour Gazette*, January, 1941, p. 17.

26. Men who came within the age group liable to be called for compulsory military service (initially single men between twenty and twenty-six years of age) were not admitted unless they had medical rejection slips, and during 1942 ineligibility was extended to male farm and rural workers without special permits from National Selective Service. "Progress Statement on Training Programme, April 1st to December 31st, 1941," PAC, RG 27, Vol. 725, file 12-2-1; "War Development of the Training Programme."

27. *Labour Gazette*, May, 1941, p. 571.

28. "Summary of Proceedings of the Dominion-Provincial Conference on the War Emergency Training Program," *Labour Gazette*, April, 1941, p. 427.

29. Memo. of November 3, 1941, to the Minister of Labour from R.F. Thompson re Progress Report of the War Emergency Training Programme, PAC, RG 27, Vol. 725, file 12-2-1.

30. As early as April, 1940, the decision of the Ontario government to close the Dominion-Provincial Home Service Training Schools in its province provoked a series of letters in protest from various women's associations. Ontario Archives, RG 3, Mitchell Hepburn Papers, General Correspondence, Public 1940, "Youth Training Movement"; 1941 "Labour Department."

31. "Thompson Memo. re Progress Report of the War Emergency Training Programme..."

32. "Progress Statement on Training Programme, April 1st to December 31st, 1941," PAC, RG 27, Vol. 725, file 12-2-1.

33. Report to the Minister of Labour re War Training Programme, June 5, 1941, PAC, RG 27, Vol. 725, file 12-2-1.

34. "Progress Statement on Training Programme, April 1st to December 31st, 1941."

35. "War Development of the Training Programme."

36. Frederick Edwards, "Night-and-Day School," *Maclean's*, May 1, 1942, pp. 16-17, 22-24.

37. "War Development of the Training Programme."

38. *Ibid.*

39. See Chapter Three.

40. "Training of Women Under War Emergency Training Programme," PAC, RG 27, Vol. 744, file 12-14-16-12, vol. 1.

41. Directives from Major-General H.F.G. Letson, Adjutant-General, to G.O.C.-in-C. Atlantic Command, G.O.C.-in-C. Pacific Command, and All

District Officers Commanding, Feb. 8, 19, 1943, PAC, RG 24, reel no. C-5301, file HQS 8984.

42. "Establishment of National Selective Service in Canada," *Labour Gazette*, April, 1942, pp. 405-06.

43. "War Emergency Training Program: Statistical Summary for November, 1942," *Labour Gazette*, December, 1942, pp. 1427-33.

44. "War Emergency Training Program: Statistical Summary for August, 1941," *Labour Gazette*, September, 1941, p. 1103; "War Emergency Training Programme: Statistical Summary for February, 1942," *Labour Gazette*, March, 1942, p. 299; "Training of Women Under War Emergency Training Programme."

45. We are using "skill" and "skilled" in the traditional sense. The whole question of the nature and definition of "skilled" work is a complex one worthy of study. See, for example, Mercedes Steedman, "Sex and Skill in the Canadian Needle Trades 1890-1940," paper presented at the annual meeting of the Canadian Historical Association, Ottawa, June 11, 1982.

46. Speech reported in the *Labour Gazette*, April, 1942, p. 414.

47. "Canada's War Emergency Training Programme for 1941: Report of the Inter-Departmental Committee on Labour Co-ordination," *Labour Gazette*, January, 1941, p. 15.

48. With respect to female industrial workers in the First World War in Britain, Gail Braybon has described a similar phenomenon at work in the official "dilution of skilled labour" policy, which, once the processes of production had been sufficiently subdivided, meant that the women replacing men "learned only sections of the work their male predecessors had done." Gail Braybon, *Women Workers in the First World War: The British Experience* (London: Croom Helm, 1981), pp. 51-65.

49. Leslie Roberts, "Fire Power," *Maclean's*, May 15, 1942, pp. 13-14.

50. Thelma LeCocq, "Woman Power," *Maclean's*, June 15, 1942, p. 11.

51. The "powered fuselage conveyor assembly line," where all of the work was done by women, provided one illustration of this "fitting jobs to women." "There, and on the engine balcony, air driven wrenches and screw drivers, light weight electric drills and rivet squeezers are the rule. Special supports are used to hold jigs and assemblies, the weight of which would cut down the efficiency of women workers if they had to hold them as men did." "Women Workers - A Problem," *Canadian Aviation*, November, 1943, pp. 78, 80.

52. R. Eric Crawford, "Ingenuity Pays Big Dividends Noorduyn Factory Men Find: Method Improvement Study Results in Many Clever Machines and Factory Ideas," *Canadian Aviation*, January, 1943, pp. 39-43, 80.

53. "War Emergency Training Program: Statistical Summary for October, 1942," *Labour Gazette*, November, 1942, p. 1292.

54. Frederick Edwards, "Night-and-Day School," *Maclean's*, May 1, 1942, p. 22.

55. Mary Oliver, "A Wartime Schoolroom," *Canadian Business*, January, 1944, pp. 69, 90. The instruction in that "Wartime Schoolroom" took

place outside the War Emergency Training Program as any courses of less than two weeks were regarded as training on the job. "War Development of the Training Programme"; Gladys Ross, interview with Helen Lenskyj, Toronto, August 25, 1983.

56. Roberts, "Fire Power," pp. 13-14.

57. Men whose ethnic backgrounds would have been an obstacle to their admission to the ranks of skilled labour before the war also benefited from the wartime revolution in vocational training, as noted by Roberts, "Fire Power," p. 14.

58. "War Development of the Training Programme"; "Wartime History of Employment of Women and Day Care of Children," n.d., but completed before August 24, 1950, PAC, RG 35, Series 7, Vol. 20, file 10, part I.

59. LeCocq, "Woman Power," pp. 10-11, 40; Lotta Dempsey, "Women in War Plants," Mayfair, May, 1943, p. 93.

60. "Women Workers – A Problem," pp. 78-80.

61. LeCocq, "Woman Power," pp. 10-11, 40. According to Edwards' article on Toronto's Central Technical School, women were preferred for a certain kind of meter assembly because they were less affected with colour blindness than men and the meter assembly to which he referred required "the accurate weaving of twenty-six strands of wire, each wrapped in a different colored covering." Edwards, "Night-and-Day School," p. 22.

62. Radio address on Canadian women's accomplishments in the war effort, by Arthur MacNamara, the second Director of National Selective Service, reported in the Labour Gazette, September, 1943, pp. 1216-17.

63. If she had directly replaced a man who had entered military service, her chances for holding on to that job at war's end were limited by other factors as well, a main one being the Reinstatement in Civil Employment Act of 1942, which guaranteed veterans their jobs back after discharge. See, Canada, Department of Labour, DISMISS but . . . what of a JOB? (Ottawa: King's Printer, 1945).

64. Memorandum of April 30, 1943, from F.H. Sexton, Director of Technical Education, Department of Education, Nova Scotia, to T.D.A. Purves, Deputy Minister of Labour, Nova Scotia, PAC, RG, 27, Vol. 605, file 6-24-1, vol. 1.

65. "Rehabilitation of Women of the Armed Services," by Olive Ruth Russell, Executive Assistant, Rehabilitation Branch, Department of Veterans' Affairs, Feb. 19, 1945, PAC, MG 31, K 13, Vol. 1.

66. Routine Letter #141, January 7, 1943, to all Regional Directors, from R.F. Thompson, Director of Training, Department of Labour, Ottawa, PAC, RG 27, Vol. 744, file 12-14-16-12, vol. 1. On August 1, 1942, the Vocational Training Coordination Act replaced the Youth Training Act, which had expired on March 31, 1942, as the authority for vocational training under the auspices of the Dominion government. The War Emergency Training Program had had the rehabilitation of ex-service personnel, insofar as it involved vocational training, as part of its

responsibilities since 1942. As the end of war came into sight, the emphasis in training shifted more in the direction of rehabilitation and post-war planning. By Order-in-Council PC 1976 of March 21, 1944, the very name "Wartime Emergency Training Program" was scrapped for one more appropriate to the post-war peacetime world: "Canadian Vocational Training." Canada, Department of Labour, *Report of the Department of Labour for the Fiscal Year ending March 31, 1943* (Ottawa: King's Printer, 1943), p. 29; Canada, Department of Labour, *Report of the Department of Labour for the Fiscal Year ending March 31, 1945* (Ottawa: King's Printer, 1945), p. 56.

67. "Wartime History of Employment of Women and Day Care of Children," p. 81.

68. See, for example, L.C. Marsh and O.J. Firestone, "Will There Be Jobs?" *Canadian Affairs*, 1, 18 (October 1, 1944).

69. *DISMISS but . . . what of a JOB?*

70. As reported by Anne Fromer, "Post-War Employment Field Graphed by Weir Report," *Saturday Night*, April 22, 1944, p. 6.

71. See Chapter Three. Also Routine Letter #141 of Jan 7, 1943, to all Regional Directors from R.F. Thompson.

72. Canada, Advisory Committee on Reconstruction, *VI: Post-War Problems of Women – Final Report of the Subcommittee*, November 30, 1943 (Ottawa: King's Printer, 1944). For a thorough discussion of the sub-committee's composition, history, and impact, see Brandt, " 'Pigeon-holed and Forgotten': The Work of the Subcommittee on the Post-War Problems of Women, 1943."

73. "Post-War Working Intentions of Civilians as Indicated by Answers Given on D.L.R. 57-58 Forms Completed by 29,845 People in Canada," PAC, RG 27, acc. no. 70/450, box 14, file 208.

74. Janet R. Keith, "Situations Wanted: Female," *Canadian Business*, November, 1944, p. 74.

75. "Women To-Morrow," an address by Captain Olive Ruth Russell to the University Women's Club, Dalhousie University, Halifax, Nova Scotia, March 15, 1944, PAC, MG 31, K 13, Vol. 1. At the time of this address, Russell was one of two personnel selection counsellors (Army Examiners) with the Canadian Women's Army Corps.

76. Leonard Marsh, Part IV: "Family Needs," *Report on Social Security for Canada 1943*, with a new Introduction by the Author and a Preface by Michael Bliss (Toronto: University of Toronto Press, 1975), pp. 195-232.

77. In 1944 the sole woman on the Economic Advisory Board of the Province of Quebec, Renée G. (Mme. Henri) Vautelet, produced a similar report on the post-war problems of Quebec women. It too bristled with unresolved tension between granting that women needed to seek employment outside the home and proposing policies that would "reduce industry's economic reasons for employing women in preference to men." The change in provincial government in August, 1944, had terminated the work of the Economic Advisory Board of the Province of Quebec,

and Vautelet's report might never have seen the light of day had it not been translated into English under the title *Post-War Problems and Employment of Women in the Province of Quebec* and published by the Montreal Local Council of Women in August, 1945. Copy at PAC, MG 30, C 175, Vol. 1, file 5.

78. Canada, Wartime Information Board, *Looking Ahead: Our Next Job*, Canadian Post-War Affairs: Discussion Manual No. 3 (Ottawa: King's Printer, 1945), p. 11.

79. For a discussion of government-funded child care and tax incentives for married working women, see Chapter One.

80. *Report of the Department of Labour for the Fiscal Year ending March 31, 1945*, p. 56.

81. The one minor exception to all this equality of status and opportunity that Dr. Russell acknowledged was the unavailability of out-of-work benefits to the married female veteran whose husband was deemed capable of maintaining her. "Rehabilitation of Persons from the Armed Forces with Special Reference to Ex-Service Women," Address to the Business and Professional Women's Club, Ottawa, March 13, 1945, by Olive Ruth Russell, Exec. Asst., Rehabilitation Branch, D.V.A., PAC, MG 31, K 13, Vol. 1.

82. *DISMISS but ... what of a JOB?*, p. 29.

83. "Rehabilitation of Women of the Armed Services," by Olive Ruth Russell, Exec. Asst., Rehabilitation Branch, D.V.A., Feb. 19, 1945, PAC, MG 31, K 13, Vol. 1.

84. Quoted by Russell, *ibid.*

85. Before July, 1944, in the Department of Pensions and National Health.

86. In rural areas, local Canadian Legion branches provided the initial interviewing service.

87. War Emergency Training Agreement, Schedule "K" (1944-45), *Rehabilitation Training*, PAC, RG 27, Vol. 725, file 12-2-1.

88. *DISMISS but ... what of a JOB?*, pp. 28-29.

89. Canada, Department of Veterans' Affairs, *Back to Civil Life*, 2nd rev. ed. (Ottawa: King's Printer, 1944), pp. 18-19.

90. The trainee was to receive up to 80 per cent of the wage to be paid on completion of the training, with an increasing proportion of that cost to be borne by the employer and a correspondingly decreasing proportion to be met by refunds from DVA. Canadian Vocational Training War Emergency Training Agreement, Schedule "L" (1945-1946), Rehabilitation Training, PAC, RG 27, Vol. 725, file 12-2-1, vol. 2.

91. Appendix "Y" to Canadian Vocational Training War Emergency Training Agreement, Schedule "K" (1945-1946), copy at PAC, RG 27, Vol. 742, file 12-14-7-1.

92. *Back To Civil Life*, 2nd rev. ed.

93. *Back To Civil Life*, 2nd rev. ed., p. 14.

94. A short story in a post-war issue of *Maclean's* took as subject the problem of what a veteran (male understood) was to do when he returned to find

his peacetime job held by a "girl" "stubborn as well as beautiful." The story's proposed solution – "Marry her" – was meant only semi-facetiously. Ron Broom, "Marry the Girl!" *Maclean's*, October 1, 1945, pp. 16-17, 22, 25-26, 28.

95. *Back To Civil Life*, 2nd rev. ed., p. 24.

96. Letter of Nov. 10, 1945, to Mr. A.D.P. Heeney, Clerk of the Privy Council, Ottawa, from the Minister of Labour, Humphrey Mitchell, PAC, RG 27, acc. no. 71/98, vol. 2, file 22-5-6-7.

97. The Dominion Civil Service Circular Letter 1945-17, dated November 17, 1945, called for renewed enforcement of the pre-war discriminatory policy, which stated that: " 'Any female employee in the public service shall, upon the occasion of her marriage, be required to resign her position.' " Quoted in memo. of Dec. 3, 1945, to Mr. W.S. Woods, Deputy Minister, Dept. of Veterans' Affairs, from E.L.M. Burns, Director General of Rehabilitation, drafted by Dr. Olive Ruth Russell, PAC, MG 31, K 13, Vol. 1.

98. *Towards Equality for Women* (Ottawa: Status of Women Canada, 1979), p. 5.

99. Employment Service and Unemployment Insurance Branch of the Dept. of Labour, Employment Circular, May 17, 1945, on Pre-Employment Vocational Training for Women Survey, PAC, RG 27, acc. no. 71/328, vol. 2, file 90: results discussed in Minutes of Conference of Supervisors of Women's Training, Canadian Vocational Training, Ottawa, Feb. 11, 12, 13, 1946, PAC, RG 27, Vol. 748, file 12-15-5, vol. 1A.

100. 23rd Report on National Selective Service Operations, Feb., 1945, PAC, RG 27, acc. no. 71/328, box 3.

101. In a letter dated April 10, 1944, R.F. Thompson, Director of Training, Department of Labour, asked Mrs. E.D. Hardy, president of the National Council of Women, to contact women's organizations, particularly the National Council of the YWCA, for "suggestions for various types of training which would afford reasonable assurance for employment" for women in the post-war period. PAC, RG 27, Vol. 744, file 12-14-16-12, vol. 1. In Routine Letter No. 334 of September 24, 1945, Marion M. Graham, Supervisor of Women's Training, CVT, reminded all regional directors to establish "close liaison with local and provincial women's organizations" for the "valuable indication" they could give of the particular "employment demands and opportunities" for women in each district. PAC, RG 27, Vol. 748, file 12-15-5, vol. 1.

102. See, for example, "Will Maids Come Back?," *Chatelaine*, June, 1944, pp. 21-22; Katharine Kent, "Crisis in the Kitchen," *Maclean's*, October 15, 1945, pp. 10, 62.

103. Memo. of March, 1945, to Mary Eadie, Supervisor, Women's Division, Employment and Selective Service Office, Toronto Branch, from Ombra Dill, Supervisor, Household Assistants, attached to letter of March 15, 1945, to Mrs. Rex Eaton, Assoc. Director, NSS, Ottawa, from Mary Eadie, for G.S. Collins, Mgr., Employment and Selective Service Office, Toronto

Branch, PAC, RG 27, Vol. 748, file 12-15-5, vol. 1A.

104. Questioned in the House in 1945 on the problem of too many women in the labour force, Minister of Labour Mitchell announced that women "have preferred – and I think this is a pretty sound conclusion to arrive at – to return to home-keeping." House of Commons, *Debates*, 1945, p. 2371. See M. Theresa Nash, "Images of Women in National Film Board of Canada Films During World War II and the Post-War Years (1939 to 1949)" (Ph.D. dissertation, McGill University, 1982).

105. Russell, "Women To-Morrow," emphasis in the original.

106. "Since woman's full right to work has been taken for granted in the war emergency and she has been able to prove her efficiency, is it not natural to assume that in the employment market after the war her claim to the right to employment should be based on her merits rather than her sex." *Ibid.*

107. Russell, "Rehabilitation of Women of the Armed Services," emphasis in the original.

108. Whyard, "Dr. Russell – Rehabilitation," for *Saturday Night*, draft, June 19, 1945, copy at PAC, MG 31, K 13, Vol. 1.

109. Letter of Nov. 18, 1944, to Miss Isobel Robson, Winnipeg, from R.F. Thompson, Director of Training, Dept. of Labour, PAC, RG 27, Vol. 748, file 12-15-5, vol. 1.

110. Letter of March 20, 1945, to A. MacNamara, Deputy Minister, Department of Labour, from R.F. Thompson, Director of Training, Department of Labour, PAC, RG 27, Vol. 1523, file X5-12, part 1.

111. See, for example, her "Rehabilitation of Women of the Armed Forces."

112. Rehabilitation Information Committee Minutes of July 11, 1945, PAC, RG 27, Vol. 3575, file 11-8-9-9, vol. 1; letter of Aug. 20, 1945, to Marion M. Graham, Superintendent of Women's Training, CVT, from Edith C. Scott, Lieut., WRCNS, Directorate of Rehabilitation, Naval Service, Department of National Defence, Ottawa, PAC, RG 27, Vol. 748, file 12-15-5, vol. 1; letter of Aug. 20, 1945, to Training Branch, Dept. of Labour, Ottawa, from A.C.P. Clayton, Group Captain, for Chief of the Air Staff, Air Service, Dept. of National Defence, PAC, RG 27, Vol. 748, file 12-15-5, vol. 1; letter of Sept. 6, 1945, to Bertha G. Oxner, Director of Women's Work, University of Saskatchewan, from Marion M. Graham, Supervisor of Women's Training, CVT, Ottawa, PAC, RG 27, Vol. 748, file 12-15-5, vol. 1.

113. Letter of July 9, 1945, to Mr. J. Andrew, Rehabilitation Information Committee, Wartime Information Board, Ottawa, PAC, MG 31, K 13, Vol. 1; letter of Feb. 18, 1946, to A. MacNamara from Fraudena Eaton, PAC, RG 27, Vol. 748, file 12-15-5, vol. 1A.

114. Letter of Sept. 5, 1945, to Miss Marion Graham, Supervisor of Women's Training, Dept. of Labour, from Olive Ruth Russell, Exec. Asst. to the Director General of Rehabilitation, Dept. of Veterans' Affairs, PAC, RG 27, Vol. 748, file 12-15-5, vol. 1.

115. Address given to the Winnipeg Local Council of Women by Dr. Olive

Ruth Russell, Feb., 1946, PAC, MG 31, K 13, Vol. 1.

116. "Solving Shortages of Home Assistants," *Labour Gazette*, February, 1946, p. 196.

117. The opening of such a school in the Maritime provinces was not felt to be warranted. Routine Letter #388, April 3, 1946, to all Regional Directors from R.F. Thompson, Director of Training, CVT, PAC, RG 27, Vol. 744, File 12-14-16-12, vol. 1.

118. Letter of Nov. 13, 1945, to Marion Graham, Supervisor of Women's Training, Dept. of Labour, from Mary D. Salter, Superintendent of Women's Rehabilitation, Dept. of Veterans' Affairs, PAC, RG 27, Vol. 748, file 12-15-5, vol. 1.

119. Press releases "Homemaking" and "Homemaking Course" prepared for opening of the Homemaking and Family Living Course for ex-servicewomen in Toronto on Feb. 18, 1946, PAC, RG 27, Vol. 748, file 12-15-5, vols. 1, 1A.

120. Letter of July 24, 1945, to Miss Bernice Coffey, Women's Editor, *Saturday Night*, from Olive Ruth Russell, Exec. Asst. to the Director General of Rehabilitation, PAC, MG 31, K 13, Vol. 1. Also Scott to Graham, Aug.20, 1945: "Having the homes of ex-service people well managed by capable trained housewives will help greatly both in the re-establishment of the returning generation and in restoring a stable peace-time society."

121. Letter of Feb. 14, 1946, to Mrs. Rex Eaton, Assoc. Dir., N.S.S., from A. MacNamara, Deputy Minister of Labour, Canada, PAC, RG 27, Vol. 748, file 12-15-5, vol. 1A.

122. Letter of Feb. 18, 1946, to Mr. A. MacNamara, Deputy Minister of Labour, Ottawa, from Fraudena Eaton, PAC, RG 27, Vol. 748, file 12-15-5, vol. 1A.

123. Memo. of March 2, 1946, to Mr. MacNamara from A.H. Brown, PAC, RG 27, Vol. 748, file 12-15-5, vol. 1A.

124. "Training for Post-War Employment," *Labour Gazette*, April, 1945, p. 523.

125. Forwarded with a covering letter to Humphrey Mitchell, Minister of Labour, Aug. 2, 1945, by Mrs. G.D. Finlayson, Corresponding Secretary, National Council of Women of Canada, PAC, RG 27, Vol. 748, file 12-15-2, vol. 1A.

126. Quoted in a letter of Feb. 25, 1946, to Marion Graham, Dept. of Labour, from Mrs. C.D. Rouillard, Chairman, Public Affairs Committee, National Council of the YWCA of Canada, PAC, RG 27, Vol. 748, file 12-15-5, vol. 1.

127. "Solving Shortages of Home Assistants," *Labour Gazette*, February, 1946, p. 195.

128. Letter of Feb. 20, 1945, from Marion Graham, Supervisor of Women's Training, to Chief, Legislation Branch, Dept. of Labour, attention Miss Mackintosh, PAC, RG 27, Vol. 744, file 12-14-16-12, vol. 1.

129. According to one review of rates as advertised in local newspapers throughout Canada, for general housework, live-in monthly wages ranged

from $25 in Nova Scotia to $40 in Vancouver and Quebec City, $40 to $60 in Toronto, $35 in Regina and Saskatoon. The prevailing rate for day workers in Toronto was 50 cents an hour with carfare and lunch. See the untitled report attached to Fraudena Eaton's note of Jan. 15, 1946, that the "review was made on a date within the month commencing December 7th, 1945." PAC, RG 27, Vol. 748, file 12-15-5, vol. 1.

130. The authorization to provide vocational training under the Canadian Vocational Training program for persons referred to CVT by the Employment Service of the Unemployment Insurance Commission was established by Order-in-Council PC 1388 of March 8, 1945. "Training: Post-War Training Programmes in Canada," *Labour Gazette*, July, 1945, p. 1023.

131. Canadian Vocational Training Programme, Appendix B, For Women Veterans, Dept. of Labour, April, 1947, PAC, RG 27, Vol. 744, file 12-14-16-12, vol. 1.

132. For a full discussion of the "Home-Aide" project, see Ruth Pierson, " 'Home-Aide': A Solution to Women's Unemployment After World War II," *Atlantis*, 2, 2 (Spring, 1977-Part II: Conference Issue), pp. 85-96.

133. Dept. of Labour Routine Letter 346, Nov., 1945, to all Regional Directors from Marion M. Graham, Supervisor of Women's Training, CVT, Ottawa; also the follow-up memo. of Dec. 1, 1945, to all Superintendents of Women's Training in CVT Regional Offices, PAC, RG 27, Vol. 748, file 12-15-5, vol. 1.

134. Memo. of Jan. 11, 1946 to A. MacNamara from R.F. Thompson, PAC, RG 27, Vol. 748, file 12-15-5, vol. 1.

135. Canadian Vocational Training, War Emergency Training Agreement, Schedule "K" (1945-1946), PAC, RG 27, Vol. 725, file 12-2-1, vol. 2.

136. Letter of Dec. 13, 1945, to Mr. J. Smith, Manager, National Employment Service, Calgary, from Joe H. Ross, Regional Director, CVT, Alberta, PAC, RG 27, Vol. 748, file 12-15-5, vol. 1.

137. Personal letter of Dec. 6, 1945, to Mr. MacNamara, with copy to Mrs. Eaton, from Margaret McWilliams, PAC, RG 27, Vol. 748, file 12-15-5, vol. 1A.

138. Letter of Dec. 21, 1945, to Mr. A. MacNamara from Fraudena Eaton with copy to Mrs. M. McWilliams, PAC, RG 27, Vol. 748, file 12-15-5, vol. 1A.

139. Women's Rehabilitation Annual Report, 1946-1947, draft prepared by Dr. Olive Ruth Russell, PAC, MG 31, K 13, Vol. 1.

140. *Ibid.*

141. W.S. Woods, *Rehabilitation (A Combined Operation)* (Ottawa, 1953), pp. 256-57.

142. Mrs. Rex Eaton's speech to a Regional Rehabilitation Training Conference in Vancouver, 2nd week of March, 1946, PAC, RG 27, Vol. 748, file 12-15-5, vol. 1A.

143. CVT Conference Report, Feb. 11-14, 1946, PAC, RG 27, Vol. 748, file 12-15-5, vol. 1A.

144. Mrs. Eaton's speech to a Regional Rehabilitation Training Conference in Vancouver.

145. Letter of April 15, 1946, to Marion Graham, Supervisor of Women's Training, CVT, from Mary D. Salter, Superintendent of Women's Rehabilitation, Dept. of Veterans' Affairs, re: Visit of Superintendent to Vancouver District, March 9-18, 1946, PAC, RG 27, Vol. 744, file 12-14-16-12, vol. 1.

146. Canadian Vocational Training Programme, Appendix B, For Women Veterans, Dept. of Labour, April, 1947, PAC, RG 27, Vol. 744, file 12-14-16-12, vol. 1.

147. See Chapter One. There is also evidence that unemployed women, some of them displaced from insurable jobs in the offices and plants of war production, were denied Unemployment Insurance benefits if they refused to take jobs as domestics. See House of Commons, *Debates*, Stanley Knowles, July 14, 1947, p. 5636.

148. Olive Ruth Russell, "Women Veterans and Their Rehabilitation," *Echoes* (Summer, 1946), pp. 7, 25, 27, copy at PAC, MG 31, K 13, Vol. 1.

149. Rehabilitation Information Committee, Press Survey on Rehabilitation for January, 1946, PAC, RG 27, Vol. 3575, file 11-8-9-9, vol. 2.

150. Memo. of Feb. 20, 1946, to Chief, Legislation Branch, attention Miss Mackintosh, from Marion M. Graham, Supervisor of Women's Training, PAC, RG 27, Vol. 744, file 12-14-16-12, vol. 1.

Chapter 3, "CWAC of All Trades"

1. As Cynthia Enloe has argued, the perception that the military is an exclusively male domain results from ideological constructions of masculinity and femininity and the drawing of formal lines between "in" and "not in" the professional armed forces. *Does Khaki Become You? The Militarization of Women's Lives* (London: Pluto Press, 1983). See also Barton C. Hacker, "Women and Military Institutions in Early Modern Europe: A Reconnaissance," *Signs: Journal of Women in Culture and Society*, 6, 4 (Summer, 1981), pp. 643-71.

2. Female nurses who served with the militia in the North-West Campaign of 1885 against the second Riel rising were the first women to be recognized as forming part of a Canadian military force in the field. At the time of the Boer War a Canadian Nursing Service was formed and a militia order authorized Canadian Nursing Sisters to go overseas commissioned as lieutenants. See Nicholson, *Canada's Nursing Sisters*, pp. 18-47.

3. " 'Manpower' Problems of the Women's Services During the Second World War," Report No. 68, Historical Section (GS), Army Headquarters, by J.M. Hitsman, June 17, 1954, DH, DND, AHQ Rpt. (D68), p. 8, hereafter cited as Hitsman Report.

4. Almost 50,000 women resident in Canada had served in the women's services by the time of their dissolution in 1946: 20,497 in the CWAC;

16,221 in the Women's Division of the RCAF; and 6,665 in the WRCNS. An additional 4,439 served in the Nursing Services of the three forces. Altogether they represented about 2 per cent of the female population in Canada between the ages of fifteen and forty-five. Counting women recruited outside Canada, a total of 21,624 women served in the CWAC; 17,467 in the RCAF (WD); and 7,126 in the WRCNS. CWAC Statistics, DH, DND, 113.3C1065 (D3) CWAC. See also National Personnel Records Centre, Ottawa: Canadian Army Statistics/War 1939-45/CWAC. Appointments and Enlistments/By Month and Year of Appointment and Enlistment/Recapitulation; Royal Canadian Air Force/War 1939-45/ Intake of Male and Female Personnel/By Month and Year of Appointment or Enrolment; Royal Canadian Navy/War 1939-45/Female Personnel/By Province (Address on Appointment or Enrolment).

5. Colonel C.P. Stacey, *Six years of War*, Vol. 1: *The Army in Canada, Britain and the Pacific* (Ottawa: Queen's Printer, 1955), p. 3.

6. J.L. Granatstein and J.M. Hitsman, *Broken Promises: A History of Conscription in Canada* (Toronto: Oxford University Press, 1977).

7. W.A.B. Douglas and Brereton Greenhous, *Out of the Shadows: Canada in the Second World War* (Toronto: Oxford University Press, 1977), pp. 29, 27.

8. Wallace Clement, *The Canadian Corporate Elite: An Analysis of Economic Power* (Toronto: McClelland and Stewart, 1975), pp. 246, 317, 319, 322; Peter C. Newman, *The Canadian Establishment*, Vol. 1 (Toronto: McClelland and Stewart, 1975), pp. 170, 183, 291.

9. Patricia E. Roy, "The Soldiers Canada Didn't Want: Her Chinese and Japanese Citizens," *Canadian Historical Review*, LIX, 3 (September, 1978), p. 341.

10. T.G. Jaycocks, "Members of Canadian Women's Army Corps Release Able Men for Front Line Duty," *Saturday Night*, January 24, 1942, p. 4.

11. Stacey, *Six Years of War*, Vol. 1, p. 124.

12. Precedents for these civilian women's paramilitary corps can be found in the First World War. See Barbara M. Wilson, *Ontario and the First World War 1914-1918: A Collection of Documents*, Ontario Series of the Champlain Society, No. 10 (Toronto: University of Toronto Press, 1977), pp. lxxxvi-lxxxviii.

13. Letter of December 7, 1938, to Brigadier J.C. Stewart, DSO (District Staff Officer), MD No. 11, Work Point Barracks, Victoria, B.C., from Jean L. (Mrs. Hugo) Rayment, Victoria, B.C. PAC, RG 24, Vol. 6280, file HQ 32-1-443.

14. Communicated in British Army Order 199, Sept. 27, 1938, PAC, RG 24, Vol. 6280, file HQ 32-1-443.

15. Telegram of Aug. 28, 1940, to Col. J.L. Ralston, Minister of National Defence, Ottawa, from Mrs. Norman Kennedy, Controller, B.C. Women's Service Corps, PAC, RG 24, Vol. 2152, file HQ 54-27-32-7, vol. 1.

16. Communication of May 11, 1940, to E.W. Hamber, Lieutenant-Governor of British Columbia, from Joan B. Kennedy, Controller, B.C. Women's

Service Corps, PAC, RG 24, Vol. 6280, file HQ 32-1-443.

17. Pencilled note, n.d., but location in file indicates ca. Feb., 1941. PAC, RG 24, Vol. 2152, file HQ 54-27-32-7, vol. 2.

18. Letter of Nov. 18, 1942, to Major-General B.W. Browne, Director-General of the Reserve Army, from (Mrs.) Florence Seymour Bell, Chief Commandant, Women's Volunteer Reserve Corps, Montreal, PAC, RG 24, Vol. 2152, file HQ 54-27-32-7, vol. 2.

19. Letter of Jan. 15, 1943, to Joan Kennedy, Director, CWAC, from Jeanne Thisot, *La Presse*, Montreal, PAC, RG 24, Vol. 2252, file HS 54-27-111-1, vol. 2.

20. See note 16.

21. Newspaper clipping, n.d., PAC, RG 24, Vol. 2152, file HQ 54-27-32-7, vol. 1.

22. Letter of October 7, 1941, to Deputy Minister, Dept. of National Defence, from Isabel Fraser, Commanding Officer, Women's Auxiliary Service Patrol of Niagara Falls, PAC, RG 24, Vol. 2152, file HQ 54-27-32-7, vol. 2.

23. Letter of December 7, 1942, to Lt.-Col. Joan Kennedy, CWAC, from Mrs. E. Bradbrooke, Lt.-Col., Officer Commanding the Saskatchewan Auxiliary Territorial Service, Saskatoon Branch, PAC, RG 24, Vol. 2252, file HQ 54-27-111-1, vol. 2.

24. See note 16.

25. Memorandum of Aug. 21, 1939, to Organization from Colonel R.J. Orde, Judge Advocate-General; memo. of Sept. 6, 1940, to A.G. from Lt.-Col. A.A.G. Org. 1(b); memorandum of Nov. 18, 1942, to D. of Admin. from Lt.-Col. J.E. MacDermid, A.D., PAC, RG 24, Vol. 6280, file HQ 32-1-443; Vol. 2152, file HQ 54-27-32-7, vol. 1; Vol. 2152, file HQ 54-27-32-7, vol. 2.

26. Memorandum on "Auxiliary Militia Service of Canada (for Women)" sent with covering letter of Dec. 7, 1938 (see note 13), requesting that it be forwarded to Ian Mackenzie, Minister of National Defence, Ottawa, PAC, RG 24, Vol. 6280, file HQ 32-1-443.

27. Memorandum of Feb. 22, 1939, to Deputy Minister from C.G.S., PAC, RG 24, Vol. 6280, file HQ 32-1-443.

28. PAC, RG 24, Vol. 6280, file HQ 32-1-443.

29. "Women Eager to Serve," *Victoria Daily Times*, Dec. 5, 1940; letter of Dec. 14, 1940, to Major-General B.W. Browne, A.G., from Joan Kennedy, Controller, B.C. Women's Service Corps, PAC, RG 24, Vol. 2152, HQ 54-27-32-7, vol. 2.

30. A memorandum of June 28, 1940, to the Minister of National Defence from the District Officer Commanding Military District No. 2 pointed on the one hand to the increasing difficulty of obtaining "efficient personnel in certain employments in home establishments" and on the other to the "large number of well qualified women volunteers" whose services could be best utilized if they formed "part of a uniformed, officially constituted Corps subject to disciplinary rules and regulation."

Memorandum of June 28, 1940, to The Secretary, Dept. of National Defence, from Brigadier R.O. Alexander, DOC, MD No. 2., Camp Borden, Ont., PAC, RG 24, Vol. 2152, file HQ 54-27-32-7, vol. 1.

31. Hitsman Report, p. 3.

32. Confidential letter of April 29, 1941, from Secretary of the Cabinet War Committee to the Associate Deputy Minister, Dept. of National War Services, PAC, RG 44, Vol. 33, Women's Voluntary Services General, vol. 1.

33. See note 16. Letter of July 15, 1941, to The Secretary, Dept. of National Defence, from Major-General R.O. Alexander, G.O.C.-in-C., Pacific Command, Headquarters, Esquimalt, B.C., PAC, RG 24, Vol. 2152, file HQ 54-27-32-7, vol. 2.

34. "Women Clerks with D.N.D. 1st October 1940," PAC, RG 24, Vol. 2152, file HQ 54-27-32-7, vol. 2.

35. Major-General Browne, in a memorandum of Sept. 4, 1940, to the Minister of National Defence, spoke of "complete control." PAC, RG 24, Vol. 2152, file HQ 54-27-32-7, vol. 1.

36. Memo. of Oct. 15, 1940, to A.G. from Brigadier G.G. Anglin, DOC, MD No. 7, Saint John, N.B.; Memo. of Feb. 2, 1941, to D.A.G. from Lt.-Col. H.T. Cock, PAC, RG 24, Vol. 2152, file HQ 54-27-32-7, vols. 1, 2.

37. Interview with Beryl Eileen Beeson (Steel), W12005, MD No. 12, November 8, 1979, in Edmonton, Alberta.

38. Minutes of Meeting held in the office of the D.A.G.(M), June 30, 1941; Minutes of Meeting of the Cabinet War Committee, June 24, 1941, PAC, RG 24, Vol. 2252, file HQ 54-27-111-2, vol. 1.

39. Memorandum of Aug. 12, 1940, to Ralston from Browne, PAC, RG 24, Vol. 2152, file HQ 54-27-32-7, vol. 1.

40. Section IX, para. 133(a), "Regulations for the C.W.A.C., 1941," PAC, RG 24, Vol. 2252, file HQ 54-27-111-2, vol. 1. See also the Prologue to Kathleen Robson Roe, *War Letters from the C.W.A.C.* (Toronto: Kakabeka Publishing Co., 1975), p. 1. As one of the earliest volunteers (fifth in MD No. 1) Robson entered the CWAC before uniforms were available. She and her friends, recruited from the Red Cross Voluntary Corps, were allowed to wear their Red Cross uniforms until the CWAC ones were issued.

41. A survey in early 1943 disclosed that there were still at least ninety women's volunteer corps in existence in Canada, "with a strength of 199 Officers and 6,917 Other Ranks." Memo. of March 5, 1943, to CGS from Major-General H.F.G. Letson, PAC, RG 24, Vol. 2252, file HQ 54-27-111-1, vol. 2.

42. Second half of 1942, beginning of 1943. See correspondence in PAC, RG 24, Vol. 2152, file HQ 54-27-32-7, vol. 2; Vol. 2252, file HQ 54-27-111-1, vol. 2.

43. See note 35.

44. Stacey, *Six Years of War*, vol. 1, p. 127.

45. See notes 16 and 26.

46. "Women Eager to Serve," *Victoria Daily Times*, Dec. 5, 1940.

47. The Adjutant-General's circular letter of Oct. 1, 1940, and the replies to it are to be found in PAC, RG 24, Vol. 2152, file HQ 54-27-32-7, vol. 1.

48. Appendices VI and VII, "Regulations for the C.W.A.C., 1941."

49. Minutes of National Selective Service Conference, London, Ont., Feb. 15, 16, 17, 1943, PAC, RG 24, reel no. C-5322, file HQS 9011-11-5.

50. Memo. of Aug. 19, 1942, to Adjutant-General from Lt.-Col. J.E. McKenna, PAC, RG 24, reel no. C-5301, file HQS 8984.

51. Secret Memorandum of July 19, 1942, to MGO, QMG, CGS, from AG, PAC, RG 24, reel no. C-5301, file HQS 8984.

52. Extract from Minutes of Meeting of Army Council held July 29, 1942, in Memo. of Aug. 1, 1942, to DAG(A) from W.H.S. Macklin, Brig., for AG, PAC, RG 24, reel no. C-5301, file HQS 8984.

53. *Saturday Night*, October 17, 1942, p. 42.

54. Cynthia Enloe argues that, in order for militaries to use female labour as they will, women need to be kept under "sufficient control" and "the key to that control" is the "definition of women as creatures marginal to the military's core identity" – combat. As her fascinating account of "the elasticity of 'combat' " discloses, it has tended to expand and contract in Western militaries in inverse relation to manpower needs. The closer women have approached combat in reality, the more it has eluded them definitionally. Enloe, *Does Khaki Become You?*, pp. 6, 155.

55. Memorandum of Sept. 10, 1942, to DAG(A) from DM and R; Memorandum of Aug. 9, 1942, to DAG(A) from Colonel H.A.P. Francis, DM and R, PAC, RG 24, reel no. C-5301, file HQS 8984.

56. AG's Circular Letters of 14 and 20 April 1943 re Selection of CWAC Plotter-Telephonists, GOR, DH, DND, 006.066(D17). See also DH, DND, 169.009(D56). "The 'kinetheodolite' [was] a combination of a camera and a surveyor's instrument and the device record[ed] anti-aircraft shell bursts. Through a system of intricate calculations it [could be used to] determine errors in the gun fire. . . . The device [was] never used in actual battle, but [came] into service as the best method of grading marksmanship." *C.W.A.C. News Letter*, February, 1944, p. 5.

57. *50 Questions and Answers about the CWAC* (Ottawa: King's Printer, 1944), p. 1. DH, DND, 156.063(D2).

58. PAC, National Photography Division, Negatives Z-2506-3, Feb. 2, 1944, Z-1759-1, July 7, 1943, Z-25-04-4, Feb. 2, 1944, and Z-3727-(1-15), April 5, 1945.

59. " 'Jill' Canuck Has Become CWAC of All Trades," *Saturday Night*, March 4, 1944, p. 4.

60. Secret Circular Letters of Dec. 19, 1942, Jan. 20, Feb. 8, 19, 1943, reporting deployment of CWAC Other Ranks completing Basic Training, PAC, RG 24, reel no. C-5301, file HQS 8984.

61. See note 49.

62. CWAC Tradesmen at 28 Mar 45, Mach Rec 14-4-2, May 8, 1945, PAC,

RG 24, reel no. C-5300, file HQS 8981.

63. "Specifications for Selection: Tradeswomen and Non-Tradeswomen, C.W.A.C., 1944," PAC, RG 24, Vol. 11, 994. Batwoman is the female equivalent to batman, an officer's servant.

64. Known as the "Kine-CWACs," they were posted to an anti-aircraft training centre near Hartlen's Point, Eastern Passage, Nova Scotia, where, outfitted in sheepskin coats and heavy woollens, they braved the inclement weather of the windswept rocky coast to carry out their duties. Conrod, *Athene, Goddess of War*, pp. 142, 169-70, 185-86.

65. PAC, RG 24, Vol. 2173, file H.Q. 54-27-45-10, vols. 2, 3.

66. Memorandum of Dec. 4, 1942, to DAG(C) from J.H. Sunley, DAR 2nd, PAC, RG 24, reel no. C-5303, file HQS 8984-2.

67. Conrod, *Athene, Goddess of War*, pp. 99, 134-35, 162, 199-200.

68. *Information for the Use of Women Who Wish to Apply for Enrolment as Full-Time Auxiliaries in the Canadian Armed Forces* (Ottawa: King's Printer, August, 1941), copy at DH, DND, 951.059(D16).

69. "Information for Use in Employment and Selective Service Offices: Requirements as to Enlistment and Conditions Attaching to Service in the Women's Branches of the Armed Forces," Form UIC 777, 1943, PAC, RG 27, acc. no. 71/328, vol. 1, file 101.

70. Conrod, *Athene, Goddess of War*, pp. 78-79.

71. Stacey, *Six Years of War*, vol. 1, p. 126; Section XII, para. 158, "Regulations for the C.W.A.C., 1941." Section XII, para. 182, "Regulations for the Canadian Women's Army Corps, 1942," HQ 54-27-111-44. DH, DND, 113.3C1(D1).

72. "Although it had been considered originally that the ratio of replacement might be three to two, in practice it was to work out to one for one in most trades; indeed, in a few instances two airwomen were able to replace three airmen." Hitsman Report, pp. 6-7.

73. "Suggested Rates of Pay Based on Comparative Civil Service Rates," Feb., 11, 1941, PAC, RG 24, Vol. 2152, file HQ 54-27-32-7, vol. 2.

74. See note 35.

75. "Statement of Costs – Canadian Women's Army Corps," Appendix "B1," August, 1941, PAC, RG 24, Vol. 2252, file HQ 54-27-111-2, vol. 1.

76. Section XII, para. 183(a), "Regulations for the C.W.A.C., 1942." There were three levels of trades pay. Depending on the trade and his or her efficiency at the trade, a service person was given a Group "A," Group "B," or Group "C" trades pay rating. The pay at each level, however, was not the same for men and women. Servicemen with a "C" grouping received 25 cents a day additional to basic pay, with a "B" grouping 50 cents, and with an "A" grouping 75 cents. The scale for women was 15, 30, and 50 cents a day extra. See note 49. Also letter of July 31, 1943, to Unemployment Insurance Commission, Ottawa, from Captain T.H. Johnstone, Combined Services Committee, PAC, RG 24, reel no. C-5303, file HQS 8984-2.

77. See note 35.

78. Section III, para. 22(e), "Regulations for the C.W.A.C., 1942"; *Information for the Use of Women Who Wish to Apply for Enrolment as Full-Time Auxiliaries in the Canadian Armed Forces* (Ottawa: King's Printer, August, 1941), copy at DH, DND, 951.059(D16).

79. "Reasons applicants have given for not being interested in enlistment," n.d., but presumably late 1942 or early 1943, PAC, RG 27, Vol. 1523, file 21-16, part 1.

80. Section XII, para. 190, "Regulations for the C.W.A.C., 1942."

81. Reported in Minutes of the Canadian Women's Army Corps Staff Officers Conference, Nov. 18, 1942, DH, DND, 325.059(D1).

82. PAC, MG 28, I 25, Vols. 83, 85.

83. See note 50.

84. "Suggested Syllabus for the Instruction of N.S.S. Appointed to Deal with Prospective Recruits to the Women's Services of the Armed Forces," prepared by Directorate of Army Recruiting, Feb., 1943, PAC, RG 24, reel no. C-5303, file HQS 8984-2.

85. See Chapter Four.

86. *Report: An Enquiry into the Attitude of the Canadian Civilian Public Towards the Women's Armed Forces* (Montreal/Toronto: Elliott-Haynes Ltd., 1943), pp. 21, 25.

87. *Report of Enquiry – Canadian Women's Army Corps: Why Women Join and How They Like It*, April-May, 1943, pp. 13, 15. Copy at DND, DH, 168.009 (D91).

88. See Chapter Five.

89. "Canadian Forces – Increases of Pay for Women's Services," July 24, 1943. *Dominion of Canada Official Report of Debates: House of Commons*, Vol. V, 1943 (Ottawa: King's Printer, 1944), pp. 5357-58.

90. It might also be argued that the concentration of CWAC personnel in occupations not entitled to trades pay as well as in trades with the lowest level of trades pay, plus the absence of women from the highest military ranks, would have preserved an inequality of income on average between men and women in the Army.

Because the CWAC as originally established was not "part of the military Forces of Canada," women in the CWAC were not initially eligible for post-discharge and rehabilitation benefits available to male soldiers. The CWAC's incorporation into the Canadian Army in March, 1942, rectified that injustice.

91. Minutes of Conference of District CWAC Officers, April 18, 19, 20, 1944, Appendix 29, CWAC Preliminary History, DH, DND, 113.3C1(D1).

92. "Recommendations for an Advertising and Promotion Campaign to Stimulate French Canadian Enlistment in the Canadian Women's Army Corps," submitted Feb. 2, 1945, to Colonel Mary Dover, Assistant Director of Recruiting, NDHQ, from Hector Fontaine, Advertising Agencies of Canada, War Finance Advertising Group, DH, DND, PARC, box 4824, S-2730 – 1/15, vol. 1.

93. "Wartime History of Employment of Women and Day Care of Children,"

n.d., PAC, RG 35, Series 7, Vol. 20, file 10, part I, pp. 84-85.

94. Copy of Order-in-Council PC 6289, August 13, 1941, in DH, DND, 113.3C1(D1).
95. Section 1, para. 2, "Regulations for the C.W.A.C., 1941."
96. Memo. of Sept. 16, 1941, to Director of Organization from DAG(M), PAC, RG 24, Vol. 2253, file HQ 54-27-111-2, vol. 5.
97. *Ibid.*
98. Director-General, CWAC, presumably Col. Margaret Eaton, "Preliminary Historical Narrative, History of the CWAC & Appendices" (n.d., but from internal evidence c. mid-1945), p. 8.
99. Section II, para 9(a), "Regulations for the C.W.A.C., 1941."
100. Draft Copy of Regulations and Instructions for the Canadian Women's (Army) Service, June 23, 1941, PAC, RG 24, Vol. 2252, file HQ 54-27-111-2, vol. 1.
101. See note 98, p. 5; Stacey, *Six Years of War*, vol. 1, p. 125.
102. Section I, para. 6; Section VI, para. 62(a), (b), (c), (d), "Regulations for the C.W.A.C., 1941."
103. Memorandum of Sept. 2, 1940, to Adjutant-General from Ralston, PAC, RG 24, Vol. 2152, file HQ 54-27-32-7, vol. 1.
104. Ralston (at Canadian Military Headquarters in London) to C.G. Power, Minister of National Defence for Air, Tel. No. GS 3051, Nov. 29, 1940. PAC, RG 24, Vol. 12, 777, file 42/Min. ND/1. For this reference I am indebted to Steve Harris.
105. Memorandum of Jan. 31, 1942, to Ralston from Browne; memo. of Feb. 10, 1942, to Major-General H.F.G. Letson, from Ralston, PAC, RG 24, Vol. 2253, file HQ 54-27-111-2, vol. 5.
106. Memorandum of April 8, 1943, to Letson, Adjutant-General, from Browne, Director-General of the Reserve Army, PAC, RG 24, Vol. 2252, file HQ 54-27-111-1, vol. 2.
107. Memorandum of Feb. 10, 1942, to Letson from Ralston. See note 105.
108. Memorandum of Jan. 1, 1942, to O/A, CWAC, from Col. H. Cock, D. of O. & A., PAC, RG 24, Vol. 2252, file HQ 54-27-111-2, vol. 3.
109. Letter of Jan. 7, 1942, to Adjutant-General from General H.F. McDonald, Chairman, General Advisory Committee on Demobilization and Rehabilitation, PAC, RG 24, Vol. 2253, file HQ 54-27-111-2, vol. 4.
110. Copy of Order-in-Council PC 1965, March 13, 1942, to be found in DH, DND, 113.3C1(D1).
111. Circular letter of May 9, 1942, to All CWAC Staff Officers from Major Joan B. Kennedy, O/A, CWAC. PAC, RG 24, Vol. 2253, file HQ 54-27-111-2, vol. 5.
112. *Ibid.*
113. Abbreviations and Definitions, "Regulations for the C.W.A.C., 1942."
114. Section VI, "Regulations for the C.W.A.C., 1942."
115. GO 150 (April 30, 1942), PAC, RG 24, Vol. 2253, file HQ 54-27-111-2, vol. 5.
116. Section I, paras. 5, 6(a), 6(b), "Regulations for the C.W.A.C., 1942."

117. Adjutant-General's Confidential Letter of Aug. 4, 1941, PAC, RG 24, Vol. 2252, file HQ 54-27-111-2, vol. 1.

118. See note 98, p. 6.

119. *Ibid.*, p. 11.

120. *Ibid.*, p. 5.

121. Minutes of 143rd Meeting of the Officers Selection, Promotion, Reclassification and Disposal Board, April 28, 1944, PAC, RG 24, reel no. C-5257, file HQC 8686-4.

122. Memorandum of May 12, 1944, to the Minister from Adjutant-General, initialled by J.L. Ralston, n.d., PAC, RG 24, reel no. C-5257, file HQC 8686-4. Interview with Margaret Eaton Dunn, London, England, May 9, 1978.

123. Memorandum of Oct. 21, 1945, to Adjutant-General from H.D. Graham, Brigadier, DGA(A); Memorandum of Oct. 24, 1945, to DAG(A) from Colonel M.C. Eaton, DG/CWAC; Memorandum of Oct. 30, 1945, to DAG(A) from Lt.-Col. D.I. Royal, DD/CWAC; Memorandum of Jan. 19, 1946, to D. Org., through S.O., CWAC, from J.R.R. Gough, Brigadier, DAG (B), PAC, RG 24, reel no. C-5257, file HQC 8684-4.

124. Letter of Oct. 12, 1946, to Headquarters, Western Command, from Lieutenant-General, Chief of the General Staff; letter of Oct. 18, 1946, to the Secretary, Army Headquarters, Ottawa, from F.P. Worthington, Major-General GOC, Western Command, HQ, Western Command, Edmonton, PAC, RG 24, reel no. C-5302, file HQS 8984.

125. Memorandum of March 18, 1946, to Miss M. Graham, Training Branch, Department of Labour, from Lt.-Col. Daisy I. Royal, Staff Officer, CWAC, PAC, RG 27, Vol. 744, file 12-14-16-12, vol. 1.

126. "Canada's Women Make History," caption to Canadian Army photo on cover of *The Rally Magazine*, 5, 1 (January, 1943). DH, DND, 156.009(D3).

127. Robson Roe, see note 40; Phylis Bowman, *We Skirted the War!* (Prince Rupert, B.C.: P. Bowman, 1975); conversation on March 13, 1978, with Mrs. Alice Sorby, formerly Deputy Director, CWAC, at Canadian Military Headquarters, London, England.

128. Jaycocks, see note 10; "A Tribute to the Canadian Women's Army Corps from His Excellency, the Governor General of Canada," inside cover of *CWAC Digest: Facts About the C.W.A.C.* DH, DND, 156.063(D1).

129. Heidi Hartmann, "Capitalism, Patriarchy, and Job Segregation by Sex," *Signs*, 1, 3, part 2 (Spring, 1976), pp. 152-53.

130. "Suggested Notes for the Guidance of Speakers at the National Selective Service Schools," Feb. 9, 1943, sent out from the Office of Director of Army Recruiting, PAC, RG 24, reel no. C-5303, file HQS 8984-2.

131. "No 'pistol packing momma,' this, only a member of the Canadian Women's Army Corps 'looking over' the war equipment used by her brothers on active service overseas. . . ." Caption to Canadian Army photo showing CWAC corporal sitting astride the barrel of an artillery piece in an armaments show in Ottawa in May, 1944. PAC, National Photography

Division, negative Z-2766-6.
132. PAC, National Photography Division, negative Z-972-1, Nov. 11, 1942, and negative Z-2611-1, "C.W.A.C. Recreation – Firing on Indoor Range," March 10, 1944. *C.W.A.C. News Letter*, Spring, 1945, p. 2, and May, 1945, p. 2.
133. "Notes for the Assistance of Speakers at School for N.S.S. Employment Office Personnel," Feb., 1943, PAC, RG 24, reel no. C-5303, file HQS 8984-2.
134. "One CWAC Staff Officer expressed the general feeling [after Dieppe]: 'Women will stay behind and support the men in the very necessary jobs they can do the best. They will not try to take their place in the front line. It is the duty of women to give life, not take it.' " Conrod, *Athene, Goddess of War*, p. 87.

Chapter 4, Wartime Jitters over Femininity

1. *Saturday Night*, September 26, 1942, p. 10.
2. Lotta Dempsey, "Women Working on Ships and Aircraft," *Mayfair*, June 1943, p. 74.
3. Notes for the Assistance of Speakers at School for NSS Employment Office Personnel, February, 1943, PAC, RG 24, reel no. C-5303, file HQS 8984-2.
4. *Globe and Mail*, December 24, 1942, p. 8; December 31, 1942, p. 13.
5. " 'Jill' Canuck Has Become CWAC of All Trades," *Saturday Night*, March 4, 1944, p. 4.
6. Margaret Ecker, *Globe and Mail*, December 26, 1942, p. 8.
7. Copies in PAC, RG 24, Vol. 2256, file HQ 54-27-111-144, vol. 1.
8. "Suggested Notes for the Guidance of Speakers at the N.S.S. Schools," "Further Suggested Notes . . . ," February, 1943, PAC, RG 24, reel no. C-5303, file HQS 8984-2.
9. *Women in Khaki*, n.d., but internal evidence places publication in second half of 1942, DND, DH, 164.069 (D1).
10. According to the nationwide survey of CWAC other ranks carried out in April-May, 1943, "about 20% of CWAC women belonged to a volunteer women's part-time service organization prior to enrolling in the CWAC. Most of these belonged to one of the unofficial uniformed women's corps or the Red Cross." *Report of Enquiry – Canadian Women's Army Corps: Why Women Join and How They Like It*, April-May, 1943, p. 23, copy at DND, DH, 168.009(D91).
11. "Strength – Canadian Women's Army Corps as at 27 March 1943" was 354 officers plus 9,741 other ranks, totalling 10,095. PAC, RG 24, reel no. C-5303, file HQS 8984-2.
12. Weekly Strength Returns by D. Org. DND, DH, 113.3C1065 (D3) CWAC.
13. Letter of October 1, 1943, to newspaper editors from Captain T.H. Johnstone, Combined Services Committee, PAC, RG 24, reel no. C-5303,

file HQS 8984-2. By July 1, 1943, 28,000 women had been accepted by the three services, 13,000 by the CWAC. *Report – C.W.A.C.: Why Women Join and How They Like It* (hereafter *C.W.A.C. Report*), p. 11.

14. Communication of January 30, 1943, to all regional superintendents, from R.G. Barclay, Assistant Director, Employment Service and Unemployment Insurance Branch, PAC, RG 24, reel no. C-5303, file HQS 8984-2.

15. Memorandum of March, 1943, to the Minister from Major-General H.F.G. Letson, PAC, RG 24, reel no. C-5303, file HQS 8984-2.

16. Minutes of the 89th Meeting of the National Campaign Committee, February 22, 1943, PAC, RG 24, reel no. C-5303, file HQS 8984-2.

17. *Report: An Enquiry into the Attitude of the Canadian Civilian Public Towards the Women's Armed Forces* (Montreal/Toronto: Elliott-Haynes Limited, 1943), p. 3, hereafter cited as Elliott-Haynes, *An Enquiry*.

18. *C.W.A.C. Report*, pp. 3-4.

19. Elliott-Haynes, *An Enquiry*, p. 8.

20. *Ibid.*, p. 9.

21. *Ibid.*, p. 12.

22. *Ibid.*, p. 13.

23. *C.W.A.C. Report*, p. 28.

24. Elliott-Haynes, *An Enquiry*, p. 14.

25. *Ibid.*

26. *Ibid.*, p. 32.

27. *C.W.A.C. Report*, p. 28.

28. *Ibid.*

29. Elliott-Haynes, *An Enquiry*, p. 15.

30. *Ibid.*

31. *Ibid.*, p. 25.

32. *C.W.A.C. Report*, p. 26.

33. PAC, RG 24, Vol. 2252, file HQ 54-27-111-1, vol. 2.

34. *C.W.A.C. Report*, p. 12.

35. Letter of July 26, 1943, to Gentlemen from T.H. Johnstone, Captain, Combined Services Committee, PAC, RG 24, reel no. C-5303, file HQS 8984-2.

36. PAC, RG 24, Vol. 2252, file HQ 54-27-111-1, vol. 2; reel no. C-5303, file HQS 8984-2, *passim*.

37. Elliott-Haynes, *An Enquiry*, p. 24.

38. Notes for the Assistance of Speakers for NSS Employment Personnel, February, 1943, PAC, RG 24, reel no. C-5303, file HQS 8984-2; NSS Representatives Conference, London, Ontario, February 15-17, 1943, PAC, RG 24, reel no. C-5322, file HQS 9011-11-5.

39. Director-General, CWAC, presumably Col. Margaret C. Eaton, "Preliminary Historical Narrative, History of the CWAC & Appendices" (n.d., but internal evidence suggests ca. mid-1945), p. 33, copy at DH, DND, 113,3C1(D1).

40. *Ibid.*, p. 34.

41. *Women in Khaki*, p. 20.

42. Cut-sheet of suggested sponsored ads for the CWAC, summer/autumn 1943, DH, DND, 164.069 (DI).

43. Minutes of meeting to discuss CWAC depot companies, February 10, 1944, in office of D. Org. (R), PAC, RG 24, reel no. C-8410, file HQS 9011-11-0-2-1.

44. Bowman, *We Skirted the War!*, p. 3.

45. *C.W.A.C. Report*, p. 24.

46. *Ibid.*, pp. 33-34.

47. Lionel Shapiro, *The Sixth of June* (Garden City, N.Y.: Doubleday, 1955); Geoffrey Cotterell, *Westward the Sun* (London: Eyre & Spottiswoode, 1952).

48. *Maclean's*, January 1, 1943, p. 7.

49. Elliott-Haynes, *An Enquiry*, p. 27.

50. Hitsman Report, p. 12.

51. PAC, National Photography Collection, Z-2600-8, 7/3/44, Maj.-Gen. Potts and daughter, Cpl. Edith, CWAC, at Kitchener, CWAC, #3 Basic Training Centre.

52. *C.W.A.C. Report*, p. 15.

53. "Glamour Girl of 1942," *National Home Monthly*, September, 1942, p. 36.

54. PAC, National Photography Collection, Z-2766-8.

55. Some World War II servicewomen remember without fondness their having been used as sex objects. One wrote that "as an RCAF (WD) I was involved in displaying my legs on a float in an advertising effort to recruit young men (so-called) still in high school. What a horrid memory" Letter to author from Shirley Goundrey, dated October 17, 1977.

56. *50 Questions and Answers about CWAC* (Ottawa: King's Printer, 1944), p. 7.

57. Draft copy of Regulations and Instructions for the Canadian Women's (Army) Service, June 23, 1941, PAC, RG 24, Vol. 2252, file HQ 54-27-111-2, vol. 1.

58. The five CWAC officers, including Lt.-Col. Margaret Eaton, later Director-General, CWAC, had recommended that in lieu of the cash allowance "articles of underclothing, etc., be added to the present scale of issue of clothing for CWAC serving in Canada." Although the committee members concurred, no action was taken at higher levels. Proceedings of a Meeting of the Dress & Clothing Committee (Army), July 6, 1943, PAC, RG 24, Vol. 2255, file HQ 54-27-111-40, vol. 1. Lt.-Col. D.I. Royal, then senior staff officer, CWAC, reported that the cash allowance for underclothing had been inadequate in her "Report and Recommendations on the Canadian Women's Army Corps" of August 29, 1946, PAC, RG 24, Vol. 2254, file HQ 54-27-111-2, vol. 9.

59. Lotta Dempsey, "They're Still Feminine!" *Maclean's*, January 1, 1943, p. 7.

60. Thelma LeCocq, "War Wear," *Maclean's*, August 15, 1942, p. 15.

61. From Marjorie Winspear's column, "Beauty & Fashions," *National Home*

Monthly, October, 1942, p. 58.

62. *Maclean's*, March 1, 1942, p. 3.

63. RCN photo by Photographer Sheraton, RCNVR, *Telegram* Print Collection, York University Archives.

64. PAC, National Photography Collection, Z-61-2, "C.W.A.C. Winter Driving Uniform," January 9, 1942.

65. Emphasis in original. Master-General of the Ordnance Letter No. 64/1944, July 22, 1944, PAC, RG 24, Vol. 2255, file HQ 54-27-111-33, vol. 3.

66. Proceedings of a meeting of the Women's Dress and Clothing Committee (Army), October 6, 1944, PAC, RG 24, Vol. 2255, file HQ 54-27-111-40, vol. 1. See also Army photo of a military transport driver in dress uniform of skirt and jacket, pumping up a tire of a staff car. PAC, National Photography Collection, Z-3187-1, September 27, 1944.

67. "Glamour Girl of 1942," p. 38.

68. *Maclean's*, November 15, 1942.

69. *50 Questions and Answers About CWAC*, p. 9.

70. Section IX, para. 120(b), "Regulations for the C.W.A.C., 1941," PAC, RG 24, Vol. 2252, file HQ 54-27-111-2, vol. 1; Section IX, para. 40(b), "Regulations for the C.W.A.C., 1942," HQ 54-27-111-44, DH, DND, 113-3C1 (D1).

71. Section IX, para. 118(e), "Regulations for the C.W.A.C., 1941"; Section IX, para. 137(e), "Regulations for the C.W.A.C., 1942."

72. *50 Questions and Answers About CWAC*, p. 9.

73. Conrod, *Athene, Goddess of War*, p. 55.

74. Caption to Army photo, PAC, National Photography Collection, negative Z-2337-5, December 3, 1943.

75. Caption to Army photo, PAC, National Photography Collection, negative Z-2337-2, December 3, 1943.

76. See also PAC, National Photography Collection, "C.W.A.C. Beauty Culture," negative Z-2431-3, January 8, 1944.

77. "Army hair-do regulations of no hair below collars caused a little trouble, but most CWACs were quick to the occasion, passed off glamorous tresses as a war luxury and now more and more appear with boyish and military hair cuts." James C. Anderson, "Police Women for the Army," *Saturday Night*, April 24, 1943, p. 26.

78. "Sergeant To Dress Airwomen's Hair: Department is Set Up as Morale Booster," *Globe and Mail*, December 8, 1942, p. 10; "A WREN's Life Aboard HMCS Conestoga," *Mayfair*, July, 1943, p. 22; *Women in Khaki*, p. 24. While morale-boosting clearly was the main purpose behind the provision of hairdressing facilities within the women's services in Canada, in England, according to the one-time Director of the Auxiliary Territorial Service, another purpose was served: keeping heads clear of lice. Leslie Violet Lucy Evelyn Mary Whateley, *As Thoughts Survive* (London: Hutchinson & Co., 1948).

79. PAC, National Photography Collection, caption to Army photo, Z-3082-32, August 18, 1944; Army photos "C.W.A.C. Training Class, High School

of Commerce," Z-3528-(1-4), January 27, 1945.

80. PAC, National Photography Collection, Army photo, "C.W.A.C. (C.B.) at Argyle Barracks," Z-2440-18, January 11, 1944.

81. PAC, National Photography Collection, Army photos, "C.W.A.C. Buy New Spring Clothes," Z-2710-(1020), April 17, 1944. See also the cartoon drawn for *Maclean's* by Jaboo, May 1, 1939, p. 22.

82. PAC, National Photography Collection, Z-2405-3, December 27, 1943.

83. Rosamond "Fiddy" Greer's account of life in the Women's Royal Canadian Naval Service during World War II contains this personal recollection: "When two sisters slept together in a lower bunk across from mine, the thought of lesbianism never crossed my mind. This is not at all surprising, as I had never even heard of it. The more worldly-wise than I (which was probably almost everyone) may have known about 'it,' but none spoke the unmentionable word and for some time I thought how nice it was that the girls could comfort one another when they felt homesick. However, one day I heard that they had been 'found out': shortly afterwards they disappeared from *Stadacona*; and I surmised that 'something funny' had been going on. I was learning; although not too swiftly . . . for a long time after the incident I thought lesbians were rather peculiar sisters." Rosamond "Fiddy" Greer, *The Girls of the King's Navy* (Victoria, B.C.: Sono Nis Press, 1983), pp. 83-84.

84. *C.W.A.C. Report*, pp. 18, 24.

85. PAC, National Photography Collection, Army photos "In Barracks," negatives Z-1765-(1-9), July 7, 1943.

86. PAC, National Photography Collection, Army photo, negative Z-1885-17, August 11, 1943.

87. PAC, National Photography Collection, Army photos, negatives Z-2544-23 and 24, February 16, 1944.

88. PAC, National Photography Collection, Z-4037-2.

89. Elliott-Haynes, *An Enquiry*, p. 27.

90. *50 Questions and Answers About CWAC*, p. 11.

91. "Private of C.W.A.C. Weds Army Corporal," *Globe and Mail*, December 2, 1942, p. 11.

92. PAC, National Photography Collection, Army photos "C.W.A.C. Wedding," negatives Z-2586-(1-9), March 1, 1944; "C.W.A.C.-Navy Wedding at Kildare Barracks," negatives Z-3796-(1-4), April, 1945.

93. NSS Representatives Conference re Recruitment of Women for Armed Services, London, Ontario, February 15, 16, 17, 1943, PAC, RG 24, reel no. C-5303, file HQS 8984-2.

94. CWAC Recruiting Pamphlet used in Military District No. 4 in January-March, 1943, campaign, DH, DND, 164.069(D1).

95. Godfrey Winn, "Through Fair Weather and Foul, Britain's . . . Women Ferry Pilots Fly that Men May Fight," *Saturday Night*, November 28, 1942, pp. 4-5; D.K. Findlay, "Anywhere to Anywhere," *Maclean's*, April 15, 1943, pp. 12-13, 57, 61.

96. Mary Ziegler, *We Serve That Men May Fly: The Story of Women's Division*

Royal Canadian Air Force (Hamilton, Ontario: R.C.A.F. (W.D.) Association, 1973), pp. 66-67.

97. *Globe and Mail*, September 9, 1942, p. 9; October 10, 1942, p. 11. Discussed in Marie T. Wadden, "Newspaper Response to Female War Employment: *The Globe and Mail* and *Le Devoir* May-October 1942" (History honours dissertation, Memorial University of Newfoundland, May, 1976), pp. 13-14. Statement of Major-General Knox quoted in Conrod, *Athene, Goddess of War*, p. 96.

98. L.S.B. Shapiro, "They're Still Women After All," *Saturday Night*, September 26, 1942, p. 10.

99. *C.W.A.C. Report*, p. 15.

100. Memorandum of July 22, 1943, to DAG(C) from Director of Army Recruiting, PAC, RG 24, reel no. C-5303, file HQS 8984-2.

101. "Suggested Notes for the Guidance of Speakers at the National Selective Service Schools," February 9, 1943, sent out from the Office of Director of Army Recruiting, PAC, RG 24, reel no. C-5303, file HQS 8984-2.

102. See Ruth Milkman, "Redefining 'Women's Work': The Sexual Division of Labor in the Auto Industry During World War II," *Feminist Studies* 8, 2 (Summer, 1982), pp. 336-72, for a discussion of the flexibility of what she calls "the idiom of sex typing" as a component of "the resilience of the structure of job segregation by sex." Milkman shows how shifting composition and application of the idiom of sex typing in the U.S. auto industry both legitimated and curtailed the "redefinition of the boundaries between 'women's work' and 'men's work' " during the war and helped facilitate the return to pre-war patterns of occupational segregation by sex during post-war reconversion. "[T]he reproduction of job segregation by sex," Milkman argues, is "a process that is always occurring." And this *"job segregation,"* she further argues, "coincides with a *gender hierarchy* within the labor market."

103. See Chapter Three.

104. Thelma LeCocq, "Woman Power," *Maclean's*, June 15, 1942, pp. 10-11, 40.

105. Drawn for *Maclean's* by Vic Herman, September 15, 1945, p. 32.

106. Memorandum of July 22, 1943, to DAG(C) from Director of Army Recruiting, PAC, RG 24, reel no. C-5303, file HQS 8984-2.

107. Copy at DH, DND, 164.069 (D1).

108. Sponsored CWAC advertising, summer/autumn 1943, DH, DND, 164.069 (D1).

Chapter 5, Ladies or "Loose" Women

1. Letter of March 29, 1984, to Nancy Kiefer in response to her advertisement for information on women who attended the University of Toronto during the Second World War.

2. *C.W.A.C. Report*, p. 17.

3. Exceptions were occasionally made in the case of officers. Interview with Margaret Eaton Dunn, London, England, May 9, 1978.

4. CARO 4834, mentioned in memo. of June 27, 1943, to AG through the DAG (A) from Colonel D.F. MacRae, D. Org., PAC, RG 24, reel no. C-5300, file HQS 8981.

5. Secret Army message (AG 2656) of May 4, 1945, to Canmiltry from Defensor; Secret Army message (AG 6695) to Canmiltry from Defensor. PAC, RG 24, reel no. C-5300, file HQS 8981.

6. See Bland, " 'Guardians of the race,' " pp. 373-88.

7. Hitsman Report, p. 12. The Auxiliary Territorial Service of Great Britain was also the object of a "whispering campaign" that began as early as 1940 but was laid to rest, according to the Director of the ATS during the period 1943-1946, by the British White Paper "Report of the Committee on Amenities and Welfare Conditions in the Three Women's Services," issued August, 1942. Leslie Violet Lucy Evelyn Mary Whateley, *As Thoughts Survive* (London: Hutchinson & Co., 1948), pp. 21, 32, 41, 71.

8. PAC, RG 24, reel no. C-5303, file HQS 8984-2.

9. Hitsman Report, pp. 12-13; "Immorality of Service Women," Wartime Information Board – Reports Branch, confidential memorandum, March 19, 1943, DH, DND, Public Archives Records Centre, box 4824, S-2730 – 1/ 15, vol. 1.

10. "Morale & Morale Surveys – Policy," RCAF, 1942-43, PAC, RG 24, Vol. 3541, file HQ 927-23-1. All future references to this survey are drawn from this file.

11. Elliott-Haynes, *An Enquiry*, p. 22.

12. *C.W.A.C. Report*, Table (d), p. 27.

13. The Elliott-Haynes report (pp. 23, 30) also showed that, between parents and young men, a higher proportion of the brothers and boyfriends of eligible young women "criticized service women on moral grounds."

14. *C.W.A.C. Report*, Table (g), p. 28, p. 12.

15. Letter of August 16, 1943, to chief editorial writers of Canada's daily papers from Pilot Officer Carl Reinke, Combined Services Committee, WRCNS, CWAC, RCAF, PAC, MG 28, I 25, vol. 84.

16. Letter of December 22, 1941, to Director of Medical Services, DP and NH, from Lt.-Col. W.C. Arnold, RCAMC, for DGMS, PAC, RG 24, reel no. C-5318, file HQC 8994-12.

17. See PAC, RG 24, reel C-5296, file HQC 8972, *passim*.

18. "Venereal Disease – C.W.A.C. – Jan.-June 1943," PAC, RG 24, reel no. C-5296, file HQC 8972; Reprint from the First Annual Report of the Department of National Health and Welfare for the fiscal year ended March 31st, 1945, PAC, RG 24, Vol. 6618, file HQ 8994-6, vol. 10; confidential communication of February 9, 1945, to District Officer Commanding, Military District No. 13, Calgary, Alta., DOC, MD No. 10,

Winnipeg, Man., DOC, MD No. 6, Halifax, Nova Scotia, from Brigadier A.C. Spencer, A/Adjutant-General, PAC, RG 24, reel no. C-5296, file HQC 8972.

19. "Special Report on Discharged Personnel, June 1943 – Analysis of the Returns on the Pro Formas Sent Out to All Ex-Service Women, C.W.A.C., Discharged for Pregnancy," PAC, RG 24, reel no. C-5296, file HQC 8972.

20. Hitsman Report, p. 14.

21. Interview with Alice Thompson, Calgary, Alberta, November 13, 1979.

22. "Immorality of Service Women," Wartime Information Board – Reports Branch, confidential memorandum, March 19, 1943, DH, DND, PARC, box 4824, S-2730 – 1/15, vol. 1.

23. Memorandum of June 14, 1943, to DAG(C) from R.S. White, i/c Promotion, Combined Services Committee, PAC, RG 24, reel no. C-5303, file HQS 8984-2.

24. Suggested Syllabus for the Instruction of Representatives of NSS Appointed to Deal with Prospective Recruits to the Women's Services of the Armed Forces, PAC, RG 24, reel no. C-5303, file HQS 8984-2.

25. As an expression of opposition to women's admission into the military, servicemen's part in the spreading of lewd stories about servicewomen bears comparison with the reaction of some male medical students and lecturers in the 1880's to women's admission to medical school. See "Historical Sketch of Medical Education of Women in Kingston," read [by Elizabeth Shortt] before the Osler Club, Queen's University, September 14, 1916, in Ramsay Cook and Wendy Mitchinson, eds., *The Proper Sphere: Women's Place in Canadian Society* (Toronto: Oxford University Press, 1976), pp. 155-65. I am grateful to Jane Lewis for the suggested comparison.

26. Collection of forty postal intercepts dissuading women from joining the services and/or from volunteering for overseas service, attached to memorandum of August 17, 1943, DH, DND, PARC, box 4824, S-2730 – 1/15, vol. 1.

27. "Immorality of Service Women," Wartime Information Board.

28. Quoted in J.N. Buchanan, "Canadian Women's Army Corps, 1941-1946," Report No. 15, Historical Section (GS), Army Headquarters, May 1, 1947, copy at DH, DND.

29. Minutes of Meeting of the Combined Services Committee, June 9, 1943, PAC, RG 24, reel no. C-5303, file HQS 8984-2.

30. HQ 54-27-111-20, (DAR 84), May 31, 1943, DH, DND, 322.009 (D180).

31. Adjutant-General's circular letter (R. 712) of August 15, 1944, PAC, RG 24, Vol. 2252, file HQ 54-27-111-1, vol. 2.

32. *C.W.A.C. Report*, p. 21: 32 per cent of those responding to the question "How did you first learn of the CWAC?"

33. Memo. of July 22, 1943, to DAG(C) from Director of Army Recruiting, PAC, RG 24, reel no. C-5303, file HQS 8984-2.

34. Preliminary Historical Narrative, p. 25.

35. Letter dated August 8, 1944, from Edmonton, Alberta. In an Appendix to Preliminary Historical Narrative, DH, DND, 113.3C1(D1).

36. Communication of Lt.-Col. B.M. Clerk, SAAG, to AG, July 28, 1943, quoted by Buchanan, "Canadian Women's Army Corps."

37. Report on Canadian Women's Army Corps, by Capt. Ruth Crealock, Sept. 30, 1943, PAC, RG 24, reel no. C-5303, file HQS 8984-2; "History of C.W.A.C.: Preliminary Historical Narrative," pp. 22-26, DH, DND, 113.3C1; Report and Recommendations on the Canadian Women's Army Corps, by Lt.-Col. D.I. Royal, Staff Officer, CWAC, Aug. 29, 1946, p. 26, PAC, RG 24, Vol. 2254, file HQ 54-27-111-2, vol. 9.

It is noteworthy that this explanation is reproduced uncritically and thus perpetuated in Conrod, *Athene, Goddess of War*, pp. 83-84, 125-26, 132, 144. His history of the Corps is endorsed by Margaret C. Dunn, formerly Col. Margaret Eaton, Director-General, CWAC. Conrod adds a xenophobic touch by implying that enlistment of United States women, terminated early in 1944, was a part of the misguided "open-door" policy.

38. Letter of August 3, 1945, to the Secretary, Dept. of National Defence, from Major-General, GOC-in-C, Pacific Command, PAC, RG 24, reel no. C-5296, file HQC 8972-1-11.

39. A survey was carried out on "all reported cases of pregnancy among unmarried CWAC personnel during the period 1 Jan 44 until 15 Aug. 44." The report compared the mean "M" (intelligence) test score for the sample of unmarried pregnant CWACs in the study with the mean CWAC score, based on a sample of 1,428 cases, and found the latter slightly higher. However, "M" test scores were available for only 219 of the 276 unmarried pregnant women in the survey sample and the report did not account for the missing 57 scores. "Report on analysis of data on pregnancy among unmarried C.W.A.C. personnel," November, 1944, PAC, RG 24, reel no. C-5296, file HQC 8972.

40. HQ 54-278-111-20 FD 49, July 3, 1943, to Org. from Brig. Sutherland (DAG), quoted in Preliminary Historical Narrative, p. 24.

41. 54-27-111-20 FD 58 (DAR 2), Sept. 28, 1943, to DAG(C) from Dir. of Army Recruiting, Appendix 17 to Preliminary Narrative History.

42. Circular Letter (DAR 150) of Feb. 25, 1944, to all District Recruiting Officers from the Director of Army Recruiting, PAC, RG 24, reel no. C-8410, file HQS 9011-11-0-2-1.

43. Preliminary Historical Narrative, p. 25.

44. "Special Report on Discharged Personnel, June 1943 – Analysis of the Returns on the Pro Formas Sent Out to All Ex-Service Women, C.W.A.C., Discharged for Pregnancy," PAC, RG 24, reel no. C-5296, file HQC 8972.

45. Memorandum of Aug. 23, 1943, to Lt.-Col. Margaret Eaton, AAG, CWAC, from Brigadier G.B. Chisholm, Director-General of Medical Services, PAC, RG 24, reel no. C-5296, file HQC 8972.

46. Memorandum of Dec. 18, 1944, to DGMS from Major G.C. Maloney,

RCAMC, CWAC Consultant, PAC, RG 24, reel no. C-5296, file HQC 8972.

47. Memorandum on CWAC Recruiting, 54-27-111-20 FD 58 (DAR2) of Sept. 28, 1943, to DAG(C) from Dir. of Army Recruiting, Appendix 17 to Preliminary Historical Narrative, copy at DH, DND, 113-3C1(D1).

48. Memorandum of June, 1943, to DAG(C) from Capt. T.H. Johnstone, for Combined Services Co., PAC, RG 24, reel no. C-5303, file HQS 8984-2.

49. "College Girls Are Needed in the C.W.A.C.," Sponsored CWAC Advertising, summer/autumn 1943, DH, DND, 164.069(D1).

50. Emphasis in original. Memo. on CWAC Recruiting, 54-27-111-20 FD 58 (DAR2) of Sept. 28, 1943, to DAG(C) from Dir. of Army Recruiting, Appendix 17 to Preliminary Historical Narrative, DH, DND, 113.3C1(D1).

51. Lotta Dempsey, "Women's Wartime Services," *Mayfair*, July, 1943, p. 64.

52. Memo. on CWAC Recruiting of Sept. 28, 1943, to DAG(C) from Dir. of Army Recruiting, Appendix 17 to Preliminary Historical Narrative.

53. Minutes of meeting in offices of DGMS on pregnancy in the CWAC, May 27, 1943, PAC, RG 24, reel no. C-5296, file HQC 8972.

54. Confidential memorandum of June 8, 1943, to DGMS from Lt.-Col. C.V. Ward, RCAMC, AMD9, PAC, RG 24, reel no. C-5296, file HQC 8972.

55. *50 Questions and Answers About CWAC*, p. 5.

56. Minutes of District CWAC Officers' Conference, February 6-8, 1945, DH, DND, 115.1009 (D22).

57. "Report and Recommendations on the Canadian Women's Army Corps," prepared by Lt.-Col. D.I. Royal, Staff Officer, CWAC, Aug. 29, 1946, PAC, RG 24, Vol. 2254, file HQ 54-27-111-2, vol. 9.

58. *CWAC Digest: Facts about the C.W.A.C.*, DH, DND, 156.063(D1).

59. Memorandum of Feb. 16, 1944, to D. Admin. from M.C. Eaton, Lt.-Col., AAG (CWAC); communication of February 26, 1944, to Canadian Military Headquarters, London, from Major-General H.F.G. Letson, AG, PAC, RG 24, reel no. C-5296, file HQC 8972.

60. *50 Questions and Answers About CWAC*, p. 11.

61. "Military Policewomen in Big Sister Role," *Globe and Mail*, December 5, 1942, p. 12.

62. Inside cover, *Canadian Geographical Journal*, December, 1943.

63. Cut-sheet of suggested Sponsored CWAC Advertising, summer/autumn 1943, DH, DND, 164.069(D1).

64. Quoted in Bowman, *We Skirted the War!*, p. 70.

65. Dempsey, "Women's Wartime Services," p. 64.

66. "Immorality of Service Women," Wartime Information Board.

67. Memorandum of June 10, 1943, to DAG(C) from R.S. White, i/c Promotion, PAC, RG 24, reel no. C-5303, file HQS 8984-2.

68. MG 28, I 25, vol. 84, *passim*.

69. Letter of July 25, 1943, to Mrs. Edgar D. Hardy, Pres., National Council

of Women of Canada, from Major-General H.F.G. Letson, AG, Department of National Defence, MG 28, I 25, vol. 84.

Chapter 6, VD Control and the CWAC

1. Catharine A. MacKinnon, "Feminism, Marxism, Method, and the State: An Agenda for Theory," *Signs: Journal of Women in Culture and Society,* 7, 3 (Spring, 1982), pp. 515-44.

2. See the Adjutant-General's Circular Letter of Oct. 1, 1940, and the replies to it, in PAC, RG 24, Vol. 2152, file HQ 54-27-32-7, vol. 1.

3. Special permission was required for any exception to this rule. HQ Circular Letter of Aug. 19, 1941, referred to in memo. of May 12, 1942, to AM 3 from Major Joan B. Kennedy, O/A, CWAC, PAC, RG 24, vol. 2253, file HQ 53-27-111-2, vol. 5.

4. Sheila Ryan Johansson has reproved women's historians for using the term "status of women" "as if it were a perfectly self-evident concept" and has gone on to urge us to recognize that at any given time in any given society "the status of women is a composite of many details about the rights, duties, privileges, disabilities, options, and restrictions that the women of a specific group experience as they move through an inevitable progression of age-groups and social roles." She has further recommended that historians of women ground their judgements as to the changing status of women in explicit and specific comparisons of the rights and restrictions facing a certain group of women with those facing an equivalent group of men at the same time from the same society. Johansson, " 'Herstory' As History," pp. 405-10.

5. February, March, 1943, PAC, RG 24, Vol. 6617, file HQ 8994-6, vol. 1.

6. Order-in-Council PC 4398, PAC, RG 24, Vol. 6617, file HQ 8994-6, vol. 1.

7. "Venereal Disease Control Division," reprinted from the First Annual Report of the Department of National Health and Welfare for the fiscal year ended March 31, 1945, PAC, RG 24, Vol. 6618, file HQ 6994-6, vol. 10.

8. See Chapter Five.

9. Memo. of Feb. 1, 1943, to AG from DGMS, PAC, RG 24, Vol. 6617, HQ 8994-6, vol. 1.

10. Memo. of Nov. 27, 1941, to AG from DGMS, PAC, RG 24, Vol. 6617, file HQ 8994-6, vol. 1.

11. Letter of Dec. 22, 1941, with memo. attached, to DMS, DP & NH, from Lt.-Col. W.C. Arnold, RCAMC, for DGMS, PAC, RG 24, reel no. C-5318, file HQC 8994-12.

12. Letter of Mar. 3, 1942, to DGMS from DMO, MD 4, Montreal, PAC, RG 24, reel no. C-5318, file HQC 8994-12.

13. Memo. of June 10, 1942, to DAG from Lt.-Col. J.E. McKenna for Director, CWAC, PAC, RG 24, reel no. C-5318, file HQC 8994-12.

14. Memo. of June 26, 1942, to AG (through D. of O. & A.) from Brigadier O.M.M. Day, DAG, PAC, RG 24, reel no. C-5318, HQC 8994-12.

15. Memo. of July 9, 1942, to MGO, QMG, CGS, from AG, PAC, RG 24, reel no. C-5318, HQC 8994-12.

16. Minutes of Meeting of July 28, 1942, PAC, RG 24, reel no. C-5296, file HQC 8972.

17. DGMS Circular Letter No. 192/1942, PAC, RG 24, reel no. C-5926, file HQC 8972; DGMS Circular Letter No. 244/1943 (July 23, 1943), PAC, RG 24, Vol. 6617, file HQ 8994-6, vol. 3.

18. DGMS Circular Letter No. 236/1943, "The Diagnosis and Treatment of Gonorrhoea in Male Personnel," PAC, RG 24, Vol. 6617, file HQ 8994-6, vol. 3.

19. For the last point, I am grateful to discussion with Jeanne L'Esperance.

20. Theodor Rosebury, Microbes and Morals: The Strange Story of Venereal Disease (New York: The Viking Press, 1971).

21. "Venereal Disease Control in Canada," compiled by the Social Science Research Council, Washington, D.C., n.d., PAC, RG 29, Vol. 1234, file 311-V2-5, vol. 1.

22. Susan Sontag, Illness as Metaphor (New York: Vintage Books, 1979).

23. " 'For All Our Sakes': A Talking Slide Film About Syphilis," reprinted from the Journal of Social Hygiene of the American Social Hygiene Association (1937), p. 20, PAC, RG 29, Vol. 1234, file 311-V2-3, vol. 2.

24. FR & I (Can.) 222 (1).

25. Amendment to the FR & I of the Canadian Armed Forces, announced through GO 377 on Oct. 5, 1942, the amendment effective May 15, 1942.

26. Herbert L. Herschensohn, "Spirochaeta Pallida," Hygeia: The Health Magazine, December, 1936, reprinted together with two other articles in a pamphlet entitled Syphilis, PAC, RG 29, Vol. 1234, file 311-V2-3, vol. 3.

27. Confidential communication of Jan. 17, 1942, to DGMS from Ross Millar, M.D., DMS, DP & NH: Memo. of July 9, 1942, to MGO, QMG, & CGS from AG, PAC, RG 24, reel no. C-5318, file HQC 8994-12.

28. Letter of Oct. 27, 1943, to The Secretary, DND, from Brigadier F.L. Armstrong, DOC, MD 3, PAC, RG 24, vol. 6617, file HQ 8994-6, vol. 3.

29. DGMS Circular Letters Nos. 236 (June 10, 1943), "The Diagnosis and Treatment of Gonorrhoea in Male Personnel," and 244 (July 23, 1943), "The Diagnosis and Treatment of Gonorrhoea in Female Personnel," PAC, RG 24, Vol. 6617, file HQ 8994-6, vol. 3.

30. Confidential communication of Dec. 21, 1944, to Major-General in Charge of Admin., CMHQ, London, Engl., from AG, NDHQ, Ottawa, PAC, RG 24, Vol. 6617, file HQ 8994-6, vol. 6.

31. AG's Confidential Circular Letter, R. 439, of July 1, 1943, PAC, RG 24, Vol. 6618, file HQ 8994-6, vol. 11; RG 24, reel no. C-5318, file HQC 8994-12.

32. Report of VD Control Inspection Trip to MD 4, Jul. 3-6, 1944, by Capt. W.G. Allison, RCAMC, RVDCO (CWAC); Daily Intelligence Report, Aug. 22, 1944, to DDGMS(A) from Lt.-Col. D.H. Williams, AMD 5 (VDC), PAC, RG 24, Vol. 6617, HQ 8994-6, vol. 5; Memo. of Aug. 22, 1944, to D. Org. from DGMS, and an AG's Circular Letter of Sept. 5, 1944, PAC, RG 24, reel no. C-5318, file HQC 8994-12.

The same correspondence called attention to another stigmatizing practice in the CWAC, that of not allowing members under ambulatory treatment for VD after release from hospital to proceed on courses or to new postings until completion of treatment. It, too, was seen to result in stigmatization of VD patients and was brought to a halt by the identical AG's Circular Letter of Sept. 5, 1944.

33. Report of VD Control Inspection Trip to MD 4, Jul. 3-6, 1944, by Capt. W.G. Allison.

34. Canadian Army Routine Orders dealing with Venereal Disease Control, PAC, RG 24, Vol. 6618, file HQ 8994-6, vol. 10.

35. Memo. of Nov. 17, 1944, to DG, CWAC, from Brigadier W.P. Warner, Acting DGMS, and memo. (n.d.) to DGMS from Col. M.C. Eaton, DG, CWAC, PAC, RG 24, reel no. C-5318, file HQC 8994-12.

36. RO 5314. See note 34.

37. For a discussion of the "whispering campaign," see Chapter Five.

38. Confidential letter and memorandum of Nov. 15, 1944, to DGMS from Capt. C.G. Sheps, DVDCO, for DMO, MD 12; letter of Dec. 15, 1944, to DMO, MD 13, from Brigadier W.P. Warner, Acting DGMS, PAC, RG 24, reel no. C-5318, file HQC 8994-12.

39. RO 5543 in "Venereal Disease Control in the C.W.A.C.," Confidential Report of April 13, 1945, PAC, RG 24, reel no. C-5318, file HQC 8994-12.

40. "Management of Neurosyphilis," prepared by Division of VD Control, Dept. of National Health and Welfare, Oct. 16, 1944, PAC, RG 29, Vol. 1234, file 311-V2-4, vol. 1.

41. Circular Letter of Jan. 22, 1944, to DMOs, all M.D.s, & CMO, Pac. Com., from DGMS, PAC, RG 24, reel no. C-5318, file HQC 8994-12; DMO Circular Letter No. 482 of Sept. 27, 1944, to all MOs, MD 3, Kingston, Ont., from Col. A.D. Lundon, RCAMC, DMO, MD 3, RG 24, Vol. 6617, file HQ 8994-6, vol. 6.

42. Confidential Communication of May 2, 1944, to DMO, MD 12, Regina, from DGMS; Confidential Air Mail Letter of May 8, 1944, to DGMS from DMO, MD 12, PAC, RG 24, Vol. 6617, file HQ 8994-6, vol. 5.

43. Daily Intelligence Report VD Control, May 11, 1944, to DDGMS(A) from Lt.-Col. D.H. Williams, AMD5 (VDC), PAC, RG 24, Vol. 6617, file HQ 8994-6, vol. 5.

44. War Diary VD Control, June 9-16, 1944, to DDGMS(A) from Lt.-Col. D.H. Williams, AMD5 (VDC), PAC, RG 24, Vol. 6617, file HQ 8994-6, vol. 5.

45. Letter of Dec. 21, 1943, to The Chairman, Joint Services, Penicillin

284 "THEY'RE STILL WOMEN AFTER ALL"

Committee, from DGMS, PAC, RG 24, Vol. 6617, file HQ 8994-6, vol. 3.

46. Memo. of Feb. 29, 1944, to Lt.-Col. D.H. Williams from Major S.L. Williams, RVDCO, AMD5 (VDC), reporting on DGMS Staff Meeting of Feb. 29, 1944, PAC, RG 24, Vol. 6617, file HQ 8994-6, vol. 4.

47. According to the report on a VD control inspection trip to MD 5, March 20-21, 1944, penicillin had been available in the district so far for only one case of fever-therapy-resistant gonorrhoea. PAC, RG 24, Vol. 6617, file HQ 8994-6, vol. 4.

48. Minutes of the 28th Meeting of the Joint Services Penicillin Committee, June 19-20, 1944, PAC, RG 24, reel no. C-5318, file HQC 8994-12; VD Control Daily Intelligence Report of Aug. 29, 1944, to DDGMS(A) from Lt.-Col. Williams, AMD5 (VDC), PAC, RG 24, Vol. 6617, file HQ 8994-6, vol. 5.

In March, 1943, it was reported that for "the period from the inception of the Corps [September, 1941] to December 31, 1942, . . . the incidence of Gonorrhoea is 6 cases per thousand per annum, and Syphilis 3 cases per thousand per annum." There were no civilian statistics available anywhere in Canada to which those figures could be compared. Memo. of March 4, 1943, to AG from J.C. Meakins, Brigadier, DDGMS(P) for DGMS, PAC, RG 24, reel no. C-5296, file HQC 8972.

During the first half of 1943 the VD rate in the Canadian Women's Army Corps increased. Based on number of cases reported from military districts in Canada and the average monthly strength of the Corps during the period January through June, 1943, the incidence of VD could be calculated as 25.8 per thousand members of the CWAC per annum. "Venereal Disease - C.W.A.C. - Jan.-June 1943," PAC, RG 24, reel no. C-5296, file HQC 8972. A comparable statistic calculated for the Army as a whole (including the CWAC) was 32 per thousand per annum for the year 1943. During 1944 the VD rate in the CWAC decreased, as did also that for the Army as a whole. The incidence of VD in the CWAC in Canada, April 1, 1944, to June 20, 1944, was "12 per 1000 strength per annum, as compared with a rate of 13 for the first quarter of 44." Daily Intelligence Report, Aug. 30, 1944, to DDGMS from Lt.-Col. D.H. Williams, AMD5 (VDC), PAC, RG 24, Vol. 6617, file HQ 8994-6, vol. 5. The comparable statistic calculated for the Army as a whole (including the CWAC) was 29 per thousand per annum for the year 1944. See note 7.

49. See note 39.

50. Letter of Sept. 30, 1944, to The Secretary, DND, from Major-General E.-J. Renaud, DOC, MD4, Montreal; letter of Oct. 16, 1944, to DOC, MD4, from A.C. Spranger, Acting AG, PAC, RG 24, reel no. C-5296, file HQC 8972.

51. See Dorothy Dinnerstein, *The Mermaid and The Minotaur: Sexual Arrangements and Human Malaise* (New York: Harper & Row, 1976), pp. 35-75.

52. PAC, RG 24, Vol. 6617, file HQ 8994-6, vol. 1.

53. From Jan. 1, 1940, to June 30, 1943, the Navy reported 85,580 days
 lost to venereal disease, the Army, 465,322, and the Air Force 146,357.
 Blair Fraser, "VD . . . No. 1 Saboteur"; Department of National Defence
 (Navy, Army, and Air Force), "This Is What VD Costs!" reprinted from
 Maclean's, February 15, March 1, 1944, PAC, RG 24, Vol. 6618, file
 HQ 8994-6, vol. 11.

54. J.W. Tice et al., "Some Observations on Venereal-Disease Control in the
 Royal Canadian Air Force," Canadian Journal of Public Health, 37, 2
 (February, 1946), p. 47.

55. Memo. of Apr. 28, 1944, to DDGMS(A) from Lt.-Col. D.H. Williams,
 AMD5 (VDC), PAC, RG 24, Vol. 6617, file HQ 8994-6, vol. 5.

56. CGS Circular Letter of June 28, 1943, PAC, RG 24, Vol. 6617, file HQ
 8994-6, vol. 3.

57. See note 39.

58. See note 46.

59. "The Venereal Disease Control Programme in the Canadian Army in
 the War of 1939-45," n.d., p. 17, PAC, RG 24, Vol. 6618, file HQ 8994-
 6, vol. 11.

60. Protection Against V.D., Prepared under the Direction of the Chief of
 the General Staff, Canada (Ottawa: King's Printer, 1944), pp. 2, 9, 12,
 13; PAC, RG 24, Vol. 6618, file HQ 8994-6, vol. 11.

61. Tice et al., "Some Observations," p. 54.

62. "Venereal Disease Control in First Canadian Army," Summary of
 Venereal Disease Control Officers' Reports for month ending Nov. 30,
 1944, Appendix "C," PAC, RG 24, Vol. 6618, file HQ 8994-6, vol. 10.

63. Protection Against V.D., p. 2. Page 10 of the same pamphlet carried the
 assurance: "Personal decontamination, if thoroughly carried out, will give
 a high degree of protection."

64. Marie Pichel Warner and Benjamin W. Warner, "Syphilis," Hygeia, March,
 1937, contained in pamphlet of reprinted articles entitled Syphilis, see
 note 26.

65. Confidential Circular Letter of Apr. 25, 1944, on Venereal Disease
 Control – Programme & Policy (CWAC), PAC, RG 24, reel no. C-5318,
 file HQC 8994-12.

66. Special Report No. 178, "Venereal Disease/Unit Practice and Opinion,"
 Prepared by Research and Information Section, AG Branch, March 14,
 1945, PAC, RG 24, Vol. 6618, file HQ 8994-6, vol. 8.

67. Stacey, Six Years of War, vol. 1, p. 127.

68. Mr. McCann, House of Commons, Debates, May 18, 1944, p. 3031.

69. Mr. Bruce, ibid., p. 3026.

70. Videotape prints of both these films are viewable at the National Film
 Archives, Ottawa.

71. Fraser, "VD . . . No. 1 Saboteur."

72. A copy of the pamphlet For Your Information is in PAC, RG 24, Vol.
 6618, file HQ 8994-6, vol. 11.

73. See note 65.

74. Copy at PAC, RG 24, Vol. 6618, file HQ 8994-6, vol. 11.

75. *Protection Against V.D.*, p. 17.

76. "Suggested Lecture Material for Non-Medical Officers of M.D.3," prepared in office of DMO, MD3, Kingston, Ont., Oct. 18, 1943, sent with covering memo. of Aug. 1, 1944, to DMO, MD4, Montreal, from DGMS, PAC, RG 24, Vol. 6617, file HQ 8994-6, vol. 5.

 Nor did the increasing availability and use of penicillin in treatment of VD bring an end to these warnings. An "Outline V.D. Lecture for Soldiers Awaiting Repatriation," May 15, 1945, recommended planting this thought in the soldiers' minds to reflect on while watching the VD film they would be shown: "think of your Mother and Dad, your girl friend, your wife and children. What would they think of you if you were sent to hospital because you had caught Gonorrhoea or Syphilis?" PAC, RG 24, Vol. 6618, file HQ 8994-6, vol. 8.

77. See note 58 and quotation in text.

78. *Protection Against V.D.*, p. 17.

79. See warning in *You and Your Corps*, cited above.

80. See note 42 and text.

81. "Outline V.D. Lecture For Soldiers Awaiting Repatriation."

82. Emphasis mine. Fraser, "VD . . . No. 1 Saboteur."

83. Copy at PAC, RG 24, Vol. 6618, file HQ 8994-6, vol. 11.

84. Consider the "darker implication" of the modern use of disease imagery and metaphor in political rhetoric, as discussed by Sontag, *Illness as Metaphor*, pp. 78-85. The Canadian Army was not alone in thus personifying gonorrhoea and syphilis. In John Horne Burns, *The Gallery* (New York: Harper & Brothers Publishers, 1947), p. 279, an American GI who contracts VD in Naples in 1944 is shown a sample of his "own polluted blood" under a microscope: "Sophie Spirochete. Just one of the girls but what she can do to you! . . . Better than a bomb, though somewhat slower."

85. War Diary VD Control – Programme & Policy, Aug. 11-18, 1944, to DDGMS(A) from Lt.-Col. D.H. Williams, AMD5 (VDC), PAC, RG 24, Vol. 6617, file HQ 8994-6, vol. 5. After the war the booklet was described as "written in a style with appeal for the ordinary soldier and profusely illustrated with pictograms which served to illustrate the reading material, again with popular appeal." "The Venereal Disease Control Programme in the Canadian Army in the War of 1939-45," p. 13.

86. The closest I have come to finding an equivalent male figure was not in VD literature but in a woman's advice column in the *Globe and Mail*, Dec. 19, l942, p. 11. The columnist, Angelo Patri, addressing female war workers and "girls" entertaining men in service clubs, cautioned them to beware of "the soft love tones of a selfish man, who takes what he can get wherever he gets it in the way of pleasure." Behind the "word of advice" lay the same threat of social consequences as used in the VD control material for servicewomen: "A word to those young women, so completely

devoted to their country's good, so inexperienced in the ways of a man with a maid, so ignorant of the ways of the world with a young woman who incurs its displeasure, as to be helpless in the face of a major mistake. Watch yourself. You and you only will live your life through and after this war. You and you only will have to suffer for any mistake you make in association with a serviceman."

87. See the "Decoration" by Hilton Hassell illustrating the article "This Is What VD Costs!"

88. Tice *et al.*, "Some Observations," pp. 51, 50.

89. Department of National Health and Welfare, Epidemiology Division, *Venereal Disease in Canada: Annual Report 1969*, Ottawa, p. 18.

90. See Mary Douglas, *Purity and Danger: An Analysis of Concepts of Pollution and Taboo* (New York: Frederick A. Praeger, 1966).

91. J.W. Tice *et al.*, "Sources and Modes of Venereal Disease Infection in the Royal Canadian Air Force," *Canadian Medical Association Journal*, LI, 5 (November, 1944), p. 402.

92. Fraser, "VD . . . No. 1 Saboteur"; "Take Care – Syphilis and Gonorrhoea Can Cripple You For Life," n.d., PAC, RG 24, Vol. 6618, file HQ 8994-6, vol. 10.

93. *Protection Against V.D.*, p. 7.

94. Inspection Report Venereal Disease Control, Sept. 22, 1943, by Capt. G. Leclerc, RVDCO for MD Nos. 4 & 5, PAC, RG 24, Vol. 6617, file HQ 8994-6, vol. 3. There was racial prejudice at work here as well as sexual, as Mr. Gauthier argued in the House. Referring to an official report that claimed that "Montreal and Quebec are more badly hit by the venereal evil than any other city in the dominion" and that named as "principal cause of the trouble the commercialization of prostitution" in those two cities, Gauthier pointed out that the report had utterly failed to mention "the fact that people from all over the dominion have thronged to these two cities since the outbreak of the war." House of Commons, *Debates*, February 28, 1944, p. 963.

95. PAC, RG 24, Vol. 6617, file HQ 8994-6, vol. 4.

96. Walter Mulligan, Chief Constable of Vancouver, B.C., "Cooperation By the Police in Venereal Disease Control," presented at the Police Officers' Convention for Canada in Windsor, Ont., on Sept. 28, 1949, PAC, RG 29, Vol. 1234, file 311-V2-3, vol. 2.

97. Donald H. Williams, "Commercialized Prostitution and Venereal-Disease Control," *Canadian Public Health Journal*, 31, 10 (October, 1940), p. 462.

98. Donald H. Williams, "The Facilitation Process and Venereal Disease Control: A Study of Source Finding and Suppression of Facilitation in the Greater Vancouver Area," *Canadian Journal of Public Health*, 34, 8 (September, 1943), pp. 405, 397, 401, 402, 399. Williams' views were echoed by Mr. Bruce in the House. While he recognized that "the fight against VD is a fight against squalor, slums, overcrowding, bad housing, hunger, neglect and insecurity," what aroused his indignation were the women who accosted "young naval ratings under nineteen years of age"

trying to return to their quarters at night and the "professionals and, even worse, amateurs," who pestered young airmen checking into hotels. House of Commons, *Debates*, May 18, 1944, p. 3025.

99. "VD . . . No. 1 Saboteur" and "This Is What VD Costs!"

100. Report on visit to Pacific Command on Feb. 3-4, 1944, and Report on visit to MD 12 on Apr. 6, 1944, both by Major S.L. Williams, RVDCO, Western Area, PAC, RG 24, Vol. 6617, file HQ 8994-6, vol. 4.

101. Tice *et al.*, "Sources and Modes of Venereal Disease," pp. 397-98.

102. Tice *et al.*, "Some Observations."

103. Tice *et al.*, "Sources and Modes of Venereal Disease," pp. 398-99.

104. "Outline V.D. Lecture for Soldiers Awaiting Repatriation," May 15, 1945, PAC, RG 24, Vol. 6618, file HQ 8994-6, vol. 8.

105. *Protection Against V.D.*, p. 7; "Outline V.D. Lecture for Soldiers Awaiting Repatriation."

106. Fraser, "VD . . . No. 1 Saboteur."

107. D.H. Williams, "Canada's National Health and Venereal Disease Control," *Canadian Journal of Public Health*, 34 (June, 1943), p. 265.

108. "Security Against Hidden Syphilis for the Canadian Home," n.d. (but between some time in 1944 and the end of the war), PAC, RG 29, Vol. 1234, file 311-V2-3, vol. 2.

109. Williams, "The Facilitation Process," p. 399.

110. Cable of Aug. 21, 1945, to DGMS, Ottawa, from DMO, MD 10, Winnipeg, PAC, RG 24, Vol. 6618, file HQ 8994-6, vol. 8.

111. PAC, RG 24, Vol. 6618, file HQ 8994-6, vol. 11.

112. Minutes of the 47th Meeting of the Dominion Council of Health, May 28-29, 1945, PAC, RG 29, microfilm reel C-9816.

113. Shapiro, *The Sixth of June*, p. 225.

114. Tice *et al.*, "Some Observations," p. 53.

115. See note 66.

116. Apr. 13, 1945, PAC, RG 24, reel no. C-5318, file HQC 8994-12.

117. Memo. of Apr. 24, 1945, to DGMS from Sara Dubo, Captain, RCAMC, PAC, RG 24, reel no. C-5296, file HQC 8972-1-13.

Conclusion: "When Fluffy Clothes Replace[d] the Uniform"

1. Community Silverplate ads, *Maclean's*, November 1, 1943, back cover, December 1, 1943, back cover.

2. Pat and Hugh Armstrong, *The Double Ghetto: Canadian Women and Their Segregated Work* (Toronto: McClelland and Stewart, 1978), p. 19; Hugh and Pat Armstrong, "The Segregated Participation of Women in the Canadian Labour Force, 1941-1971," *Canadian Review of Sociology and Anthropology*, 12, 4, part 1 (November, 1975), pp. 370-71.

3. Richard L. Edsall, "This Changing Canada – Postwar trend: more marriages among younger set/ more weddings later in the year," *Canadian Business*, March, 1957, pp. 44, 46.

4. "Wartime History of Employment of Women and Day-Care of Children,"

Part 1, p. 75; Canada, Department of Labour, *Women at Work in Canada: A Fact Book on the Female Labour Force* (Ottawa: The Queen's Printer, 1959), pp. 14-24.

5. *Canadian Home Journal*, April, 1945, p. 1972; *National Home Monthly*, May, 1945, pp. 58-59.

6. Margaret Ecker Francis, "When Fluffy Clothes Replace the Uniform," *Canadian Home Journal*, July, 1947, pp. 14-15, 56, 58.

7. See, for example, Carol R. Berkin and Clara M. Lovett, eds., *Women, War & Revolution* (New York: Holmes & Meier, 1980).

8. Dorothy Johnson, "Feminism, 1943," *Canadian Forum*, XXI, 266 (March, 1943), pp. 352-53.

9. Persis Charles, "Women and the Two World Wars: Report on Conference at Harvard," *Women's Studies Quarterly*, XII, 2 (Summer, 1984), p. 7.

10. Judy LaMarsh, *Memoirs of a Bird in a Gilded Cage* (Toronto: McClelland and Stewart, 1968), pp. 2, 3.

11. Doris Anderson, *Rough Layout* (Toronto: Seal Books, 1982), pp. 93-100, 116-19.

12. Allan Bérubé, "Coming Out Under Fire: The untold story of the World War II soldiers who fought on the front lines of gay and lesbian liberation," *Mother Jones*, VIII, 2 (February/March, 1983) pp. 23-29, 45.

13. Joy Kogawa, *Obasan* (Toronto: Lester and Orpen Dennys, 1981); Ann Gomer Sunahara, *The Politics of Racism: The Uprooting of Japanese Canadians During the Second World War* (Toronto: James Lorimer, 1981).

Index

Adjutant-General, Canadian Army, 102, 103, 104-05, 106, 107, 108, 118, 119, 123, 124, 170, 175, 176, 190, 192, 193, 194, 197

Advertising, 41-42, 43, 44, 47, 48, 132, 133, 153-54; "sponsored," 138, 139, 167-68

Advisory Committee on Reconstruction, 40

Air Transport Auxiliary, Great Britain, 161-62

Alberta, 32, 63, 69, 71; signs Dominion-Provincial Wartime Day Nurseries Agreement, 51; Calgary, 51, 86; Edmonton, 29, 51, 97

Alcohol, 206

Allatt, Patricia, 20

Amazons, 127, 162

Anderson, Karen, 19

Anderson, Lisa, 19

Armed services, Canadian, 100, 130, 169; *see also* Canadian Army; Royal Canadian Air Force; Royal Canadian Naval Service.

Artists' Guild, War Council of, 30

Auxiliary Territorial Service (ATS), United Kingdom, 97, 117, 118, 119, 162, 277 n7

Beauty salons, 156

Bell bottoms, 150-51

Bland, Lucy, 16

Blatz, Dr. W.E., 51

Bobak, Molly Lamb, 111

Book-keeping, 77

Boyd, W.S., 55

Breadwinner, male as, 12, 71, 79, 93

British Columbia, 9, 10, 32, 63, 69, 71, 97, 99, 189; Burton, 38-39; New Westminster, 99; Prince Rupert, 99, 140; Vancouver, 10, 66, 86, 97, 99, 209, 210; Vernon, 99; Victoria, 35, 66, 97, 99

British Columbia Women's Service Corps, 97, 98, 99, 100, 101, 104, 122

British Commonwealth Air Training Plan Schools, 100

Browne, Major-General B.W., 102, 103, 104-05, 106, 107, 119

Business and Professional Women's Clubs, Canadian Federation of, 40

Camp followers, 103

Canada Rubber Company, 52

"Canada's Women March to the Colours," 138

Canadian Army, 13, 95, 96, 97, 100, 101, 102, 103, 117, 118, 119, 124, 129-30, 133, 170, 180, 189, 190, 191, 192, 193, 195, 196, 197, 198, 199, 200, 203, 204, 206, 207, 209,

210, 211, 212, 213; general requirement for uniformity, 154; manpower shortages, 100-01
Canadian Auxiliary Territorial Service (CATS), 97, 98
Canadian Aviation, 73, 74
Canadian Broadcasting Corporation (CBC), 26, 38, 138
Canadian Expeditionary Force, 96
Canadian Forum, 218
Canadian Home Economics Association, 86
Canadian Home Journal, 216, 217
Canadian Press, 217
Canadian Vocational Training Program (CVT), 62, 76-92, 256 n66; "brides' course," 85-87, 89; home assistants' course, 85, 89, 90, 91
Canadian Welfare Council, 50-51
Canadian Women's Army Corps (CWAC), 13, 15, 16, 21, 38, 70, 95-128, 131, 133, 134-42, 156, 158, 159-60, 163, 166, 173, 183-84, 217-18, 219-20; background of members, 111; comprised 2.8 per cent of total strength of Canadian Army, May, 1945, 104; Corps Command, 111, 117-18, 122-24, 193-94; disbanded September 30, 1946, 124; eligibility requirements, 169; established August 13, 1941, 95; integrated into Canadian Army (Active), March 13, 1942, 119-120, 190; military law, degree to which came under, 117, 118, 120; morale, 176, 178, 182; occupations, 105-113; occupational distributions of other ranks as of March 28, 1945, 110-11; overseas service, 111-12, 170; participation in operational duties, 107-08, 125; pay and benefits unequal to men's in Canadian Army, 113-17, 267 n67, 268 n90;

regulations, 117, 118, 120, 122; regulations governing dress, 141-42, 147-49, 150, 152; regulations governing jewelry, 154; regulations governing use of makeup, 154; strength of, 133; strength as at 27 March 1943, 271 n11; total number of women serving in, 262-63 n4; trades training in, 106-07, 108-09; uniform, design of, 139-40; VD control program in, 188-214; VD rates in, 284 n48
Canadian Women's Army Corps: Why Women Join and How They Like It: CWAC opinion survey of 1943, 135, 136-38, 140, 141-42, 158, 163, 166, 169, 171, 174, 176, 271 n10
CWAC Digest: Facts about the CWAC, 163-64
CWAC News Letter, 146-47, 160, 177
Canadian Women's Auxiliary Air Force (CWAAF), 189; established July 2, 1941, 95; *see also* Royal Canadian Air Force (Women's Division)
Canadian Women's Voluntary Services (Ontario Division), 35-37
Catering for tourists, 64
Central Technical School, Toronto, 70, 73
Chapman, A., 24
Chatelaine, 39
Chatelaine Institute, 41
Chief of the General Staff, Canadian Army, 107, 199
Child care, 19, 30, 38, 49-60, 61, 79, 85, 87, 92, 218; child-care training, 65; *see also* Dominion-Provincial Wartime Day Nurseries Agreement
Chinese Canadians, 96
Chisholm, Brigadier, 182
Churchill, Winston, 78
Civil Service, 29, 82, 101, 114

"Civvy Street," 217
Claxton, Brooke, 59-60
Class differences, 54, 56, 57, 63, 64,
 65-66, 67, 89, 93, 113, 152, 153,
 169, 177, 179
Clerical work, 49, 70, 77, 83, 91, 100,
 101, 105, 106, 107, 108, 109, 110,
 111, 113, 211; "commercial
 refresher," 64
Cohen, Marjorie, 12, 19, 62
Combat, 13, 107-08, 129, 266 n54;
 man's privilege, right, 97; service
 women released servicemen for,
 133, 166; women in, 14-15, 187;
 women's exclusion/exemption
 from, 13, 14, 104, 117, 127-28, 160-
 62, 180, 271 n134
Condoms, 200
Conscription, 96
Cooks, 70, 100, 105, 107, 108, 109, 110,
 113; cook's helper, 105
Co-operative Commonwealth
 Federation, 218
Corps de Réserve National féminin, 97
Corps of Military Staff Clerks,
 Canadian Army, 106, 123
Cosmetics, 153-54
Crealock, Captain Ruth, 177, 178
Criminal Code, 99

Davidson, George F., 50-51
Defence Industries Limited, Cherrier,
 Quebec, 53
Defence of Canada Regulations, 99
Delinquency, juvenile, 50
Dempsey, Lotta, 131, 141, 149, 181, 185
Dependency, 13, 20, 84; more
 prolonged in daughters than in
 sons, 170
Depression, 9, 23, 33, 62-67; fear of
 post-war return to, 77
Diamond engagement ring, 141
Director-General of Medical Services,
 Canadian Army, 123, 172, 182,
 189, 191, 193, 195, 196, 197, 199,
 212
Directorate of Army Recruiting, 115-
 16, 125, 127, 131, 135, 138, 166,
 172, 176, 178, 180, 181
District Rehabilitation Board, 81
Domestic service, 9, 12, 61, 63-67, 69,
 83-86, 87-92, 211, 262 n147;
 efforts to raise status of, 88-89;
 post-war shortage, 83-84;
 unattractive features of, 64-65,
 66-67; wage levels during
 depression, 252 n15; wage levels
 in 1945, 260-61 n129
Domestic Workers' Union No. 91, 66
Domesticity, 21, 84, 93, 132-33, 135,
 137, 169, 180, 182-83, 186, 217,
 218, 220
Dominion-Provincial Wartime Day
 Nurseries Agreement, 49-60, 61,
 220; fees charged mothers, 246-47
 n128; signed by Alberta,
 September, 1943, 51; signed by
 Ontario, July 29, 1942, 51; signed
 by Quebec, August 3, 1942, 51;
 terminated in Ontario, 56-60;
 terminated in Quebec, 55-56; see
 also Child care
Dominion Rubber Company, 47
Double day of labour, 29, 216
Double standard of sexual morality,
 179, 194, 213-14
Dover, Mary, 176
Dratch, Howard, 19
Dressmaking, 64, 69, 83, 91
Driver, 70, 105-06, 110, 111, 113, 152,
 217
Dubo, Captain Sara, 214

Eadie, Mary, 27, 55
"Early Preventive Treatment" (EPT)
 for VD, 199, 200
Eaton, Fraudena (Mrs. Rex), 23-24, 27,
 28, 29, 30, 44, 46, 47, 50, 51, 54,
 55, 57, 58, 61, 87, 89, 90, 91
Eaton, Margaret, 123-24, 178;

promoted to Colonel and appointed Director-General, CWAC, April, 1944, 123

Echoes, 92

Elliott-Haynes Limited of Montreal and Toronto, survey of public opinion re women's services, 134-38, 139, 141, 171, 174

Emancipation, 17, 22, 131, 132, 215; *see also* Liberation

Employment, *see* Paid work; Unpaid work

Employment and Selective Service Offices, 24-25, 29, 30, 31, 51, 61, 81; questionnaire re married women, 47; women's divisions of, 27

Engels, 13

Enloe, Cynthia, 262 n1, 266 n54

Equality, 12-13, 22, 79, 80, 93, 96, 131, 132, 195, 214, 220; in accessibility to VD medical services within armed forces, 190-91; wartime egalitarian rhetoric, 94

Factory worker, 211; *see also* War industry; Power sewing machine operation; Textile workers

Farm Labour Agreement, Dominion-Provincial, 32

Farm Service, 44

Federation of Catholic Charities, 56

"Feminine mystique," 9, 22, 240 n2

Femininity, 14, 20, 21, 62, 129-68, 177, 182-83, 219, 220, 262 n1; and chastity, 170; and cosmetics, 153-55; and deference toward men, 162; and delicacy, 180; and domesticity, 180; and dress, 147-52, 156-57, 181-82; and flightiness, 149; and frequent changes of mind, 157; and "gentility," 152, 154-55; and glamour, 142-47; and hair-dos, 155-56; and heterosexuality, 157-60, 162; and nar-

cissism, 144; and softness, fragility, passivity, and gentleness, 129; and uniforms of women's services, 139-42; and vulnerability, 162; as difference from men, 180, 181; fear of loss of, 15, 139, 162, 163, 168, 186-87; military life antithetical to, 180, 181-83; ornamental function of, 144

Feminism, 22, 215, 218, 220; feminist analysis of women's oppression, 62; post-war backlash against, 219

"Feminization" and de-skilling of production, 74-76, 94

Finance, Department of, 49

Fonda, Henry, 158

For Your Information, RCAF VD film for servicewomen, 201, 202, 203

France, invasion of, June, 1944, 31

Francis, Margaret Ecker, 217

Fraser, Blair, 198, 201, 206, 211

"Full employment," 79

Fultan, Sgt. D.B., CWAC, 177

Garment industry, 29, 30-31

General Motors of Canada, 132

Gentility, 152-55, 171, 173

"Glamour shots," 142-44, 175

The Globe and Mail, 55, 131, 160

Goldman, Nancy Loring, 14

Gonorrhoea, 191, 193, 206, 209; gonococcus *Neisseria gonorrhoeae*, 192; sulpha-resistant cases of, 195-96

Goodfellow, W.A., 58, 59, 60

Goundry, Shirley, 10-11. 219, 273 n55

Governor General of Canada, 25, 163-64

Greyeyes, Mary, 113

Grier, Margaret, 51, 56, 57, 58

Grierson, John, 18

Gunnarson, Corporal Caroline, 147

Hairdressing, 83, 91

Handicrafts, 63

Hardy, Mrs. Edgar D., 29, 80, 186
Hartmann, Susan M., 19
Heise, B.M., 58
Here Come the Waves (1945), 149
Herman, Vic, 164, 166-67
Heterosexuality, 157-60, 162, 184-85
Hitler, Adolf, 14, 44
"Home Aide" project, 89-91; see also
 Domestic service
Home Service Training Schools, 64,
 65-67, 69, 89, 250-51 n4; see also
 Domestic service
House of Commons, 188
"Housewives' shifts," 29-30; see also
 Paid work, part-time
Hutton, Betty, 149

If You Love This Planet, 18
Income Tax, concession to working
 wives, 11, 92; amendment to the
 Income War Tax Act of July,
 1942, 48-49; rescinded, 49, 60
Inflation, 40
Institute of Child Study, University of
 Toronto, 51, 52
Inter-Departmental Committee on
 Labour Co-ordination, 68, 72
Interior decorating, 64
It's Up To You, RCAF VD film for
 servicemen, 201, 202

James, Dr. F.Cyril, 40
Japanese Canadians, 96, 219
Jeunesse ouvière catholique, 47
Job training, 12, 21, 62-93
Job segregation by sex, 12-13, 20, 28,
 61, 62, 63, 64, 70, 71, 73, 74, 75-76,
 77, 79-80, 81, 82, 83, 84, 92, 93,
 94, 105-13, 276 n102
Johannson, Sheila Ryan, 16
Johnson, Dorothy, 218

Kay, Brigadier Orville M.M., 119
Keep Your Powder Dry (1945), 149
Kennedy, Joan B. (Mrs. Norman R.),
 97, 98, 99, 100, 122-23, 154, 218
Kiefer, Nancy, 18
Kildare Barracks, Ottawa, 158, 159
Kinetheodolite operators, 108, 109, 111,
 266 n56
King, William Lyon Mackenzie (Prime
 Minister), 23, 50, 54, 70-71
Kirkpatrick, G.D. (Mrs.), 59
Knox, Jean, 162

Labour, Department of, 11, 22, 44, 47,
 49, 50-51, 54, 60, 65, 78, 80, 81,
 82, 83; Information Division of,
 46; misgivings re "brides' course,"
 87; Public Relations Office of, 31;
 Research and Statistics Branch of,
 24; Training Branch of, 69, 70, 77
Labour Gazette, 69, 73
Labour reserve, women as, 11, 22, 23,
 24, 25, 26, 27, 28, 29, 60, 124
Ladies, 173
Lady/"loose" woman dichotomy, 168,
 188, 201, 204-06, 213-14
LaMarsh, Judy, 218
LaPierre, Dr. G.L., 56
"Latch-key" children, 50
Laundress, 110, 113
LeCocq, Thelma, 74-75, 149, 164
Lenin, 14
Lesbian, 158, 219, 275 n83
Letson, Major-General H.F.G., 107, 119
Liberation, 9, 10, 11, 218-20; see also
 Emancipation
Ligue pour les droits de la femme/
 League for Women's Rights, 40
Local Council of Women of Toronto,
 40, 44
"Loose" woman, 197, 204, 207, 211,
 214; as menace, 206

Machiavelli, 13
Mackenzie, Ian, 218
MacKinnon, Catharine A., 188
Maclean's, 72, 75, 141, 149, 164, 166-
 67, 198, 201, 206, 210

MacNamara, Arthur, 29, 49, 55, 57, 58
Maid, *see* Domestic service
Male economic primacy, 68-69, 71, 82, 216
Manitoba, 69; Brandon, 29; Winnipeg, 35, 86, 216
Marriage, 21, 77, 159-60, 185, 202, 215-16
Married women, 11, 29, 31, 48-49, 60, 92, 218; and VD, 212; barred from federal civil service, 82-83; childless, 27; eligible for Women's Services, 114; eligible to join CWAC, 169; in paid work, 245-46 n113; received unequal treatment in rehabilitation measures, 80, 82; with children not urged to work, 24; with children, working out of economic necessity, 47; with dependent children, not eligible for Women's Services, 114
Marsh, Leonard C., 79
Master General of the Ordnance, Canadian Army, 107, 147, 139, 152
Masculinity, 14, 130, 174, 180, 203, 262 n1; and combat, 129; and commanding authority, 163; and hardness, toughness, action, and brute force, 129; and military service, 139; compatible with regimentation, 183; military uniform linked with, 140-41; "protective role," 174; suited to danger and risk of life, 162; man the protector/aggressor, 127
Maximum hours legislation for household workers, 88, 89
Mayfair, 132, 181
Media, 132, 133, 138, 220; Provincial news stories, 139
Militarism, 96
"Militarization," 220
Militarization of housework, 41-45
Military, 9, 17, 96, 99, 207; enforced

anonymity and uniformity of life in, 180, 181; law, 117, 118, 120; male exclusivity of, 130; masculine institution *par excellence*, 95
Minimum wage legislation, 66; for household workers, 88, 89
"Miss Canada Girls," 38
Mitchell, Humphrey (Minister of Labour), 24, 54, 55, 56, 58, 59, 60
Moffats Ltd., 47
Montreal Association of Protestant Women Teachers, 56
Montreal Council of Social Agencies, 56
Montreal Standard, 142
"Moral panic," 15, 170, 173, 185, 187, 238 n10
Morin, Renée, 47
Munitions and Supply, Department of, 31, 43, 150

Nash, M. Teresa (Terri), 18
National Council of Women, 29, 40, 64, 80, 88, 241 n27; endorsement of women's services, 185-86; urges equality of pay and benefits for service women, 115; urges extension of Unemployment Insurance Act to household workers, 88, 89
National Defence, Department of, 99, 100, 101, 102, 103, 115, 129, 130, 161, 185, 186, 198; and unexamined notions of womanhood, 130
National Defence Headquarters (NDHQ), 97, 100, 101, 102, 104, 105, 107, 115, 116, 117, 118, 122, 123, 125, 135, 139, 175, 183, 186, 189, 190, 194, 196
National Employment Service, 83
National Film Board of Canada, 18, 138
National Health and Welfare, Department of, 59
National Home Monthly, 43, 52, 149,

150, 217; "Glamour Girl" of 1942, 142, 153

National Revenue, Department of, 49

National Selective Service (NSS), 22, 23, 24, 26, 28, 29, 30, 31, 33, 44, 46, 47, 50, 54-55, 60, 71, 82, 83, 109, 133, 139, 238-39 n13; Advisory Board, 28; Women's Division, 11, 23-24, 27, 50, 52, 61, 89, 238-39 n13

National War Finance Committee, 44

National War Services, Department of, 35, 37, 100, 102, 103, 119; initially in charge of recruitment for CWAC, 117

Navy, see Royal Canadian Naval Service

New Brunswick, 69; Moncton, 29

Newfoundland, 10

Non-traditional jobs, 62, 67, 78, 94, 130, 220; employers' reluctance to employ women in, 74; trades training in, 71

Noorduyn Aviation Limited, 73

Nova Scotia, 48, 76; Halifax, 29, 77, 105; Sydney, 35

Nursing, 49, 61, 64, 65, 77, 91, 218; home nursing, 64, 65; nurses' aides, 83; nursing orderly, 111; nursing sisters, 77, 95, 97

Nursing services, 262 n2; Royal Canadian Army Medical Corps, 122, 124

Nursing Services, total number of women serving in during WWII, 263 n4

Ontario, 31, 32-33, 49-55, 56-60, 69, 220; Brantford, 52, 53; Dundas, 144; Dunville, 31; Galt, 52, 53; Hamilton, 31, 53, 60; Kitchener, 70, 156; London, 60; Niagara Falls, 99; Oshawa, 52, 53, 57; Ottawa, 29; Peterborough, 30, 97; Preston, 66; Sarnia, 53; St. Cath-
arines, 31, 52, 53; Toronto, 30, 50, 51, 52, 53, 57, 58, 59, 60, 78, 84, 85, 86, 97, 106; Welland, 31; Windsor, 53

Ontario Farm Service Force, 32-33, 44; Farm Girls' Brigade, 33; Farmerette Brigade, 33; Ontario Women's Land Army, 32; Women's Land Brigade, 33

Overalls and bandana, 44, 141, 149

Pacifism, 17, 219

Paid work, and unpaid work, the connection between for women, 11, 12-13, 19-20, 24, 27, 28, 29, 48, 62, 79, 84, 93, 220, 256-57 n77; average hourly wage of women, 117; farm labour, 9; marital status of women in, 216; "marriage bars" to, 218; part-time, 9, 27, 28, 29, 30, 31, 46; recruitment of women for, 10-11, 18, 22, 23, 24, 26, 27, 28-32, 44, 46, 47, 48, 132, 133; temporary, 180; unskilled and semi-skilled, 19; women's inferior position in labour market, 62; women's labour force participation, 9, 11, 21, 22, 31, 61, 79-80, 89, 215, 250 n189, 251 n9; women's limited access to "skilled" trades, 71, 74; women's post-war intentions re, 77-78

Palmolive soap, 154

Paquette, J.A., 55, 56

Paramilitary service corps, women's volunteer, 97-100, 101, 102, 103, 104, 129, 133, 139, 271 n10; membership in 1943, 265 n41; membership numbered 6,700 by 1941, 97; precedents for in First World War, 263 n12

Patriarchy, 13, 14, 125, 217; patriarchal family model, 93; patriarchal ideology, 94

Patriotism, 10, 11, 12, 23, 41, 43, 44, 46,

47, 48, 76, 203, 218
"Patriotute," 211
Penicillin, 192, 195-96
Pensions and National Health,
 Department of, 77, 192, 195;
 Venereal Disease Control
 Division, 189
Physical education, 63
"Pick-up," 207, 210-11, 213
"Pin-up," 144, 146-47, 220
Policewomen, military, 21, 183
Postal sorters, 110, 113
Post-War Problems and Employment of
 Women in the Province of Quebec,
 256-57 n77
Post-War Problems of Women,
 Subcommittee of Advisory
 Committee on Reconstruction, 40
Power sewing machine operation, 64,
 69, 83
Pregnancy, "illegitimate," 16, 172, 177,
 183, 189; rate among unmarried
 civilian women aged 18-28, 172;
 rate among unmarried women in
 CWAC, 179; screening potential
 CWAC recruits for, 179
Prince Edward Island, 69
Promiscuity, 15-16, 177, 195, 203, 207,
 212-13, 214, 220; among
 servicewomen and servicemen
 compared, 172-73; consequences
 of for men as compared with for
 women, 204; related to prophy-
 laxis, 199
Pronatalism, 87
Prostitution, 16, 153, 207, 212; seen as
 source of infection, 209-11
Protection Against V.D., Canadian
 Army VD control pamphlet, 203,
 204, 209, 211
Proudly She Marches, 138, 147-48
Public Archives of Canada (PAC), 11,
 16
Public sphere/private sphere, 9, 14, 20,
 84, 94, 211-12, 215, 220

Quartermaster General, Canadian
 Army, 107
Quebec, 31, 49-51, 53-56, 60, 61, 69,
 71, 220, 256-57 n77; Gaspé, 39;
 Montreal, 26, 31, 53, 56, 86, 97,
 217, 287 n94; Quebec City, 86,
 287 n94

Racial prejudice, 287 n94
Radio, 29, 138
Ralston, Colonel J.L., Minister of
 National Defence, 102, 103, 104,
 116, 119, 139, 170
Rape, 211
Reconstruction, post-war, 12, 40, 61,
 216; major social policy
 statements, 79
Recruitment of women, 13, 219-20; for
 Canadian Women's Army Corps,
 108-09, 117, 134, 140, 142, 154-57,
 163-64, 166-67; emphasized
 propriety, 183-84; policy of "mass
 recruiting," 177-78; policy of
 "selective recruiting," 178-79; for
 RCAF (WD), 148-49; for women's
 services, 10, 102, 103, 131, 132,
 133, 137, 138, 139, 142, 175, 176,
 180, 183; Combined Services
 Committee, 133, 134, 137, 138;
 effect of unequal pay and
 benefits, 115-16; effect of VD
 discharge policy, 190; effect of
 "whispering campaign," 170;
 resistance to, 133
Red Cross, 39, 265 n40, 271 n10
Registration of employable younger
 women, September, 1942, 24, 26
Rehabilitation benefits, 90-91, 268 n90;
 CWAC members eligibility for,
 199; unequal application to ex-
 servicewomen, 82
Re-instatement in Civil Employment
 Act, 1942, 82
Report: An Inquiry into the Attitude of
 the Canadian Civilian Public

Towards the Women's Armed Forces, 135-38, 139, 141; *see also* Elliott-Haynes Limited

Réserve canadienne féminine, 97-98

Richstone, Mary, 43

Rifle practice, 99, 103, 104, 107, 127

Roe, Kathleen Robson, 265 n40

Rough Layout, 219

Roy, Patricia E., 96

Royal, Lt.-Col. Daisy I., 124, 178

Royal Canadian Air Force (RCAF), 95, 124, 129, 133, 185, 189, 190, 199, 200, 209, 211; Chaplains' survey of attitudes toward women in, 171, 174-75; VD educational films, 201-02, 203

Royal Canadian Air Force (Women's Division), 10, 95, 131, 133, 139, 140, 141, 142, 155-56, 175, 173, 217; eligibility requirements, 113; parachute riggers, 162; total number of women serving in, 263 n4

Royal Canadian Army Cadets, 119

Royal Canadian Army Medical Corps, 127, 214, 217; Division of Venereal Disease, 189; female doctors in, 124; Nursing Service of, 95

Royal Canadian Naval Service, 95, 129, 133, 185, 189, 190, 209

Royal Military College, 96, 104

Runciman, Doris, 86

Russell, Dr. Olive Ruth, 78-79, 80, 82, 84, 85, 86, 87, 91, 92

St. John's Council on the Status of Women, 10

Sales clerking, 64, 83

Salter, Dr. Mary, 91

Sanders, Byrne Hope, Director, Consumer Branch of Wartime Prices and Trade Board, 39

Saskatchewan, 66, 71, 113; Regina, 29, 101-02, 105; Saskatoon, 29, 86, 97

Saturday Night, 52, 97, 107-08, 109, 129, 138, 131

"Scientific Management," 72

Service jobs, 27, 113, 125, 217; in bakeries, 29; in hospitals, restaurants, hotels, laundries, and dry-cleaning establishments, 27, 28, 29, 31, 46

Sexual division of labour, 9, 11, 12-13, 19, 28, 61, 63, 84, 93, 94, 113, 125, 130, 169, 187, 215, 216, 220; between arms bearers and non-arms bearers, 104, 129; breakdown of, 132; fear of reversal of, 164, 166-67; women's primary responsibility for child care and housework, 12, 67, 186

Sexual division of power, 13, 128, 188

Sexual hierarchy of authority, 14, 20, 120-22, 124, 125, 127-28, 130, 160, 162, 162-63, 187, 215, 216, 218, 219, 276 n102

Sexual respectability, 168, 171, 180; at heart of femininity, 170; fear of loss of, 170, 171; threatened by enlistment, 186-87; "women's vulnerable point," 174

Sexual status of women, 16-17, 21, 197

Sexuality, 15, 16, 211; male control over female, 21, 188; protection/regulation of female, 16, 21, 197, 201, 211-12; two-sided conception of women's, 188; threat of female sexual independence, 15, 16, 220

Shapiro, Lionel S.B., 129, 138, 162-63, 212-13

Shoulder to Shoulder, 131, 185

Single women, 22, 24, 25, 27, 31; mobilized first for civilian war work, 22, 24; transferred from rural to war industrialized areas, 25

Sixth of June, The, 212-13

Skill, 19, 71, 72, 74; concept of, 254 n45

Slacks, wartime popularization of for women, 149-52

Small Arms Limited, 73-74

Smart, John, 11
Smellie, Elizabeth, Matron-in-Chief, Nursing Service, RCAMC, 122
Sontag, Susan, 192
Sorby, Alice, 162-63
Stacey, C.P., 96, 97
Status of women, concept of, 281 n4
Stenography, 77, 83, 91, 108
Stephens, Mrs. Norman C., 28
Storewomen, 107, 108, 110, 111, 113
Straub, Eleanor, 19
Sub-Committee on the Post-War Problems of Women, 78; final report of, 79; final report recommended domestic training, 84
Sulphonamides, 191, 192, 195, 196
Switchboard operator, 110, 113
Syphilis, 191, 193, 206; spirochete *Treponema pallidum*, 192

Teaching, 49, 61, 77, 218
Telephone operator, 105
Textile workers, 30-31, 49, 83
Three Queens But I'll Pass, 206-07
Tobias, Sheila, 19
Toronto Board of Education, 54, 58
Toronto Telegram, 150
Toronto Welfare Council, 54
Trades and Labour Congress of Canada, 66
Transfer of women, from East and West to central Canada, 32
Trey, Joan Ellen, 18
Turner, Lana, 149
Turner, Phyllis, 37

Underwood typewriter, 102
Unemployment, 9, 12, 23, 68, 71, 79, 94; among ex-servicewomen, 92; domestic service as solution to women's, 65, 67, 83; Dominion-Provincial Youth Training Program introduced in 1937 to alleviate, 63, 64; layoff of more than 80,000 women war workers,

April, 1945, 77; women's, 61, 251 n8, 262 n147; women's confinement to home solution to men's, 84, 87
Unemployment Insurance Act, 88, 89
Unemployment Insurance Commission, 262 n147
Unpaid work, domestic labour, 12, 23, 33, 41-45, 87; volunteer work, 9, 12, 23, 35-40, 135-36; salvage collection, 33, 34, 36, 37, 38
University education, 77
University of Toronto, 18, 51, 52
"Unwomanly," 174

Vautelet, Renée G. (Mme. Henri), 256-57 n77
Venereal disease, 16-17, 172, 177; Canadian Women's Army Corps anti-VD campaign, 38; communicability of, 191, 192-93; control program for servicewomen compared with that for servicemen, 188-214; control program in civilian society, 207, 209, 212; "Early Preventive Treatment," 199, 200; education, 200-01; incidence in Canadian Army, 172; incidence in CWAC, 172; incidence reduced in CWAC, 179; inequalities in protection for servicewomen, 213-14; leading cause of medical non-effectiveness in the Canadian Army, 198; medical treatment of, 192; perceived as "punishment for sin," 192; predatory female but no predatory male, 206-07, 209-12; prophylaxis, 199, 200; rates in CWAC and Army, 284 n48; women not men seen as sources of infection, 209; *see also* Gonorrhoea; Syphilis
Veterans, 18, 80; of the Great War, 69; ex-servicemen, 12, 82, 90-91, 217-

18, 257-58 n94; ex-servicewomen and domestic work, 85

Veterans' Affairs, Department of, 78, 80, 81, 82, 85, 87, 91, 218

Victory gardens, 33, 38

Victory Loans, 35, 44

Vultee Aircraft Incorporated, 73, 74

Waitressing, 27, 64, 83, 105, 107, 109, 211

War Emergency Training Program, Dominion-Provincial 1940-44, 62, 67-76, 81, 255-56 n66; men given priority in, 68-69, 71; narrow, job-specific for women, 74, 76; non-traditional trades training for women, 71; number of civilian women trained, 76; proportion of female trainees in, 69, 71; range of trades instruction given women, 71; shorter training period for women, 73, 76; trades training for armed forces, 68, 70; war industrial training, 68, 69-70

War industry, 25, 26, 27, 30, 31, 44, 46, 73, 74, 132, 133, 135, 136, 141, 153-54, 191, 210, 215, 218; first woman welder, 142; peak of women's involvement in, 77; state-subsidized child care mainly limited to women working in, 53-55; women's entrance into non-traditional trades in, 130

War Measures Act, 68

Ward aides in hospitals, 27, 83

Wartime Information Board, 79, 170-71, 185; report on "whispering campaign," 173-74, 175

Wartime Labour Relations Board, 40-41

Wartime Prices and Trade Board, 37, 39, 149; Consumer Branch of, 39-40

"Wastage," 191, 207; in Canadian Army caused by VD, 197-98

"We Serve That Men May Fight," 160

"We Serve That Men May Fly," 160

Weddings, military, 184-85

Weeks, Mary, 52

Weir Report, 1944, on post-war employment prospects, 77

Welfare Council of Greater Toronto, 59

West, Mrs. W.E. (Nell), 35

Westinghouse of Canada, 132

"Whispering campaign," 15, 17, 169, 170, 173-77, 178, 185, 186-87, 188, 277 n7; limited basis to, 172

Williams, (Dr.) Lieutenant-Colonel D.H., 189, 206-07, 210, 212

Williamson, Wilma, 144, 156, 157

Wilson, Barbara, 16

Wings on Her Shoulder, 148-49, 155-56

Winspear, Marjorie, 52

Womanhood, 9, 15, 130, 168, 191, 219, 220; and creation and preservation of human life, 127, 129, 166, 168, 271 n134; and concept of the eternally feminine, 166; and dexterity, 74-76; and domesticity, 78, 132, 182-83; and pollution, 209; and subordination and subservience to men, 160; and tolerance for tedium, 74-76, 162; life in armed forces unsuitable for, 180; nature of affected by promiscuity, 204; supportive of men, 43, 162; war changed nothing in nature of, 133; woman the protected/victim, 127

"Womanpower," 9, 11, 24, 79, 102, 108, 164; valued less than manpower, 190

Women At War, 133

Women in Khaki, 140

Women's Army Corps, U.S., 149

Women's Auxiliary Air Force of Great Britain, 100

Women's Auxiliary Service Patrol of Niagara Falls, 99

Women's Employment Committee of the National Employment Commission, 64; final report of 251 n7-8

Women's Home Defence Corps, Great Britain, 107-08

Women's Institutes of Canada, Federated, 38-39; convenor of War Services, 39

Women's right to work, 11, 22, 23, 61, 78, 79, 259 n106

Women's Royal Canadian Naval Service (WRCNS), 133, 139, 140, 141, 142, 156, 173, 263 n4; and bell bottoms, 150-51; eligibility requirements, 113; established July 31, 1942, 95

Women's Services, 9, 13, 26, 44, 77, 87, 129, 137, 188, 215; ambivalence of Canadian society to, 186-87; disapproval of women's joining, 135, 136-37; disbanded 1946, 124; eligibility for in early days, 113; expected expansion of 1943, 133; greatest need for "Stenographers, Clerical Help and Cooks," 109; opposition to, 171-72, 173-75, 176; pay and benefits unequal to servicemen's, 113-17; regulations governing length of hair, 155-56; 61 per cent of eligible women never considered joining, 137; total number of women serving in during WWII, 262-63 n4; trades training in, 70; see also Canadian Women's Army Corps; Royal Canadian Air Force (Women's Division); Women's Royal Canadian Naval Service

Women's Voluntary Services (WVS) Division of the Department of National War Services, 35, 36, 37, 38; "Volunteer Week" September 12-20, 1943, 38; volunteers for day nurseries, 52

Women's Voluntary Services Centres, 35, 37, 38; Block Plan, 37

Women's Volunteer Reserve Corps of Montreal, 97

"Women's work," need to define servicewomen's jobs as, 164

Work, see Paid work; Unpaid work

You and Your Corps, VD control pamphlet for CWAC, 203, 207

Young Women's Christian Association (YWCA), 64, 65, 66; National Council of the Canadian, 88, 154; urges extension of workmen's compensation to household workers, 88, 89; running training courses for household workers during depression, 252 n12; Women's Active Service Club, Ottawa, 154-55

Youth Training Program, Dominion-Provincial, 1937-40, 62, 63-67, 68, 69, 85, 255 n66; domestic training for women, 63-67

THE CANADIAN SOCIAL HISTORY SERIES

Terry Copp,
The Anatomy of Poverty: The Condition of the Working Class
in Montreal 1897-1929, 1974.

Michael Bliss,
A Living Profit: Studies in the Social History
of Canadian Business, 1883-1911, 1974.

Gregory S. Kealey, Peter Warrian, Editors,
Essays in Canadian Working Class History, 1976.

Alison Prentice,
The School Promoters: Education and Social Class
in Mid-Nineteenth Century Upper Canada, 1977.

Susan Mann Trofimenkoff and Alison Prentice, Editors,
The Neglected Majority:
Essays in Canadian Women's History, 1977.

John Herd Thompson,
The Harvests of War: The Prairie West, 1914-1918, 1978.

Donald Avery,
"Dangerous Foreigners": European Immigrant Workers
and Labour Radicalism in Canada, 1896-1932, 1979.

Joy Parr, Editor,
Childhood and Family in Canadian History, 1982.

Howard Palmer,
Patterns of Prejudice:
A History of Nativism in Alberta, 1982.

Tom Traves, Editor,
Essays in Canadian Business History, 1984.

Alison Prentice and Susan Mann Trofimenkoff, Editors,
The Neglected Majority:
Essays in Canadian Women's History, Volume 2, 1985.

Ruth Roach Pierson,
"They're Still Women After All":
The Second World War and Canadian Womanhood, 1986.